THE NATURAL HISTORY OF FLOWERS

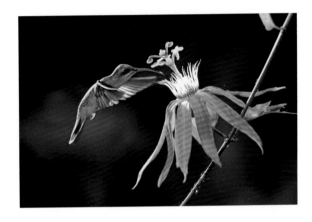

Gideon Lincecum Nature & Environment Series
Sponsored by Jerry B. Lincecum and Peggy A. Redshaw

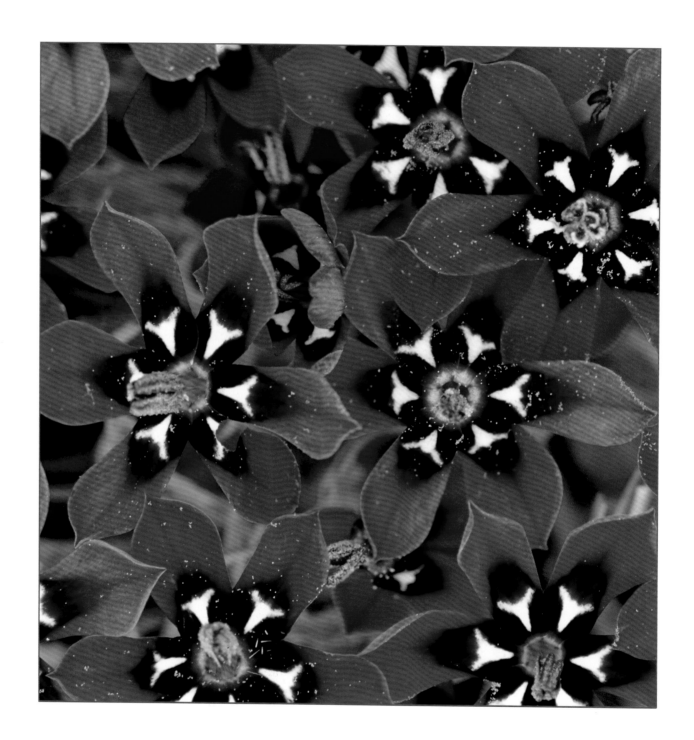

THE NATURAL HISTORY

of

FLOWERS

Michael Fogden & Patricia Fogden

TEXAS A&M UNIVERSITY PRESS | College Station

This paper meets the requirements
of ANSI/NISO Z39.48–1992 (Permanence of Paper).
Binding materials have been chosen for durability.
Manufactured in China
through Four Color Print Group

Library of Congress Cataloging-in-Publication Data

Names: Fogden, Michael, author. | Fogden, Patricia, author.
Title: The natural history of flowers / Michael Fogden and Patricia Fogden.
Other titles: Gideon Lincecum nature and environment series.
Description: First edition. | College Station : Texas A&M University Press,
[2018] | Series: Gideon Lincecum Nature and Environment Series | Includes
bibliographical references and index.
Identifiers: LCCN 2017057887| ISBN 9781623496449 (book/cloth : alk. paper) |
ISBN 9781623496456 (e-book)
Subjects: LCSH: Flowers. | Human-plant relationships. | Animal-plant relationships.
Classification: LCC QK653 .F64 2018 | DDC 582.13--dc23 LC record available at
https://lccn.loc.gov/2017057887

CONTENTS

Preface, vii

Acknowledgments, ix

CHAPTER 1. *Flowers and Humans*, 1

CHAPTER 2. *The Evolution of Flowering Plants*, 10

CHAPTER 3. *Flowers*, 13

CHAPTER 4. *Pollination Syndromes*, 38

CHAPTER 5. *Pollinator Behavior*, 70

CHAPTER 6. *Mimicry and Deceit in Flowers*, 72

CHAPTER 7. *Flower Predators, Nectar Thieves, and Flower Defenses*, 80

CHAPTER 8. *Antipollinators*, 84

CHAPTER 9. *The Flower's Final Act: Seed Production and Dispersal*, 86

CHAPTER 10. *Seed Dispersal Syndromes*, 92

CHAPTER 11. *Fruit Spoilers and Seed Predators*, 124

CHAPTER 12. *The Seasonality of Flowering and Fruiting*, 130

CHAPTER 13. *Pollination, Seed Dispersal, and Coevolution*, 133

CHAPTER 14. *Selected Neotropical Plant Families, Genera, and Species*, 136

Alstroemeriaceae: *Bomarea*, 136

Bignoniaceae: *Hadroanthus, Tabebuia*, and *Cydista*, 137

Bromeliaceae (Bromeliad Family), 139

Cecropiaceae: *Cecropia*, 143

Chloranthaceae: *Hedyosmum*, 144

Clusiaceae: *Clusia* and *Symphonia*, 145

Coriariaceae: *Coriaria*, 149

Ericaceae (Heath Family), 149

Fabaceae: *Inga, Calliandra, Erythrina*, and *Mucuna*, 151

Heliconiaceae: *Heliconia*, 155

Lauraceae (Avocado Family), 159

Loranthaceae and Viscaceae (Mistletoe Families), 161

Marcgraviaceae (Shingle Plant Family), 164

Melastomataceae (Melastome Family), 167

Moraceae: *Ficus* (Fig Family), 170

Orchidaceae (Orchid Family), 175

Passifloraceae: *Passiflora* (Passion Flower Family), 182

Rubiaceae (Coffee and Quinine Family), 186

Siparunaceae: *Siparuna*, 190

Solanaceae (Potato and Tobacco Family), 191

Glossary, 197

References, 201

Index, 207

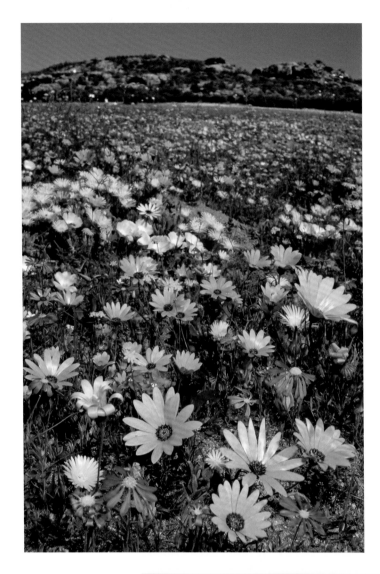

Figures 1 and 2. Good winter rains produce spectacular displays of daisies and other flowers in Namaqualand, South Africa. The colors, shapes, scents, and other characteristics of the flowers have evolved to attract pollinators.

PREFACE

FLOWERS and their final product—fruits and seeds—have played an important role in human activities for thousands of years. Even so, many of us have given little thought to the real purpose of flowers—to the reasons for their beauty and structure, to the significance of their colors and smells, or to their function in the life and survival of plants. Why are flowers colorful? Why do some flowers have a heavenly fragrance while others smell like dung or rotting carcasses? Why are blackberries sweet and juicy? And why are nuts encased in hard shells? The answers to these questions are the subject of this book. Together, flowers, fruits, and seeds enhance a plant's chances of survival by contributing to two vital processes that help spread a plant's genes—cross-pollination (which promotes variation and diversification) and seed dispersal. Some flowers are pollinated by wind or water, but most, especially in the tropics, are designed to attract bees, butterflies, birds, bats, or other pollinators (figs. 1 and 2). Many fruits, too, are designed to attract animals to disperse the seeds that carry their genes (figs. 3 and 4). The diverse and sometimes bizarre ways by which flowers and fruits have persuaded animals to carry their pollen and seeds to and fro are described and illustrated in the following chapters.

This account is not a comprehensive survey of pollination and seed dispersal. That would be difficult because there are about 260,000 species of flowering plants (angiosperms) in about 490 families worldwide. Our object is simply to discuss and illustrate a representative sample of flowering and fruiting strategies as well as the interactions between plants and their pollinators and dispersers. We have concentrated on plants that we have found to be photogenic and those that have interesting relationships with pollinators and seed dispersers. Our coverage is biased toward Central and South America but also includes material and photographs from North America, Europe, Africa, Southeast Asia, and Australia. Examples from Costa Rica and Ecuador, where we have lived for many years, feature prominently throughout. Almost all the photographs were taken in natural habitats and depict natural behavior by pollinators and seed dispersers as well as nectar thieves and seed predators. More comprehensive, academic surveys are available for both pollination and seed dispersal, some of the most useful being *Diversity and Evolutionary Biology of Tropical Flowers* (Endress 1994); *The Natural History of Pollination* (Proctor, Yeo, and Lack 1996); *Pollination and Floral Ecology* (Willmer 2011); and *Principles of Dispersal in Higher Plants* (van der Pijl 1972). We also recommend Peter Bernhardt's *The Rose's Kiss* (1999), which is an entertaining exploration of the biology of flowers. References for all five titles are included in the reference list.

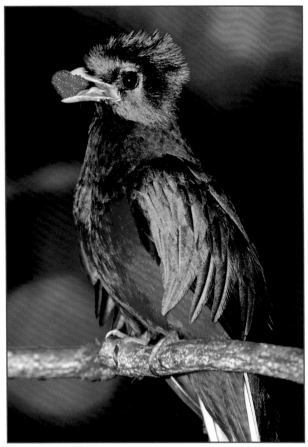

Figures 3 and 4. Similarly, the characteristics of fruits have evolved to facilitate seed dispersal. These lurid blue berries (*Psychotria*) have evolved to attract birds, as has the wild thimbleberry (*Rubus rosifolius*) in the bill of the resplendent quetzal (*Pharomachrus mocinno*).

For the taxonomy and scientific names of flowering plants at the family level, we have followed *Flowering Plants of the Neotropics* (Smith et al. 2004). At the level of genus and species, we have followed local floras or enlisted the help of botanists with expert local knowledge. However, note that the classification and taxonomy of plants is not static. Scientific names change regularly as botanists advance their understanding of plant relationships. Note specifically that recent studies by the Angiosperm Phylogeny Group show that monocots form a natural monophyletic group but that dicots do not and have been split. The majority of dicots are now placed in a natural group called the eudicots, while most of the remainder are in a group called magnoliids, which retain the characteristics of more primitive angiosperms.

Although common names have no standing among professional biologists, they are extremely important for amateur naturalists. We have therefore used well-established English common names for plants and animals whenever possible but have added scientific names for species and genera when first mentioned or whenever we feel that extra clarity is needed. And we have used scientific names for the tropical plants and animals for which no English names exist. We have generally not used scientific names when referring to groups of plants that are very familiar—for example, oaks, poppies, buttercups, and evening primroses—nor for familiar animal groups—for example, elephants, howler monkeys, toucans, jays, tanagers, bumblebees, hoverflies, and hawkmoths. We have avoided technical botanical terms as much as possible, but a good number are unavoidable. Definitions for those can be found in the glossary. We have also avoided discussing the chemistry of flower pigments and scents. For those interested in knowing more about these subjects, *The Natural History of Pollination* and *Pollination and Floral Ecology* are good starting points.

ACKNOWLEDGMENTS

IN WRITING this book and taking the photographs, we have benefited from the research of numerous biologists, many of whom are cited in the bibliography. Many others—biologists and friends—have generously provided identifications of plants and insects, background information, accommodation, or other logistical help. We are grateful and indebted to the following: John Atwood, Gabriel Barboza, John Blake, Bill Busby, the late John and Doris Campbell, David and Deborah Clark, Robert Colwell, Eladio Cruz, Philip DeVries, Jan Feil, Peter Feinsinger, Adrian Forsyth, Robin Foster, Gordon and Juta Frankie, Lawrence Gilbert, the late Luis Diego Gomez, the late Wolf Guindon, William Haber, Winnie Hallwachs, Barry Hammel, Hank Howe, Stephen Hubble, Carol Hughes, Daniel Janzen, Lou Jost, Richard Laval, Douglas Levey, Bette Loiselle, Jack Longino, Karen and Alan Masters, Francisco Morales, Greg Murray, Shahid Naeem, Piotr Naskrecki, Nick Owens, the late Ted Parker, Richard Parsons, Christopher Perrins, Alan Pounds, George Powell, Jack Putz, Peter Raven, Sarah Sargent, Mary Seely, the late David Snow, Gary Stiles, Marco Tschapke, Orlando Vargas, Freddie Villao, the late Otto von Helverson, Nathaniel Wheelwright, York Winter, Martin and Barbara Woodcock, and Willow Zuchowski.

We are also grateful for comments made by two anonymous reviewers who read and commented on the manuscript and for the professional expertise of the editors and designers at Texas A&M University Press. We wish to give special thanks to acquisitions editor Stacy Eisenstark (our first contact at Texas A&M University Press), project editor Pat Clabaugh, and copyeditor Laurel Anderton for her sympathetic editing.

THE NATURAL HISTORY OF FLOWERS

FLOWERS AND HUMANS

Flowers in Human Culture: Art and Agriculture

Flowers have featured prominently in human cultural and artistic activities for thousands of years. Flowers were being used to ornament women's hair in ancient Egypt at least 4,500 years ago, and the art of flower arranging was practiced in China, Greece, and Rome over 1,000 years ago. Flowers have inspired the work of artists around the world and are the subject of many important paintings, Monet's water lilies and van Gogh's sunflowers and irises being the most famous Western examples. Flowers with great symbolic or artistic significance include the rose in Western countries; peonies in China; cherry blossoms and chrysanthemums in Japan; and the lotus flower (*Nelumbo nucifera*) in India. Flowers have also inspired the work of poets. William Wordsworth's poem about daffodils, "I Wandered Lonely as a Cloud," is one of the most loved and popular of all time in the English-speaking world.

Nowadays, flowers are used to send messages of love to family and significant others and are an important traditional and decorative feature at weddings and other festive occasions. Flowers are also used to commemorate death and sacrifice—flowers have been found in tombs in the pyramids of ancient Egypt, and today bouquets are placed on graves and at the sites of fatal accidents and disasters. "Poppy Day" in the United Kingdom, Canada, Australia, New Zealand, and other Commonwealth countries commemorates those who died during the First World War. At that time, red poppies bloomed profusely all across the devastated land of the Flanders battlefields and came to symbolize the blood spilled in the war (fig. 5).

Today, flowers have great economic importance. The huge global market for garden plants, houseplants, and cut flowers is worth billions of dollars. Holland has long been a major center for the production and distribution of flowers, but the market has shifted. Cut flowers are now flown around the world from tropical developing countries such as Colombia, Ecuador, Kenya, and Uganda to major markets in the United States, Europe, and Japan.

The final products of flowers—fruits and seeds—are vitally important as food. Early people ate wild berries, nuts, and seeds, and those in hunter-gatherer societies still do. The three principal foods in the world today—rice, wheat, and maize—are the single-seeded fruits of the flowers of grasses.

Figure 5. Red poppies such as these commemorate those who died in the First World War.

Domestication of these cereals is thought to have begun about 12,000 years ago. In China, wild rice was being collected at least 12,000 years ago and has been domesticated for 8,000 years, thereafter spreading westward to India and beyond (fig. 6). Wheat, which originated in the Fertile Crescent (the Middle Eastern region that stretches from the Persian Gulf through Iraq, Syria, Lebanon, Jordan, Israel, Palestine, and northern Egypt), has also been a staple food for at least 12,000 years and was sufficiently important to be involved in religious rituals in many European and Asian cultures. The wild ancestor of maize (corn) is one of several species of grass found in Mexico called teosinte. The species in question (*Zea mays* ssp. *parviglumis*) does not look much like maize but is very similar at the DNA level and appears to be its direct ancestor. It is found in southwestern Mexico.

Cocoa and coffee are two other products derived from seeds. Cocoa (or chocolate) comes from the seeds of the cacao, *Theobroma cacao* (Malvaceae), a tree native to the Amazon Basin but cultivated in Mexico and Central America (originally by the Aztecs and Mayans) for at least 3,000–4,000 years. It was introduced into Europe by the Spanish conquistadors in the mid-seventeenth century (fig. 7). Coffee (*Coffea arabica*, Rubiaceae), native to Ethiopia, has a more recent history. It was first cultivated and used to brew coffee in Arabia in the mid-fifteenth century and was first imported into Europe in the seventeenth century. Several coffee species are now cultivated, but *C. arabica* accounts for gourmet coffees and about 80 percent of total production. Most of the rest comes from *C. canephora*, commonly known as "robusta coffee," which is hardier than *C. arabica* and originated in sub-Saharan Africa.

Many of today's most popular and well-known

fruits also have a recorded history going back several thousand years. There is evidence that figs were cultivated in the Jordan Valley over 11,000 years ago, making them the oldest-known noncereal crop. Grapes were used for wine making 8,000 years ago in the Near East, and dates were being hand pollinated in Mesopotamia 3,500 to 5,500 years ago.

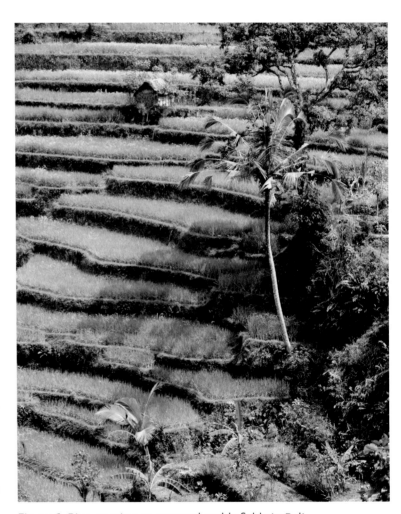

Figure 6. Rice growing on terraced paddy fields in Bali. Rice is the most important cereal worldwide, providing more than one-fifth of the calories consumed by people. Rice is wind pollinated and not dependent on bees or other animal pollinators.

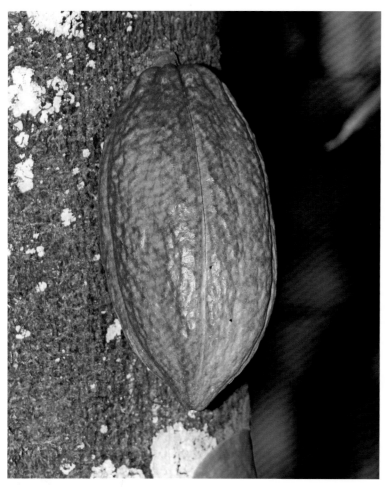

Figure 7. A cacao fruit (*Theobroma cacao*) on a tree in Costa Rica. Cacao is native to lowland rain forests from southern Mexico to the Amazon Basin and is pollinated by midges (*Forcipomyia*, Ceratopogonidae). The fruit (or pod) contains 20–60 seeds (beans) embedded in a white pulp. The seeds are the main ingredient of chocolate, while the pulp is used to make refreshing drinks. There is archaeological evidence that cacao has been cultivated in Mesoamerica since at least 1900 BC.

Other fruits that have been grown for several thousand years include apples and oranges in China, pomegranates in Persia, and bananas in India.

Early humans ate fruits and nuts and no doubt dispersed seeds in much the same way as other mammals. However, with the rise of agriculture about 10,000–12,000 years ago and the human population explosion that resulted, the role of humans in seed dispersal became dramatically more important. People invented agriculture—useful plants were cultivated, enhanced by selection of favorable traits, and carried to new areas, resulting in huge extensions of their range, far beyond their original, natural boundaries. Major crop plants, such as wheat, rice, maize, potatoes, coffee, grapes, apples, oranges, bananas, and others are now grown throughout the world, limited only by their basic ecological requirements. And, beguiled by their beauty, humans have enabled ornamental blooms, such as roses, chrysanthemums, and tulips, to become more widely distributed than all but a few wildflowers.

Because of the value of plants as food or ornaments, humans have essentially entered a mutualistic relationship with many of them. Unfortunately, this has contributed enormously to the destruction of natural habitats, including forests, grasslands, and wetlands. Appalling deforestation continues unabated in tropical Asia, the Amazon Basin, and elsewhere, and the insidious spread of agrolandscapes is causing an inevitable loss of diversity everywhere. Recent agricultural developments have seen an enormous expansion of crops such as palm oil, soy, rapeseed, and maize—the latter grown not even for food, only for conversion into biofuels, or burnable biomass for energy production in anaerobic digesters (fig. 8). It is hardly surpris-

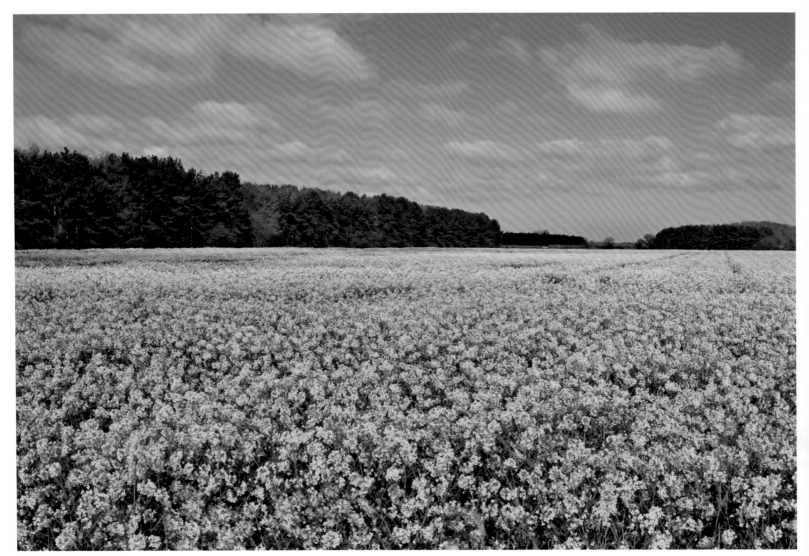

Figure 8. Rapeseed (*Brassica napus*) growing in Norfolk, England. Rapeseed is currently the third largest source of vegetable oil in the world and is also used in the production of animal feed and biodiesel. Rapeseed flowers produce abundant nectar. If used appropriately, as an element of ecological farming alongside hedgerows and flower-rich field borders, rapeseed is a crop that could benefit bee populations.

ing that our planet is now, in what is known as the Anthropocene epoch (the age of humans), undergoing its sixth episode of mass extinctions, the first since the loss of the dinosaurs and other organisms some 66 million years ago.

The Worldwide Pollinator Crisis

In recent years, worrying global declines of both wild and managed bee populations, particularly in Europe and North America, have received a lot of publicity. In the United States, 30–40 percent of commercial honeybee colonies have been lost since 2006, and there are now fewer colonies than at any time in the last 50 years. In Europe, losses differ from country to country, but since 1985, they have amounted to around 25 percent in much of Europe and 54 percent in the United Kingdom. Other areas with significant losses of honeybee colonies include China, Japan, and the Nile Valley in Egypt. If bee

losses are allowed to continue, the outcome is likely to be serious (fig. 9).

Losses are not confined to managed honeybees. For example, a study by Laura Burkle and coworkers (2013) compared data collected in rural Illinois between 1888 and 1891 with data collected in 1971–1972 and 2009–2010, a time when a largely forested landscape was reduced to forest fragments. The study found that more than half of over 100 wild bee species had been lost and that the ability of the remaining species to pollinate the whole range of available plants had been seriously degraded.

These losses are a reason for concern because bees, both wild bees and managed honeybees, are essential pollinators of many crops. The three most important crops—wheat, rice, and maize—are wind-pollinated exceptions, but it is estimated that no fewer than 70 of the 100 most important food crops, and at least a third of global food production, depend on bees and other animals for pollination. So do valuable fodder crops, such as alfalfa and clover. Pollinators are essential for some crops (e.g., melons, blueberries, cocoa/chocolate, almonds, and Brazil nuts) and very important for many others (e.g., avocados, apples, cherries, and plums) if good crop yields are to be obtained.

According to a recent study (Garibaldi et al. 2013), the losses of wild bees may be even more worrying than losses of managed honeybees (figs. 10–12). The study, involving 50 researchers, was carried out worldwide on 41 crop systems. It showed that wild bees (bumblebees and social bees in many genera) were twice as effective as honeybees in pollinating the crops studied, including almonds, cherries, coffee, mangoes, watermelons, tomatoes, strawberries, blueberries, rapeseed, red clover, and others. It also showed that when wild bees are absent,

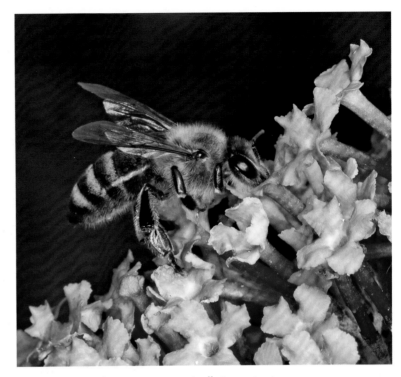

Figure 9. Honeybees are economically important pollinators but are declining throughout much of the world because of multiple factors, including extensive monocultures, pesticides, and parasites, and especially habitat destruction and the associated loss of biodiversity.

crops are less productive whatever the abundance of honeybees. Clearly, honeybees are not an adequate replacement for wild pollinators and we should avoid depending too much on managed honeybees, particularly because a single species is more vulnerable to disease and environmental change than a group of many pollinator species. Vast monocultures, such as California's almond groves, are potentially vulnerable. At present, pollination of the groves depends entirely on managed honeybees, which have to be trucked in from all over the United States—a total of 1.7 million hives are needed, about 85 percent of all the available hives in the country. The situation is all

Figures 10, 11, and 12. Communities of wild native bees, such as bumblebees (*Bombus*), flower bees (*Anthophora*), and leafcutter bees (*Megachile*), are even more important than honeybees but are declining for similar reasons.

the more grave because the area of almond groves is expanding (to satisfy increased demand for almonds from China) at the same time as managed honeybees are suffering increased mortality.

Bees, both wild and managed, are dying for many different reasons, known and unknown, and often interrelated. Suggested causes for the loss of honeybee colonies, often referred to as "colony collapse disorder," include viruses and parasites, exposure to insecticides and other agricultural chemicals, malnutrition, loss of habitat, global warming, or a combination of factors. The parasitic mite *Varroa destructor* is one of the most serious threats to honeybees. Apparently it originated in Asia but has now spread throughout much of the world. *Varroa* mites feed on the blood of adult honeybees and their larvae and help spread deadly viruses and other diseases. A *Varroa* infection usually leads to the death of a bee colony within two or three years.

The ability of bees, including wild species, to resist parasites and diseases is influenced by their general fitness, particularly the quality of their nutrition and their exposure to insecticides and other agricultural chemicals. In agricultural areas, bees are exposed to a toxic "pesticide cocktail" in the collected pollen that is the main protein source for their colonies and broods. Researchers have found residues of more than 150 chemicals in bee pollen samples, and multiple chemicals in individual samples. A study by C. A. Mullin and coworkers (2010), carried out across 23 US states and a Canadian province, stated that "surviving on pollen with an average of seven different pesticides seems likely to have consequences"—an understatement if ever there was one. Indeed, the quantity of chemicals applied to crops can be staggering. Felicity Lawrence, author of two best-selling exposés about the food business,

Not on the Label and *Eat Your Heart Out*, wrote in the *Guardian* in the United Kingdom on October 3, 2016, "British farmers growing wheat typically treat each crop over its growing cycle with four fungicides, three herbicides, one insecticide and one chemical to control molluscs. They buy seed that has been pre-coated with chemicals against insects. They spray the land with weedkiller before planting, and again after. They apply chemical growth regulators that change the balance of plant hormones to control the height and strength of the grain's stem. They spray against aphids and mildew. And then they spray again just before harvesting with the herbicide glyphosate to desiccate the crop, which saves them the energy costs of mechanical drying." Much the same happens with many crops throughout the world.

A group of pesticides known as "neonicotinoids" is attracting much attention. Unlike contact pesticides, which remain on the surface of stems and leaves, neonicotinoids are systemic pesticides that are absorbed by the plant. If an animal ingests any part of the plant, including its pollen or nectar, it ingests the pesticide. Furthermore, only 5 percent of the pesticide is absorbed by the plant; the other 95 percent ends up in the soil, groundwater, or other plants, where it is a danger to diverse insects, birds, and other animals, including microscopic soil fauna. Chemicals can have adverse effects on bees even if they do not kill. Neonicotinoids, for example, may compromise essential behavior, including navigation and spatial orientation, foraging and flower recognition, and learning.

By converting forests and grasslands into farms, modern industrial agriculture causes habitat for wild bees to shrink more every year. The creation of vast monocultures and the application of herbicides remove the bee-friendly flowers that once mingled with crops. The monocultures bloom for only a few

weeks, so there is no food for wild bees the rest of the year. Global warming is resulting in yet more problems, notably a mismatch between the timing of flowering and the emergence of bees in spring— nowadays they do not always coincide.

What can be done to improve matters? Banning the use of the worst of the agricultural chemicals that harm bees would be an effective first step. It would be in accordance with the Rio Declaration on Environment and Development (sponsored by the United Nations Environment Programme and signed by 172 countries in 1992) and its "precautionary principle," which is defined as follows: "Where there are threats of serious or irreversible damage, lack of full scientific certainty shall not be used as a reason for postponing cost-effective measures to prevent environmental degradation." Regrettably, many governments ignore the precautionary principle on the grounds that banning neonicotinoids and other chemicals might be harmful to crop production, farming communities, and consumers. It is unfortunate that democratic governments with a mandate of only a few years tend to act to secure short-term political advantages rather than avoid longer-term disasters.

Improving resources for wild bees and other pollinators would be a useful second step. Modern agriculture is dominated by large-scale monocultures that combine extensive use of herbicides with the elimination of hedges and other natural or seminatural areas. In such an environment, plant diversity is very low and useful flowers so few that bees find it difficult or impossible to find sufficient food. What is needed is a return to ecological farming, the way farming was carried out throughout much of human history. Ecological farming helps in several ways: it avoids monocultures and maintains natural or seminatural areas in proximity to crops; it keeps hedgerows and flower-rich field borders (fig. 13); and it includes crops such as clover, melons, sunflowers, and rapeseed that provide a rich source of nectar and pollen. By restoring populations of wild bees and other pollinators, ecological farming improves the effectiveness of pollination and improves crop yields. Indeed, a study by Lora Morandin and Mark Winston (2006) showed that farmers could maximize profits by not cultivating up to 30 percent of their land and instead leaving it to grow flowers for pollinators, thereby saving on cultivation costs while benefiting from higher yields on the remaining 70 percent.

There is little doubt that modern intensive agriculture has caused populations of wild bees to become so impoverished that there is a real threat of a pollinator crisis. However, the publicity surrounding the crisis has produced some benefits. More and more urban and suburban gardens are being planted with a mix of bee-friendly flowers, and rooftop gardens are proliferating (and attracting bees) in major cities around the world. Leading the way are cities as far apart as New York, Chicago, London, Berlin, Singapore, Sydney, and Osaka. There are even vertical gardens in which buildings are festooned with plants. In some areas the changes are so profound that suburbia and cities are now better for bees than parts of the surrounding countryside.

The greening of suburbia and cities is not just good for bees. It has other beneficial effects: green roofs are heat shields that dramatically reduce the cost of air conditioning and heating; they reduce rain runoff; they produce oxygen and reduce the levels of harmful pollutants; and, not least, they have a marked therapeutic effect, contributing to a general feeling of well-being.

Figure 13. Annual flowers, including corn marigolds (*Chrysanthemum segetum*) and cornflowers (*Centaurea cyanus*), growing in a field margin in England. Set-aside field margins enhance habitat for wildlife, including populations of essential crop pollinators.

THE EVOLUTION
OF FLOWERING PLANTS

Flowering plants appeared quite late in the evolution of plants, only about 125 million years ago. Dry land was first colonized more than 400 million years ago, in the Silurian period, by plants derived from green algae. By about 300 million years ago, during the Carboniferous period, ferns, club mosses, and horsetails had evolved and diversified. They reproduced by means of wind-dispersed, dustlike spores, and some were treelike in stature, reaching heights of 30 meters (100 feet) or more. The first seed-producing plants, including the gymnosperms (conifers and others), appeared and diversified about 250 million years ago, during the late Paleozoic, and gymnosperms were dominant for the next 100 million years, alongside dinosaurs. Although gymnosperms produce seeds, they lack flowers. Their ovules are exposed to the air, and pollination occurs when pollen is blown by the wind or is carried by an insect from pollen cone to ovule. Most modern gymnosperms are wind pollinated, but long before the appearance of flowering plants, many ancient gymnosperms were pollinated by insects, including lacewings, scorpion flies, flies, beetles, and moths. Fossils of insects in all these groups have been found in amber 105–165 million years old, some with gymnosperm pollen stuck to their mouthparts or bodies. Subsequently, many gymnosperm pollinators succeeded in making the transition to feeding on and pollinating flowering plants.

Four groups of gymnosperms—conifers, cycads, Gnetales, and *Ginkgo*—have survived until the present, the most important being the conifers. Today, coniferous trees still occur in most parts of the world and dominate the northern temperate regions of Europe, Asia, and North America. All conifers and the maidenhair tree (*Ginkgo biloba*) are wind pollinated, but most of the Gnetales (*Ephedra, Welwitschia,* and *Gnetum*) and at least some cycads are pollinated by insects. The bizarre *Welwitschia mirabilis*, endemic to the Namib Desert, is pollinated by the *pyrrhocoreid* bug *Probergrothius sexpunctatus* and other insects (figs. 14 and 15); *Ephedra foeminea* is pollinated by nocturnal moths and flies attracted by reflective pollination drops that shine in moonlight; and some cycads are pollinated by beetles.

Fossil evidence shows that flowering plants (angiosperms), most of which are pollinated by animals, evolved about 125 million years ago and,

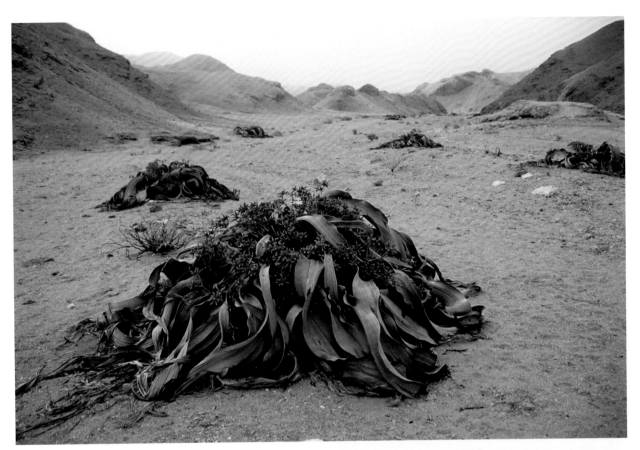

Figure 14. The extraordinary gymnosperm *Welwitschia mirabilis* is endemic to the Namib Desert in southern Africa. It consists of only two leaves that grow continuously, splitting and fraying as they do so, giving the impression of many leaves. Large specimens may be well over 1,500 years old. *Welwitschia* has male and female cones on separate plants.

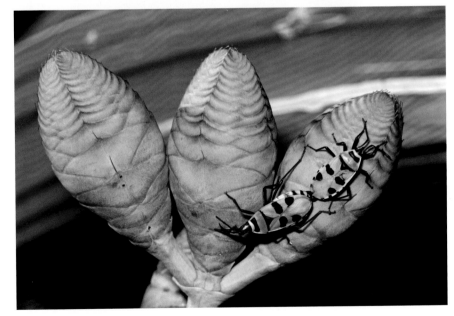

Figure 15. *Welwitschia* is pollinated by insects, mainly flies and bugs. The bugs in this case are a mating pair of a pyrrhocoreid bug (*Probergrothius sexpunctatus*) on female cones. Insects are attracted by the nectar that is secreted by both the male and female cones.

within a geological "twinkling of an eye" of only 20–30 million years, became the dominant plants on Earth. Fossilized flowers in amber, dating to 100 million years ago in the mid-Cretaceous, even show pollen tubes penetrating a flower's stigma. The appearance in flowering plants of large quantities of new, nutritious foods in the form of nectar, pollen, fruits, and seeds created opportunities for totally new and diverse types of pollinators and dispersers. Insects, followed by birds and mammals, became

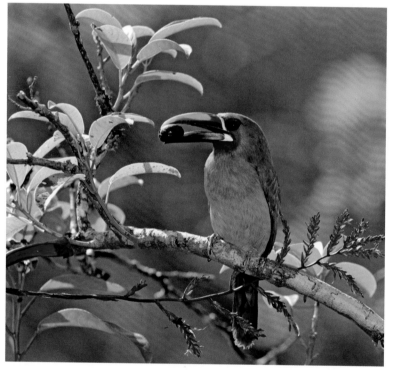

Figure 16. An emerald toucanet (*Aulacorhynchus prasinus*) about to deliver a passion fruit (*Passiflora*) to nestlings in a nest cavity. One important difference between pollination and seed dispersal is that pollinators are rewarded if they carry pollen from one flower to another, but seed dispersers are rewarded in advance, regardless of where seeds end up—under a parent tree, in a nest cavity, or in some other adverse site.

specialized to take advantage of the new resources, after which came predatory species to exploit the exploiters. Also, by enlisting the help of animals to disperse their genes in their pollen and seeds, plants were able to quickly colonize new, distant areas on a massive scale.

The 125 million years during which plants and animals have been evolving together has been ample time for plants to proliferate and evolve countless ways for insects and other animals to carry and distribute their pollen from flower to flower. Much the same is true of seed dispersal. Unlike young animals, the offspring of plants—seeds—cannot move by themselves and have to disperse in some other way. Again, most flowering plants have resolved the dilemma by using animals to disperse their seeds far and wide. With the appearance of flowering plants and a multitude of pollinators and seed dispersers, the world was transformed, becoming a more colorful and diverse place.

The processes of pollination and seed dispersal by animals are similar in some respects—both use a range of rewards, mostly edible, to get animals to accomplish the task for them. However, there are important and interesting differences. As Wheelwright and Orians (1982) pointed out, flowers provide a clear target for pollinators, which receive a reward when they pick up pollen and another when they deliver it to a different flower—there is "payment on delivery." On the other hand, a flowering plant's target for its seeds is unknown to dispersers, and many or most seeds end up in unsuitable places (fig. 16). Even so, potential seed dispersers, mainly frugivorous (fruit-eating) birds and mammals, are "paid in advance"—they are rewarded when they take the fruits, regardless of whether they deliver seeds to a site suitable for germination and seedling survival.

FLOWERS

The Structure of Flowers

Flowers are specialized plant organs whose ultimate purpose is to produce seeds and assist in their dispersal. Flower structure varies enormously but typically follows a basic plan consisting of four kinds of floral parts arranged in concentric whorls or rings that together sit on the receptacle—a fancy name for the expanded end of the flower stalk. The outermost whorl consists of sepals, which together form the calyx, an often green, leaflike structure with the primary function of protecting the developing bud. Next comes a whorl of petals, forming the corolla, usually the most colorful and conspicuous part of the flower, designed to attract pollinators from a distance. These two outermost whorls, the sepals and petals, are sterile and take no part in the actual production of seeds. The innermost whorls are the reproductive organs. The male organs are a whorl or whorls of stamens that make up the androecium ("house of man"). Each stamen consists of a slender filament topped by a pollen-producing anther. The stamens surround the female centerpiece, the gynoecium ("house of woman"), which consists of one or more carpels, each of which is made up of an ovary that contains one or more ovules and is connected by a stalklike style to a stigma, which is a receptor for pollen. A group of fused carpels is called a pistil.

This basic plan is highly variable, particularly in the number of sepals, petals, stamens, and carpels. The flowers of a great many plants have five sepals and five petals (fig. 17). Buttercups, crane's-bills, and primroses are familiar examples. Crucifers, such as honesty (*Lunaria annua*), mustards, and wallflowers, typically have four sepals and four petals, the latter arranged in a cross (hence the name "crucifers"). Poppies also have four petals, but only two sepals, whereas lilies, irises, and other monocots have three of each. Irises, lilies, and passion flowers have sepals that closely resemble the petals in size and color, contributing to the overall display. Both sepals and petals are then called tepals and form a perianth (fig. 18). Cacti and water lilies have numerous tepals, often 20 or more (fig. 19). In some flowers, such as marsh marigolds (*Caltha palustris*) and pasqueflowers (*Pulsatilla vulgaris*), only the petal-like sepals are brightly colored, and the petals are reduced or missing (fig. 20).

The number of stamens and carpels is also variable. There is just one stamen in most orchids, but scores or hundreds in rockroses (*Cistus*) and cacti. In the case of brush flowers, which include shaving-brush flowers (*Pseudobombax* and *Pachira, Bombacaceae*) and numerous leguminous flowers (*Inga, Calliandra,* and *Mimosa*), the stamens are long

Figure 17. Borage (*Borago officinalis*) is one of the many flowers in many different families that have five colorful petals and five sepals. The latter have the primary function of protecting the developing bud.

Figure 19. The flowers of cacti, in this case an Arizona barrel cactus (*Ferocactus wislizeni*), often have more than 20 tepals.

Figure 18. Satin flowers (*Romulea sabulosa*) in the Western Cape of South Africa belong to the iris family (Iridaceae). Their beautiful perianth is made up of three petals and three sepals, which, being almost identical in form and color, are known as tepals.

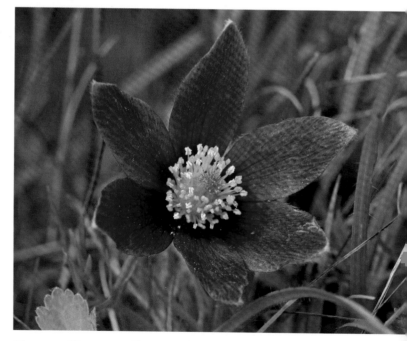

Figure 20. The pasqueflower (*Pulsatilla vulgaris*) lacks visible petals. Instead, its colorful sepals provide the display that attracts insect pollinators.

Figure 21. Brush flowers, such as this Ecuadorean *Calliandra*, lack petals but have abundant, brightly colored stamens that provide a conspicuous long-distance display to pollinators. Here the blossom has attracted a white-necked jacobin (*Florisuga mellivora*).

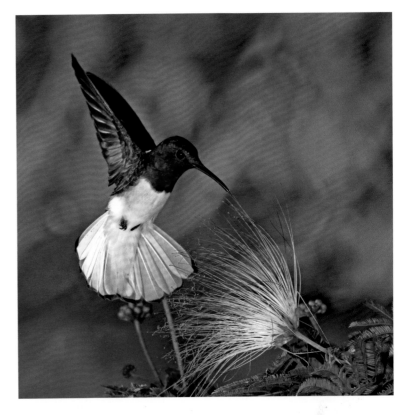

and often colorful. They are the flower's dominant feature and their main long-distance visual signal (fig. 21). Carpels vary in number, but two to five is typical in many families. The number of ovules per carpel also varies. One per carpel is common, but the three carpels characteristic of orchids are extraordinary in that each may contain hundreds of thousands of ovules.

The structure of flowers varies in other ways, including symmetry. Flowers with radial symmetry (known as actinomorphic flowers), such as buttercups, poppies, wild roses, mallows, and anemones, allow visiting pollinators to land facing in any direction and orient themselves in any position. They are often visited by a great variety of relatively unspecialized pollinators. The petals and sepals of some actinomorphic flowers are fused to form a bell-like or tubular shape, as in bellflowers (*Campanula*), many heaths (Ericaceae), and fire-cracker flowers (*Brevoortia*, *Asparagaceae*) (fig. 22). Flowers with bilateral symmetry (known as zygomorphic flowers), such as pea flowers, toadflaxes, and orchids, tend to be visited by a less diverse group of more specialized pollinators. Their structure, particularly the shape and position of a "landing platform," encourages or compels pollinators to take up positions that make successful pollination more likely (fig. 23). The petals and sepals of zygomorphic flowers are often fused to form the complex bilateral shapes seen in snapdragons and monkeyflowers. Such shapes are potential barriers to undesirable visitors. Many flow-

ers, with both types of symmetry, are pendent (hang downward), which helps exclude unwanted visitors by requiring better flying and landing skills.

Most flowers, including such familiar favorites as common foxgloves (*Digitalis purpurea*), milkweeds (*Asclepias*), sages (*Salvia*), and goldenrods (*Solidago*), are grouped together in inflorescences (clusters of flowers in the form of a spike, umbel, raceme, or spadix), which enhances the attractiveness of the floral display to passing pollinators (fig. 24). Many are in open inflorescences with individual flowers well separated, though inflorescences also occur in a compact form resembling single flowers. Clovers and daisies are good examples of compact inflorescences. A clover "flower" really consists of numerous flowers clustered together at the tip of the stem. And a daisy is a composite head consisting of

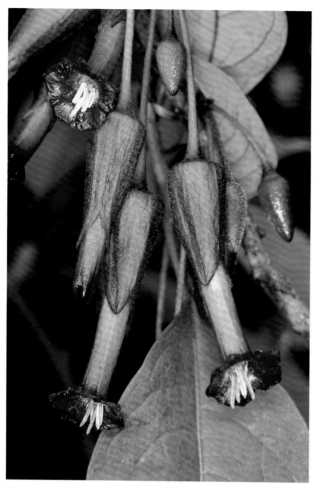

Figure 22. In these South American witches' fingers (*Iochroma calycinum*, Solanaceae) the petals and sepals are fused to form tubular flowers that are visited and pollinated by long-billed hummingbirds.

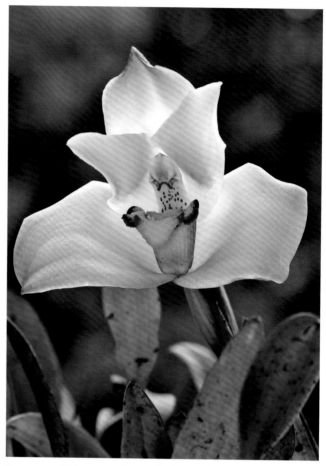

Figure 23. This attractive orchid (*Maxillaria grandiflora*) is an example of bilateral symmetry. An important feature is the lip, which provides a landing platform for insect pollinators. In this species the lip also provides a reward in the form of edible pseudopollen.

many tiny flowers called florets. The outer part of a typical daisy consists of ray florets, which are usually white, yellow, or purple. They resemble normal petals and provide an attractive long-distance display. The central disk consists of tightly packed tube florets, often of a contrasting color, which produce nectar (fig. 25). Other members of the composite family (Asteraceae) differ. Dandelion types have only ray florets, while thistle types have only tube florets. Of course, pollinators are not botanists and treat clovers, daisies, dandelions, and thistles as single flowers, as do we. It has been suggested (and widely accepted) that the word "blossom" should be used for a single pollination unit, whether it is a single flower (e.g., a buttercup, passion flower, or orchid) or a compact inflorescence (e.g., a clover or daisy). Other compact inflorescences are found in mimosoid genera (e.g., *Acacia, Mimosa, Calliandra,*

Inga) and Australian bottlebrush trees (*Callistemon, Myrtaceae*).

Not all flowers are pollinated by animals. Many are pollinated abiotically, the majority by wind but some by water. Flowers that are pollinated abiotically have no need to be showy to attract pollinators and are usually much simplified and lack colorful petals (fig. 26). Wind-pollinated flowers include those of many common trees—such as oaks, elms, alders, and hazels—as well as almost all grasses. Superficially, most do not resemble flowers at all.

Figure 24. Flowers are often grouped together in inflorescences, as they are here in Sturt's desert pea (*Swainsona formosa*), an Australian flower that is pollinated by honeyeaters (Meliphagidae).

Flowers and Pollination

The primary function of a flower is reproduction, that is to say the production of seeds followed by their dispersal. The process begins with sex (pollination)—the transfer of pollen, the male genetic material, from the anthers of male flowers to the receptive stigmas of females. However, pollination is not an end in itself. It is simply the first step in the process that leads to fertilization. On reaching the stigma, a pollen grain absorbs moisture from stigmatic secretions and germinates. It then develops a pollen tube that penetrates the stigma surface, grows down the style, and enters an ovule, resulting in fertilization. Once fertilized, the ovules develop into seeds.

In some flowers, pollen is transported abiotically,

by wind or water, but in most it is carried by animal pollinators—mainly insects but also birds and mammals (and even lizards on oceanic islands such as New Zealand and Mauritius). Pollinators are sexual intermediaries for plants (fig. 27). To achieve pollination, flowers provide a reward, advertise its presence to potential visitors using visual and olfactory signals, and are constructed in a way that encourages or forces visitors to come into contact with their stamens and stigma, thereby facilitating the transfer of pollen. Pollen and nectar are the most common rewards, but there are several others.

In a small number of flowers pollinated by insects (with examples in at least 25 families of flowering plants), and by a few mammals and birds, pollen is not transferred directly from the stamens to visiting pollinators. Instead pollen is shed before the flower opens and deposited onto some other part of the flower, which then acts as a "pollen presenter" to visiting pollinators. The secondary pollen presenter is usually close to the stigma, often somewhere on the style but sometimes on the petals. For example, in bellflowers and some proteas (*Leucospermum*, Proteaceae), pollen is deposited onto the hairy tip of the style, ready to be picked up by a visiting pollinator as soon as the flower opens. After a day or two, the style tip diverges, exposing receptive stigmas ready to receive pollen from another flower. What is the advantage of secondary pollen presentation? It probably results in greater accuracy in the transfer of pollen to the stigma.

Rewards

Pollen

Pollen may well have been the original reward for the earliest pollinators, which probably included beetles, flies, moths, and thrips. According to the fossil record, these earliest pollinators, preserved in amber, evolved long before flowering plants, up to 165 million years ago, and fed on the pollen of extinct gymnosperms. Nowadays, pollen is used as a reward for many insects. It is very nutritious—rich in protein, with smaller quantities of carbohydrates, minerals, and vitamins—and costly for a plant to produce. Most flowers that rely on nectar as a reward produce relatively little pollen, but in other, specialized flowers, pollen is the only reward. There are about 20,000 species of pollen-only flowers in more than 70 families, accounting for 7–8 percent of all flowering plants. Most are pollinated by bees. Their pollen grains tend to be small, dry, and dust-like rather than sticky, and they are produced in generous quantities. They get caught in the hairs that

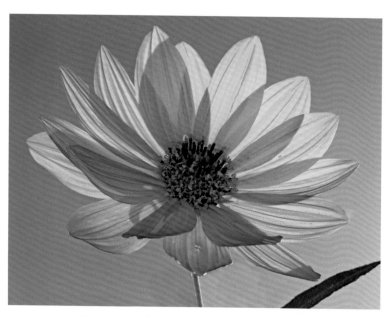

Figure 25. Like other daisies, the perennial sunflower (*Helianthus*) is really a compact inflorescence, consisting of many individual flowers (or florets) clustered together. There are two types of florets—tube florets in a central disk surrounded by ray florets that resemble normal petals.

cover many bees (fig. 28), especially bumblebees, and most grains are collected by grooming and subsequently consumed. Grains that are missed are available for pollination. Poppies and rockroses are good examples of pollen-only flowers that are attractive to bees. Smaller numbers of pollen-only flowers are visited by hoverflies and beetles (fig. 29).

Another group of specialized pollen-only flowers are adapted for buzz pollination (or sonication) by bees (see chapter 4). Typical examples include shooting stars and cyclamens (*Dodecatheon* and *Cyclamen*, Primulaceae), many melastomes (Melastomataceae), tomatoes and other species of Solanum (Solanaceae), and some blueberries (Ericaceae). The anthers of buzz-pollinated flowers release pollen through a tiny pore when they are vibrated at the correct frequency. They effectively exclude all pollen collectors except bees that buzz at the right frequency.

Nectar

Nectar, a watery solution of sugars and other nutrients, is produced by nectaries—floral tissues that sometimes reveal themselves with a sheen of moisture or beads of nectar. These tissues may occur almost anywhere on a flower (or as extrafloral nec-

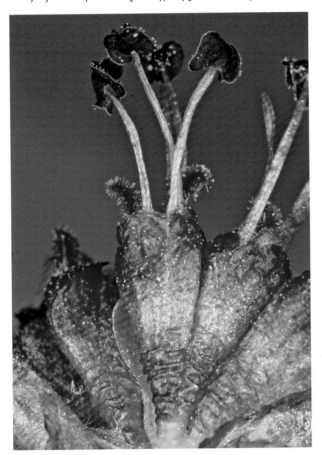

Figure 26. The flowers of the English wych elm (*Ulmus glabra*) and other wind-pollinated flowers are much simplified and hardly resemble flowers at all. The purplish-red flowers of elms are bisexual (or perfect), with two stigmas and four or five stamens.

Figure 27. Pollinators are sexual intermediaries. This sparkling violetear (*Colibri coruscans*) has visited a bromeliad (*Pitcairnia commixta*) and collected pollen on its crown, and it may visit and pollinate another flower.

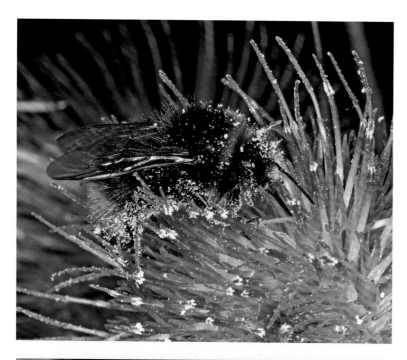

Figure 28. A red-tailed bumblebee (*Bombus lapidarius*) at a spear thistle (*Cirsium vulgare*). The thistle's florets have deposited pollen all over the bumblebee's body. The bee will collect the pollen later when it grooms itself.

taries) and are placed where they can help attract, and simultaneously manipulate, a pollinator into a position that ensures efficient pollen transfer. Disk nectaries are a common type, situated at the base of a flower and forming a prominent ring around the ovary and stamens (fig. 30). Other sites where nectar is produced include sepals, petals, carpels, and stamens. Stigmatic secretions can also contain sugars, and their function is similar to that of nectar. Sometimes nectar is secreted into, and stored in, tubes or spurs. Familiar flowers with nectar

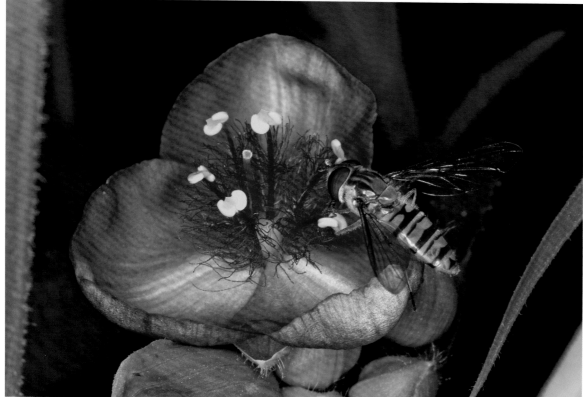

Figure 29. This marmalade hoverfly (*Episyrphus balteatus*) is collecting pollen at a spiderwort (*Tradescantia*), a specialized flower in which pollen is the only reward. Hoverflies are important pollinators, second only to bees.

spurs include columbines, jewelweed and bizzie-lizzies, toadflaxes, violets and pansies, and many orchids (fig. 31). The most celebrated example is the Madagascar star orchid (*Angraecum sesquipedale*), with a nectar spur 40 centimeters (16 inches) long or more. Flowers with long nectar spurs are pollinated mostly by long-tongued insects, especially hawkmoths. They are also targeted by short-tongued bumblebees that gain access by chewing holes into the spurs.

Nectar is rich in energy but less rich than pollen in other nutrients, though it does have some useful constituents other than sugars, including amino acids, proteins, antioxidants, and minerals. The quantities and concentrations in which nectar is pro-duced are variable and are adjusted to encourage repeated visits by suitable pollinators. Flowers pollinated by bats and hummingbirds produce copious, rather dilute nectar, while those pollinated by bees and other insects secrete smaller quantities of more concentrated nectar. Often overlooked is that nectar is a significant source of water in arid habitats where free water is rarely available.

A study by Herbert and Irene Baker (1975) found

Figure 30. Nectar is produced in nectaries that can occur almost anywhere on a flower. In this hollyhock (*Alcea rosea*) being visited by a tree bumblebee (*Bombus hypnorum*), the nectaries are in a ring around the base of the ovary and stamens.

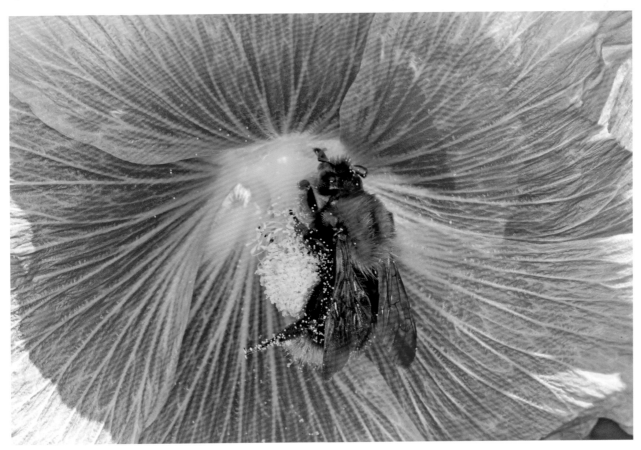

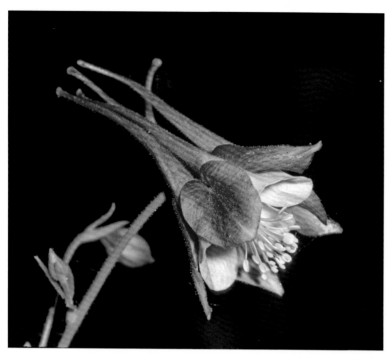

Figure 31. In the North American western red columbine (*Aquilegia elegantula*), nectar is stored in long nectar spurs where it is available to hummingbirds.

that nectar varies in the sugars it contains. Flowers that are visited and pollinated by hummingbirds, butterflies, hawkmoths, and many bees secrete nectar rich in sucrose, whereas those normally pollinated by bats and passerine birds (including American orioles and tanagers, Australian honey-eaters, and Old World sunbirds) have nectar rich in glucose and fructose, sugars that are also found in fruits. The significance of these differences is not obvious, though it has been suggested that American orioles (and some other passerine species) lack the enzyme sucrase, which would enable them to digest sucrose. Nevertheless, in our experience, the differences are of little concern to nectar-feeding bats and birds, including American orioles and other

passerine birds, all of which take both types of sugar with relish. Many hummingbirds are enthusiastic visitors to bat flowers, mopping up nectar left over from the night before. And in both Costa Rica and Ecuador, two nectar bats—Geoffroy's tailless bat (*Anoura geoffroyi*) and Underwood's long-tongued bat (*Hylonycteris underwoodi*)—visit our hummingbird feeders, which contain sucrose solutions, just as readily as the hummingbirds for which they are intended. There are other examples. Numerous flowers in Central and South America are visited by both hummingbirds and nonhummingbirds (the latter including American orioles, tanagers, and honeycreepers). Good examples include species of coral tree (*Erythrina,* Fabaceae), *Sarcopera* (Marcgraviaceae), and *Handroanthus* and *Tabebuia* (both Bignoniaceae).

Other rewards

Other, more esoteric rewards are produced by flowers to attract pollinators, especially insects. They include modified stamens that sometimes form a food reward, oils, resins, perfumes, chemicals the insects can use to make pheromones, and breeding sites, both fake and genuine. Compared with pollen and nectar, such rewards are used by very few species. Even so, they are vital for many of the insects involved (e.g., euglossine orchid bees, fig wasps, and yucca moths) and provide some of the most interesting and bizarre examples of pollination biology.

The existence of oil flowers was discovered only in 1969, but fatty oils have since been found worldwide in more than 2,400 plant species in at least 10 families of flowering plants, most notably in the Scrophulariaceae, Malpighiaceae, and Cucurbitaceae (Buchmann 1987). The oils, which are a richer source of energy than either nectar or pollen, are

secreted by glands called elaiophores. The oils are collected by female solitary bees of a few genera found around the world (e.g., *Macropis*, *Centris*, *Rediviva*), using mop-like structures on their specially adapted legs. They use the oils to feed their larvae and to waterproof their nest linings.

Waterproof resins are used by numerous stingless bees (Meliponini) and solitary bees as nest-building materials. Most resins are obtained from wounds in the bark of trees, but flowers in two tropical plant genera, *Dalechampia* (Euphorbiaceae) and *Clusia* (Clusiaceae), offer floral resins as a reward to bee pollinators (fig. 32). In addition to being excellent nest-building materials, the resins have bactericidal properties that offer some protection to the eggs and larvae inside the bees' nests.

The remaining rewards include stigmatic exudates, which are secretions involved in pollen capture, germination of pollen grains, and maintenance of stigma moisture. They double as an oily or sugary reward attractive to various small insects and probably attracted the small flies and beetles that were the archaic pollinators of flowers. Numerous flowers provide food bodies in the form of sterile stamens called staminodes, which attract pollinators. Orchids attract male orchid bees with perfumes that the bees collect and use to attract females. Many flowers in the Asteraceae and Boraginaceae attract male glasswing butterflies (Ithomiinae) with pyrrolizidine alkaloids, which the males use as precursors for pheromones needed in courtship (fig. 33). And there are numerous flowers that attract pollinators by appearing to offer breeding sites as a reward (see chapter 6).

Warmth is yet another reward that is available in a number of flowers. Thermogenesis (the ability of a plant to raise its temperature above that of its surroundings) is associated with flowers in sev-

Figure 32. A stingless bee (*Melipona fallax*) collecting floral resin from an unusual flower (*Clusia uvitana*) in rain forest in Costa Rica. The waterproof resin is used in nest construction and also has bactericidal properties.

eral families, notably the arums (Araceae), water lilies, and at least some species of custard apples (Annonaceae), all of which are visited and pollinated by beetles. The warmth increases the volatility of the attractant odor and probably encourages beetles to remain in the flowers, where they are occasionally provided with special food bodies and sometimes form mating aggregations. Some bowl-shaped flowers, usually with highly reflective surfaces, achieve higher-than-ambient air temperatures by acting as parabolic reflectors, reflecting heat to their center. Others achieve the same end by having dark patches on their petals—highly absorptive surfaces that mimic solar panels. Heliotropic flowers go a stage further. They track the motion of the sun from east to west, so they always face the sun (fig. 34). The added

Figure 33. This Costa Rican glasswing butterfly (*Greta annette*) is collecting pyrrolizidine alkaloids from flowers of *Tournefortia glabra*. The butterflies use the alkaloids as building blocks for the production of pheromones. The latter are used to attract females and some are passed on to females, making them unattractive to other males and distasteful to predators.

warmth might be beneficial to both pollinator and flower in several ways. Insect pollinators are likely to be attracted by any added warmth that enables them to remain active when conditions are cold. It might be especially beneficial to pollinators that are on the wing early in the year in northern latitudes or at high altitudes. From the point of view of the plant, added warmth may speed up germination of pollen grains and be beneficial for seed development in flowers growing in early spring or in cold climates.

Familiar heliotropic flowers include sunflowers and many shallow, bowl-shaped species, including poppies, pasqueflowers, buttercups, floating-hearts (*Nymphoides*), and many others.

Advertisement

Botanist R. A. Raguso (2004) described flowers as "sensory billboards" emitting signals to potential pollinators through various sensory pathways. The dominant advertising signals are usually visual or olfactory, but they can be enhanced, or sometimes made less effective, when they interact with

Figure 34. Yellow floating-hearts (*Nymphoides*) are heliotropic—they turn so that they always face the sun. The added warmth attracts pollinators and helps them remain active in cold weather.

other signals. For example, the dead horse arum (*Helicodiceros muscivorus*), native to Corsica and Sardinia, attracts blowflies by looking and smelling like carrion, but flies are more likely to enter the floral chamber when heat is an added attraction. It is thought that the arum mimics the cooling temperature of a recently dead animal, signaling that it is ready for egg laying. Signals can also act in succession, as when an odor draws a butterfly to a flower but visual cues guide its tongue to the nectary. Or multiple signals may be essential, as in the case of hawkmoths that need both visual and olfactory cues

Figure 35. A coppery-headed emerald (*Elvira cupreiceps*) visiting hot lips (*Psychotria elata*) in a cloud forest in Costa Rica. The red liplike bracts surrounding the white flowers make the visual display conspicuous to pollinators.

to be attracted to feed at a flower. Also, a pollinator's prior experience and familiarity with a flower may make all cues superfluous.

Color

The colors of flowers attract insects, birds, and some mammals by advertising the presence of nectar, pollen, or some other reward. The colors are influenced by the visual acuity and color preferences of animals, which differ significantly in insects, birds, and mammals. In most flowers the long-distance visual display designed to attract pollinators is formed by the petals, often in combination with the sepals, and is sometimes augmented by colorful modifications of other structures (fig. 35). Examples include the enlarged sterile flowers seen in hydrangeas; the red calyx lobes of *Warszewiczia* (Rubiaceae); the colorful

bracts of poinsettia, hot lips (*Psychotria*, Rubiaceae), and lobster claw plants (*Heliconia*); the enlarged, colorful stamens of brush flowers; and the red leaves growing close to the flowers of many ericads and gesneriads. Flowers that are pollinated by nocturnal insects or bats are often white, or at least pale, making them more visible in dim light (fig. 36).

A considerable number of flowers exist in different color varieties and so attract different pollinators. In California, for example, the sticky monkeyflower (*Mimulus aurantiacus*, Phrymaceae) has a red form in coastal areas, pollinated by hummingbirds, and a yellow form inland, pollinated by hawkmoths. The wild radish or jointed charlock (*Raphanus raphanistrum*, Brassicaceae) provides another example. Its white morph attracts bumblebees, while its "insect-purple" morph attracts butterflies. There are also flowers in several families that change color with age, or sometimes as a post-pollination response, to let potential visitors know that pollination has occurred and nectar or other rewards are no longer on offer. In lantanas (*Lantana*, Verbenaceae), the new flowers at the center of the inflorescence are yellow while they are producing nectar and then change to red (or pink or orange in some varieties), resulting in an inflorescence with two colors (fig. 37). The Brazilian yesterday-today-and-tomorrow (*Brunfelsia pauciflora*, Solanaceae) is another example. It is purple to begin with, turns lavender, and then turns white. Most such flowers retain enough color to prolong their overall long-distance display.

Nectar guides

The German theologian and naturalist Christian Sprengel (1750–1816), sometimes called the "father of floral biology," was the first to recognize and draw

Figure 36. This epiphytic cactus (*Epiphyllum lepidocarpum*) flowers at night and is pollinated by hawkmoths. The flower's white color enhances its visibility at night.

attention to the significance of nectar guides—namely, that they provide visual directions to pollinators at short distances. The yellow ring that surrounds the flower entrance in forget-me-nots (*Myosotis*, Boraginaceae) was the first example to attract his attention (fig. 38). Nowadays, it is well known that many flowers have nectar guides, usually in the form of concentric circles, converging lines, arrow-like pointers, or contrasting patches, which direct pollinators to the site of nectaries (or other rewards) (fig. 39). Some nectar guides, including those of such familiar flowers as dandelions, many daisies, and evening primroses, can be seen

only in ultraviolet light, which is visible to bees and other insects but not to most vertebrates. Some nectar guides change color when the flower is pollinated and stops producing nectar. The pretty yellow ring of forget-me-nots, for example, turns an unremarkable dull white.

Scent

Most birds lack a sense of smell, but most other pollinators have an acute sense of smell and live in a rich olfactory world. Flowers exploit their ability by using scents as well as color for long-distance attraction of pollinators. To our unsophisticated noses, floral scents fall into one of four main categories.

Figure 38. The yellow ring around a forget-me-not's center is a nectar guide. This wood forget-me-not (*Myosotis sylvatica*) is being visited by a dark-edged bee fly (*Bombylius major*).

Figure 37. An ithomiine butterfly (*Mechanitis*) feeding at *Lantana camara*. Newly opened *Lantana* flowers are yellow while they are secreting nectar but turn red as they age and stop producing nectar. Red flowers also produce a less attractive scent.

Figure 39. This South African iris (*Lapeirousia oreogena*) displays prominent arrow-like nectar guides.

Many have pleasing, perfume-like scents like those found in roses, jasmines (*Jasminum*), and lavenders. They are typical of flowers pollinated by bees, butterflies, and moths (fig. 40). The second category includes the mildly disagreeable, musky or yeasty smells associated with fermenting fruit. They are found in flowers pollinated by bats or tropical beetles. The third category includes the foul smells that flowers use to attract flies and beetles that breed in dung or decaying flesh (fig. 41). And the fourth category includes scents released by orchids that mimic the pheromones that various female bees and wasps use to attract males.

Some flowers have olfactory guides—patches on their petals where scent production is more concentrated. These olfactory patches are like nectar guides in providing short-distance directions to the location of rewards. Not surprisingly, they often coincide with visible or ultraviolet nectar guides.

The scent of a flower can differ for various reasons. Flowers that occur at both high and low altitudes, for example, may be visited by different pollinators and have appropriately different scents. Also, changes in scent sometimes occur after a flower has been pollinated, the scent "switching off" or otherwise changing to indicate that nectar is no longer available. A few flowers, such as lantana, change both their color and scent.

Figure 40. A purple-bibbed whitetip (*Urosticte benjamini*) at Cinchona (Rubiaceae) in Ecuador. The flowers have a potent, sweet fragrance that humans can detect in rain forest at distances of 30 meters (33 yards) or more. The flowers are visited and pollinated by bees and butterflies but also attract small hummingbirds.

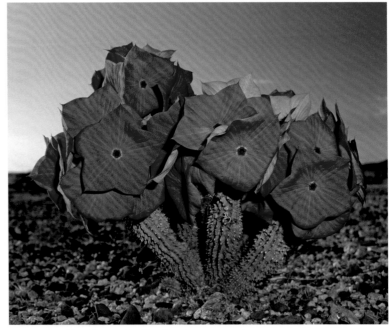

Figure 41. *Hoodia gordonii*, often known as the bushman's hat, is a carrion plant found in the Namib Desert. The flowers smell strongly of a rotting carcass and attract carrion flies and blowflies (Calliphoridae).

The scent of flowers also changes if visiting pollinators leave a temporary scent "footprint," indicating to later visitors that a flower's nectar has been recently (but temporarily) depleted. Scent marking occurs in bumblebees, honeybees, and some stingless bees, and the scent marker of any one species is often recognized by species in other genera. It has been reported that some bees even avoid flowers recently visited by a hoverfly.

Acoustic nectar guides

Hundreds of species of plants in Central and South America are pollinated by nectar-eating bats. Like most bats, these nectar eaters orient to and detect food (insects, fruit, or flowers) by echolocation, an ability exploited by bat-pollinated flowers that have evolved floral structures (modified petals or leaves shaped like a concave "acoustic mirror") that work as a parabolic reflector. They make the flowers conspicuous by reflecting the acoustic energy of the bats' echolocating calls back toward the bats. To a bat, the acoustic signal may well appear as bright

as a cat's eyes reflecting a flashlight beam do to us. Acoustic nectar guides, or "sonar guides," were first described in *Mucuna holtonii* (Fabaceae) by Dagmar and Otto von Helversen (1999) and have since been found in other bat flowers, including *Mucuna urens* (fig. 42) and *Marcgravia evenia* (Marcgraviaceae). It seems more than likely that acoustic nectar guides will be found in many other bat-pollinated flowers.

Self-Pollination and Cross-Pollination

Self-pollination occurs when pollen from a flower pollinates that same flower or flowers on the same individual plant. Cross-pollination occurs when pollen is transferred from one flower to flowers on a different plant.

Bisexual flowers and self-pollination

The majority of flowering plants have bisexual (hermaphrodite or perfect) flowers—every flower is both male and female, and functional anthers and stigmas are relatively close together, so that self-pollination followed by self-fertilization (autogamy, often known as selfing or inbreeding), with or without an outside pollinator, is potentially easy. Self-pollination increases the probability of seeds being produced but has the disadvantage of producing offspring lacking the variability that might be advantageous in a changing environment. Even so, self-pollination is

Figure 42. An Underwood's long-tongued bat (*Hylonycteris underwoodi*) visiting flowers of the Costa Rican vine *Mucuna urens*. The flowers have an acoustic nectar guide that helps echolocating bats find them.

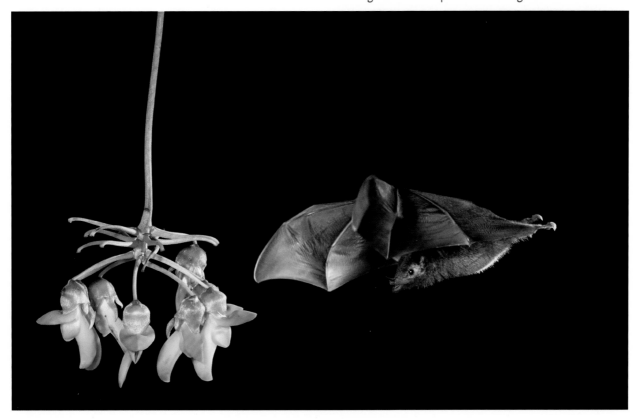

quite common in ephemeral plants that live for only a few weeks, and in plants that flower in areas where unpredictable cold or wet weather can result in a lack of pollinators. It is also important in pioneer species that invade new areas where appropriate pollinators may be absent. Self-pollination is much rarer in long-lived perennial plants and in tropical plants. Whether self-pollination or cross-pollination is more beneficial depends on a plant's ecology and life history.

Many flowers are capable of self-pollination as a backup system if cross-pollination fails. Clearly, self-pollinated seeds are better than none at all. The European bee orchid (*Ophrys apifera*) is an example of a flower that self-pollinates in the absence of pollinators. In southern Europe, the bee orchid is visited by male solitary bees in the genera *Eucera* and *Tetralonia* and is pollinated by "pseudocopulation" (i.e., the attempted copulation by a male insect, such as a bee, wasp, or fly, with a flower that in some way resembles a female insect of the same species). However, visits by bees are rare in northern Europe, and successful self-pollination is the norm. A day or two after opening, a British bee orchid's pollinia drop free of the anther and are suspended close to the stigma. With a puff of wind, the pollinia swing against the sticky stigma and adhere to it, resulting in self-pollination (fig. 43).

Self-pollination also occurs in so-called cleistogamous flowers (from the Greek for "closed marriage"), which automatically self-pollinate before they open and regularly produce viable seeds. Cleistogamous flowers are an advantage when growing conditions are poor; that is, when there are deficiencies in nutrients, rainfall, or light. They need fewer resources because they generally have smaller petals, produce less pollen, and have no need for

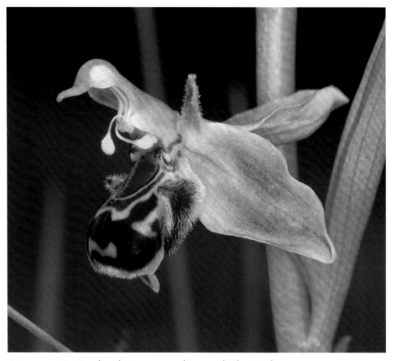

Figure 43. In England, European bee orchids (*Ophrys apifera*) are rarely visited by pollinators, and self-pollination is the norm. Here a pollinium has been blown by the wind against the orchid's receptive stigma.

nectar. Some cleistogamous flowers have two types of flowers, one of which relies on cross-pollination, the other on self-pollination. In many violets, for example, the first type flowers very early and attracts appropriate insect pollinators, provided any are active. However, if the spring weather is cold or wet, many flowers never receive a visit and remain unpollinated. The second type of violet flower is small and inconspicuous and appears later in the spring or early summer. It never opens but self-pollinates automatically and produces at least some seeds.

Bisexual flowers and cross-pollination

Although self-pollination is sometimes advantageous, cross-pollination followed by cross-

fertilization (known as outbreeding) is generally preferable because it promotes genetic variability by spreading favorable genes and producing new combinations of genes that might be beneficial in changing environments (e.g., because of climate change). For that reason, many flowers have adaptations that prevent self-pollination and promote cross-pollination. There are three main sorts of adaptations. Flowers can avoid self-pollination physiologically, so that pollen and ovules from the same flower or flowers on the same plant are incompatible; or temporally by having anthers that shed pollen either before or after the stigmas are receptive, never at the same time; or spatially by keeping their functional anthers and stigmas well separated.

PHYSIOLOGICAL SELF-INCOMPATIBILITY

Plants that are self-incompatible must have the ability to recognize and discriminate between their own pollen and pollen from other plants. The ability to recognize "self" and "nonself" is commonplace in living organisms but usually involves recognition and rejection of "nonself" (as in the human immune system). In the case of self-incompatibility in plants, it is recognition and rejection of "self" that takes place. Sometimes it also involves the rejection of the pollen produced by close relatives. Self-incompatibility can involve various processes—pollen may be rejected at the surface of the stigma (which happens in many crucifers and daisies); or the growing pollen tube may be rejected before it reaches the ovule (as in poppies, evening primroses, and many grasses); or the incompatibility may act at a later stage, causing developing ovules to abort (common in many tropical trees). In the case of the common poppy (fig. 44), which has been studied genetically, it was shown that any one plant was

capable of breeding with more than 80 percent of the other members of the population but was completely incapable of cross-pollinating with about 5 percent, mostly close relatives.

TEMPORAL INCOMPATIBILITY

This operates when a flower's anthers and stigmas are not functional at the same time, a strategy known as dichogamy. There are two forms—one in which the anthers shed their pollen before the stigmas are receptive (known as protandry), and another in which the stigmas are receptive before pollen is released (protogyny).

Protandry is found in many plant families. It is particularly common in plants with upright flower spikes, such as mints and sages (*Mentha* and *Salvia*, both Lamiaceae), willowherbs (*Epilobium*, Onagraceae), and foxgloves and mulleins (Digitalis and *Verbascum*, both Scrophulariaceae), all of which are typically visited from bottom to top by insect or bird pollinators. The common foxglove and rosebay willowherb (*Chamerion angustifolium*), which are pollinated by bumblebees, are classic examples (fig. 45). Their flowers open in sequence starting from the bottom and remain open for several days. If numerous flowers are open, the lowest ones tend to be in the female phase, the higher ones male. Bumblebees visit the lowest flowers first because they produce more nectar, and work their way upward. If they are carrying pollen when they arrive, they are likely to deposit it on the stigma of female flowers. Higher up, bumblebees collect fresh pollen from flowers in the male phase and, after flying off, carry it to the lowest, probably female, flowers on a nearby inflorescence, resulting in cross-pollination.

Protogyny is found in many familiar plants, including buttercups, crucifers, and plantains

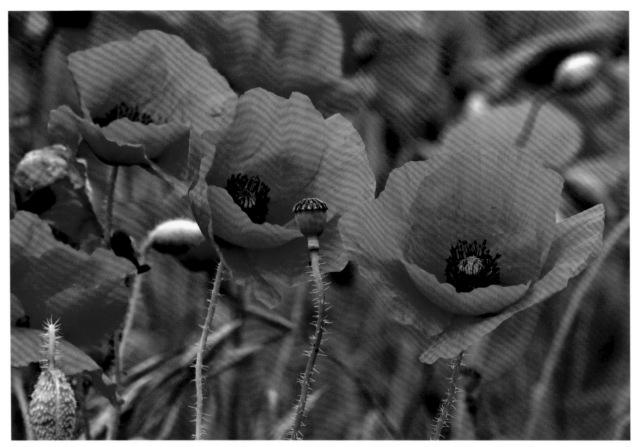

Figure 44. The common poppy (*Papaver rhoeas*) is an example of a flower that is made self-incompatible by means of a physiological barrier. A poppy may be abundantly self-pollinated and a pollen tube may begin to grow as normal, but it is then blocked before it reaches the ovule.

(*Plantago*). It is also strongly associated with some of the more primitive plant families, including arums, water lilies, magnolias (Magnoliaceae), custard apples and soursops (Annonaceae), and pipe vines (Aristolochiaceae), many of which have trap flowers. Most trap flowers smell strongly, often of dung or rotting meat, and attract flies or beetles. Insects arriving with pollen when the trap first opens fly or fall to the bottom of the trap, where they pollinate the already receptive female flowers. There they are detained for a day or two, by which time the anthers have matured, showering the insects with pollen before releasing them to fly to another trap. Meanwhile the female flowers have become unreceptive and self-pollination is prevented.

Sometimes protogyny is associated with self-compatibility. If they have not been pollinated, the stigmas of protogynous flowers sometimes remain receptive even after pollen has been released. Hence, self-pollination is possible if prior cross-pollination has failed.

SPATIAL INCOMPATIBILITY

This occurs when stigmas and anthers are separated in space. In orchids and milkweeds (*Asclepias*, Apocynaceae), for example, pollen is concentrated into a few compact masses called pollinia. They make contact with a stigma only after attaching to a pollinator and being transported to another flower.

In numerous open, bowl-shaped flowers, such as poppies, buttercups, and crane's-bills, the stamens are splayed apart from the stigmas at the center of the flower. Visiting insects tend to alight on the central stigma, depositing any pollen they are carrying. They then come into contact with the anthers as they crawl around among the stamens, feeding or collecting pollen, and eventually fly off to visit another flower. In some flowers, including the gloriosa lily (*Gloriosa superba*), the style and stamens point in different directions (fig. 46).

Another variation on spatial incompatibility involves heterostyly, a breeding system in which there are two or three different forms of a flower. Heterostyly is found in several families, including primroses, borages (Boraginaceae), wood sorrels (*Oxalis*), and others. European primroses (*Primula vulgaris*) and cowslips (*P. veris*), for example, come in two forms, with the anthers and stigmas situated at different but equivalent levels on different plants (fig. 47). In the "pin" form, the style is long, with the stigma visible at the entrance of the corolla tube, while the anthers are halfway down the tube. In the "thrum" form, the positions of the stigma and anthers are reversed. Pollen is carried on different parts of the proboscis of visiting pollinators so that pollen from pin flowers is normally transferred to thrum stigmas, and vice versa. Heterostyly is usually combined with self-incompatibility—pollen transfer between plants of the same type rarely results in fertilization.

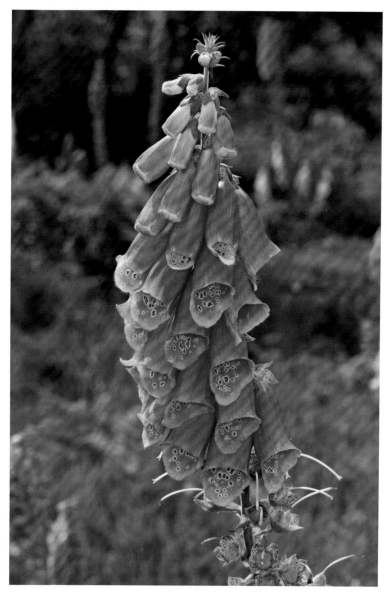

Figure 45. The common foxglove (*Digitalis purpurea*) provides a good example of flowers that avoid self-pollination by temporal incompatibility—the anthers shed their pollen before the stigmas are receptive.

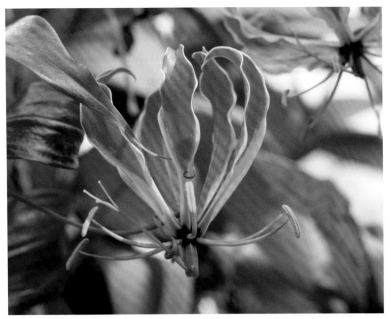

Figure 46. This Ugandan flame lily (*Gloriosa superba*) avoids self-pollination by spatial incompatibility—its stigma is sharply directed to one side, away from the stamens.

Figure 47. Heterostyly is a version of spatial incompatibility involving two or more different forms of a flower. In these cowslip (*Primula veris*) flowers, for example, the "pin" form on the left and the "thrum" form on the right have anthers and stigmas at different but equivalent levels.

Unisexual flowers

Although the majority of flowering plants worldwide have bisexual flowers, about 15 percent have unisexual flowers, which are either male or female. About a third of these (5 percent of all flowering plants) are monoecious (a term based on the Greek for "one house")—they are species in which separate male and female unisexual flowers occur on the same plant. The rest are dioecious ("two houses")—they have unisexual flowers but the males and females occur on different plants.

Monoecious species include many widespread wind-pollinated trees, such as oaks, beeches, hazels, birches, alders, and hornbeams. Male and female flowers on the same plant are separated spatially, but self-fertilization can still occur (fig. 48). The possibility is reduced in hazels, alders, and most other species by protogyny (female flowers or catkins mature earlier than male flowers on the same plant).

Well-known dioecious plants in temperate areas include hollies, willows, viscaceous mistletoes (Viscaceae), and the common stinging nettle (*Urtica dioica*). Self-pollination and self-fertilization are clearly impossible in dioecious flowers, so an

external pollinating agent, either animal or abiotic, is essential. Many dioecious species are pollinated by insects. Male flowers tend to be larger and more conspicuous than females, increasing the likelihood that they are visited before females, which is clearly necessary for successful pollination to take place.

Asexual reproduction

Quite a number of plants reproduce asexually, a process in which new plants are produced that are genetically identical to the parent plant. They are produced vegetatively from plant parts, such as bulbs, rhizomes, and runners, sometimes resulting in clones that cover large areas. A cloned grove of quaking aspens (*Populus tremuloides*) in Utah in the United States has over 40,000 stems and covers an area of 43 hectares (106 acres). The average age of the stems is 130 years, but the root system is at least 80,000 years old, perhaps much older.

Some flowers produce seeds from unfertilized ovules. This process, known as agamospermy, is quite common in the daisy and rose families and is found, for example, among dandelions, hawkweeds, whitebeams, and brambles. In some species, including the common meadow buttercup (*Ranunculus acris*), reproduction is sometimes sexual and sometimes asexual, probably because the fertilization of an initial ovule stimulates other ovules to produce seeds even without being fertilized.

Figure 48. The castor-oil plant (*Ricinus communis*) is monoecious, with unisexual flowers on the same plant. The male flowers are pale yellow and have numerous conspicuous stamens; the females have prominent red stigmas. Both sexes lack petals, and wind pollination is the norm.

POLLINATION 4 SYNDROMES

The majority of flowers, especially those living in the tropics, rely on animals to disperse their pollen and possess different suites of characters—structure, colors, scents, and rewards—that match the sensory abilities of their pollinators. Flowers that are pollinated abiotically, by wind or water, also possess appropriate characters. These suites of characters, known as "pollination syndromes," make it possible to predict a flower's likely pollinator, at least whether it is pollinated by bats, hummingbirds, bees, butterflies, or wind. It must be emphasized that syndrome groupings, though useful, are often quite loose. One leading pollination researcher, Leendert van der Pijl (1961), aptly described his syndrome groupings as "classes with bad boundaries but a clear center." On the other hand, many basic syndrome categories are easily split into more than one syndrome. Flies provide clear examples. Most flies probably belong in the "opportunistic, unspecialized insect syndrome," but the extremely long-tongued flies that occur in southern Africa are very specialized and clearly belong in their own separate, long-tongued fly syndrome, as do the flesh flies and blowflies attracted to flowers that mimic rotting flesh.

As well as matching the sensory abilities of pollinators, flower characteristics are also designed to prevent or deter visits by inappropriate pollinators—visits that rarely result in pollination but waste resources and sometimes result in damage to the flower. The colors of flowers are much influenced by the nature of the color vision of pollinators. The eyes of bees, for example, are sensitive to colors at the blue end of the spectrum, including ultraviolet (which is invisible to us), but not to red. For this reason, bee-pollinated flowers are usually some shade of ultraviolet, blue, purple, or yellow but not red. On the other hand, hummingbird-pollinated flowers are often red, not so much because hummingbirds see red better than blue (they do not), but because red does not attract bees (which often damage flowers by biting holes in their nectaries). Red also has the advantage of being very conspicuous to birds from far away, for birds have good long-distance vision. Flowers that are pollinated abiotically, by wind or water, are very different from animal-pollinated flowers, lacking attractive petals, scents, and rewards, and often do not resemble flowers at all. It used to be believed that wind pollination was primitive in flowering plants (angiosperms), as it is in conifers (gymnosperms). However, the fossil record suggests that wind pollination came later for flowering plants. Early fossil flowers were clearly insect pol-

linated, and there is almost no wind pollination in the most primitive angiosperm families that survive today.

Though the characteristics of a flower give a good indication of its likely pollinators, categories are not always clear cut. Some flowers attract a wide range of visitors, including bats and birds as well as insects, many of which may be effective pollinators. For example, the purple tubular florets of porterweed (*Stachytarpheta frantzii*) look like insect flowers. They do indeed attract a multitude of long-tongued insects, including bumblebees, orchid bees (*Eulaema* and *Euglossa*), long-horned bees (*Eucera*), diurnal hawkmoths (fig. 49), and butterflies, espe-

cially skippers (Hesperiidae). However, in both Costa Rica and Ecuador, the flowers also attract more than 30 species of hummingbirds (fig. 50), as well as Tennessee warblers (*Vermivora peregrina*), bananaquits (*Coereba flaveola*), and flowerpiercers (*Diglossa*). In spite of such "generalist" flowers, the concept of pollination syndromes has considerable practical value.

Flowers with ambivalent characteristics may be in the process of changing strategies or simply hedging their bets. *Quararibea costaricensis* (Malvaceae) is a common tree in Costa Rican cloud forests, where conditions are often cold, windy, and wet. It has typical moth flowers, white with a sweet fragrance,

Figure 49. A diurnal hummingbird hawkmoth (probably *Aellopus*) at porterweed (*Stachytarpheta frantzii*). Porterweed attracts many other insects, including bees and butterflies, especially skippers.

Figure 50. Although it has the characteristics of an insect flower, porterweed also attracts many hummingbirds, in this case an immature Esmeraldas woodstar (*Chaetocercus berlepschi*).

Figure 51. A coppery-headed emerald (*Elvira cupreiceps*) feeding at a flower of *Quararibea costaricensis* (Bombacaceae) in a cloud forest in Costa Rica.

which are visited and pollinated by hawkmoths at night and visited by hummingbirds by day. Perhaps the flowers are receptive only at night, but the fact that they secrete nectar all day suggests that they might well be receptive by day as well as by night. The trees may well be relying on hummingbirds as pollinators whenever it is too cold or too wet for hawkmoths to be active (fig. 51).

The white powder-puff blossoms of *Inga* trees (Mimosoideae) may also be hedging their bets.

Several species secrete nectar by both night and day, attracting an exceptionally diverse array of potential pollinators, including bats, hummingbirds, hawkmoths, and various other insects (see Fabaceae, chapter 14).

Not surprisingly, there are big latitudinal differences in the prevalence of different syndromes. Pollination by bats and birds is commonplace in the humid tropics, where flowers are available year round, but less common in areas with extreme climates, with long freezing winters or severe dry seasons. Pollinating bats and birds are not uncommon in seasonally "wet" deserts such as the Sonoran Desert, which enjoys summer rains, but they are

not prevalent in extremely dry deserts, such as the central Sahara and Namib. Tropical botanist Kamal Bawa (1985, 1990) found that up to 98 percent of flowering plants in lowland tropical rain forests in Costa Rica are pollinated by animals and that wind pollination is very rare.

By contrast, wind pollination is relatively common in temperate or other areas where plants of the same species form monocultures or grow at least relatively close together.

Pollination by Mammals

Bats are by far the most important mammalian pollinators, though nonflying mammals play a significant role in some parts of the world, especially Australia and southern Africa. Pollination by bats is much rarer than pollination by insects. Nevertheless, there are bat flowers in about 70 plant families. Bats require a nutritionally expensive reward of nectar or pollen, but in return they are capable of carrying pollen long distances. Bats are excellent at providing cross-pollination. Bat pollination is a mainly tropical phenomenon, though giant saguaro cacti (*Carnegiea gigantea*) and agaves in the southwestern United States are pollinated by lesser long-nosed bats (*Leptonycteris yerbabuenae*) that arrive as summer migrants from Mexico.

Bat flowers open at dusk, usually for a single night, and tend to be large, sturdy, and strong enough to support a bat. Many are bell shaped and are often suspended on long stems so that they dangle clear of vegetation, providing easy access to flying bats. Cauliflorous or pendent flowers are common, and most have a relatively wide corolla, suitably shaped to accept a bat's snout. Some are white, or sufficiently pale to make them visible in dim light (fig. 52), but others have dull colors, per-

haps rendering them cryptic to nonpollinators. Bat flowers usually have a strong, sour or yeasty smell, suggestive of overripe fruit or fermentation. This scent is the primary long-distance attractant, although, as already mentioned, some bat flowers also have acoustic nectar guides.

As well as copious nectar, many bat flowers produce abundant pollen, which collects on the fur of visiting bats in substantial quantities, much of it being consumed later while the bats are grooming. Pollen from bat flowers is rich in two amino acids, proline and tyrosine, both of which are important to bats (and other vertebrates). As stated by Howell (1976), proline is necessary for connective tissue, particularly for building robust wing and tail mem-

Figure 52. An Underwood's long-tongued bat (*Hylonycteris underwoodi*) at a Costa Rican bat flower (*Macrocarpaea valerioi*, Gentianaceae). Note the wide opening to the corolla, suitably shaped for a bat's snout.

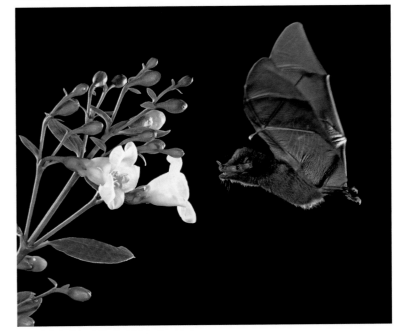

branes, and tyrosine is essential for milk production. The amino acids are released when the tough, protective coat of the pollen is dissolved in a mixture of hydrochloric acid (secreted by bats in their stomach), nectar, and their own ingested urine.

Although bats are the principal mammalian pollinators of flowers, a number of nonflying mammals are important pollinators in South Africa and Australia. In South Africa, the Namaqua rock mouse (*Aethomys namaquensis*) and other rodents are the main pollinators of a few species of *Protea* and *Leucospermum* (Proteaceae), the others being pollinated by birds or insects. The rodent-pollinated flowers resemble bat flowers in being large, robust, and dull colored, and by having a yeasty smell and secreting abundant nectar. They differ in being hidden inside vegetation, often close to the ground and facing downward, where they are easily accessible to their rodent pollinators. They provide an interesting contrast with the many bird-pollinated *Protea* and *Leucospermum* flowers, all of which have characters typical of the bird pollination syndrome.

In Australia at least 25 species of small, mouselike marsupials and rodents have been recorded feeding at flowers in the Proteaceae and Myrtaceae. The most important include the honey possum (*Tarsipes rostratus*) (fig. 53), sugar glider (*Petaurus breviceps*), feathertail glider (*Acrobates pygmaeus*), pygmy possums (*Cercartetus*), and several marsupial mice (*Antechinus*). Some have special adaptations for feeding on nectar and pollen. The honey possum, for example, is a tiny, mainly nocturnal marsupial with an elongated snout and a long, protrusible tongue with a brush tip for collecting nectar and pollen. It also has comblike ridges on its palate that squeeze nectar and pollen from its tongue as it moves the tongue rapidly in and out of its mouth.

Figure 53. This honey possum (*Tarsipes rostratus*) is feeding on a flowering scarlet banksia (*Banksia coccinea*) in Western Australia. The honey possum is one of numerous nonflying mammals that are involved in the pollination of flowers in Australia. Photo courtesy of Gerry Ellis/Minden Pictures.

Most of the other flower-visiting marsupials have a more omnivorous diet and are less specialized, though several, including the feathertail glider and pygmy possums, have a brush-tipped tongue.

Pollination by specialized nonflying mammals is less well known in the New World, though various mice (*Oryzomys fulvescens* and others) are thought to pollinate *Blakea chlorantha* (Melastomataceae) in Costa Rican cloud forests. The Amazonian *chupa-chupa* tree (*Quararibea cordata*, Malvaceae) is another night-flowering species that appears to be pollinated by nonflying mammals. According to Janson, Terborgh, and Emmons (1981), it is visited intensively by three different nocturnal opossums, night monkeys (*Aotus trivirgatus*), kinkajous (*Potus flavus*), and olingos (*Bassaricyon alleni*). Chupa-chupa flowers are also visited by diurnal monkeys (*Cebus*, *Saimiri*, and *Saguinus*), birds, and insects. In

fact, so much nectar is available for so much of the day that it seems likely that the flowers can be pollinated at almost any time. A tree that we watched at La Selva Biological Station in Costa Rica was still attracting birds well into the afternoon. It was visited by 17 species in a few hours, including birds

Figure 54. A mantled howler monkey (*Alouatta palliata*) feeding on leguminous flowers (*Pterocarpus michelianus*) in a Costa Rican dry forest. Howler monkeys are basically flower predators but sometimes accumulate pollen on their face and may pollinate some flowers.

as different in size and basic ecology as oropendolas, woodpeckers, orioles, honeycreepers, and hummingbirds.

Among other examples, woolly opossums (*Caluromys*) are known to drink nectar from balsa flowers (*Ochroma pyramidale*, Bombacaceae) and may well move pollen from flower to flower at least occasionally. Woolly opossums have also been reported to be the main pollinators of *Marcgravia nepenthoides*, a species with very large nectaries that are well separated from the flowers. Smaller *Marcgravia* species are pollinated by small nectar bats.

Many other mammals exploit flowers opportunistically and some may be effective pollinators, at least occasionally. Bush babies (*Galago*) feed at flowers of African baobab trees (*Adansonia*), and research in South Africa (du Toit 1990) suggests that even giraffes may be sporadic pollinators of *Acacia* trees, though they eat 85 percent of all flowers within reach and are probably detrimental overall, rather than beneficial. In the dry forests of Costa Rica, we have often seen and photographed mantled howler monkeys (*Alouatta palliata*) feeding on the massed flowers of various leguminous trees (fig. 54). Monkeys are usually destructive feeders but sometimes accumulate pollen loads on their faces and may well pollinate at least some flowers. In Madagascar, mouse lemurs (*Microcebus*) as well as some larger species are major pollinators, and according to Kress et al. (1994), the black-and-white ruffed lemur (*Varecia variegata*) is the most important pollinator of the traveler's palm (*Ravenala madagascariensis*, Strelitziaceae).

Pollination by Birds

Birds are active throughout the year, regardless of weather conditions, and need a reliable year-round food supply. In humid tropical regions, the year-round availability of flowers allows several different groups of birds to specialize as nectar feeders, often using a succession of 20 or more flower species in the course of a year. The most important groups include the hummingbirds, American orioles, and honeycreepers in North, Central, and South America; sugarbirds (*Promerops*), sunbirds (Nectariniidae), and white-eyes (*Zosterops*) in Africa and tropical Asia; and lorikeets (*Trichoglossus*), honeyeaters (Meliphagidae), and white-eyes in Australasia.

Although pollination by birds is a mainly tropical phenomenon, bird-pollinated flowers are nevertheless common in temperate areas of North and South America. This is possible because the pollinators involved (hummingbirds and American orioles) are long-distance migrants that survive the northern and southern winters by moving to warmer climes. Rufous hummingbirds (*Selasphorus rufus*), for example, migrate several thousand kilometers between Alaska and Mexico, and ruby-throated hummingbirds (*Archilochus colubris*) migrate from as far north as Canada to as far south as Costa Rica and Panama. Baltimore and orchard orioles (*Icterus galbula* and *I. spurius*) fly even farther, to northern South America. In the Southern Hemisphere, the green-backed firecrown (*Sephanoides sephanoides*) is an austral migrant, breeding in southern Chile and Argentina as far south as Tierra del Fuego and migrating north and east during the austral winter. These migrants are not dependent just on bird flowers. The ruby-throated hummingbird, for example, winters in large numbers in Costa Rica's deciduous forests during the dry season (fig. 55). It is a time when hummingbird flowers are scarce but bee flowers are flowering profusely. The ruby-throated hummingbird is especially attracted to two leguminous bee-pollinated species—*Myrospermum frutescens* and *Gliricidia sepium.*

Figure 55. This immature male ruby-throated hummingbird (*Archilochus colubris*) is visiting leguminous flowers of *Gliricidia sepium*. Ruby-throated hummingbirds are long-distance migrants, many of them, like this one, wintering in dry forests in Costa Rica.

In temperate areas of the Old World, there are no nectar-feeding groups of long-distance migratory birds, so bird-pollinated flowers are found mainly in tropical regions of Asia, Australasia, and Africa. The southern temperate regions of Africa are an exception. There, the relatively mild climate allows some flowering throughout the year. Bird-pollinated flowers are plentiful and are visited by numerous species, including sunbirds and endemic sugarbirds (figs. 56 and 57). And again, in temperate Australia, bird-pollinated flowers are common in arid and semiarid areas, where specialized nectar-feeding lorikeets, honeyeaters, and others are highly mobile, moving between areas where adequate rainfall has stimulated flowering.

The main features of bird-pollinated flowers are similar the world over. Most are diurnal and sturdily constructed. They lack any scent, because most birds lack a sense of smell, and they produce copious, rather dilute nectar. Bright colors are the main long-distance display. Red and orange flowers are common—colors that render flowers inconspicuous to bees (which see poorly at the red end of the spectrum)—and their vibrant appearance is often enhanced by long-lasting, colorful bracts or calyxes. However, birds readily learn to visit flowers of just about any color. Many are enthusiastic early-morning visitors to bat flowers, which are mostly

Figures 56 and 57. A Cape sugarbird (*Promerops cafer*) on a pincushion protea (*Leucospermum cordifolium*) and a male scarlet-chested sunbird (*Chalcomitra senegalensis*) at an aloe. Both of these South African species visit flowers to feed on nectar. Unlike hummingbirds, they cannot hover efficiently and need a perch close to flowers in order to feed. Sunbird photo courtesy of Carol Hughes.

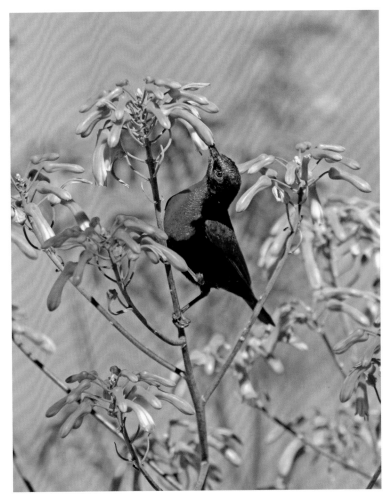

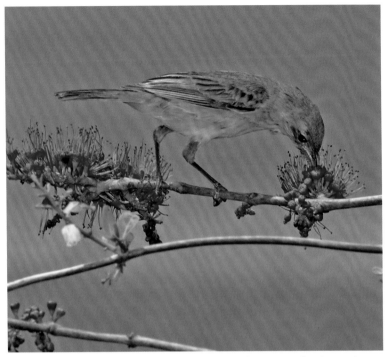

Figure 58. A female mangrove warbler (*Setophaga petechia bryanti*) feeding at a liana (*Combretum farinosum*) in a Costa Rican dry forest. The flowers are pollinated mainly by hummingbirds but, being easily accessible, also attract perching birds.

whitish, cream, or greenish, where they finish off any nectar left over from the night before. Bird flowers are quite variable in structure. Many, though by no means all, fall into one or another of various groups, including tubular flowers, gullet flowers, spurred flowers, and brush flowers. The most important differences in the structure of bird flowers are related to access—hummingbirds typically hover while feeding, so hummingbird flowers lack a landing site or perch. The flowers are usually pendent or oriented horizontally and provide unimpeded access to hovering hummingbirds. On the other hand, orioles, honeycreepers, sunbirds, lorikeets, honeyeaters, and other nonhummingbirds cannot hover and need a perch close to flowers in

order to feed (fig. 58). Sunbirds are a minor exception in having a little hovering ability. Indeed, they often hover for a few seconds at the exotic hummingbird flowers that are commonly planted in gardens throughout the tropics. Sunbirds also resemble hummingbirds (though in a less extreme way) in having bills that vary in length and curvature to match different flowers.

Hummingbirds are the most specialized of the birds that pollinate flowers. Books on hummingbirds often suggest that the length and curvature of their bills fit the flowers at which they feed, but this is true in only a general way. There is almost never a simple one-to-one relationship. On the contrary, most hummingbird flowers are visited by many different species. Hummingbirds are best divided into only two major groups based on their bills, one group with a long, straight or curved bill, and a much bigger group with a shorter, straight bill. The hummingbirds in the first group, which include the hermits, lancebills, incas, and sword-billed hummingbird (*Ensifera ensifera*), visit specialized flowers with a long, tubular, often curved corolla (fig. 59). There is a big overlap in the selection of flowers they visit. In the Costa Rican lowlands, for example, any flowers of the lobster claw plants *Heliconia pogonantha* and *H. longa* are likely to be visited by all the hermits in the area. Their bills may not fit all the flowers perfectly, but their long, flexible tongues easily compensate. The second group of hummingbirds, which have relatively short bills, are capable of feeding at virtually any flower with a short corolla (fig. 60). A clump of firebush (*Hamelia patens*, Rubiaceae) in the Caribbean lowlands of Central America may well attract six or seven short-billed species on most mornings and a few others over a period of days or weeks. Even so, there is a tendency

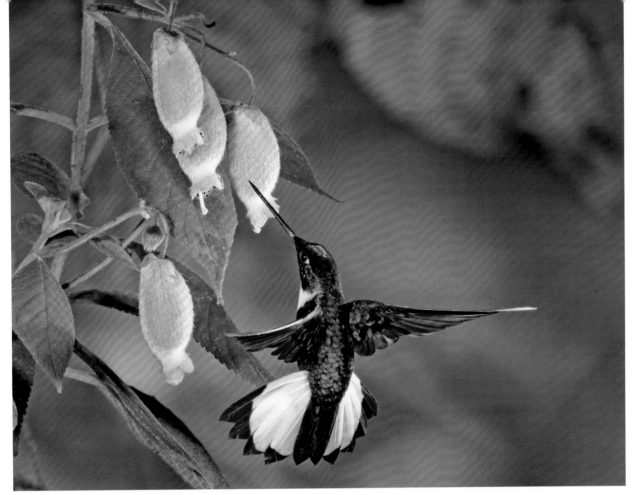

Figure 59. The collared inca (*Coeligena torquata*) is a good example of a long-billed hummingbird capable of feeding at flowers with a long corolla, in this case *Capanea affinis* (Gesneriaceae).

for the hummingbirds with the shortest bills to visit the shortest flowers, and those with longer bills to go to longer flowers.

Hummingbirds are also segregated by behavior. American biologists Peter Feinsinger and Robert Colwell, both of whom studied hummingbirds in Costa Rica (1978), classified hummingbirds according to the ways in which they visit and exploit flowers—in other words, according to their ecological roles or "professions." Their category of high-reward trapliners corresponds to the long-billed hummingbirds, described above, that trapline specialized flowers with a long corolla. These flowers produce copious nectar (hence the high reward) but are usually too scattered to be worth defending. Trapliners exploit them by following a long route through the forest and retracing the route several times a day. On the other hand, territorialists defend large patches of flowers against all other hummingbirds, including members of their own species. They do not move far. In addition to trapliners and territorialists, Feinsinger and Colwell mention such antisocial hummingbird professions as marauders, filchers, and piercers, all of which steal nectar. Marauders and filchers steal from territorial hummingbirds, while piercers extract nectar through holes that they make in the base of flowers.

These ecological roles are useful shorthand for hummingbird behavior but are not rigid categories. The way a hummingbird forages is determined by opportunity and need, and it adjusts its behav-

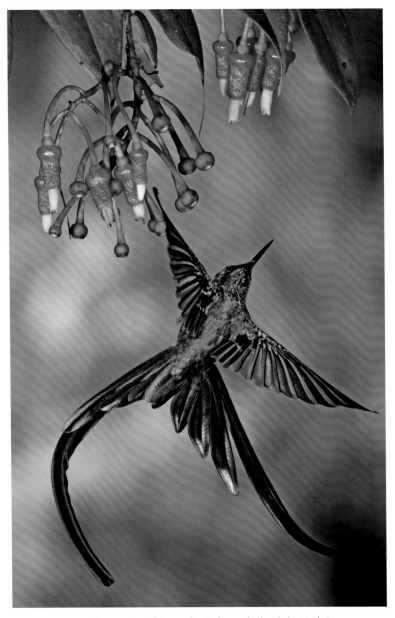

Figure 60. This male violet-tailed sylph (*Aglaiocercus coelestis*) lives in Andean cloud forests. It is a short-billed hummingbird that feeds at flowers with a short corolla. Here it is at the ericad *Psammisia columbiensis*.

ior accordingly, from season to season, day to day, or even hour to hour. A hummingbird may be a territorialist first thing in the morning, when nectar is flowing strongly in the flowers it is defending, and then trapline intermittently when the flow decreases. A filcher that steals from a territorialist in the morning is a low-reward trapliner when it feeds at the same flowers, now undefended, in the afternoon. Or it may even become a territorialist by defending the flowers against other small hummers. Many hummingbirds are occasional piercers.

One interesting question is why some flowers attract hummingbirds and other birds as pollinators, rather than insects. After all, insects can be attracted with a smaller reward of nectar. The probable reason is that hummingbirds are more reliable as pollinators when the weather is bad, particularly at high altitudes. Bees and butterflies are inactive if it is too wet or too cold, so then flowers dependent on them do not get pollinated. On the other hand, hummingbirds are active in any weather, no matter how cold, wet, or windy. It is no real surprise, then, that there are many more hummingbird-pollinated flowers in the highlands than in the lowlands.

Pollination by Lizards

Though not significant on a world scale, lizards are now known to be pollinators of flowers on numerous islands around the world. Important examples include New Zealand and its offshore islands, Tasmania, Mauritius and other islands in the Indian Ocean, Madeira, and the Balearic Islands.

In New Zealand, many gecko species (*Hoplodactylus*) feed on nectar from flowers of numerous native plants. Herpetologist A. H. Whitaker (1987) found that large amounts of pollen adhere to their bodies, particularly the throat, and

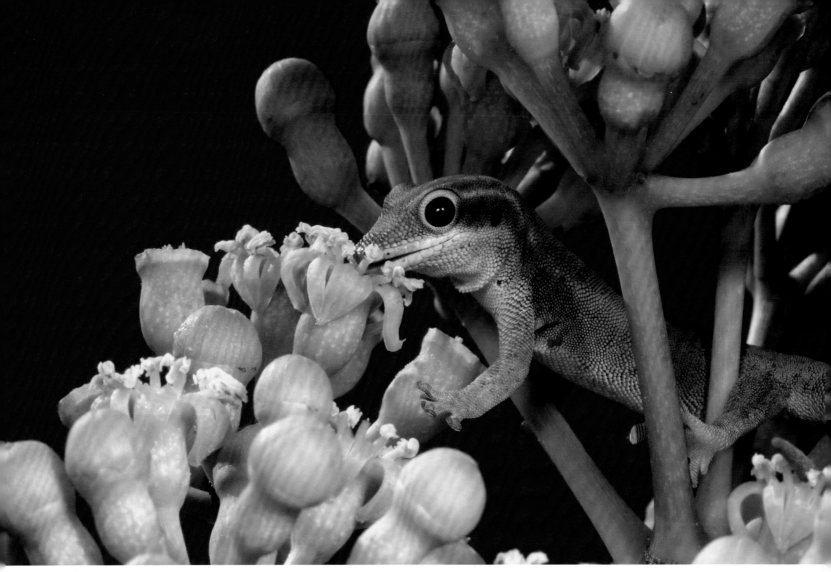

Figure 61. Geckos are significant pollinators on some remote islands. This ornate day gecko (*Phelsuma ornata*) is feeding on the nectar of endemic *bois boeuf* flowers (*Gastonia mauritiana*) on Mauritius. Photo courtesy of Mark Moffett/Minden Pictures.

some remains in place for at least 12 hours, more than enough time for it to be carried to other flowers of the same species. Whitaker suggested that the scales on the throat of the geckos are specially modified to collect pollen, implying that the geckos perhaps have a mutualistic relationship with native flowers and may be important pollinators.

Another interesting plant-lizard relationship exists above the tree line in Tasmania. According to M. Olsson and colleagues (2000), the endemic snow skink (*Niveoscincus microlepidotus*) regularly forages at the flowers of one of the most abundant plants in the habitat, the honey bush (*Richea scoparia*, Ericaceae). To get at the concealed nectar, the skink tears open a cap of fused petals that protects the flowers. Although the skinks never transport pollen themselves, they expose the stigmas and anthers, making them accessible to insect pollinators. The actions of the skinks dramatically increase the probability of successful pollination and seed set.

In the Indian Ocean, day geckos (*Phelsuma*) visit and pollinate many different flowers on many islands, including several that are rare island

endemics (fig. 61). On Mauritius, the relationship between day geckos and rare endemic plants has a unique feature. Most floral nectars are clear, but Mauritius boasts three endemic plants that have colored nectar. *Nesocodon mauritianus* (Campanulaceae) has blood-red nectar, while *Trochetia boutoniana* and *T. blackburniana* (both Malvaceae) have red and yellow nectar, respectively. Experiments with artificial flowers by Dennis Hansen and coworkers (2006) have shown that the day gecko *Phelsuma ornata* (which coexists with all three plants) prefers colored over clear nectar, demonstrating that colored nectar acts as an attractive visual signal.

Herpetologists J. M. Olesen and A. Valido (2003) have suggested various reasons for the success of lizards as pollinators on islands—that lizards often occur at high densities, whereas pollinating birds and insects, which might compete, are relatively scarce; that insects for lizards to eat may be in short supply on remote islands, whereas there is a surplus of floral food; and that predation risks are lower on islands than on the mainland, making it safer for lizards to expand their foraging behavior.

Pollination by Opportunistic, Unspecialized Insects

Though many flowers are adapted to attract specialized, often long-tongued insect pollinators, including bees, wasps, butterflies, and moths, many others are generalized, visited opportunistically, and pollinated by a motley collection of insects—mainly flies, wasps, and beetles—all of which are small and have a short tongue. Entomologist S. A. Corbet (2006) described such flowers as "specialized to be ecological generalists" (fig. 62). As a group, they tend to have small, inconspicuous, whitish (to the human eye) flowers, which are usually fragrant and which give easy access to nectar and pollen. They are often aggregated into dense, flat inflorescences, which provide a landing platform for insects as well as make them conspicuous at long distances. Prime temperate examples include such familiar plants as cow parsley (*Anthriscus sylvestris*), wild carrot

Figure 62. Wild carrot (*Daucus carota*) with its dense inflorescence is a typical example of a generalized flower that attracts a diverse selection of opportunistic insect pollinators. This inflorescence has attracted one ichneumon wasp, one fly, one dark-winged fungus gnat (*Sciara hemerobioides*), and three red soldier beetles (*Rhagonycha fulva*).

Figure 64. A hoverfly or sun fly (*Helophilus pendulus*) at a bramble flower (*Rubus fruticosus*). Shallow, open flowers like those of bramble often attract unspecialized pollinators.

Figure 63. Many beetles are specialized pollinators, but most small species visit unspecialized flowers where they munch on floral tissues as well as nectar and pollen. They are useful pollinators in only a minor way. This longhorn beetle (*Strangalia maculata*) is feeding on rough chervil (*Chaerophyllum temulum*).

(*Daucus carota*), hogweed (*Heracleum sphondylium*), and hemlock (*Conium maculatum*) in the umbellifer family (fig. 63). Umbellifers are abundant and conspicuous throughout northern temperate regions in summer. A study carried out in Utah (Hawthorn, Bohart, and Toole 1956) recorded 334 insect species in 37 families visiting carrot flowers. Other flowers that attract similar unspecialized pollinators include those of ivy (*Hedera helix*), elderberries, hawthorns, rowans, the wayfaring tree (*Viburnum lantana*), and,

in the tropics, the flowers of many large forest trees. More-showy flowers that attract many unspecialized pollinators include the composite flowers of daisies and numerous shallow, open flowers such as buttercups, wild roses, and the flowers of brambles (fig. 64).

A possible advantage of the aggregated heads of umbels and the composite heads of daisies is that their numerous individual flowers are likely to be pollinated by different insects with pollen delivered from different plants. This increases the potential for genetic variability, which enhances the ability of organisms to adapt to changes in their environment.

The many species of umbellifers look very similar and can be difficult to identify. In *The Natural History of Pollination*, it is suggested that they are

Müllerian mimics of each other and that the umbellifer-like inflorescence of many plants in other families, such as elderberries and rowans, might also be involved. It is thought that there is an advantage in this convergence of floral structure and color and that it is likely to improve rates of pollination. Müllerian mimicry may also be involved in other families, notably the daisy family, in which many species have all-yellow flowers that are difficult to distinguish (e.g., dandelions, hawkbits, and hawkweeds).

Pollination by Bees

Bees are by far the most important pollinators and visit a prodigious variety of flowers. They are obligate flower visitors and are particularly industrious because they, unlike other insects, feed their larvae as well as themselves on both pollen (which is rich in protein, fat, and other nutrients) and nectar (which they convert to honey) and have to visit lots of flowers to collect the quantities they need to pro-

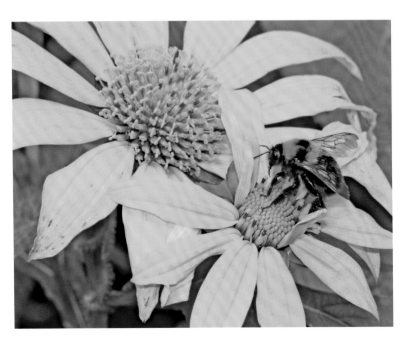

vision their nests (fig. 65). Many bees are effective long-distance pollinators because they range over distances of several kilometers. Some of the larger carpenter and orchid bees are trapliners. According to tropical ecologist Daniel Janzen (1971), orchid bees are capable of foraging over distances of 20 kilometers (12 miles) or more each day. They behave much like hummingbirds, concentrating on a small number of plant species that produce a few flowers each day for several weeks or months. They are immensely important for the pollination of flowers of widely dispersed plants.

The flowers visited by bees are generally sweet smelling but are otherwise very diverse. Bees visit flowers of many different colors but favor yellow, blue, purple, and ultraviolet (they see poorly at the red end of the spectrum). Their ability to distinguish different colors probably contributes to the constancy with which they visit particular flowers—a clear-cut aid to achieving efficient cross-pollination.

Bees are also influenced by the shape of flowers and their need for a landing platform. Small bees show a preference for radially symmetrical flowers such as poppies, crane's-bills, and bramble flowers, which provide a straightforward surface on which to alight. Many other flowers have an open trumpet shape, so that bees can land in the entrance. Bumblebees and other large bees sometimes show a preference for bilaterally symmetrical (zygomorphic) flowers with a stiff lower lip that serves as a landing platform. When alighting on a bilaterally symmetrical flower, pollinators are obliged to take up a

Figure 65. An Ecuadorean bumblebee (*Bombus*) visiting a daisy (*Bidens andicola*). Bees are quite variable in the length of their tongue. This one has a short tongue and is largely restricted to feeding at flowers, like this daisy, with readily accessible nectar.

Figure 66. An orchid bee (*Euglossa platymera*) at porterweed (*Stachytarpheta frantzii*). Some orchid bees have a tongue longer than their body and can reach deep-seated nectar inaccessible to most bees.

particular position to access nectar or other rewards. Doing so allows the transfer of pollen between flower and pollinator to be managed with great precision. Good examples are found among the snapdragons, monkeyflowers, legumes, and many others.

Bees are variable in size, ranging from less than 2 millimeters (0.08 inch) long in some stingless bees to 25 millimeters (1 inch) or more in carpenter bees (*Xylocopa*), and 39 millimeters (1.5 inches) in the leafcutter bee (*Megachile pluto*). Bees also vary in the length of their tongue (proboscis). Bees with a short tongue are restricted to visiting flowers with readily accessible nectar, whereas long-tongued bees can reach deep-seated, "hidden" nectar. Some orchid bees have a tongue longer than their body (fig. 66).

Bees are well adapted to collect pollen, most of which they use to feed their larvae. They are particularly important for specialized pollen-only flowers that provide little or no nectar. There are nearly 20,000 pollen flowers (about 7–8 percent of all flowering plants) in various families, notably the Melastomataceae and Solanaceae, that are buzz pollinated by bees, especially bumblebees, a procedure more correctly called sonication or vibratory pol-

len collection. Buzz-pollinated flowers have tubelike anthers containing dry, dustlike pollen that is accessible only through a small pore at the anther's tip. While clinging to the flower with their legs or mandibles, bumblebees vibrate their wing muscles at frequencies in the region of 320–410 cycles per second, transmitting a vibration through their body to the anthers. When the anthers vibrate in harmony, pollen spurts from the pores and onto the bee (fig. 67). Apart from bumblebees, other bees that practice buzz pollination include orchid bees, carpenter bees, and numerous solitary bees, though not honeybees (*Apis mellifera*). Buzz pollination is almost restricted to bees, a few bee-mimicking hoverflies (*Volucella* and *Eristalis*) being the only exceptions.

Most bees are hairy, furry in the case of bumblebees, and carry an electrostatic charge that attracts

pollen over a short distance. Pollen literally jumps onto the bee and gets caught among its hairs. Bees then groom themselves, collect the pollen, and pack it into a storage organ. Small solitary bees in the family Colletidae simply carry pollen in their crop, mixed with nectar. Many other bees, including leafcutter and mason bees (Megachilidae), use their legs to scrape pollen onto a pollen brush (or scopa) on the underside of their abdomen (fig. 68). Honeybees and bumblebees pack pollen into special pollen baskets (corbiculae) on their hind legs (fig. 69). Bees are also involved in several out-of-the-ordinary, specialized relationships with flowers. Oil-collecting bees, first described by Vogel (1969), use their legs rather than their mouthparts to collect oil produced as a reward by flowers in various families. Some South African bees (*Rediviva*), for example, have extralong, mop-like front legs that they dip into the oil that collects in the long floral spurs of a few South African oil flowers (*Diascia*, Scrophulariaceae). In another example, male orchid bees have legs with cushion- or sponge-like constructions of modified hairs, called "velvet patches," which enable them to collect and carry orchid perfumes that they use to attract females. Bees are also important participants in the pollination of bee orchids (*Ophrys*) by pseudocopulation, a process in which orchids use sexual deception to attract male bees (or wasps or other insects) by mimicking female visual and olfactory mating signals.

Honeybees are unique among insects in having a "dance language" (von Frisch 1954). Scout bees dance when they return to the hive to communicate information about a food source. The dance indicates the direction and distance to the flowers, as well as their abundance and the concentration of their nectar. Scent indicates the type of flower involved.

Figure 68. An orange-vented mason bee (*Osmia leaiana*) on a crane's-bill (*Geranium*) in an English garden. Many bees collect and transport pollen in a special storage organ. Mason bees use a pollen brush (or scopa) on the underside of their abdomen.

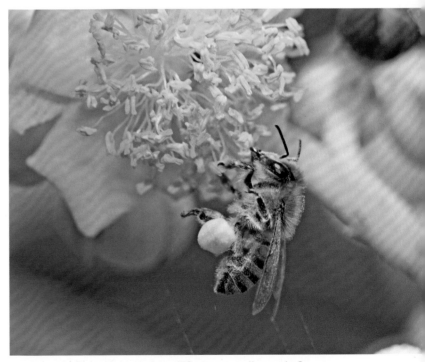

Figure 69. A honeybee (*Apis mellifera*) at a pollen-only flower (*Saurauia*). Pollen is stored and transported in pollen baskets (or corbiculae) on its hind legs.

Pollination by Wasps

Unlike bees, wasps are mainly predatory, for the most part feeding themselves and their larvae on insects and spiders. Even so, many are regular flower visitors, seeking nectar as an energy source and, during hot weather, for its water content. Overall, wasps are too smooth and hairless to collect much pollen on their body and are less important than hairy bees as pollinators, though there are notable exceptions. For example, tiny fig wasps (Agaonidae) are the only pollinators of the roughly 750 species of figs that exist worldwide (see Moraceae, chapter 14).

Figure 70. Wasps are responsible for the pollination of many orchids. Here a European tree wasp (*Dolichovespula sylvestris*) is leaving a broad-leaved helleborine orchid flower (*Epipactis helleborine*) with a pollinarium stuck to its head. Photo courtesy of Nick Owens.

Figure 71. In Ecuador many miniature orchids, such as this *Trichosalpinx dura*, are pollinated by tiny wasps. The wasp here, with a pollinarium stuck to its thorax, is only a few millimeters long.

In general, wasps are short tongued and, as pollinators, behave more like flies than like bees. Most of the flowers they visit and pollinate are the same unspecialized types favored by flies and a host of other small insects. Favorites include ivy and umbellifers. The few European flowers specifically adapted to attract and be pollinated by wasps tend to be dull red or brownish, and rather globular in shape. Common figwort (*Scrophularia nodosa*) and some helleborine orchids (*Epipactis*) are well-known wasp flowers (fig. 70). Yellow-green and white are preferred colors for wasps in tropical America, where a multitude of miniature orchids are pollinated by

tiny wasps (fig. 71). More unusual are the orchids that are pollinated by wasps by pseudocopulation. Those involved include many bee orchid relatives in the genus *Ophrys*, as well as numerous orchids in Australia—for example tongue orchids (*Cryptostylis*) and hammer orchids (*Drakaea*)—and a few others in South Africa.

Pollination by Flies

Along with beetles, flies are thought to have been among the ancient pollinators of the first flowering plants, probably attracted by stigmatic secretions and pollen. Flies are very diverse. Many are short-tongued, opportunistic visitors to unspecialized flowers (e.g., umbellifers, hawthorns, and rowans) and can be important pollinators, especially in high-altitude and high-latitude regions where bees are usually scarce or absent (fig. 72). However, many flies are very small and tend to move only a short distance between flowers, which limits their value as cross-pollinators.

Hoverflies (Syrphidae), also known as flowerflies, are important pollinators in many parts of the world. They are usually considered second in importance only to bees. They can be divided into three groups depending on whether they feed mainly on pollen, mainly on nectar, or on a mixture of both. Pollen feeders have a short, thick tongue 2–4 millimeters (0.08–0.16 inch) long and favor open, yellow or white flowers with easily accessible pollen. Nectar feeders have a much longer, narrower tongue 5–12 millimeters (0.2–0.5 inch) long, which is suitable for extracting nectar from narrow tubes (fig. 73). Mixed feeders tend to be intermediate. Hoverflies resemble bees in showing flower constancy. Willmer (2011) described them as "clever" flower visitors. Like bees, they easily use landmarks to navigate, and they deal

Figure 72. Greenbottle blowflies (*Lucilia*) are common visitors to flowers. They have a short tongue suitable for mopping up easily available nectar. This greenbottle is visiting Canadian goldenrod (*Solidago canadensis*). Note the yellow pollen on its underside.

with different types of flowers efficiently. For example, when collecting nectar from the numerous florets of a marigold, sunflower, or other large daisy, they recognize when they have completed a full circuit around the blossom's center and then leave.

Bee flies (Bombyliidae) have an even longer tongue than any hoverfly, enabling them to take nectar from flowers with a moderately long nectar tube. Bee flies often hover when feeding but sometimes fine-tune the aim of their long, rigid tongue by holding on to a flower with their legs (fig. 74). They are as hairy as many bees and readily carry pol-

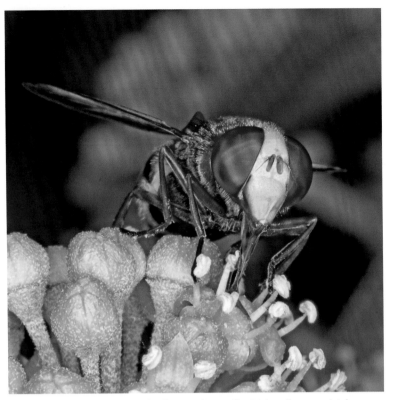

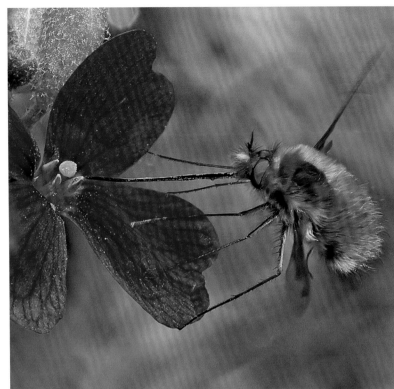

Figure 73. The hornet hoverfly (*Volucella zonaria*) has a relatively long tongue for a hoverfly and takes a lot of nectar, in this case at ivy flowers (*Hedera helix*). Hoverflies, also known as flowerflies, are important pollinators, second in importance only to bees.

Figure 74. A dark-edged bee fly (*Bombylius major*) feeding at aubretia (*Aubrieta deltoidea*). Bee flies have a much longer tongue than any hoverfly and can feed at flowers with a long nectar tube. They are as hairy as many bees and readily carry pollen from flower to flower.

len on their body. In England in spring, dark-edged bee flies (*Bombylius major*) are very attracted to flowers that are purple, blue, orange, or yellow, such as aubretia (*Aubrieta deltoidea*), forget-me-nots, wallflowers, and primroses.

In South Africa, a number of very specialized flies have exceptionally long tongues. Species of tangle-winged flies (Nemestrinidae), for example, have tongues 70 millimeters (2.8 inches) long, about four times the length of their body. This enables them to access the nectar at the bottom of the equally long floral tubes of painted petal irises (*Lapeirousia*) (fig. 75). At first sight, the relationship between fly and flower appears to be a good example of coevolution, a relationship in which both participants have mutu-

ally influenced each other's evolution. However, the fly is just one member of a fly community, all with exceptionally long tongues, that also includes bee flies, horseflies (Tabanidae), and other nemestrinids. The flies interact with flowers in several families, notably the Geraniaceae, Iridaceae, and Orchidaceae, all with an exceptionally long corolla or nectar spur. Together, the community of flowers and flies is an outstanding example of diffuse coevolution (see chapter 13).

Tiny flies or midges in the families Cecidomyiidae and Ceratopogonidae are involved in the pollination of many tropical flowers, though details are often poorly known. Midges are especially important for the chocolate industry. In spite

Figure 75. A tangle-winged fly (Nemestrinidae) delicately inserting its extraordinary tongue into the exceptionally long floral tube of a painted petal iris (*Lapeirousia oreogena*). Note the pollen on the front of the fly's head.

of being cultivated for thousands of years, beginning with the chocolate-loving Aztecs, the flowers of cacao or cocoa trees (*Theobroma cacao*) still have to be pollinated by midges (*Forcipomyia*, Ceratopogonidae).

There are also fly pollination syndromes involving mimicry and deceit in which flies are attracted to, and sometimes trapped in, flowers with simulated egg-laying sites (see chapter 6).

Pollination by Beetles

Together with flies, beetles have often been considered to be among the archaic pollinators of flowers. Indeed, fossil evidence shows that beetles first appeared more than 270 million years ago, long before the appearance of both flowering plants and bees. The majority of beetles have chewing mouthparts and tend to be destructive feeders. Peter Endress (1994) described them as uncouth "mess and soil" pollinators that browse on floral tissues as well as pollen and nectar. It is no surprise, then, that the ovaries of specialized beetle flowers are well protected by their carpels. To avoid being damaged too much by feeding beetles, some beetle flowers divert the beetles' attention to special food bodies. The Australasian spice bush (*Eupomatia laurina*, Eupomatiaceae) is an extreme case. Its flowers lack petals but instead have many edible, petal-like staminodes.

According to Peter Bernhardt (2000), the two most important groups of specialized beetle flowers are "chamber blossoms" and "painted-bowls." Chamber blossoms are most common in rain forests and other humid tropical habitats. Good examples include species of *Annona* and *Guatteria* (Annonaceae), *Magnolia* (Magnoliaceae), and many aroids (Araceae). The flowers (or blossoms) tend to be large and robust, roomy enough to accommodate several beetles (fig. 76). Most are cream or greenish, with a fermenting, fruity, or spicy scent, quite unlike the sweet fragrance (to humans) of butterfly or moth flowers.

Some of the most interesting examples of beetle-pollinated chamber blossoms are found in the aroid

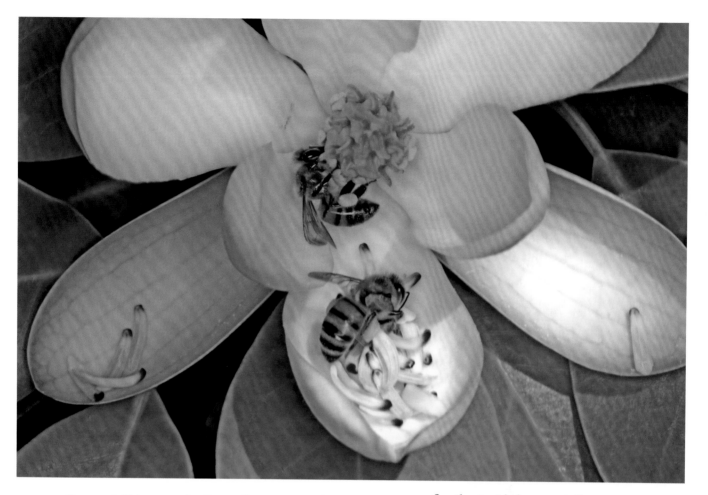

Figure 76. This magnolia (*Magnolia poasana*) is found in cloud forests in Costa Rica. It closely resembles other *Magnolia* species and is supposedly pollinated by nocturnal beetles. However, climate change has resulted in significant changes. Africanized honeybees have moved to higher elevations in Costa Rica and in 1999 reached the area around our house there. They have become common and often take over and breed in nest boxes intended for resplendent quetzals and other birds. They are regular visitors to *Magnolia* flowers.

or arum family. Aroids have an inflorescence, or spadix, surrounded by a leaflike spathe. In the Costa Rican elephant's ear arum (*Xanthosoma undipes*), studied by botanist Lloyd Goldwasser (2000), and in many other aroids, the spadix is covered by female flowers at the base and male flowers at the top, separated by a ring of sterile food flowers (fig. 77). The female flowers are more or less enclosed in a chamber formed by the spathe. The flowers are protogynous—the stigma of female flowers is receptive only before pollen is shed by the male flowers—thereby ensuring that self-pollination is avoided. The inflorescence lasts for two days. On the first day, in the pistillate phase, the spadix heats up at dusk, releas-

ing a sweet menthol scent that attracts scarab beetles (*Cyclocephala*), some of them carrying pollen from an inflorescence visited earlier. The spadix heats up to over 40°C (104°F), well over the ambient temperature of about 18°C (64°F). The warmth increases the volatility of the attractant scent and probably encourages beetles to save energy by staying in the spathe. The beetles descend to the chamber and pollinate the female flowers, which are receptive only on the first day. The beetles remain for 24 hours, mating and feeding on the ring of sterile flowers. On the second evening, in the staminate phase, the spadix reheats and the upper, male flowers release pollen. The beetles crawl up the spadix and fly off, covered with pollen, to repeat the process at another, newly opened inflorescence. From the point of view of the beetles, the inflorescence forms a mating chamber and also provides food and energy-saving warmth. Goldwasser recorded as many as 38 beetles in a spathe and an average number of 7. In the elephant's ear, the mating chamber formed by the spathe allows beetles to enter or leave at will, though many stay to take advantage of the availability of warmth, food, and mates. Many other aroids, however, have a trap structure enabling them to detain beetles (or flies in some species) for a day or two, and so increase the likelihood of pollination. Beetle traps are also found in water lilies, including the giant species *Victoria amazonica* and *V. cruziana*.

The second main group of specialized beetle flowers is known as painted-bowl blossoms. As their name suggests, the flowers form an upright cup or bowl, and most are brightly colored. They are most prevalent in warm-temperate or Mediterranean climate zones. For example, in Namaqualand (in South Africa and adjoining Namibia), monkey beetles (Scarabaeidae), which are rather hairy, are the major

Figure 77. A scarab beetle (*Cyclocephala sexpunctata*) on the inflorescence of an elephant's ear arum (*Xanthosoma undipes*). Pollination takes place over the course of two nights (see text).

pollinators of many of the bright yellow or orange daisies, with little or no scent, that flower in gorgeous profusion after good winter rains (see preface). Monkey beetles are particularly attracted to colorful bowl-shaped flowers with contrasting dark centers and spots (fig. 78). Most feed on floral tissues, though some specialize on pollen or nectar.

They make efficient beelike pollinators, flying rapidly from flower to flower in search of mates as well as food. They often carry several different types of pollen, so flower constancy (see chapter 5) is probably not the norm.

Blister beetles (Meloidae) in the genus *Nemognatha* are among the strangest beetle pollinators. Their mouthparts are extremely elongated and form a tonguelike structure used to suck nectar from flowers. Unlike the coiled tongue of a butterfly or moth, the mouthparts of *Nemognatha* are rigid. Nevertheless, both structures are equivalent in being derived from the same basic body parts—the maxillae.

Finally, there are many smaller beetles that visit small, unspecialized flowers along with a host of flies and wasps. Like larger beetles, they munch

Figure 78. A monkey beetle (Scarabaeidae) on a terracotta gazania flower (*Gazania krebsiana*).

indiscriminately on flower tissues as well as on pollen and nectar. They can be useful pollinators in a minor way, though most are not as active as bees, flies, and butterflies, and they are therefore less likely to carry pollen over long distances. The tiny pollen beetles (*Meligethes*, Nitidulidae), for example, that are so common in temperate habitats often remain for several hours in a single flower and rarely affect pollination in any significant way.

Pollination by Butterflies

Butterflies are sun loving and like to perch and bask while imbibing nectar from flowers. Typical butterfly flowers are diurnal and sweetly scented, and they provide a good landing platform, either in the form of a fairly large, single flower, or many small flowers aggregated together. Familiar examples of both types include honesty, wallflowers, brambles, knapweeds (*Centaurea*), lavenders, butterfly bush (*Buddleja davidii*), red valerian (*Centranthus ruber*), and lantana (fig. 79). Most butterfly flowers in the temperate zones are blue, purple, pink, or yellow, but, unlike most insects, some tropical butterflies are sensitive to red. In the Neotropics, many glasswing butterflies and passion-vine butterflies (*Heliconius*) are attracted to flowers that are either red or have red ancillary structures, such as calyxes, bracts, or leaves. Lantana, *Warszewiczia*, hot lips, poinsettia, and the tropical milkweed *Asclepias curassavica* are obvious examples (fig. 80). Butterfly flowers secrete moder-

Figure 79. The European peacock butterfly (*Aglais io*) is a common visitor to butterfly bushes (*Buddleia davidii*). *Buddleia* flowers are typical butterfly flowers. They secrete plentiful nectar and are sweetly scented, and the densely packed inflorescence provides an excellent landing platform.

Figure 80. An ithomiine tigerwing butterfly (*Mechanitis lysimnia*) feeding at tropical milkweed (*Asclepias curassavica*). The flowers produce plentiful nectar and are popular with many butterflies. Tropical milkweed is one of two plants, the other being *Lantana*, that is mimicked by orchids (*Epidendrum ibaguense* and *E. radicans*, chapter 14) that produce no nectar but nevertheless attract butterfly pollinators.

ate quantities of nectar, often in a long, thin spur that matches the long tongue of butterflies.

Though most butterflies visit flowers for nectar, passion-vine butterflies are unique among lepidopterans in being able to feed on protein-rich pollen. They gather it in sticky balls on their tongue, add a drop or two of regurgitated nectar to digest and release amino acids, knead it by rolling and unrolling their tongue, and ingest the mixture (fig. 81). Pollen is a vital source of protein that increases the longevity of passion-vine butterflies and enables females to lay eggs throughout a life of six to eight months, much longer than the few days or weeks of butterflies with a more typical nectar diet that is low in protein.

Flowers in a number of plant families, but particularly the Asteraceae and Boraginaceae, produce toxic pyrrolizidine alkaloids as a defense mechanism against herbivorous insects. These alkaloids are in turn collected by lek-forming male glasswing butterflies to serve as building blocks for the production of pheromones. The males use the latter to attract females, and during mating they pass some alkaloids on to females for assimilation, which makes the females unattractive to other males and distasteful to predators.

Inevitably, the red butterfly flowers that are common in the tropics also attract the attention of hummingbirds. The amount of nectar these flowers produce is too small to appeal to larger species, but small hummers are regular visitors.

Figure 81. A passion-vine or longwing butterfly (*Heliconius clysonymus*) collecting pollen from a flower of a cucurbit vine (*Psiguria*). Passion-vine butterflies are the only butterflies known to be able to feed on protein-rich pollen.

Pollination by Moths

Two distinct groups of nocturnal flowers are visited and pollinated by moths. Both groups are open during the night; are white, cream, or pale so that they are easily located at a distance in dim light; and have a heavy, intoxicating scent that provides a potent lure for moths. The flowers in one group lack a landing platform; have long, nectar-containing floral tubes or spurs; and are pollinated by hawkmoths that feed while hovering. Those in the other group provide a landing platform, have short nectar tubes, and are pollinated mainly by moths in the family Noctuidae that settle to feed. A few moth flowers, such as jimsonweed (*Datura stramonium*) and honeysuckle (*Lonicera periclymenum*), are regularly visited by both hawkmoths and settling moths.

Hawkmoths are the nocturnal counterparts of hummingbirds. They have similar hovering skills and a long tongue with which they probe long, tubular flowers (fig. 82). Many hawkmoths have a tongue in the region of 40–100 millimeters (1.6–3.9 inches) long, but a few have exceptional tongues more than double the length of a sword-billed hummingbird's bill. In 1862 Charles Darwin famously predicted that a hawkmoth with an extremely long tongue must be the pollinator of the newly discovered Madagascan orchid *Angraecum sesquipedale*, with a nectar spur up to 43 centimeters (17 inches) long. Forty years later, Darwin was vindicated by the discovery of an especially long-tongued Madagascan form of the African hawkmoth *Xanthopan morganii*. Hawkmoths are rapid fliers and are known to move distances of up to several kilometers at night, making them excellent long-distance pollinators (Janzen 1983b). Flowers that rely on hawkmoths for pollination occur in many genera in many families, a few of the most notable being angel's trumpets and tobacco plants (*Brugmansia*, *Datura*, and *Nicotiana*, Solanaceae), needle flowers (*Posoqueria*, Rubiaceae), and *Crinum* (Amaryllidaceae). Hovering is expensive in energy terms, and hawkmoths often save energy by landing inside flowers that are large enough to accommodate them, such as angel's trumpets. At large cactus flowers (*Hylocereus costaricensis*) in Costa Rica, tropical biologist Bill Haber (1983)

Figure 82. A convolvulus hawkmoth (*Agrius convolvuli*) feeding at flowers. Hawkmoths are skilled at hovering and have a long tongue with which they can extract nectar from flowers that have a long corolla or nectar spur. Photo courtesy of Konrad Wothe/Minden Pictures.

Figure 83. A mating pair of six-spot burnets (*Zygaena filipendulae*) on field scabious (*Knautia arvensis*). Like many day-flying moths, six-spot burnets are distasteful and are protected by their brilliant warning colors.

reported that hawkmoths were seen "to dive into the flower and crawl as far as they can into the throat," where they spent 5–20 seconds drinking nectar before backing out. While in the flower, the body and wings of the moths became coated with thousands of pollen grains.

Moths in the second group are most active at dawn and dusk. They have a short tongue (15–20 millimeters or 0.6–0.8 inch long) compared with hawkmoths and tend to visit white or light-colored flowers with relatively short nectar tubes, such as campions, pinks, and phlox in temperate areas, and sweet-smelling gardenias and jasmine in the tropics. They lack skill in hovering and prefer to settle to feed. The European silver Y moth (*Autographa gamma*) is an abundant example, and similar noctuid moths occur almost everywhere there are flowers.

Not all moths are nocturnal. Diurnal species include numerous small sphinx moths (e.g., hummingbird and bee hawkmoths) and many species with protective warning coloration, including tiger moths, burnet moths, and others in such families as the Zygaenidae, Arctiidae, Ctenuchidae, and Pericopidae. Diurnal species behave more like butterflies than like moths and visit mostly typical butterfly flowers (fig. 83).

Pollination by Other Insects,

Including Ants and Thrips

There are records of pollination by a variety of other insects and other invertebrates, including cockroaches, termites, grasshoppers, and snails, but examples are rare and they affect very few plants. Pollination by ants and thrips is slightly more significant.

Ants

Though closely related to bees and wasps and immensely significant in terms of their biomass, ants usually have a minor impact on flowers. Ants are attracted to flowers to steal nectar but are generally too smooth and hairless for much pollen to stick to them; too small to transfer pollen effectively from stamens to stigmas; and wingless and therefore unlikely to transfer pollen between different plants. By stealing nectar, most ant visitors harm flowers in a minor way, but others, attracted by extrafloral nectaries, sometimes become guards. In addition, there is a small group of plants, mostly twining, prostrate species, that are now known to be adapted to pollination by ants. Examples include ruptureworts and nailworts (*Herniaria* and *Paronychia*, Caryophyllaceae) in Europe, and Cascade knotweed (*Polygonum cascadense*, Polygonaceae) and Small's stonecrop (*Diamorpha smallii*, Crassulaceae) in North America.

Thrips

Thrips (Thysanoptera), commonly known as thunder flies (and notorious for getting inside picture frames), are minute insects 1–2 millimeters (0.04–0.08 inch) long. Many species live in flowers, where they pierce pollen grains and suck out the contents. They often carry grains of pollen caught among bristles on their body, and some are significant pollina-tors. For example, they are important pollinators of the huge canopy trees in the Dipterocarpaceae that dominate the rain forests of Southeast Asia. They also pollinate various heaths and other ericaceous plants, particularly in cold northern climates where bees and other insects are often scarce or inactive.

Pollination by Wind

Wind pollination works best when plants are clumped together and flower synchronously. It is particularly common and effective in open grassland, savanna, and other temperate habitats.

Flowers that are pollinated by wind, rather than insects or other animals, are usually much more simplified. They have no need to be colorful to attract pollinators, and their sepals and petals are usually reduced or absent. The flowers of grasses, plantains, and many trees, such as oaks, elms, and hazel, are inconspicuous and do not look at all like typical flowers (figs. 84 and 85). Their anthers are exposed to air currents or, in the case of many grasses, suspended on slender filaments so that they shake in the slightest breeze, releasing clouds of pollen. Their stigmas are exposed and finely divided, the better to capture grains of pollen. There is also evidence that electrostatic attraction might be involved in pollen capture. The pollen itself is dry and dustlike, easily carried long distances by gentle puffs of wind.

The timing of pollen release is important. In temperate woodland, flowering occurs very early in the year, when trees are still bare of leaves and the movement of wind-borne pollen is unimpeded by dense foliage. Many temperate trees release their pollen in the early afternoon, when the air is at its warmest and driest.

The stigma of wind-pollinated flowers, which is

Figure 85. A close-up of a female hazel flower showing the red styles already dusted with pollen grains.

Figure 84. Hazel (*Corylus*) is monoecious, with male and female flowers on the same tree. The familiar catkins are clusters of 200 or more individual male flowers that produce abundant pollen. The very small female flowers are visible mainly because they have bright red styles. The female flower is a tiny target for wind-borne pollen, but hazel catkins produce millions of pollen grains. Two female catkins are visible in the photograph.

the target for grains of wind-borne pollen, is typically tiny and often feathery or fanlike to aid in pollen capture, but usually no more than a square millimeter in size (about 1/650 of a square inch). So, to be effective, wind pollination demands enormous numbers of pollen grains. The quantities of pollen can be staggering—a single hazel catkin produces about 4 million pollen grains, and a single flower head of many grasses can produce 10 million grains.

Wind pollination is uncommon in tropical forests because the huge diversity of plants means that most species are relatively rare. They are at such low density, with trees so few and far between, that the chances of wind-borne pollen reaching a target are slim. There are other problems in tropical habitats, especially in rain forests, where heavy, prolonged rainfall is likely to wash pollen out of the air, and the low wind speeds that prevail in dense vegetation do not carry pollen very far. Examples of wind pollination in the tropics exist mainly at high altitudes. Oaks and alder (*Alnus acuminata*), for example,

reach high densities in the mountains of Costa Rica.

Pollination by Water

Examples of water pollination are relatively rare because water has a ruinous effect on the viability of pollen. The majority of aquatic plants raise their flowers above the water surface and are pollinated by wind or insects in the same way as land plants. Familiar examples include bogbean (*Menyanthes trifoliata*), water hyacinth (*Eichornia crassipes*), water plantains (*Alisma*), arrowheads (*Sagittaria*), spearworts (*Ranunculus*), and water lilies (fig. 86). Riverweeds (Podostemaceae) grow attached to rocks in fast-flowing rivers but flower only in the dry season, when the plants are exposed to wind or are accessible to insects.

Among other aquatic plants, there are some in which pollination takes place at or close to the water surface. A well-known example of water pollination is provided by ribbonweed (*Vallisneria spiralis*, Hydrocharitaceae), a widespread and invasive aquatic plant. Male flowers release pollen, which drifts on the water surface and eventually collides with a female flower.

There are relatively few examples of flowers that are pollinated while submerged. Among the most important are eelgrasses (*Zostera*) and other marine seagrasses. Their pollen grains, which are elongated and wormlike, are released in clouds and carried by currents through the beds of grass. They curl around any stems they contact and secure themselves to the exposed, feathery stigmas. In the case of intertidal eelgrasses, the anthers float and pollination takes place at the water surface as the tide ebbs and flows.

Figure 86. The majority of aquatic plants raise their flowers above the water surface, where they are pollinated in the same way as land plants. These water lilies (probably *Nymphaea pubescens*), which were flowering in Borneo, are no exception. Most water lilies are pollinated by beetles, some by bees.

POLLINATOR 5 BEHAVIOR

Flower Constancy

Lots of pollinators visit more than one type of flower as they forage. This risks different types of pollen becoming mixed and being carried to the wrong destination. It can even result in stigmas getting clogged with the wrong pollen. It is a potentially severe problem in the tropics, where flower diversity is very high and many pollinators visit lots of different flowers. The likelihood of successful cross-pollination is compromised.

Depending on their foraging behavior, some pollinators are much better at efficient cross-pollination than others. Some insects, especially social bees, as well as many solitary bees, hoverflies, and butterflies, show flower constancy—the habit of repeatedly visiting a relatively abundant or productive flower species to the exclusion of others. The flowers are recognized by a combination of color, shape, and scent (fig. 87). How long constancy continues is variable. It can continue for days or for just a few hours, depending on how quickly available rewards are depleted. Constancy is hugely advantageous to flowers, as it clearly increases the likelihood of successful cross-pollination. The advantage to pollinators is less obvious, but exploiting a single type of flower may be more efficient than having to use different

Figure 87. This red-tailed bumblebee (*Bombus lapidarius*) showed flower constancy as it foraged in an English meadow. Over a period of several minutes it visited only blue cornflowers (*Centaurea cyanus*) in a meadow dominated by yellow corn marigolds (*Glebionis segetum*) and red poppies (*Papaver rhoeas*). Flower constancy increases the likelihood of successful cross-pollination.

techniques to gather rewards efficiently at several different kinds of flowers.

Territorial Behavior versus Traplining

Consider the behavior of hummingbirds. A territorial hummingbird defending a large patch of flowers on a single shrub or tree rarely delivers pollen to a different plant and contributes little to cross-pollination. Paradoxically, smaller hummingbirds that intrude into territories to steal nectar are often more useful to a plant than the territory owner. Since intruders visit flowers only briefly before being chased off, they perhaps deliver pollen to a plant of the same species some distance away.

Hermit hummingbirds and other trapliners (e.g., other hummingbirds, large long-tongued bees, and hawkmoths) are very different from territorialists. They exploit high-reward flowers that are too scattered to be worth defending. They carry pollen from flower to flower over considerable distances, enhancing the likelihood of cross-pollination. Research carried out in Costa Rica by botanist Suzanne Koptur (1984) showed that cross-pollination in three species of *Inga*, pollinated by hummingbirds and hawkmoths, resulted in more fruit being set when parent trees were separated by more than a kilometer (0.6 mile), and therefore less likely to be related, than when they were closer than half a kilometer (0.3 mile). William Haber and Gordon Frankie (1982) reported the same distance effect, again in Costa Rica, for the hawkmoth-pollinated *Luehea candida* (Malvaceae). The same effect may be widespread in tropical trees.

Traplining also has potential disadvantages. Traplining hummingbirds visit a variety of flowers in the course of their rounds, which increases the risk that pollen will be mixed and carried to the

Figure 88. The bronzy hermit (*Glaucis aenea*) is a trapliner that exploits scattered high-reward flowers, often of different species. To minimize the possibility that pollen will get mixed up, high-reward flowers are constructed so that pollen is deposited on different parts of a trapliner's body. In this case, the hermit is carrying pollen from the passion flower (*Passiflora vitifolia*) it is visiting on the crown of its head, and pollen from some other flower on the tip of its bill.

wrong flowers. To minimize this problem, high-reward flowers, such as passion flowers, heliconias, and bromeliads, are constructed so that their stamens and stigmas come into contact with a specific part of a feeding hummingbird's body (fig. 88). In some species it is the bill, in others the chin, throat, crown, or some other part. This helps ensure that pollination is effective and minimizes the possibility of hybridization.

Similar scenarios are associated with other flower-pollinator interactions. For example, orchids can share orchid bee pollinators because pollinaria are placed on as many as 13 different locations on a bee's body (Roubik and Hanson 2004).

MIMICRY AND DECEIT IN FLOWERS

The relationship between plants and pollinators is self-serving and lacks any hint of intentional cooperation or altruism. Both plants and pollinators cheat each other if they can or at least interact as economically as possible. Plants benefit by cheating because they avoid or minimize the costly energy and nutrient drain of producing nectar, pollen, or other rewards. Pollinators maximize their reward by collecting it as easily as possible with the least expenditure of energy. Deceit seems to be commonest in rare, unclumped flowers that are unlikely to benefit from flower-constancy behavior by pollinators.

Orchids are the cheaters par excellence. It has been estimated that almost half of all orchids offer no reward and attract pollinators by deceit. Many are generalized flower mimics that provide visual or olfactory signals to attract potential pollinators but offer no reward. They depend on naive pollinators mistaking them for flowers that offer a reward. Others are good mimics of other flowers that grow in the same environment. Yet other orchids exhibit a wealth of deceitful pollination strategies that involve both visual and pheromone mimicry, culminating in pseudocopulation. But, as Peter Bernhardt pointed out in *The Rose's Kiss*, deceitful plants are successful "only when there is a steady supply of naïve visitors. They must bloom when a sucker is born every minute."

Another form of deceit pollination involves intersexual mimicry. It is not uncommon among the many tropical plants that have separate male and female (unisexual) flowers and has been studied in begonias (*Begonia*) and papayas or pawpaws (*Carica papaya*). In *Begonia involucrata*, for example, female flowers lack a reward, while male flowers offer pollen that attracts stingless bees (*Trigona* and *Melipona*). The male and female flowers are superficially similar in having two petal-like sepals and a sweet scent, and even though they are completely different structures, the yellow stigmas of the female flowers mimic the anthers of the males (figs. 89 and 90). Ágren and Schemske (1991) found that bees soon learn to recognize that only male flowers offer a reward, because they are visited 4–10 times as often as females. Nevertheless, mistaken visits to female flowers by inexperienced bees are sufficient to produce an average fruit set of more than 70 percent. The deceit works.

Floral deceit is also found in the form of pseudoflowers, pseudopollen, and pseudonectaries, all of which increase the overall appeal of a flower (or inflorescence) to pollinators by appearing to offer

Figures 89 and 90. This Costa Rican begonia (*Begonia involucrata*) is a well-studied example of intersexual mimicry and deceit pollination.

rewards of pollen or nectar that do not exist. Guelder rose (*Viburnum opulus*) and hydrangeas provide excellent examples of pseudoflowers. Both have umbel-like inflorescences that feature enlarged, decorative pseudoflowers around their periphery (fig. 91). The enlarged flowers are sterile and have no sexual function. They lack any reward but do help attract pollinators by enhancing the floral display. Pseudopollen comes in various guises, ranging from bright yellow sterile structures (staminodes) that resemble functional anthers, to yellow markings, mere patches of color, that mimic anthers. Good examples of pseudopollen are found in the bearded iris (*Iris germanica*), with its raised yellow "beard" on the landing petal; the common yellow monkeyflower (*Mimulus guttatus*), with raised hairy ridges on its lip; and the water hyacinth (*Eichhornia crassipes*), with a conspicuous yellow patch on its upper petal. These features attract visitors by stimulating their innate visual preferences, even if they are not always deceived into attempting to collect "pollen." Grass-of-Parnassus or bog-stars (*Parnassia*) provide a classic example of pseudonectaries. Each flower has five staminodes, each with three stalks tipped with a glistening, drop-like knob. The latter is dry and lacks any reward but readily attracts naive flies.

Figure 91. Pseudoflowers are another version of floral deceit. This hydrangea (*Hydrangea peruviana*) has enlarged pseudoflowers around the margins of the inflorescence. The flowers offer no reward but do enhance the floral display.

Flowers Offering False Brood Sites

Specialized relationships involving deceit are found in brood site pollination, in which flowers attract pollinators by mimicking and appearing to offer breeding sites. There are two main syndromes, one involving fungus flowers and the other carrion or dung flowers. In both syndromes the degree to which pollinators are deceived is variable.

Fungus flowers include a number of aroids and orchids that achieve pollination by masquerading as fungi to attract fungus gnats (Mycetophilidae and Sciaridae). The Mediterranean mousetail arum (*Arisarum proboscideum*) is a well-studied example. Its spadix is untypical for an arum in being club shaped, spongy in texture, and off white. Visually it mimics the underside of a *Boletus* fungus and also has a fungus-like odor. It is pollinated by fungus

gnats that enter the spathe and end up at the bottom among the female flowers, dusted with pollen from a flower visited previously. Female gnats lay eggs on the spadix, but the larvae do not survive. The relationship is both deceptive and parasitic.

Other fungus flowers are found in the orchid genus *Dracula*, in which the orchid's labellum (lip) looks and smells like the gills on the underside of a mushroom (fig. 92). Lorena Endara and colleagues (2010) have studied several *Dracula* species in Ecuador. The orchids attract fruit flies (*Zygothrica*, Drosophilidae), which normally court, mate, and lay their eggs on fungi. Flies gather on the orchids and accidently pollinate them as they mingle. It seems that the female flies are not stimulated to lay eggs, so the relationship is deceptive but not parasitic.

Carrion and dung flowers are found in several

Figure 92. The lip of this Ecuadorean orchid (*Dracula sodiroi*) mimics a fungus, including its smell, in order to attract fruit flies (*Zygothrica*, Drosophilidae) that habitually lay their eggs on fungi. The flies gather and accidentally pollinate the orchid as they mingle.

unrelated families, notably the Asclepiadaceae, Aristolochiaceae, Araceae, Orchidaceae, and Rafflesiaceae, all of which have independently evolved the smell and appearance of dung or rotting carcasses. Their foul stench, combined with their texture and dull purplish or brownish color, attracts blowflies (Calliphoridae), flesh flies (Sarcophagidae), and carrion beetles (Silphidae) searching for sites to lay their eggs (fig. 93). Most dung and carrion flowers provide no reward, and visiting pollinators are not always stimulated to lay eggs. However, if eggs are laid, the relationship becomes parasitic, because the resulting fly or beetle larvae quickly perish from lack of food.

The numerous species of *Rafflesia* are among the most malodorous flowers, earning them the nickname "corpse flowers." *Rafflesia arnoldii* is the largest flower in the world, reaching up to 1 meter (3.3

feet) across and 11 kilograms (24 pounds) in weight. *Rafflesia* offers no reward, but visiting flies are not stimulated to lay eggs—the relationship is deceptive but not parasitic. On the other hand, starfish flowers and Bushman's hat flowers (*Stapelia* and *Hoodia*, Apocynaceae), found in southern Africa, attract blowflies that regularly do lay eggs. The resulting larvae soon starve.

The white bat flower (*Tacca integrifolia*, Dioscoreaceae), native to eastern Asia, is spectacular when flowering (fig. 94). It more or less fits the fly-pollinated carrion-flower syndrome in having an unpleasant odor and dark purple color. The function of its long, dangling appendages is unknown. It is nectarless, and any flies that visit it are attracted by deceit. Given its bizarre appearance and obvious odor, it is strange that *Tacca* gets very few visitors and that self-pollination is the norm. It is an unusual and rather puzzling plant.

Figure 93. This Namibian carrion flower (*Stapelia acuminata*), with its color and foul stench, resembles a rotting carcass and attracts blowflies (Calliphoridae). The flies accidentally pollinate the flower while searching for a nonexistent place to lay their eggs.

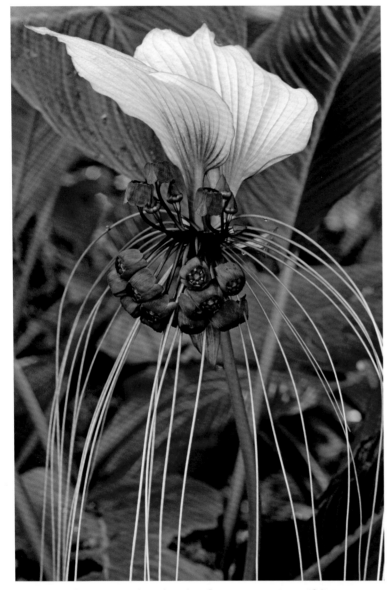

Figure 94. The spectacular white bat flower (*Tacca integrifolia*), a native of Malaysia and Indonesia, is rather mysterious. It looks and smells as though it should be fly pollinated, but it receives very few visits by any pollinator. Self-pollination is the norm.

There are also numerous orchids that mimic dung or rotting flesh. Many species of *Bulbophyllum*, for example, have a foul smell that attracts flies. Many also have extraordinary adornments, including hairs, plumes, and other appendages, which vibrate and apparently enhance their attractiveness to flies. All have a hinged lip that tips when a fly lands on it, throwing it against the pollinaria. Other fly-pollinated orchids with a foul smell include many miniature species of *Pleurothallis*, which have been variously described as smelling of fish, rancid cheese, and dog feces.

Trap Flowers

Trap flowers function in much the same way as the elephant's ear arum already described (see chapter 4), differing only in that visiting pollinators are trapped and detained for a day or two, increasing the chance of successful pollination. Numerous aroids are trap flowers (really inflorescences rather than single flowers), smelling mostly of dung or rotting meat and attracting flies and beetles. As in the elephant's ear arum, their inflorescences are protogynous (the stigmas are receptive before the anthers release pollen). Insects arriving with pollen on the first day fly or fall to the bottom of the trap and pollinate the female flowers. There they are detained for a day or two, by which time the anthers have matured, showering the insects with pollen before releasing them. Meanwhile the female flowers have become unreceptive, thereby preventing self-pollination.

Trap flowers tend to have features in common even when they are not closely related. Most have a relatively large chamber that forms the trap; transparent "window panes" that attract pollinators toward the stigma and anthers; and directional

guard hairs or slippery, lubricated surfaces that prevent escape. Once the male flowers have finished shedding pollen, the guard hairs shrivel, and other changes allow trapped insects to escape and perhaps visit and pollinate another plant.

Aroid examples of trap flowers include the dead horse arum from Corsica and Sardinia; the dragon lily (*Dracunculus vulgaris*) from the Balkans; and lords-and-ladies (*Arum maculatum*), widespread in Europe. The famous titan arum (*Amorphophallus titanum*), from Sumatra, certainly has the largest and most spectacular trap flower. It is even bigger than the flower of *Rafflesia arnoldii*, reaching a height of about 3 meters (10 feet), but it is an inflorescence, not a single flower. It has a particularly revolting smell, some of the chemicals responsible being the same as those found in rotting fish, Limburger cheese, and sweaty socks. Reports of potential pollinators attracted by the putrid stench mention large carrion beetles (*Diamesus*, Silphinae), flesh flies, and *Trigona* bees. In *The Private Life of Plants*, the BBC and David Attenborough showed tiny sweat bees entering a spathe and clambering over female flowers. The bees appeared to be genuine pollinators.

Other trap flowers that function in a similar manner (but not all mimicking dung or carrion) include Dutchman's pipes (*Aristolochia*) (fig. 95), the large Old World genus *Ceropegia* (Apocynaceae), the African root parasite *Hydnora africana* (Hydnoraceae), slipper orchids (*Cypripedium* and *Paphiopedilum*), and water lilies.

Flowers Offering Authentic Brood Sites
As we have just seen, many flowers attract fly and beetle pollinators by appearing to offer breeding sites in the form of fungi, dung, or rotting meat.

Figure 95. This Dutchman's pipe (*Aristolochia pichinchensis*) is a trap flower. Flies are attracted by its unpleasant smell and become imprisoned for a while. In due course, by which time the flies are covered in pollen, they are allowed to escape.

However, there are also at least four examples of highly evolved, symbiotic relationships in which flowers provide authentic breeding sites in return for pollination. In all four cases, both parties rely completely on each other for sexual reproduction. Deceit is not involved in these flower-pollinator relationships, but it is convenient to consider them here alongside examples of false brood site pollination.

The best-known example of this sort of symbiotic relationship is the one between figs and fig wasps. It is discussed elsewhere (see Moraceae, chapter 14), as is another example, involving small trees in the genus *Siparuna*, which are pollinated by gall midges (see Siparunaceae, chapter 14).

Another classic example involves the symbiotic relationship between species of *Yucca* (Agavaceae) and yucca moths (*Tegeticula* and *Parategeticula*) (fig.

96). In most flowers, pollination is a rather haphazard event, occurring almost accidentally as pollinators move from flower to flower (not necessarily of the same species) and inadvertently (from the pollinator's point of view) transfer pollen grains to stigmas. By contrast, the pollination of *Yucca* flowers by yucca moths is a deliberate, targeted act. Female moths methodically collect a ball of sticky pollen from the anthers of a flower, using their highly modified, tentacle-like mouthparts. They then fly to another inflorescence, find a flower not yet visited by another moth, and lay eggs in the ovary (fig. 97). Finally, they stuff pollen into the flower's stigmas, which are unified to form a tube. The whole process may be repeated several times. By the time the moth eggs hatch, the fertilized flowers will have developing seeds for the young caterpillars to eat. The

Figure 96. A soaptree yucca (*Yucca elata*) growing on gypsum dunes in New Mexico. The coevolved relationship between yuccas and yucca moths is extraordinary.

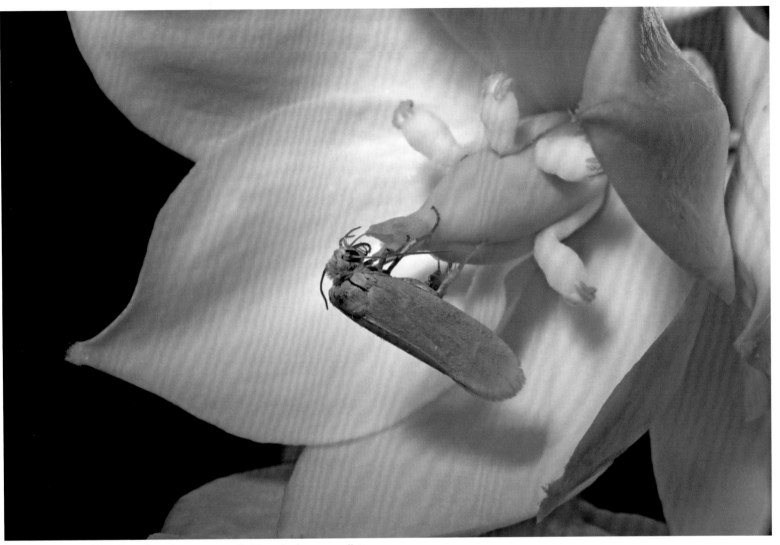

Figure 97. A female yucca moth (*Tegeticula yuccasella*) ovipositing in the ovary of a yucca flower. The pollination of yucca flowers by yucca moths is a deliberate act. The moths collect pollen in their tentacle-like mouthparts, fly to another yucca, lay eggs, and finally stuff pollen into a flower's tubelike stigma.

caterpillars eat only a small proportion of the available seeds, leaving the rest to develop normally. *Tegeticula yuccasella*, the yucca moth involved with most yuccas, has now been shown to be a complex of several species, each associated with one particular *Yucca* species.

A fourth example of brood site symbiosis involves the Australasian spice bush (*Eupomatia laurina*), studied by Armstrong and Irvine (1990), which is pollinated by weevils (*Elleschodes*). The weevils are attracted by the fruity, musky smell of the flowers. The latter lack petals but have numerous fused stamens and staminodes, which together form a substantial, nutritious structure. Carrying pollen, the weevils enter the structure, feed on the staminodes, and lay eggs. Within hours the mass of staminodes falls to the ground, where it provides shelter and food for the developing weevil larvae. The female parts of the flower are not damaged by the weevils and develop normally.

FLOWER PREDATORS, NECTAR THEIVES, AND FLOWER DEFENSES

Not all visitors to flowers are pollinators. We have already noted that the relationship between plants and potential pollinators is self-serving and that the rewards offered by flowers are often stolen if readily available.

Whole flowers, and the nectar they contain, are eaten by a diverse assortment of mammals and birds, including monkeys (see chapter 4), deer, squirrels, pigeons, barbets, grosbeaks, and many more. Other flower eaters include black ctenosaurs (*Ctenosaura similis*) and numerous insects, notably leafcutter ants (*Atta*). The depredations are sometimes serious. In England in the 1950s and 1960s, Eurasian bullfinches (*Pyrrhula pyrrhula*) took so many flower buds in orchards that they were considered a threat by the commercial fruit-growing industry. Many growers trapped more than a thousand bullfinches annually. Massive flower destruction has also been reported in the tree *Symphonia globulifera* (Clusiaceae) in Costa Rica. A troop of Geoffroy's spider monkeys (*Ateles geoffroyi*) being studied by Riba-Hernandez and Stoner (2005) destroyed or damaged most of the flowers on 10 trees within their home range. None of these set fruit, though 7 of 10 trees outside their home range did.

Nectar is a desirable food and is pilfered by many animals that are nonpollinators. Squirrels bite into nectaries (fig. 98), and flowerpiercers (small birds with a modified bill) pierce the base of long flowers to extract nectar otherwise out of reach. Several hummingbirds, notably the stripe-tailed hummingbird (*Eupherusa eximia*) (fig. 99), wedge-billed hummingbird (*Schistes geoffroyi*), and black-eared and purple-crowned fairies (*Heliothryx auritus* and *H. barroti*), have needle-sharp bills and specialize in piercing flowers. They almost always avoid contact with a flower's reproductive structures and rarely visit flowers legitimately. Many other hummingbirds pierce flowers opportunistically or steal nectar through existing holes. In Costa Rica, violet sabrewings (*Campylopterus hemileucurus*) have even learned to pierce the bountiful nectaries of the bat-pollinated bromeliad *Werauhia nephrolepis* before the flowers have opened, and spot-breasted orioles (*Icterus pectoralis*) do the same at the tree *Pachira quinata* (Bombacaceae). Nectar is also stolen by many insects. The worst culprits are short-tongued bumblebees, carpenter bees, and stingless bees, all of which regularly bite holes in the nectaries of flowers if they cannot reach the nectar legitimately

Figure 98. A Costa Rican variegated squirrel (*Sciurus variegatoides*) biting into the nectary of a pochote flower (*Pachira quinata*) and stealing nectar. Pochote flowers are pollinated by bats at night, but leftover nectar attracts many birds, including parrots, woodpeckers, and orioles, as well as squirrels.

(fig. 100). Beetles browse on floral tissues, including stigmas and anthers. Ants steal nectar from all but the most inaccessible nectaries.

In spite of being only about 0.6 millimeter (0.002 inch) long, flower mites (Ascidae) also rank as significant nectar thieves. Flower mites live inside flowers, where they feed on nectar and pollen. Numbers per flower vary from a few to more than 100, and they can have a considerable impact, sometimes consuming up to half the nectar intended for pollinators. Flower mites are found in flowers of many families, but we have personally encountered them mainly in hummingbird-pollinated flowers, especially species of *Heliconia, Passiflora, Centropogon,* and many epiphytic heaths (Ericaceae). As well as competing for food, flower mites take advantage of hummingbirds by hitching rides between flowers. The mites jump onto a feeding hummingbird's bill and race up it to shelter in the

bird's nostrils. Different species of mites are specific to different flowers, so more than one species may hitch a ride at the same time. Each mite has to identify the correct flower at which to disembark (probably using odor cues) and has only a second or two in which to make the decision and race down the bill (fig. 101).

Flowers have to find a balance between encouraging legitimate pollinators and defending themselves against the depredations of herbivores and nectar thieves. The flowers as well as the foliage of many plants are laced with toxic or distasteful compounds that deter herbivores. And flowers with a long

Figure 99. The stripe-tailed hummingbird is one of several hummingbirds that specialize in piercing the nectaries of flowers in order to steal nectar.

Figure 100. A buff-tailed bumblebee (*Bombus terrestris*), which has a short tongue, stealing nectar by piercing the long nectar spur of a columbine (*Aquilegia vulgaris*).

corolla often have a tough calyx that surrounds the nectaries and resists piercing by birds and hole biting by bees. Legitimate pollinators are not affected.

Some plants protect their flowers with the help of extrafloral nectaries that attract and reward ants for standing guard and providing protection against small nectar thieves and herbivorous insects. Extrafloral nectaries occur in over 100 families of flowering plants. Important genera include *Inga* with 294 species, *Acacia* with 204 species, and *Passiflora* with 322 species.

Ants as formidable as the bullet ant (*Paraponera clavata*), so called because its sting is said to be as painful as a bullet wound, are quite capable of deterring almost any unwanted visitor (fig. 102). However, the ants themselves are often nectar thieves as well as guards, and they are only marginally useful. In fact, numerous plants keep ants

away rather than encourage them. Many make use of an impassable water barrier or other obstruction. Teasels (*Dipsacus*), for example, have pairs of leaves on their main stem that collect rainwater, forming moats that prevent access to the flowers. In tank bromeliads and some species of *Heliconia*, the developing buds are submerged and protected in water-filled pools or bracts. In other bromeliads, developing buds are enclosed within a jelly-like mucilage. And in the stinking passion flower (*Passiflora foetida*), the barrier takes a different form—a network of sticky, glandular bracts capable of trapping small insects.

Figure 101. Even though they are tiny, flower mites (*Ascidae*) are significant nectar thieves and use hummingbirds to hitch a ride from flower to flower. Here six mites are disembarking from the bill of a long-billed hermit (*Phaethornis longirostris*) and are about to enter a passion flower (*Passiflora vitifolia*).

Figure 102. A bullet ant (*Paraponera clavata*) guarding ginger flowers (*Costus pulverulentus*). The bullet ant is attracted by the ginger's extrafloral nectaries. Note the drop of nectar visible on the right-hand side of the inflorescence.

ANTIPOLLINATORS

As mentioned previously, not all visitors to flowers are pollinators. In addition to herbivores and nectar thieves, there are predatory snakes, praying mantises, and crab spiders that lie in wait among or in flowers and prey on visiting pollinators. The orchid researcher H. M. Ospina (1969) used the name "antipollinators" for such predators. Perhaps the most remarkable and beautiful examples are the golden morph of the eyelash pit viper (*Bothriechis schlegelii*), which sometimes preys on hummingbirds, and two flower mantises—the Malaysian orchid mantis (*Hymenopus coronatus*) and the African *Pseudocreobotra wahlbergi*, both of which regularly prey on bees and butterflies (fig. 103). Early instars (developmental stages) of both species are capable of varying in color (from white to pink in the orchid mantis, and either greenish or reddish in the African species), enabling them to match their chosen flowers. Other examples of antipollinators include mantis-flies (Mantispidae) and numerous spiders, particularly crab spiders. The latter are usually white or yellow and often sit inside matching trumpet-shaped flowers, waiting to ambush visiting insects.

Of course, any patch of flowers that attracts insect pollinators is likely to attract antipollinators in the form of insectivorous birds. In fact, the tropical botanist Alwyn Gentry—an expert on mass-flowering *Handroanthus* and *Tabebuia* species (Bignoniaceae)—suggested (1983) that aerial chases by insectivorous birds "encourage" surviving pollinators to move on and so facilitate cross-pollination. Gentry considered the attraction of numerous antipollinators to be an integral part of the mass-flowering strategy. In the Americas, numerous tyrant flycatchers are skilled predators of bees and wasps, as are a number of other, less obvious species. In both Costa Rica and Ecuador, we have watched squirrel cuckoos (*Piaya cayana*) and wintering summer tanagers (*Piranga rubra*) spend hours at a time, systematically catching honeybees and other hymenopterans at flowering shrubs (fig. 104). And several small birds of prey, notably the tiny hawk (*Accipiter superciliosus*) and barred forest-falcon (*Micrastur ruficollis*), have been recorded preying on hummingbirds. In the Old World, bee-eaters are renowned for their bee-catching skills.

Figure 103. After lying in ambush on oleander flowers, an African flower mantis (*Pseudocreobotra wahlbergi*) has captured a pierid butterfly that might have pollinated the flowers.

Figure 104. The summer tanager (*Piranga rubra*) is a specialist predator of hymenopterans. On their wintering grounds in Central and South America, summer tanagers spend much time in the vicinity of flowering trees systematically catching wasps and bees. This male tanager has a wasp in its bill.

THE FLOWER'S FINAL ACT: SEED PRODUCTION AND DISPERSAL

Fruits and Seeds

The final act of the flower is the production of fruits, which are packaging for seeds, and the seeds themselves. Like animals, plants need to disperse their offspring (seeds) to areas where they can thrive and perpetuate their genes and have evolved adaptations to do so in diverse and ingenious ways. Dispersal is important for three main reasons—it moves seeds away from their parents, thereby avoiding competition with the parent plant for light, water, and nutrients; it enables the colonization of new areas; and, perhaps most importantly, it improves a seed's chances of escaping predation. When seed densities under the parent tree are very high, predation by weevils, rodents, and other seed predators can be so severe that it prevents any regeneration at all. While young animals can disperse by walking, flying, or swimming under their own power, seeds need help. Many are dispersed by wind or water, scattered by explosive capsules, or transported by attaching themselves to animal fur, but most plants, particularly in the tropics, bribe mammals and birds to disperse their seeds by offering tasty fruits as a reward.

The supply of fruits in temperate and other strongly seasonal environments is not continuous, so animals can be only part-time frugivores. On the other hand, the year-round supply of fruits in tropical forests permits mammals and birds to be specialist year-round frugivores. Specialists are extremely important vectors for seed dispersal. For La Selva Biological Station, a lowland rain forest site in Costa Rica, Gary Hartshorn (1983) estimated that of 320 tree species, the seeds of 50 percent were dispersed by birds, 13 percent by bats, 29 percent by other mammals (a total of 92 percent by birds and mammals plus one riparian fig by fish), and only 8 percent by wind. Working in Guianan primary rain forest, Dutch biologist M. G. M. van Roosmalen (1985) found seed dispersal by animals to be similarly high, at 87–90 percent. Seed dispersal by wind is more important in more seasonal forest habitats, reaching 31 percent in dry forest trees in Costa Rica and even higher in temperate woodland trees.

There are two main types of fruits—fleshy, edible ones, in which the seeds are covered by fruit pulp, and dry fruits, including capsules, pods, nuts, samaras, and others. Fleshy fruits attract animals to disperse their seeds. They are further divided into true

fruits (such as tomatoes, plums, cherries, and black-berries) and false or accessory fruits (apples, pears, and strawberries). This is a technical distinction that depends on whether the fruit develops from the ovary (true fruits) or from other floral parts. However, the animals that eat fleshy, juicy fruits and subsequently disperse the seeds do not care about the distinction—a fruit is a fruit whether it is false or not. For the sake of convenience, we here use the term "fruit" to refer to any of the edible structures that enclose seeds. However, a number of alternative names for fruits eaten by animals are widely used and are worth a brief mention (we use them occasionally). The most important are berry, drupe, aggregate fruit, multiple fruit, and aril. Berries are simple, fleshy fruits in which one to numerous seeds develop from a single ovary (fig. 105). Familiar examples include elderberries, grapes, blueber-ries, gooseberries, and tomatoes. Drupes are sim-ple, fleshy fruits with a hard, stony layer surround-ing and protecting a single seed (fig. 106). Familiar examples include olives, cherries, plums, and peaches. Aggregate fruits develop from the fusion of numerous ovaries (each of which forms a fruitlet) belonging to a single flower (fig. 107). Blackberries and raspberries are typical examples. Multiple fruits are formed from a cluster of tiny flowers, all of which produce fruits that eventually merge into a single mass. Examples include mulberries, figs, and pineapples. Arils are soft, edible tissues, often color-ful, that are attached to hard, indigestible seeds that typically develop within capsular fruits or pods.

Although fleshy fruits are easy to "catch" and are designed to be eaten, the seeds they contain do not want to be eaten and have to survive passage through the digestive tract of seed dispersers if they are to germinate successfully. In fact, the ability of

Figure 105. A blackbird (*Turdus merula*) swallowing a rowan berry (*Sorbus aucuparia*). A berry is a simple, usually juicy, fruit derived from a single flower and often contains many seeds.

Figure 106. Wild avocado fruits (*Ocotea tenera* in this case) turn from green to black as they ripen. Wild avocados are drupes—fleshy fruits containing a single seed that is enclosed in a usually hard, protective layer.

Figure 107. A hoverfly (*Helophilus pendulus*) feeding on the juice of a blackberry (*Rubus fruticosus*). A blackberry is an aggregate fruit formed by the fusion of numerous fruitlets, each derived from a single ovary.

seeds to germinate after ingestion by frugivores is quite variable. Traveset (1998) reviewed the effect of about 100 animal species (bats, nonflying mammals, birds, and reptiles) on the seeds of nearly 200 plant species. Germination was affected in only about half the plants tested. It was enhanced in about two-thirds of these and inhibited in one-third. Passage through the gut can enhance germination in two main ways—by removing fruit pulp from the seeds and by abrading the seed coat. However, any enhancement of germination is probably no more than an accidental consequence of incomplete digestion of seeds, not a mutualistic adaptation to help plants. Other relevant factors include the time seeds remain in the gut and the chemical environment in the gut.

Although fleshy fruits are designed to be eaten, they do not want to be eaten prematurely before they are ripe. Nor do they want to be damaged by seed predators that are targeting the seeds that the fruits contain. To combat such eventualities, fruits are adapted both physically and chemically. Unripe fruits tend to be green and inconspicuous, and they are protected by a thick outer skin that is tough or spiny. In ripe fruits the seed or seeds are often enclosed in a hard, difficult-to-digest, protective case, as in nuts. Most unripe fruits also contain defensive chemicals that make them distasteful or toxic. The latter adaptation is a potential problem—if fruits are supposed to be eaten by animals, they must change as they ripen from being toxic to edible. As they do so, most simultaneously change color and/or develop an attractive odor.

The second main category of fruits consists of dry pods, capsules, and other structures. The seeds of dry fruits are dispersed in diverse ways, utilizing animals, wind, explosive pods, gravity, and water. Dry fruits can be divided into two major groups—dehiscent fruits in which the seeds are contained in pods or capsules, which split open (dehisce) when mature to display or discharge the seeds; and indehiscent fruits, which remain closed when mature and rely on decay or predation to release the seeds. Dehiscent fruits are found in many plant families, the pods of sweet peas (*Lathyrus odoratus*), beans, acacias, and other legumes being among the most familiar. Other well-known examples include honesty, jimsonweed, campions, and lilies.

In some dehiscent species, the inedible pods and capsules split open to expose an edible reward in the form of bright red, orange, yellow, or white arils. Arils are fleshy, oil-rich, nutritious tissues that are derived from and partially cover the seeds (fig. 108).

Arils are particularly common and conspicuous in numerous plant families in the tropics and are extremely attractive to birds. Many migrants feast on them to fatten up for migration. Characteristic examples can be seen in *Connarus*, *Pithecellobium*, *Clusia*, and *Virola*. Some arils, known as elaiosomes, are rich in lipids and proteins and are specialized to attract ants as seed dispersers. Several examples are found among North American spring-flowering plants, such as sedges, violets, *Trillium*, and bloodroot (*Sanguinaria canadensis*).

Dry, indehiscent fruits include nuts and acorns; the winged fruits (samaras) of maples, sycamores (fig. 109), elms, and ashes; the parachuting fruits of

Figure 108. The red pods of a tree sometimes known as catclaw blackbead (*Pithecellobium unguis-cati*) splitting open to expose black seeds, partly enclosed by a white aril. An aril is a fleshy, edible covering on a seed and is often colorful to attract seed dispersers.

Figure 109. The winged seeds of sycamore (*Acer pseudoplatanus*), also known as samaras, are an example of dry, indehiscent fruits. Many are wind dispersed.

dandelions, thistles, and many bromeliads; and the "grains" of grasses. They also include burs—fruits that are covered with barbs, hooks, or spikes that stick to the skin or fur of any animals that brush against them.

Seed Size

The size of seeds is variable and is related to how they are dispersed, the size of their dispersers, and the habitat in which the seed is adapted to germinate. The wind-dispersed, dustlike seeds of orchids are the smallest and lightest of all, with as many as a million seeds per gram. They lack any significant nutrient reserves and rely totally on mycorrhizal fungi to facilitate the uptake of water and minerals during the initial growth of seedlings.

Small seeds are common among annual plants (fig. 110) and pioneer forest trees. Small seeds with a small store of nutrients are cheap to produce. It follows that plants with small seeds can produce

many more per flower than plants with larger seeds. Annual plants typically produce enormous numbers of seeds, increasing the probability that at least some will end up in suitable habitat. Pioneer forest trees also produce abundant tiny seeds, and many tropical species, such as figs and cecropias (*Cecropia*), produce seeds year round, ensuring that a continuous supply is available to exploit new light gaps created by falling trees, landslides, or floods.

Large seeds are characteristic of many rain forest trees that follow the strategy of producing relatively few seeds loaded with substantial food reserves. Large seeds are expensive for a plant to produce but aid growth after germination, resulting in healthy, well-established seedlings. The seeds of wild avo-

Figure 110. A spectacular display of Namaqualand daisies (*Dimorphotheca sinuata*) after good winter rains in the Namib Desert. Daisies like *Dimorphotheca* are annuals and have tiny seeds that are cheap to make and can be produced in enormous numbers.

Figure 111. These *Canna* pods are slowly disintegrating, allowing their seeds to fall to the ground.

cados (Lauraceae), nutmegs (Myristicaceae), and palms (Arecaceae) are good examples. They often germinate in deep shade, but their substantial reserves help them wait for the space and light they need for further progress.

Seed Dormancy

Many seeds go through periods of dormancy in which they are unable to germinate even when environmental conditions are favorable. The length of time that seeds remain dormant can vary greatly within a species. Dormancy is an advantage if it delays germination until conditions are even more favorable. Seeds that mature in late summer or autumn, for example, are likely to fare better if germination is delayed until the following spring, thereby avoiding several months of severe winter conditions.

Many plants have seeds with variable dormancy that are adapted to survive in the seed bank for weeks, months, years, or even centuries. Some *Canna* seeds, for example, remain viable for at least 600 years (fig. 111). Variable dormancy facilitates the buildup of long-term seed banks. It ensures that not all the seeds of any particular species germinate

at the same time and that at least some are likely to survive long periods of severe cold or drought. Variable seed dormancy is characteristic of plants that live in arid habitats that are climatically unpredictable and also of pioneering plants that colonize unpredictable light gaps. Some of these seeds remain viable for years, waiting for the rainfall, tree fall, landslide, flood, or fire that will create the right conditions.

A first phase of seed dispersal is carried out by animals, wind, water, or gravity, or sometimes it is done ballistically by means of exploding seedpods, but this is not always the end of the dispersal process. Many seeds do not move very far, often ending up under the parent tree or close by, but secondary dispersal can result in further movement. Variable dormancy means that some seeds survive for several months or years before they germinate, or perhaps until the parent tree dies. During this wait it is possible that storms, floods, landslides, or other random events might move some seeds a considerable additional distance, perhaps multiple times. In combination with dormancy, secondary seed dispersal may well be an important dispersal factor for many seeds.

SEED DISPERSAL **10** SYNDROMES

We have already described how flowers possess different suites of characters, known as pollination syndromes, that match the characteristics of their pollinators. Similarly, fruits conform to "dispersal syndromes" that match the characteristics of their seed's dispersers, mainly mammals and birds. However, the differences between the mammal and bird syndromes are quite loose. Mammals in particular are very opportunistic in their feeding behavior and often eat fruits intended for birds (fig. 112).

Abiotic seed dispersal syndromes (dispersal by wind and water) are relatively straightforward and depend on diverse structural adaptations. Nutritious food rewards are not required. On the other hand, seed dispersal by animals occurs in two distinctly different ways. First, the seeds of some plants are adapted to be transported passively on the skin or fur of animals (mainly mammals) with the aid of barbs, hooks, and spines. Second, and more importantly, plants and animals exchange services to their mutual advantage—a nutritious reward or bribe in the form of fruit pulp is exchanged for seed dispersal. Animals swallow seeds along with fruit pulp and regurgitate or defecate the seeds later, often some distance away. As the English ornithologist David Snow pointed out in his illuminating book *The Web*

Figure 112. Some mammals are very opportunistic and readily take bird fruits. This white-faced capuchin (*Cebus capucinus*), for example, is eating a typical red, juicy bird fruit (*Allophylus racemosus*, Sapindaceae).

of Adaptation (1976), fruits are easy prey. Unlike insects and other prey animals, fruits want to be eaten in order to disperse their seeds. Nevertheless, the relationship between fruits and seed dispersers, like that between flowers and pollinators, is self-serving and entirely lacking in altruism. Plants optimize the resources they invest in fruits and cheat if they can. Furthermore, the dispersal of seeds by mammals, birds, and other animals is, with a few exceptions, random, passive, and directionless. After fruits have been processed, their seeds are regurgitated or defecated wherever the disperser happens to be. Many seeds end up under the parent tree, where their high density attracts specialist seed predators and pathogens, or in deep shade or other unsuitable places. Rather few end up in situations suitable for germination, subsequent growth, and survival.

Three characteristics of fruits are worth emphasizing. First, most fruits are seasonal, so their availability is patchy in space and time and most animals have to vary their diet through the course of the year. Even in the wet tropics, where fruits of one sort or another are available year round, most plant species produce fruits seasonally, and periods when fruits are scarce or absent are not uncommon. Second, the nutritional value of fruits is variable. Fruits at one extreme are much more nutritious than those at the other. Low-quality fruits are generally small, juicy, and rich in carbohydrates but lacking in proteins and fats. They are cheap to produce and often occur in huge crops. Animals can use them as a valuable source of water and energy but are forced to turn to alternative sources for proteins and fats. On the other hand, high-quality fruits contain all or most of the nutrients necessary for animals to survive. They are expensive to produce and usually occur as small crops. As long as such fruits are available, animals

do not have to look elsewhere for additional nutrients. Third, fruits are easily digestible, and the time that seeds are retained in the gut is sometimes very short, particularly in specialist avian frugivores. Gut retention time affects how far seeds are likely to be dispersed. It is only 30 minutes or less in some birds and fruit bats, but much longer in omnivorous primates and herbivorous ungulates.

Seed Dispersal by Mammals

Mammals, including bats, primates, ungulates, and rodents, are important seed dispersers in many habitats. Most mammals lack color vision but have an acute sense of smell, a sensory condition that fits with many being nocturnal. Mammals have teeth and are well equipped to bite chunks from fruits and chew their food. Unlike most birds, they are not restricted to swallowing fruits whole. For that reason, fruits dispersed by mammals often have a tough, protective covering, are usually colored a dull green or brownish yellow, and emit a strong odor when ripe. However, many mammals are opportunistic and often eat fruits intended for birds.

A great many mammals include fruits in their diet, but the number that are wholly or mainly frugivorous is rather small. Fruit bats are the most specialized mammalian frugivores, but fruits are seasonally important for primates, elephants, tapirs, some deer and antelopes, and many rodents. And it may come as a surprise that many members of the order Carnivora eat fruits, which are easily digestible, and they disperse seeds quite efficiently.

Some large, mammal fruits are very smelly, the most notorious being durians (*Durio*, Bombacaceae), widely distributed in Southeast Asia, where they are regarded as a great delicacy. Even so, their smell is so overpowering that they are often

banned from hotels, public buildings, and public transport. Durian fruits are roundish, up to 1 foot (30 centimeters) long and up to 8 kilograms (18 pounds) in weight, and they have a tough, spine-covered rind. Protected inside this formidable husk are numerous seeds surrounded by pulpy arils. The great English naturalist Alfred Russel Wallace described the pulp as "a rich custard highly flavored with almonds." Wallace was a fan (as are we) and described the sensation of eating durians as being "worth a voyage to the East to experience." Others have likened it to "eating Limburger cheese in an outhouse." The American chef Anthony Bourdain, also a fan, described its taste as "indescribable, something you will either love or despise" and added that "your breath will smell as if you'd been French-kissing your dead grandmother."

Durians are incredibly attractive to many mammals (fig. 113). Their powerful odor attracts Asian elephants (*Elephas maximus*), orangutans (*Pongo*), pigs, deer, rodents, and even tigers (*Panthera tigris*). Opening the well-armored fruits requires strength and skill, a feat Asian elephants and orangutans can accomplish. But, if left long enough, durians also open naturally along sutures. It is not entirely clear which mammals are good dispersers. The seeds are known to contain toxins but are nevertheless chewed and destroyed by orangutans and probably by wild boars (*Sus scrofa*), Javan and Sumatran rhinos (*Rhinoceros sondaicus* and *Dicerorhinus sumatrensis*), and Malayan tapirs (*Tapirus indicus*). On the other hand, Asian elephants swallow the seeds and defecate them intact, often far from the parent tree. Long-tailed or crab-eating macaques (*Macaca fascicularis*) are also known to be good dispersers. Smaller species tend to feed on the fruit in situ, leaving seeds under the parent tree.

Figure 113. The Bornean orangutan (*Pongo pygmaeus*) is very partial to durians, but it usually chews the seeds, making it a seed predator rather than a disperser. Photo courtesy of Konrad Wothe/Minden Pictures.

Fruit bats

Fruit-eating bats occur in two families—the Pteropodidae in the Old World tropics and the Phyllostomidae in the New World. The Pteropodidae, often called megabats, include about 180 species of small to very large bats, ranging in weight from 15 grams (0.03 pound) up to 1,500 grams (3.3 pounds) in flying foxes (*Pteropus*). The latter are the biggest of all bats, and about 60 species occur in East Africa, tropical Asia, and Australasia, and on remote islands in the Indian and Pacific Oceans. They feed on nectar and pollen as well as fruit. Noteworthy African fruit bats include the hammer-headed bat (*Hypsignathus monstrosus*) and epauletted fruit bat (*Epomophorus wahlbergi*). Most megabats rely on vision rather than echolocation to avoid obstacles but use their keen sense of smell rather than vision to locate ripe fruits. Many occupy large roosts by day, and some cover distances of 50 kilometers (30 miles) or more per night while foraging. Louise Shilton and Robert Whittaker (2009) have provided evidence that flying foxes, which are well known to fly between oceanic islands, were involved in reintroducing some bat-dispersed plants to Krakatau after the 1883 eruptions that destroyed the island's vegetation.

Specialist fruit-eating bats in the New World belong to two subfamilies of the Phyllostomidae, the Caroliinae and Stenodermatinae, containing about 80 species (fig. 114). Compared with Old World megabats, they are small, ranging in weight from 5 grams (0.18 ounce) to no more than 70 grams (2.5 ounces). Unlike megabats, they use both echolocation and their sense of smell to locate fruits. Many species typically carry fruits 100 meters (330 feet) or more to one of several night roosts before eating them. They regularly cover several kilometers while

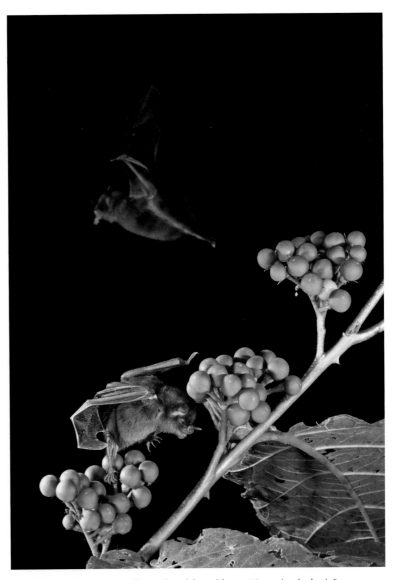

Figure 114. Highland yellow-shouldered bats (*Sturnira ludovici*) foraging for fruits of *Solanum chrysotrichum* in a cloud forest in Costa Rica. A number of bat fruits, including these, project upward and clear of foliage, thereby giving bats unimpeded access.

foraging and defecate seeds, sometimes in flight, wherever they go.

Most fruits adapted to be dispersed by bats are green, yellow green, or drab colored and have a musty, sour odor. Many bat fruits are pendent or cauliflorous, giving flying bats easy access, while *Piper* and some *Solanum* fruits are exposed to bats by projecting upward away from foliage (fig. 115). Old World megabats usually eat soft fruits completely, including small seeds, but chew fibrous fruits, swallow the juice, and spit out fibrous material and large seeds. New World fruit bats, all of which are relatively small, eat mostly fleshy fruits containing numerous tiny seeds (Muscarella and Fleming 2007). Some of the most popular are species of *Cecropia*, *Piper*, *Solanum*, and figs, all of which are characteristic of early plant succession in regenerating forest. The seeds pass through the bats intact. There is little doubt that fruit-eating bats play an important role in forest regeneration throughout the tropics.

Primates and arboreal carnivores

Primates and other arboreal mammals often consume fruits adapted for mammals while still on the tree (fig. 116). Many apes, monkeys, and lemurs rely heavily on fruits—up to 60 percent or more of their

Figure 115. *Piper lanceifolium* is another example of a bat fruit that projects upward, making it easily accessible to bats in flight. The many species of *Piper* are a staple in the diet of fruit bats (*Sturnira* and *Carollia*) in Central and South America.

Figure 116. A Chacma baboon (*Papio ursinus*) feeding on red figs in Kruger National Park in South Africa. Many primates rely on fruit for much of their diet. Primates have good color vision and are readily attracted to fruits that are intended for birds.

They can be either seed predators or seed dispersers, depending on how they handle and consume fruits. Sometimes seeds are masticated and destroyed; sometimes they are dropped or spat onto the ground below the parent tree, where their chances of survival are very low; and sometimes they are swallowed and later defecated. Because it takes several hours for seeds to pass through a primate's digestive system, defecated seeds often benefit by being moved several hundred meters from the parent tree.

Apes, monkeys, and other primates are significant dispersers of seeds of the many typical mammal fruits with tough skins that are inaccessible to smaller, arboreal frugivores. However, the majority of primates are diurnal, have good color vision, and are also attracted to colorful bird fruits. Figs and fruits in the families Melastomataceae and Solanaceae provide many good examples. A study on Barro Colorado Island in Panama (Hladik and Hladik 1969) estimated that a troop of white-faced capuchins (*Cebus capucinus*) dispersed the seeds of the melastome *Miconia argentea* at a rate of more than 300,000 per day or 150,000 per hectare per year (ca. 60,000 per acre per year).

Lemurs have been found to be important seed dispersers in rain forests in Madagascar. For example, Christopher Birkinshaw (2001), working in the Lokobe Reserve, determined that 54 percent of tree species and 67 percent of individual trees there had grown from seeds dispersed only by the black lemur (*Eulemur macaco*).

diet in bonobos (*Pan paniscus*), orangutans, gibbons (Hylobatidae), spider monkeys (*Ateles*), sakis (*Pithecia*), and the larger lemurs. However, almost all primates are basically omnivorous and turn to other foods for essential nutrients that are deficient in fruits and at times of year when fruits are scarce. Smaller primates turn mainly to insects and other animal prey while larger species, such as African colobus monkeys and Neotropical howler monkeys and woolly spider monkeys, eat foliage and other vegetable matter. The interactions of primates with fruits are complex. Primates are notoriously destructive feeders, knocking many fruits to the ground.

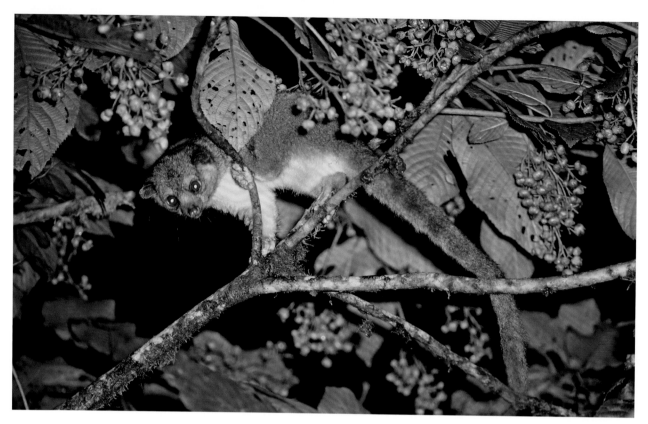

Figure 117. A northern olingo (*Bassaricyon gabbii*) foraging at night for fruits of *Saurauia montana*. The capsular fruits of *Saurauia* species (related to kiwifruits) are filled with slimy jelly in which tiny seeds are embedded. When fruits are ripe, strands of jelly and embedded seeds drip from the open capsules. The jelly tastes quite sweet and is eaten by a few birds, notably chlorophonias and euphonias, but the main dispersers are undoubtedly mammals, including kinkajous (*Potus flavus*), olingos, and probably fruit bats. In Costa Rica, *Saurauia* fruits are also enjoyed by small children, who, inspired by the dripping strands of mucilage, call them *moco* (snot fruit).

Other arboreal mammals that consume fruit include numerous members of the order Carnivora, notably the New World procyonids—raccoons (*Procyon*), coatis (*Nasua*), olingos (*Bassaricyon*), the kinkajou (*Potus flavus*), and the cacomistle (*Bassariscus sumichrasti*); a New World mustelid—the tayra (*Eira barbara*); Old World viverrids—the Asian palm civet (*Paradoxurus hermaphroditus*) and

the binturong (*Arctictis binturong*); and even a fox—the semi-arboreal American gray fox (*Urocyon cinereoargenteus*). All these animals are omnivorous, but the procyonids and palm civets, in particular, eat many fruits and disperse their seeds (fig. 117). Unlike herbivorous mammals (which need a complex stomach and long alimentary tract to break down and digest the cellulose in leaves and twigs), meat-eating carnivores are well suited to disperse seeds successfully. They tend to gulp down food items rather than chew and destroy the seeds contained inside. And they also have a rather short digestive system so that fragile seeds tend to pass through them quickly, without being damaged.

Ungulates, elephants, terrestrial carnivores, and rodents
Ripe fruits that fall to the ground are readily eaten by a lot of terrestrial mammals (fig. 118), including ungulates (e.g., rhinos, tapirs, pigs, deer, antelopes), elephants, many carnivores, and rodents.

Tapirs, pigs, deer, and other ungulates are not

Figure 118. These hog plums (*Spondias mombin*) have fallen to the ground below a tree in Costa Rica, where they are consumed by many mammals. Fruit falling to the ground is often described as dispersal by gravity. Really it is just presentation—making the fruits available for terrestrial dispersers.

particularly good dispersers and often act as seed predators. They mostly chew food thoroughly so that most seeds are crushed and digested, although seeds that are exceptionally hard may be spat out by animals chewing their cud. Only the small seeds of figs and similar fruits, which are too small to be ground up, regularly survive passage through the digestive system of an ungulate. Tapirs, wild boars, feral pigs, peccaries, and deer, which mostly destroy seeds, are known to be dispersers of many small seeds (fig. 119). The time required for seeds to pass through the gut is a crucial factor. Seeds sometimes remain in the digestive tract of tapirs, horses, and other ungulates for weeks—so long that the seeds germinate and are digested.

Elephants are important dispersers of seeds of all sizes. Savanna-dwelling African bush elephants (*Loxodonta africana*) eat and disperse many fruits seasonally, especially palm fruits, while forest-dwelling Asian elephants can usually find and eat fruits for much of the year. However, African forest elephants (*L. cyclotis*) are more frugivorous than

Figure 119. This Baird's tapir (*Tapirus bairdii*) was eating figs under a fig tree in Corcovado National Park, Costa Rica. Tapirs chew fruits thoroughly and destroy most seeds. However, fig seeds are so small that some usually pass through the tapir unharmed.

either of their African savanna and Asian relatives and have been described as "the ultimate seed dispersers." They have a profound effect on the ecology of forest trees, especially in maintaining species diversity. Researchers in the Congo rain forest (Blake et al. 2009) analyzed 855 piles of elephant dung and identified seeds from almost 100 plant species (not counting thousands of small seeds less than a centimeter in diameter) that had passed through the elephants unharmed. The time it took for seeds to pass depended on their size, varying from about a day for small seeds to three days for the largest ones. Elephants moved 82 percent of seeds more than 1 kilometer (0.6 mile) and regularly moved seeds more than 5 kilometers (3 miles). Longer-distance dispersal of seeds was quite common, with distances of up to 57 kilometers (35 miles) being recorded. Seeds also benefited by being deposited in huge piles of dung, which provided a rich source of nutrients for germinating seeds.

Many terrestrial members of the order Carnivora are omnivorous rather than carnivorous. Coyotes (*Canis latrans*), jackals, foxes, and most bears, for example, eat fruits when they are available and, as mentioned previously, are surprisingly good seed dispersers. In North America, species of Carnivora that consume fruits are among the most important dispersers of seeds. Black and grizzly bears (*Ursus americanus* and *U. arctos*), for example, consume huge quantities of berries in fall—blueberries, blackberries, cranberries, and others. Grizzly bears have been recorded eating many thousands of buffalo berries in a single day. In late summer and fall, the diet of coyotes and foxes also includes many fruits. In some areas, seasonal fruits contribute 90 percent or more of the diet of red foxes. Favored fruits include apples, plums, blueberries, blackberries, mulber-

ries, acorns, and many more. The South American maned wolf (*Chrysocyon brachyurus*) is another canine that is a significant seed disperser, with a diet of about 50 percent fruits (Motta-Junior and Martins 2002). The diet of cats, large and small, tends to be more strictly carnivorous. Even so, tigers, jaguars (*Panthera onca*), and margays (*Leopardus wiedii*) are known to eat fruits opportunistically.

Traditionally, rodents have been considered seed predators. However, because the grass seeds, acorns, and nuts eaten by rodents often occur as huge crops, they are ideal for storage for later consumption when food is scarce. In fact, many rodents, including squirrels, hamsters, kangaroo rats, pocket mice, and agoutis, routinely scatter hoard surplus food by hiding or burying it in numerous small caches, some of which remain forgotten and uneaten. It is likely that buried seeds that are forgotten survive much better on average than seeds dropped at random or below the parent tree. So, seed predators that are scatter hoarders may end up being better dispersers than many of the animals that fruits are specifically designed to attract. Recent research suggests that scatter hoarding of seeds, and later secondary movements, may result in even more effective seed dispersal than previously expected. Patrick Jansen and coworkers (2012) found that Central American agoutis (*Dasyprocta punctata*) repeatedly dug up and recached their seeds, and that seeds were also stolen by other agoutis and recached. Some seeds were recached up to 36 times, and an estimated 35 percent of seeds were moved more than 100 meters (330 feet) from the parent tree.

Pleistocene megafauna
Based on their research in Costa Rica, tropical biologists Daniel Janzen and Paul Martin (1982)

Figure 120. In the past, many large-seeded fruits would have been harvested and dispersed by extinct herbivores, such as gomphotheres and ancestral horses. Nowadays the survival of such plants is down to scatter-hoarding agoutis, such as this black agouti (*Dasyprocta fuliginosa*), as well as domestic cattle and horses.

drew attention to the many large-seeded fruits, including *Cassia grandis, Enterolobium cyclocarpum, Pithecellobium saman, Hymenaea courbaril* (all Fabaceae), and *Crescentia alata* (Bignoniaceae), that remain unharvested in contemporary dry forest habitats in Costa Rica. They suggested that these large fruits would have been harvested in the past, and their seeds dispersed, by large Central American herbivores, such as the elephant-like gomphotheres, ground sloths, and ancestral horses, that became extinct about 10,000 years ago. Given the extinction of these dispersers, one wonders how the trees have survived. Research by Winnie Hallwachs (1986) suggests that scatter-hoarding agoutis are probably

responsible for the survival of large-seeded, leguminous *guapinol* trees (*Hymenaea courbaril*) and probably other large-seeded species. As mentioned above, agoutis have been shown to repeatedly steal and recache each other's hidden seeds (fig. 120), so that seeds are moved well away from parent trees, where seed mortality approaches 100 percent. Nowadays, domestic cattle and horses may approximate the extinct dispersers. Horses, for example, are good

dispersers of seeds of the calabash tree (*Crescentia alata*, Bignoniaceae) in Guanacaste, Costa Rica.

Seed Dispersal by Birds

Many birds include fleshy fruits in their diet at times, but the number that mostly or only eat fruits is rather small. Apart from a handful of exceptions, even the few that eat nothing but fruits as adults feed protein-rich insects or small vertebrates to their nestlings. The diet of various birds changes with the seasons. Many are insectivorous during the breeding season but highly frugivorous at other times. Many

temperate-zone thrushes and warblers, for example, are almost wholly frugivorous in the late summer, autumn, and early winter when fruits are ripe and readily available. And many northern migrant flycatchers, thrushes, and warblers are highly frugivorous on their wintering grounds in the tropics of Central and South America (fig. 121), Africa, and Asia. Eastern kingbirds (*Tyrannus tyrannus*), for example, are insectivorous and territorial while breeding in North America but switch to traveling in flocks, 50–60 strong, and feeding on fruits while in South America. Being in flocks enables them to swamp the larger, territorial tropical kingbirds (*T. melancholicus*), which otherwise "own" and control fruiting resources.

Fruits intended for birds, which have a poor sense of smell but good color vision, are mostly odorless and conspicuously colored—red, black, lurid blue, or white. Many change color, from green to red or blue, or from green to black, to signal when they are ripe. The nutritional characteristics of fleshy fruits intended for birds are quite varied and probably form a continuum. Even so, it is convenient to divide them into two groups—low-quality fruits and high-quality fruits.

Opportunistic frugivores and low-quality fruits
Low-quality fruits are generally small (mostly 4–10 millimeters or 0.16–0.39 inch in diameter), soft, sweet, and juicy. They lack fats and proteins but provide a readily available source of energy-rich carbohydrates, water, vitamins, and perhaps minerals. The majority contain numerous small seeds that

Figure 121. A migrant Swainson's thrush (*Catharus ustulatus*) foraging for elderberries (*Sambucus peruviana*) on its wintering grounds in Ecuador.

Figure 122. A red-capped cardinal (*Paroaria gularis*) feeding on the small, juicy berries of *Trema*. In spite of its name, the red-capped cardinal belongs to the tanager family (Thraupidae).

are easily swallowed along with the fruit pulp. The investment of resources per fruit is small, but fruit crops are normally large. Typical examples in the temperate zone include the familiar fruits of hawthorns, rowans, and elderberries. Good Neotropical examples include small red figs, species of *Miconia* and *Conostegia* (Melastomataceae), hollowheart (*Acnistus arborescens*), and *Trema* (Ulmaceae) (fig. 122). Low-quality fruits are taken mostly by small opportunistic frugivores that use them as a quick and easy source of energy, leaving them extra time to acquire fats, proteins, and other nutrients by catching insects or other prey. New World tanagers (Thraupidae) and Old World bulbuls (Pycnonotidae) are typical examples.

Low-quality fruits vary enormously in popularity, presumably reflecting various qualities (e.g., differing nutritional values, ease of handling, and taste preferences of birds). Some fruits are so popular

Figure 123. A beryl-spangled tanager (*Tangara nigroviridis*) feeding on berries of hollowheart (*Acnistus arborescens*) in a cloud forest in Ecuador.

that birds seem to be queuing to take them as fast as they ripen, or even before they are fully ripe. In both Costa Rica and Ecuador, one of the most popular is hollowheart, which has small, sweet, watery berries that do not appear to be especially nutritious. Nevertheless, they are taken avidly in preference to almost all other small berries (fig. 123).

On the other hand, some low-quality fruits are obviously unpopular and often remain uneaten. Most eventually fall to the ground, where they lie untouched, though a few may be eaten or moved around by mammals or terrestrial birds, such as curassows and wood-quails. The family Rubiaceae provides good examples. Many species of *Gonzalagunia* and *Psychotria* have white or lurid blue fruits with a dry, Styrofoam-like consistency, lacking juicy pulp (see Rubiaceae, chapter 14).

Specialist frugivores and high-quality fruits

High-quality bird fruits tend to be large (with an upper limit of about 70 × 40 millimeters or 2.8 × 1.6 inches), with a thin layer of firm flesh surrounding a single large, often rather soft seed. The flesh is nutritious, containing plentiful carbohydrates, fats, and at least some proteins. Plants invest considerable resources per fruit, so fruit crops tend to be relatively small. The most important high-quality fruits are found among the laurels (Lauraceae), incense trees (Burseraceae), ivy trees (Araliaceae), nutmegs (Myristicaceae), and palms (Arecaceae) (fig. 124).

High-quality fruits provide a more or less complete adult diet for a select group of largish birds that are regarded as specialist frugivores. Classic examples include the oilbird (*Steatornis caripensis*), fruit pigeons (*Ducula* and *Ptilinopus*), some turacos (Musophagidae), quetzals (*Pharomachrus*), some broadbills (*Calyptomena*), and most cotingas. These species feed almost entirely on fruits as adults, but most feed protein-rich insects and other prey to their nestlings. High-quality fruits are also a major part of the adult diet of other tropical birds, notably some motmots, hornbills, and toucans, that augment their diet opportunistically with large invertebrates, frogs, small snakes, lizards, and nestling birds (fig. 125). The large size of most high-quality fruits restricts the number of frugivores that can eat them to those with a large enough gape.

In the past, it was presumed that a plant's investment in high-quality fruits is justified because specialist frugivores provide high-quality dispersal. However, there is no real evidence that specialist frugivores disperse the seeds of high-quality fruits more efficiently than opportunistic frugivores disperse the seeds of low-quality fruits. In fact, quetzals (which are frequently mentioned examples of

specialist fruit eaters) often appear to be poor dispersers. We have watched three different species of quetzals—resplendent, golden-headed, and crested (*Pharomachrus mocinno*, *P. auriceps*, and *P. antisianus*)—sit by fruiting lauraceous trees for hours at a time, feeding on the fruits (wild avocados) and regurgitating seed after seed onto the ground below

Figure 125. The chestnut-mandibled toucan (*Ramphastos swainsonii*) consumes many large, high-quality fruits but is opportunistic and also takes low-quality fruits, as well as lizards, frogs, nestling birds, and large insects. Toucans are very dexterous in the way they handle food. This individual is delicately holding a tiny berry in its bill.

Figure 124. A male resplendent quetzal with a wild avocado (*Ocotea*) for its nestlings. Quetzals are specialist fruit eaters and have a close relationship with wild avocados—fruits of trees in the family Lauraceae. In the mountains of Costa Rica, quetzals eat at least 18 different species of wild avocados, which account for about 80 percent of their diet. In their turn, avocado trees depend on quetzals and other large fruit eaters to disperse their seeds. The birds swallow the fruits whole and later regurgitate the seeds, sometimes far away from the parent tree. Bird and tree exchange services—a nutritious food supply is swapped for seed dispersal.

Figure 126. An oilbird (*Steatornis caripensis*) at its nest in a cave near Tingo Maria in Peru. The oilbird is an obligate fruit eater and feeds nothing but fruits to its nestlings. Note the two nestlings in the nest to the left and the etiolated seedlings growing from seeds that have germinated in the darkness of the cave.

the parent tree, where they were almost certain to be eaten by seed predators and had virtually no chance of survival. On the other hand, lots of opportunistic frugivorous birds are regular members of mixed-species foraging flocks that are constantly on the move, spending relatively little time in any one fruiting tree. This must enhance the likelihood that they will disperse seeds well beyond parent trees. Nevertheless, high-quality fruits do have one big advantage—they are taken preferentially, and almost all are quickly eaten by potential dispersers, regardless of the availability of other fruits.

Quetzals, toucans, hornbills, and other large frugivorous birds are not restricted to eating large, high-quality fruits. They can and often do eat some small, low-quality fruits. Indeed, it is likely that they need to consume a variety of fruits, both large and small, to get all the nutrients they need. We once watched a resplendent quetzal eat wild avocados for much of a morning. Suddenly, it swooped down to ground level, plucked a juicy red thimbleberry (*Rubus rosifolius*), and flew off into the distance. We had the inescapable impression that the quetzal fancied a change of taste—a refreshing hit of watery sweetness to offset the dry, bitter, oily pulp of wild

avocados. In any case, that single thimbleberry contained more seeds than all the nutritious avocados that the quetzal had eaten and regurgitated below the parent tree. That low-quality thimbleberry may well have been more successful in getting its seeds dispersed far away than all the high-quality avocados combined.

Not all high-quality fruits are so large that they can be eaten only by large frugivorous birds such as toucans, hornbills, and quetzals. Some wild avocados, for example, measure only about 15 × 10 millimeters (0.6 × 0.4 inch), small enough to be eaten by a much wider selection of birds. In Ecuador, a species of *Hedyosmum* (Chloranthaceae) provides another excellent example of a small, high-quality fruit.

Although a few obligate frugivorous birds eat nothing but fruits as adults, almost all feed insects or small vertebrates to their nestlings. The oilbird, studied by David Snow and described in *The Web of Adaptation*, is a remarkable exception. Oilbirds are nocturnal and roost and breed in caves (fig. 126). Like bats, they use echolocation to find their way in pitch-dark caves but rely on their eyesight while flying outside at night. Oilbirds are now known to have a keen sense of smell (rare in birds), and they use it to locate the high-quality, aromatic fruits that they favor, such as palm fruits, wild avocados, and the fruits of incense trees.

The nesting cycle of oilbirds takes five months or more, an exceptionally long time, matched only in much bigger birds of prey and seabirds. This is a consequence of their diet. The fruits eaten by both adults and nestlings contain lots of fats and some proteins, but they probably lack adequate amounts of the essential amino acids needed by females to make eggs quickly, and by nestlings to develop

quickly. A female may take more than 2 weeks to complete a clutch of two to four eggs, and nestlings take 16 weeks or more to fledge. To get the proteins they need, the nestlings have to eat so many fatty fruits for so long that they end up weighing half as much as adults. They are so obese when abandoned by their parents that they are incapable of flight. Only after they have lost weight can they fledge. In the past, fat nestlings were harvested and rendered down for their oil; hence their name, "oilbird."

Oilbirds were once thought to be poor seed dispersers. They appear to spend most of their time in their roosting and breeding caves, where tens of thousands of seeds end up being regurgitated onto the cave floor, where they perish. However, a recent study in Venezuela (Holland et al. 2009) has shown that oilbirds do not return to their caves on a nightly basis. They make extended foraging trips, traveling up to 100 kilometers (62 miles) or more from their caves. They return only every third night on average and spend daylight hours roosting in trees. It seems probable that oilbirds are important long-distance seed dispersers.

Australasian cassowaries are mainly frugivorous and rank among the most efficient seed dispersers anywhere. The southern cassowary (*Casuarius casuarius*) is certainly the most important seed disperser in the rain forests of New Guinea and northern Queensland (Stocker and Irvine 1983; Kroon and Westcott 2001) (fig. 127). It is known to consume the fruits of over 200 rain forest plants in at least 26 families, including some that are too large to be dispersed by any other Australasian bird or mammal. Favorites include the blue quandong (*Elaeocarpus angustifolius*, Elaeocarpaceae), a fruit that is unique in having an iridescent blue layer beneath its skin (fig. 128). Iridescent colors are extremely rare among

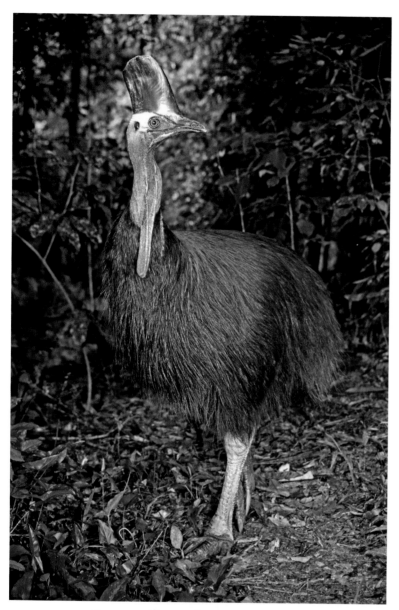

Figure 127. The southern cassowary (*Casuarius casuarius*) is the most important seed disperser in northeastern Australia and New Guinea and regularly eats fruits that are too large to be dispersed by any other Australasian bird or mammal.

Figure 128. One of the cassowary's favorite fruits is the blue quandong (*Elaeocarpus angustifolius*), a fruit that is unique in having an iridescent blue layer beneath its skin.

plants. Cassowaries swallow fruits whole. They have a gentle digestive system, and most seeds, even those with a thin seed coat, are defecated intact and viable. In fact, germination rates for some seeds are much improved after passing through a cassowary's system. Southern cassowaries range over large territories and may travel several kilometers in a day. Because seeds can take as long as 10 hours to be defecated, it follows that they are likely to be dispersed well away from the parent tree.

Adaptations of birds for feeding on fruit

Birds mostly swallow fruits whole, so the width of their gape limits the maximum diameter of the fruits they can eat. A few fruits are eaten piecemeal

by birds that are too small to swallow them whole. They peck beakfuls of pulp rather than swallow the whole thing. Small opportunistic frugivores, for example, often peck pulp from cherrylike or plum-like fruits. And the big catkin-like fruits of *Cecropia* trees are clearly designed to be eaten piecemeal by birds (or mammals) of any size. One group of diverse and conspicuous frugivores—the tanagers and related finches—rarely swallow fruits whole. Instead, they mash fruits in their bill. Many small seeds are swallowed along with juice and fruit pulp, but the tough outer skins of fruits are usually discarded along with the larger seeds, reducing the

amount of indigestible material to be swallowed that would otherwise take up space.

Birds take fruits in two main ways—while perched or in flight. Based on their work at La Selva Biological Station in Costa Rica, biologists Tim Moermond and Julie Denslow (1985) suggested that most birds are structurally adapted for one method or the other and are not likely to use both methods

Figure 129 and 130. The chestnut-mandibled toucan (*Ramphastos swainsonii*) has strong legs and a long bill, enabling it to reach for fruit in all directions. On the other hand, the black-headed trogon (*Trogon melanocephalus*) has short legs and virtually no ability to reach for fruit in any direction. It takes fruits by sallying and plucking them one at a time in flight.

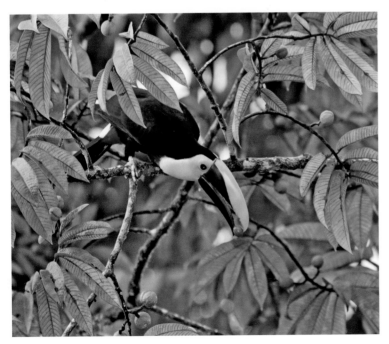

expertly. Toucans and trogons are extreme examples of the two methods. Toucans take fruits while perched and have an exceptional ability to reach for fruits in all directions—above, below, and sideways (fig. 129). This ability is facilitated by their strong legs, which enable them to reach a full body length below their perch, and by their long, dexterous bill, which increases their reach. On the other hand, trogons have very short legs and virtually no ability to reach for fruits in any direction (fig. 130). Trogons take fruits in flight, one at a time, by stalling in front of a ripe fruit and grabbing it.

However, not all birds have such short, weak legs as quetzals or such excellent reaching ability as toucans. Many birds are intermediate and readily use both methods, depending on the accessibility of the fruits in question. The Andean cock-of-the-rock (*Rupicola peruvianus*) is a good example (fig. 131). Most sources say that it feeds on fruits that it plucks in flight, but in our experience (watching birds feeding around our house in Tandayapa Valley, Ecuador), the Andean cock-of-the rock takes fruits just as often while perched. Many fruits are borne on the tip of slender twigs or dangle on long stalks, where they are inaccessible to perched birds as heavy as an Andean cock-of-the-rock. Such fruits are plucked in flight. However, other plants bear their fruits on, or within reach of, substantial branches, twigs, or other supports. Fruits that are commonly taken by the Andean cock-of-the-rock while perched include *Dendropanax* (Araliaceae), *Cecropia* (Cecropiaceae), *Hedyosmum* (Chloranthaceae), *Heliconia* (Heliconiaceae), *Ficus* (Moraceae), and *Palicourea* and *Psychotria* (Rubiaceae). Taking fruits in flight is energetically more demanding than taking fruits while perched, so it makes sense for birds to use perches when they can. In fact, numerous

fruits are distributed so that almost any bird of any size can access them easily. Examples include figs, heliconias, and hollowheart.

Although fruits are often easily available, they present significant problems for frugivorous birds. First, the weight and bulk of watery fruit pulp and indigestible seeds is a significant burden for flying birds. High-quality fruits, in particular, often contain large seeds that take up a lot of space. Birds need to get rid of such useless ballast as quickly as possible to make room for more fruits or something more nutritious. Second, the pulp of low-quality

Figure 131. The Andean cock-of-the rock (*Rupicola peruvianus*) is intermediate between toucans and trogons in how it takes fruits; it readily takes them while perched or in flight, depending on how the fruits are placed.

fruits is poor in nutrients other than sugars. Birds can use such fruits as a source of energy but need to process them quickly so they can move on to find other nutrients elsewhere. To combat such problems, birds have various mechanisms for speeding up the processing and passage of fruits. Many opportunistic frugivores simply strip off fruit pulp and drop the seeds. Others strip the flesh off in the stomach and regurgitate ballast seeds in as little as 15 minutes (fig. 132). Fruit pulp is easily digestible, and some specialized frugivores have a gentle, nonmuscular stomach and an exceptionally short gut. These include mistletoe specialists, such as euphonias (*Euphonia* and *Chlorophonia*), flowerpeckers (Dicaeidae), and silky-flycatchers (Ptilogonatidae), all of which defecate seeds within only 10–15 minutes (see chapter 13, and Loranthaceae and Viscaceae, chapter 14). Compared with mammals, frugivorous birds get rid of seeds very quickly, in minutes rather than hours or days. It follows that the seeds probably have little chance of being moved well away from the parent tree.

There is another problem—edible, fleshy fruits contain seeds that do not want to be eaten or otherwise destroyed. The seeds are usually protected mechanically with a hard seed coat or chemically with defensive compounds that render them distasteful or poisonous. Seeds with a protective seed coat present no problem for birds. Fruit pulp is stripped away in the gizzard or stomach, and the seeds easily survive passage through the digestive system until they are defecated. In the case of fruits with chemically protected seeds, the seed coat is usually fragile, leading to the danger that poisons will be released if a seed is damaged as it passes through a bird's digestive system. Again, the answer is a gentle gut. Wild avocados provide a good exam-

Figure 132. A wire-tailed manakin (*Pipra filicauda*) regurgitating a seed. Birds need to get rid of bulky seeds and other ballast as quickly as possible to make room for more fruits.

ple. Birds that regularly consume and disperse wild avocados, such as quetzals and other specialized frugivores, strip the pulp gently and quickly regurgitate the seed.

Seed Dispersal by Scatter Hoarders

Ironically, some seed predators are also important seed dispersers for a group of plants, including many trees and grasses, that combat the problem of seed predation by seed masting—that is, by producing enormous synchronized crops of seeds, sometimes at irregular intervals of several years. Some bamboos flower only at intervals of over 100 years.

Masting increases the probability that seed predators will be satiated long before all seeds have been consumed. It is a good strategy because it leads to some animals (known as scatter hoarders) storing seeds for later consumption when times are hard. These scatter hoarders often end up being good dispersers because they hide and cache thousands of seeds, often burying them, so that some are forgotten and never eaten. It is likely that forgotten buried seeds survive better on average than seeds dropped at random or below the parent tree. The most commonly stored foods are nutritious nuts or seeds, such as acorns, hazelnuts, and grass seeds, which have chemical protection to prevent them from rotting and typically remain edible for many months. Scatter hoarding is well developed in numerous rodents (e.g., agoutis, squirrels, and kangaroo rats), and birds (jays, nutcrackers, tits, and chickadees). The importance of agoutis as seed hoarders and dispersers in the Neotropics has already been mentioned. Various corvids, especially nutcrackers (*Nucifraga*) and jays (e.g., *Garrulus* and *Aphelocoma*), are even more important (Pesendorfer et al. 2016). In Germany, Eurasian jays (*Garrulus glandarius*) transport and scatter hoard an average 4,600 acorns in a single season (fig. 133). Unlike rodents, corvids sometimes carry seeds many kilometers, crossing open terrain and fragmented habitats, and often show a preference for caching seeds in disturbed areas suitable for germination and seedling survival. There is evidence that Clark's nutcrackers (*Nucifraga columbiana*), and probably other corvids, can remember the location of 70 percent or more of storage sites, even when they are buried under snow. It is an astonishing feat of long-term spatial memory. Even so, the forgotten 30 percent represent thousands of uneaten seeds that remain buried and potentially able to germinate in the spring. Although corvids eat so many seeds, they play an essential role in maintaining the health of woodland and in restoring habitats throughout much of the Northern Hemisphere. In Germany, conservationists support Eurasian jays in their role as seed dispersers by providing them with buckets of acorns, enabling them to hoard and disperse even more than they normally could.

Not all avian seed hoarders are as useful as jays and nutcrackers. Acorn woodpeckers (*Melanerpes formicivorus*) are just seed predators. They wedge their

Figure 133. Scatter hoarding is a well-developed strategy in numerous rodents and some birds, notably jays and nutcrackers. Eurasian jays (*Garrulus glandarius*), for example, are known to scatter hoard an average of 4,600 acorns per season, moving some of them considerable distances. Photo courtesy of Gianpiero Ferrari/FLPA/Minden Pictures.

acorns into holes drilled in dead trees, where none have any chance of germinating.

Seed Dispersal by Reptiles, Amphibians, and Fish

Mammals and birds are easily the most important vertebrates that disperse seeds, though lizards, tortoises, frogs, and fish play a minor role and deserve mention. When flowering plants first evolved, about 125 million years ago, it is likely that large vegetarian lizards were the first important seed dispersers. Nowadays, lizards are much less important, though a few are significant in some areas. Black ctenosaurs, for example, eat large quantities of fruits during the Central American dry season. They relish the fruits of *jocote* (*Spondias purpurea*, Anacardiaceae) and cashew (*Anacardium occidentale*) and no doubt disperse at least some seeds (fig. 134). Other reptiles known to disperse seeds include geckos and skinks in New Zealand and other island groups, and vegetarian turtles and tortoises, including giant Galápagos tortoises (*Chelonoidis nigra*). Remarkably, a Brazilian tree frog (*Xenohyla truncata*) is unique among frogs, having been shown to eat considerable quantities of small fruits and disperse viable seeds (da Silva, de Britto-Pereira, and Caramaschi 1989).

At least 200 fish species are frugivorous and are potential dispersers of seeds in the flooded forests of the Amazon Basin, the Pantanal, and other areas of South America. The fruiting seasons of many trees are timed to coincide with the annual floods, ensuring that fish that migrate into the flooded areas encounter large quantities of fruits that fall into the floodwaters, often floating and remaining available for a long time. A few fish species, sometimes

Figure 134. A Costa Rican black ctenosaur (*Ctenosaura similis*) swallowing a cashew fruit (*Anacardium occidentale*). Ctenosaurs eat a lot of fruit when it is available and probably disperse at least some seeds.

called South American trout (*Brycon*), even leap out of the water to pluck fruits from low, overhanging branches. Jill Anderson and colleagues (2009), in an investigation of the role of fish as seed dispersers, studied two commercially important, large species— the tambaqui (*Colossoma macropomum*) and the pirapitinga or red-bellied pacu (*Piaractus brachypomus*). Both species are mainly frugivorous and have huge, molar-like teeth ideal for crushing hard fruits and seeds. Both species destroy many seeds but also disperse seeds from up to 35 percent of the trees and lianas that fruit during the flood season. Many seeds are viable and germinate once the floods have receded. Studies by other scientists have recorded similar results with other fish species. There is little doubt that many trees in the flooded forest are adapted for seed dispersal by fish. Tambaqui fossils have been found dating from the Miocene, suggesting that the species may have been dispersing seeds for 15 million years or more.

Seed Dispersal by Ants and Miscellaneous Invertebrates

Invertebrates play a relatively minor role in seed dispersal, with ants being the most significant exception. Plants with ant-dispersed seeds are found almost everywhere except Antarctica. They are most abundant in Australia, where there are about 1,500 species in heathland and sclerophyll woodland, and in South Africa, where over 1,000 species occur in fynbos. Most ant-dispersed seeds provide elaiosomes as a reward. Elaiosomes are fleshy food bodies, rich in fat and other nutrients, that are attached to the seeds. Worker ants carry the seeds back to their nest and feed the fat bodies to the larvae. Used, unwanted seeds are dumped in aboveground or underground middens. Though not dispersed far,

the seeds are left in nutrient-rich locations favorable for eventual germination. Those left underground are protected from fire, floods, and other adverse environmental hazards.

Land crabs (Gecarcinidae) are omnivores and eat considerable quantities of fruit. Foraging crabs collect fallen fruits and often move some to their burrows to be eaten in safety. In India, for example, crabs collect the fruits of a swamp-dwelling nutmeg (*Myristica fatua*), consume the nutritious arils, and discard the seeds in their burrow (Krishna and Somanathan 2014). There they are protected from rodents and other seed predators and sometimes germinate. In another example, an Indo-Pacific mangrove-dwelling crab (*Cardisoma carnifex*) does much the same with fruits and seeds of pandanus palms (Lee 1985).

Charles Darwin and Odoardo Beccari, both eminent, widely experienced naturalists, independently recognized earthworms as dispersers of the tiny dustlike seeds of plants such as orchids and species of Burmanniaceae. Seeds of these plants have been found inside earthworms and are presumably defecated in their tunnels or aboveground in worm casts. In fact, L. van der Pijl (1972) reported that orchid seedlings have been found in worm tunnels in Europe. Earthworms bury seeds of many types and sizes in their burrows, where they are safe from seed predators and contribute to the seed bank. Overall, earthworms probably have a significant effect on the survival of many seeds and seedlings.

Seed Dispersal by Means of Adhesive Burs, Hooks, and Spines

As well as dispersing the seeds of edible fruits, animals (mainly mammals) also transport seeds inadvertently when fruits attach themselves to their skin

or fur (or to the clothing of people) with the aid of sticky secretions, barbs, hooks, or spines. Well-known examples include cleavers or goose-grass (*Galium aparine*) (fig. 135), burdocks (*Arctium*), American cocklebur (*Xanthium strumarium*), puncture vine (*Tribulus terrestris*), spiny bur grass (*Cenchrus longispinus*), and many other grasses. The hooks and spines of the larger burs can be lethal. In North America, where burdocks are introduced and invasive, there are many records of small songbirds becoming entangled on burdock burs and dying a slow death (fig. 136). The birds involved include chickadees, warblers, kinglets, and goldfinches. There are also records of small bats being killed.

Trample burs are very unpleasant. They are fruits with fiendish spines arranged so that one or more always point upward while the others form a stable base. In southern Africa there are several notorious trample burs—including species of *Tribulus* (Zygophyllaceae) and *Harpagophytum* (Pedaliaceae)—that have earned such names as devil's thorn, devil's claw, grapple plant, and puncture vine. They attach themselves to the hooves or feet of animals when trampled and can cause serious injuries. The animals involved include wild species (zebras, antelopes, elephants, ostriches, etc.) as well as horses, cattle, and other domestic animals. Trample burs resemble the caltrops used in war (for almost 2,000 years) as a defense against foot soldiers, horses, camels, and war elephants. Nowadays, caltrops are still used by the military and police and are particularly effective against vehicles with pneumatic tires.

Unlike mammals, birds rarely carry burs, probably because they can easily remove them by preening. However, in the tropics, birds carry the sticky fruits of *Pisonia* (Nyctaginaceae). Some species are called "birdcatcher trees." Apparently, birds are

Figure 135. Cleavers (*Galium aparine*), also known as goosegrass, catchweed, or stickyweed, is a familiar example of a plant with fruits that can attach themselves to passing animals. The fruit does indeed feel sticky to the touch, but this is because of the tiny hooked hairs that cover the stems, leaves, and fruits.

sometimes so thoroughly covered by the fruits that they are severely hampered and sometimes killed.

Seed dispersal by attachment to animal fur or skin is relatively rare, used by fewer than 5 percent of plant species, but it can be very effective when fruits are attached to wide-ranging or migratory animals. According to L. van der Pijl (1972), seed dispersal of this sort has been implicated in long-distance dispersal to remote islands and in the spread of invasive weeds. Humans are much involved in long-distance dispersal—trample burs often stick to vehicle tires and may be transported many kilometers, and species of *Tribulus* have become cosmopolitan weeds by being spread around the world on aircraft tires. It seems likely that small seeds attached to travelers'

Figure 136. Greater burdock (*Arctium lappa*) is native to Eurasia but has been widely introduced elsewhere. The hooked burs of burdock can be quite formidable, capable of entangling small birds.

clothing must occasionally pass through airports and make intercontinental journeys.

Seed Dispersal by Explosive Pods

Of all the many ways in which plants disperse their seeds, ballistic or explosive dispersal is perhaps the most startling. It occurs in the pods or capsules of legumes and in several other plant families. As the

pods or capsules dry out, tension builds up in their tissues and eventually they split open explosively, twisting violently as they do so, spraying seeds in all directions. The Central and South American sandbox tree (*Hura crepitans*, Euphorbiaceae) is the most notable example of explosive seed dispersal. According to M. D. Swaine and Tom Beer (1977), its woody capsules split open with a loud bang, expelling the seeds at speeds of up to 70 meters (230 feet) per second for distances of up to 45 meters (150 feet). Other well-known examples include the rubber tree (*Hevea brasiliensis*), which propels its seeds up to 45 meters (150 feet), and the orchid tree (*Bauhinia purpurea*, Fabaceae), which can send them up to 15 meters (50 feet) away. More familiar, less dramatic species include crane's-bills, balsams, and many legumes (fig. 137). On sunny days, the pods of gorse, brooms, and lupines burst open with loud popping sounds, scattering their seeds for several meters.

Seed Dispersal by Gravity

Dispersal by gravity alone is a category that is included in most seed dispersal accounts. However, it is difficult to be sure of clear-cut cases, and it is doubtful that it is a genuinely useful category. Many cited examples are simply heavy fruits that fall to the ground when ripe, such as apples, walnuts, horse chestnuts (*Aesculus hippocastanum*), and the large pods of some legumes. But this is just presentation—the tree making its fruits available to be consumed, or carried away and cached, by large terrestrial mammals and birds.

Cases in which there really is no apparent dispersal mechanism occur mainly in primary rain forest. Seeds germinate where they fall, success presumably depending on dormancy and survival until treefalls open up light gaps around them. Such seeds

Figure 137. Seed capsules of French crane's-bill (*Geranium endressii*), unopened (left) and with seeds ejected (right). French crane's-bill is a plant with explosive seed dispersal. Every capsule consists of five cells, each containing one seed. In the exploded capsule on the right, one cell has failed to open.

would also be subject to secondary dispersal by heavy rainfall, floods, landslides, and scatter hoarding by animals.

The seeds of *Canna* provide an intriguing case. They appear to be dispersed by gravity after falling from disintegrating capsules. *Canna* typically grows

on steep slopes, and it is easy to see how its seeds could be dispersed downhill by heavy rain or landslides. But how are they dispersed uphill? Perhaps some are moved elsewhere by rodents, though seeds that we marked in Ecuador remained in place for weeks. Some *Canna* seeds are said to remain viable for 600 years, so there is ample time for some form of secondary dispersal to take place.

Seed Dispersal by Wind

Wind-dispersed seeds are found in almost any habitat where plants are exposed to windy conditions. They are most obvious in open habitats but are also found in canopy trees and vines in tropical rain forest. They are common in some epiphytic families, notably orchids and bromeliads. For obvious reasons, wind-dispersed seeds are largely absent from the rain forest understory.

Wind-dispersed seeds have evolved independently in many plant families and have remarkably similar parachute- and airfoil-like structures to aid their dispersal. As well as being small and light, wind-dispersed seeds have no need for a reward to attract animals. Many are cheap to produce in enormous numbers, increasing the likelihood that some will reach places suitable for germination and survival. Larger wind-dispersed seeds are usually dull brown, making them inconspicuous once they have landed in leaf litter. Being cryptic may offer some protection against seed predators.

For obvious reasons, all wind-dispersed seeds are light. Orchid seeds, for example, are so small, light, and dustlike that they are easily carried long distances by the wind. Other seeds have plumes or winglike structures that enable them to float, flutter, or glide for impressive distances. Dandelions and relatives are classic examples of floaters, equipped with parachute-like tufted plumes. Other familiar examples include thistles, willowherbs, milkweeds, bulrushes, and many bromeliads. Other types of wind-dispersed seeds have one, two, or three winglike appendages that enable them to remain airborne, fluttering like a helicopter, and cover ground even in still air (fig. 138). Well-known examples include the seeds of ashes, elms, sycamores, and maples. Perhaps the most remarkable and beautiful of all winged seeds are those of *Alsomitra macrocarpa* (Cucurbitaceae), a climber found in the rain forests of Southeast Asia. Its seed has a wingspan of 13 centimeters (5 inches), and it can glide and

Figure 138. The fruits of the Ecuadorean tree *Triplaris cumingiana* have three winglike appendages that enable them to remain airborne, fluttering like a helicopter. They travel some distance from the parent tree, even in the still air inside a rain forest.

Figure 139. This Mexican example of a tumbleweed (*Kali tragus*) is native to Eurasia but is an invasive species now found in many parts of North and South America, southern Africa, and Australia.

soar for great distances. It has been found on the decks of ships at sea and is said to have inspired the design of early gliders.

There are other ways in which seeds are dispersed by wind. Many herbaceous plants, including such popular species as poppies, columbines, love-in-a-mist (*Nigella damascena*), and evening primroses, have seed capsules at the end of long stems that swing to and fro in the wind. Once the capsules have matured and opened, seeds spill or are thrown out. Many fall close to the parent plant, but on a windy day, some are thrown as far as 10–15 meters (33–50 feet). In the case of poppies, seeds spill out of tiny openings in the top of the capsule, like grains of pepper spilling from a pepper shaker.

Yet another version of wind dispersal is found in tumbleweeds. When they die, tumbleweeds curl up and break off from their root system. The entire plant forms a ball-like structure that is blown across the land, scattering seeds as it goes (fig. 139). Tumbleweeds are found in many families and are characteristic of windswept steppe and desert regions where the open terrain allows them to roll for long distances, often many kilometers.

Seed Dispersal by Water

Although many plants that grow in or beside water are pollinated by wind or insects, most aquatic plants rely on water to disperse their seeds. Most have seeds that float, aided by devices to increase buoyancy—air spaces, corky tissues, or fluffy hairs. Some small seeds float on the water surface because they are too light to break the surface tension.

Floating seeds are easily moved by water currents.

Figure 140. The seeds of yellow iris (*Iris pseudacorus*) remain buoyant for several months and, aided by flood waters, are sometimes dispersed long distances.

Eventually, as water levels recede, they may become stranded and germinate on mud or exposed shorelines. The seeds of yellow iris (*Iris pseudacorus*), for example, remain buoyant and viable for at least seven months (fig. 140). Clearly, they are likely to be dispersed long distances when conditions are favorable, especially with the help of floods. The seeds of water lilies behave rather differently. They have an aril coating that contains air pockets, enabling them to float for a while before becoming waterlogged and sinking to the muddy bottom of a pond or lake. There they germinate, perhaps colonizing new territory. The aril-coated seeds are also eaten and dispersed by birds.

Some water plants rely on asexual vegetative dispersal as well as seed dispersal. Fragments of plants are carried away by water currents and take root elsewhere. The yellow iris disperses in this way, as well as by movement of its seeds. Canadian waterweed (*Elodea canadensis*, Hydrocharitaceae) relies almost entirely on asexual dispersal. Native to North America, it was introduced to Ireland and Britain in the mid-nineteenth century and has since spread out of control, choking ponds, ditches, and streams. It is an invasive species and is now found throughout much of the world. All known populations in Europe are entirely female.

Trees such as mangroves, which grow adjacent to the sea, make use of the sea to disperse their seeds. Mangroves are especially interesting because in several genera (*Rhizophora*, *Bruguiera*, *Ceriops*, and *Kandelia*, all Rhizophoraceae), seeds germinate within fruits that are still attached to the parent tree. The germinating seeds form seedlings (propagules) that hang from the tree, sometimes continuing to develop for several weeks. Eventually they fall, per-

haps taking root in sediments near the parent tree or otherwise being dispersed by tides and currents. Some remain viable and capable of floating for several months, in which case there is a chance they will reach distant shores.

The coconut palm (*Cocos nucifera*) is the classic example of a tree with fruits that are adapted for dispersal by ocean currents. Nowadays, coconut palms are widely planted by humans, but their sole natural habitat is the narrow strip of land behind tropical beaches, just above the tide line. There, they lean toward the sea and drop ripe nuts within reach of waves. Coconuts are essentially a "survival capsule" for seeds. They have a buoyant, fibrous husk, enabling them to float and remain viable for many months. And, once the coconut arrives on a new beach, the "coconut milk" within provides nutrients and water for germination and subsequent growth. Coconut palms are thought to be native to the eastern Indian and western Pacific Oceans but now have a pantropical distribution. The new volcanic islands of Krakatau and Anak Krakatau are known to have been colonized by drift coconuts.

There are other drift seeds that are attractive and much prized by beachcombers. Many belong to tropical American rain forest trees that habitually overhang streams and rivers. Like many other water-dispersed seeds, they have a waterproof outer layer that encloses air pockets or light spongy tissue, enabling them to float and remain viable for months, or even years in some species. After falling in the water, tropical American drift seeds are washed downriver, some to the Pacific Ocean and others to the Gulf of Mexico, from where they are sometimes carried by the Gulf Stream to Greenland and northern Europe (fig. 141).

Three of the more interesting drift seeds are worth further mention. Mary's bean is the seed of a Central American vine (*Merremia discoidesperma*, Convolvulaceae). It is named after the Virgin Mary, perhaps because it has the shape of a cross on one of its sides. With the aid of the Gulf Stream and North Atlantic Drift, Mary's beans regularly reach Greenland, Norway, and the British Isles, where they are regarded as good luck charms. In the Outer Hebrides of Scotland it is believed that pregnant women will have an easy birth if they hold a Mary's bean in their hand. Elsewhere, while photographing

Figure 141. Sea hearts and Mary's beans are drift seeds prized by beachcombers. They are the seeds of two South and Central American rain forest plants (*Entada gigas* and *Merremia discoidesperma*) that habitually overhang rivers. Sometimes they are washed downriver to the Caribbean and carried by the Gulf Stream as far as northern Europe.

snakes in Costa Rica, we were offered Mary's beans to protect us from snakebite. In Mexico, Mary's beans are used as a cure for hemorrhoids. Another drift seed, the sea heart, is the seed of a leguminous rain forest liana (*Entada gigas*, Mimosoideae) native to tropical America and West Africa. It too drifts as far as Greenland, Norway, and even the North Sea (where there is a specimen in the Shell Museum in Glandford, close to our home in Norfolk). Its seeds, which are about 6 centimeters (2.4 inches) in diameter, are produced in enormous seedpods that can reach 2 meters (6.6 feet) in length. The sea heart is called *favas de Colom* or "Columbus bean" in the Azores and is said to have inspired Christopher Columbus to sail west in search of new lands. Sea hearts are used as good luck charms and are sometimes split, polished, and fashioned into tiny jewel boxes. The seeds of the gray nickernut (*Caesalpinia bonduc*, Caesalpinioideae) are sometimes viable even after two years at sea—no doubt the reason the species has a pantropical distribution. The seeds are used as good luck charms and, after being roasted and ground up, as cures for miscellaneous ailments.

Seed Dispersal Involving Fire

In regions prone to fire, notably parts of Australia and North America, many plants are well adapted to survive fire and even to use the fire's heat to help disperse their seeds. Fire is an integral part of such ecosystems and is essential for regeneration (fig. 142). Many plants native to Australia, including species of *Eucalyptus* (Myrtaceae) and *Banksia* and *Hakea* (both Proteaceae), depend on bush fires to release their seeds, sometimes using resin as a triggering mechanism. In *Banksia*, for example, the seeds are trapped in resin-filled woody follicles that are grouped together in a cone-like structure called a cob. The follicles remain closed and dormant, often for several years, until exposed to a bush fire. If the fire is hot enough to melt the resin, the follicles open and release the seeds, which fall onto burned ground—ground transformed by the fire into a nutrient-rich carpet of ash, devoid of any plants that might compete for light and water. In some *Banksia* species the timing of seed release is more refined. In these, the follicles contain a seed separator that prevents the seeds from falling out when the follicle first opens. Some separators fall out as soon as they have cooled, ensuring that seeds are released only after the fire has moved on. In other *Banksia* species the separators fall out after being moistened by rain, so that seeds are released when conditions are ideal for germination.

Some Australian *Acacia* species have other adaptations for living with fire. Their seeds drop to the ground and accumulate year after year in the seed

Figure 142. In much of Australia, bush fires are an integral part of the environment. Many native plants depend on bush fires to release their seeds, using heat as a triggering mechanism.

bank until exposed to fire. The seeds have a hard, waterproof seed coat that prevents them from absorbing moisture and germinating. Only after a hot fire causes the seed coat to crack are seeds able to germinate.

In North American regions prone to wildfires, there are conifers (which are not flowering plants) with adaptations similar to those of *Eucalyptus* and *Banksia* species. Jack and lodgepole pines (*Pinus banksiana* and *P. contorta*), for example, have resin-filled cones that remain closed, trapping seeds inside, until exposed to a fire that releases the seeds.

Seed Dispersal Involving Mimicry and Deceit

Throughout the tropics there are various leguminous species with brightly colored, berry-like or aril-like, mimetic seeds. The distribution of such seeds coincides quite well with the distribution of the models—the red, red-and-white, or red-and-black edible fruits being mimicked (McKey 1975). The seeds of *Ormosia* and *Erythrina costaricensis* (both Papilionoideae) from Ecuador and Costa Rica appear edible and enticing (fig. 143). Although they are hard and lack any nutritional value, mimetic seeds of this sort are sometimes mistaken for edible fruits and are swallowed, and later defecated intact, by presumably gullible young birds. Though the seeds are taken infrequently, they remain firmly attached in their pods and are available for weeks or even months. In Ecuador we have seen bright red *Ormosia* seeds being taken by a juvenile crimson-rumped toucanet (*Aulacorhynchus haematopygus*), and Jenkins (1969) reported blue-gray and scarlet-rumped tanagers (*Thraupis episcopus* and *Ramphocelus passerinii*) and two species of saltators (*Saltator*) swallowing the red-and-black seeds of *Erythrina costaricensis*. The advantage to the plants

Figure 143. Numerous tropical legumes, including the Costa Rican coral tree (*Erythrina costaricensis*), have brightly colored mimetic seeds. The seeds resemble edible berries but have no nutritive value. They apparently rely on inexperienced young birds to eat and later defecate them.

of having mimetic seeds is that they achieve at least some dispersal without the cost of providing a reward. In many parts of the tropics, brightly colored seeds of this sort are used to make bead jewelry.

FRUIT SPOILERS AND SEED PREDATORS

Although fruits want to be eaten, the seeds they contain and protect do not. The characteristics of fruits are a trade-off—they have to attract and reward seed dispersers but simultaneously protect the seeds inside them and discourage or punish seed predators. Seeds are attractive to seed predators because they are rich in nutrients (think of grains and nuts) intended for the development of seedlings. Seeds must also survive being harvested by animals, swallowed, and immersed in digestive juices until they are either regurgitated or defecated. Effective defenses are essential and tend to be either mechanical, in the form of hard, impenetrable seed coats, or chemical, in the form of distasteful compounds or poisons (e.g., tannins and alkaloids), or rarely both. Nevertheless, many seed predators are adapted to bypass these protective measures, aided by strong jaws, teeth, a powerful bill, or immunity to distasteful or toxic compounds.

Among mammals, the pithecine monkeys of the Amazon Basin—bearded sakis (*Chiropotes*), sakis (*Pithecia*), and uakaris (*Cacajao*)—are specialized seed predators. Though they consume some fruit pulp, they target mostly green, unripe fruits, opening them to get at the nutritious nuts inside. With their specialized teeth and powerful jaws,

they are capable of dealing with even the hardest seeds (e.g., Brazil nuts and other members of the Lecythidaceae). The black-crested mangabey (*Lophocebus aterrimus*) and relatives play a similar role in West African forests. As already noted, other important mammalian seed predators include ungulates, such as antelopes, peccaries, and tapirs, many of which chew and destroy all but the smallest seeds (fig. 144). And many rodents—for example, agoutis, spiny rats, and mice (*Proechimys*, *Liomys*), dormice, and squirrels—eat many seeds from fallen pods and are capable of gnawing holes in hard-shelled seeds. Other rodents—such as kangaroo rats—are specialist predators on grass seeds, adapted to collect and cache them in their burrows for future consumption (fig. 145).

Macaws and parrots are often referred to as frugivores, though most are really seed predators, discarding fruit pulp while consuming seeds (figs. 146 and 147). Small parakeets crack and consume even the tiny seeds of figs. Macaws and parrots often target fruits, including many legumes, that are not adapted to attract birds and are also able to eat many seeds that are heavily laced with defensive chemical compounds. These birds also do plants a disservice by damaging fruits before they are ripe, thereby

Figure 144. A gemsbok (*Oryx gazella*) eating nara melons (*Acanthosicyos horridus*). The nara plant is a native of the Namib Desert. Its fruits are a vital source of food and moisture for a host of animals, including humans. Many animals, including the gemsbok, chew and consume the seeds, which are very nutritious. Jackals and hyenas, however, swallow the seeds whole and later defecate them intact and viable.

Figure 145. Banner-tailed kangaroo rats (*Dipodomys spectabilis*) are specialist predators of grass seeds and store large quantities in their complex burrows. Kangaroo rats do not hibernate, so their store has to sustain them through the winter and well into the summer until seeds are once again available.

depriving legitimate dispersers of the chance to disperse the seeds.

Most pigeons are specialist seed predators. For example, familiar large species, such as the American band-tailed pigeon (*Patagioenas fasciata*) and European wood pigeon (*Columba palumbus*), have a large, muscular gizzard that grinds up seeds, often with the help of ingested grit. Medium and large seeds are destroyed, though at least some small seeds are now known to be defecated intact and viable. Asian and Australasian fruit pigeons and doves are important exceptions that have a gentle gut and disperse many seeds.

Numerous seed predators are found among the finches and other finch-like birds, such as the New World cardinals, grosbeaks, buntings, and sparrows, and the Old World sparrows, weavers, and waxbills. There is considerable specialization on different types of seeds that depends on size and bill characteristics. Species that feed on grass seeds, including bamboo, are mostly small and have relatively weak bills. The fringillid finches are quite varied and include European goldfinches (*Carduelis carduelis*), with tweezer-like bills for extracting seeds from thistles and teasels; Eurasian bullfinches, with bills that have a sharp edge suitable for cutting into fleshy fruits and exposing the seeds; and crossbills (*Loxia*), with crossed mandibles that help lever seeds out of pine cones. Hawfinches (*Coccothraustes coccothraustes*) have powerful bills that can crack open even the hard seeds of cherries, earning them the name *Kirschkernbeisser* ("cherrystone destroyer") in Germany.

Mention should also be made of birds that are fruit spoilers rather than seed predators. Tanagers and related emberizid finches habitually mash fruits in their bills to extract juice and pulp (fig. 148). Some seeds are swallowed, but many are

dropped under the tree along with unwanted skins. Flowerpiercers, with their bill modified to pierce flowers for nectar, are preadapted to pierce and suck the juice from fruits. Many do so, leaving spoiled, dried-out fruits hanging on the tree (see chapter 14). Several species of hummingbirds have learned to do the same thing (fig. 149).

In the flooded forests of the Amazon Basin, many fishes compete for fruits that fall into the water. Some are seed dispersers. Many species of catfish, for example, swallow fruits whole and pass their seeds intact. On the other hand, some of the larger characiform fishes are seed predators as well as dispersers. As already noted, tambaqui and pirapitinga are equipped with teeth that are adapted to crush fruits and hard seeds. Other genera, including piranhas (*Serrasalmus*), have sharp-edged teeth capable of slicing through hard seeds.

Insects may be the most important seed predators of all. Host-specific insect predators can have a devastating effect on immature seeds and fruits that are still maturing on the tree. Coreid bugs pierce the seeds and suck the contents, while bruchid beetles and pyralid moths lay eggs on the young fruits and their larvae feed on the seeds as they develop. In the case of the Costa Rican raintree (*Albizia saman*, Fabaceae), tropical biologist Daniel Janzen (1977) reported that 50–70 percent of the seed crop was killed by bruchid beetles in most years. Many or most immature fruits contain potent chemical defenses, but their seeds are nevertheless vulnerable to specialized predators. Janzen (1980), in other studies carried out in Costa Rican dry forest, showed that many such predators—particularly bruchids, weevils, and other beetles—are extreme specialists, many of them capable of eating and detoxifying the seeds of only one host plant.

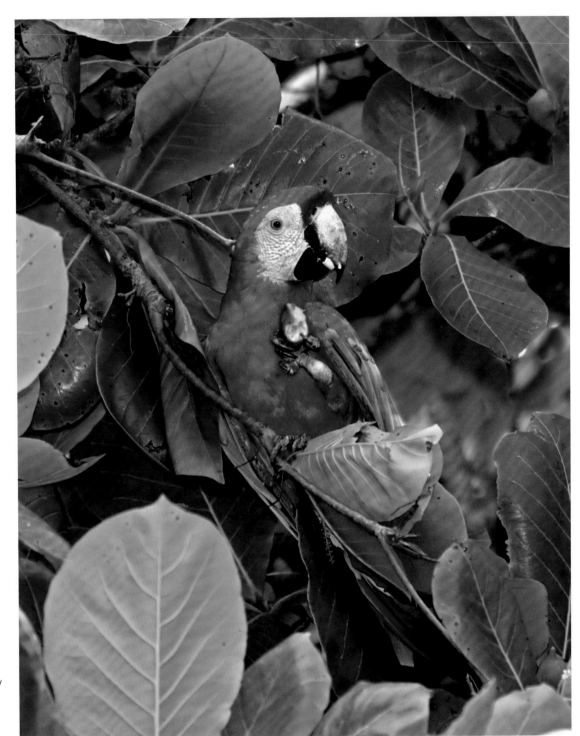

Figure 146. A scarlet macaw (*Ara macao*) biting into the tough outer covering of a fruit of a tropical almond tree (*Terminalia catappa*) to get at the seed. Although often described as fruit eaters, macaws and parrots prefer seeds. For the most part, they are seed predators rather than seed dispersers.

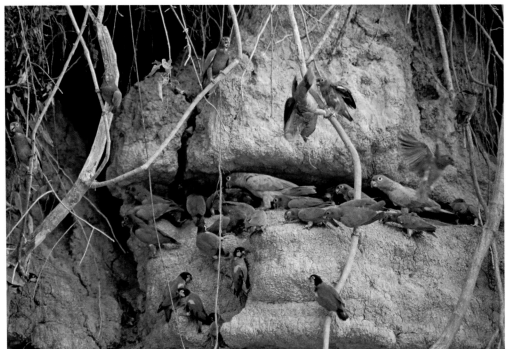

Figure 147. Parrots visiting a clay lick in Peru, including mealy Amazons (*Amazona farinosa*), blue-headed parrots (*Pionus menstruus*), and orange-cheeked parrots (*Pyrilia barrabandi*). In western Amazonia, parrots (including macaws) habitually visit exposed riverbanks (clay licks, or *colpas*) to eat clay. Parrots are adapted to eat seeds that are protected by toxic compounds, and it has been suggested that they eat clay to neutralize these toxins. However, it is now known that the birds choose soils with high concentrations of sodium, an essential element that is scarce in areas remote from the sea. Parrots eat clay only in western Amazonia, far from oceanic influences. There are no clay licks elsewhere in Central or South America, areas where parrots consume just as many toxic seeds.

The possibility of seed predation does not end with dispersal. It also occurs after seeds have been dispersed and can be even more severe than predispersal predation. Predispersal seed predators exploit mostly clustered resources and tend to be specialists—extreme specialists in the case of the host-specific insects already mentioned. On the other hand, postdispersal seed predators usually exploit many different seed types, scattered at low densities, and tend to be generalists. For example, in deciduous forests in Costa Rica, seeds of many tree species are dispersed in the dung of wild or domestic ungulates, but spiny pocket mice (*Liomys salvini*) find and eat just about every seed available. In the case of *Virola calophylla* (Myristicaceae), studied in Peruvian rain forest in Manu National Park (Russo and Augspurger 2004), black spider monkeys (*Ateles paniscus*) dispersed seeds an average of 245

Figure 148. A blue-capped tanager (*Thraupis cyanocephala*) mashing a hollowheart berry (*Acnistus arborescens*) in its bill.

Figure 149. A rufous-tailed hummingbird (*Amazilia tzacatl*) piercing a hollowheart berry (*Acnistus arborescens*) and drinking its juice.

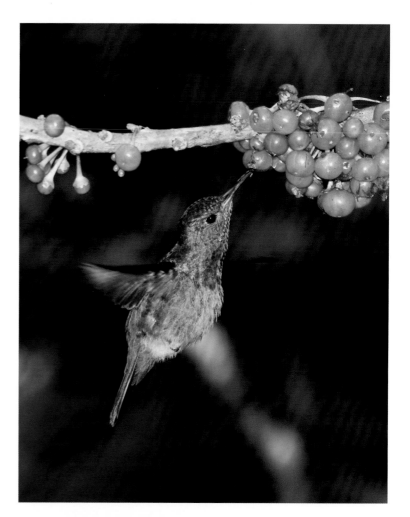

meters (268 yards), often in small dung piles. Of these seeds, 99 percent failed to produce seedlings because of seed predation by spiny rats (*Proechimys*) and scolytid beetles.

Finally, it must be emphasized that many animals regarded as good dispersers are often no better than fruit thieves. As pointed out by Howe (1983), the extent to which a frugivore is a dispersal agent or simply a fruit thief depends on many factors (fig. 150). How long does the animal continue feeding? How is the fruit handled? Are seeds regurgitated under or close to the parent tree? Are seeds dropped or regurgitated in nest cavities? And what happens to the seeds after they are dispersed? For example, when oilbirds regurgitate seeds in a nesting cave, or quetzals and toucans regurgitate seeds in a nest cavity or below a fruiting tree, they are fruit thieves, not dispersers.

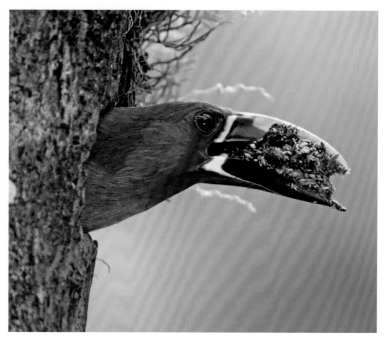

Figure 150. An emerald toucanet (*Aulacorhynchus prasinus*) leaving its nest cavity with its beak full of seeds and debris. Frugivorous birds that regurgitate seeds in their nest cavity are seed predators rather than dispersers. But, by cleaning its nest and discarding seeds in the forest, the toucanet becomes a disperser.

THE SEASONALITY OF FLOWERING AND FRUITING

The differences between seasonality in the tropics and seasonality in temperate areas have major consequences. In temperate and other strongly seasonal climates, the timing of flowering and fruiting of most plants is determined by temperature or rainfall and tends to be synchronized (fig. 151). Flowers and fruits are available for only a limited part of the year, so animals cannot be year-round specialists and are forced to change their behavior during the course of the year. Many animals hibernate, estivate, or migrate, while others change their diet, and many flowering plants, especially trees, depend on wind for pollination and seed dispersal rather than animals.

On the other hand, the year-round presence of flowers and fruits in wet, tropical rain forests permits many animals, particularly mammals and birds, to be year-round specialists. Hummingbirds and sunbirds, for example, can be year-round, specialist nectar feeders and pollinators. And many mammals and birds are year-round, specialist frugivores and easily the most significant dispersers of seeds.

Flowering and fruiting seasonality in the wet tropics varies from plant to plant and is influenced by a variety of factors—many species flower and fruit predictably just once a year; some species exhibit steady-state flowering, with just a few flowers per day for many months; others produce both flowers and fruits almost continuously for several months, and sometimes simultaneously (fig. 152); yet others have highly synchronized flowering and fruiting episodes several times a year. In seasonal habitats in the tropics, flowering tends to occur in the dry season to avoid damage to flowers by heavy rain but also, more importantly, to take advantage of increased insect activity. Synchronized mass flowering—the so-called big-bang strategy—often occurs in the dry season, usually after unpredictable, heavy showers. In Costa Rica, for example, three species of yellow-flowered *Handroanthus* (Bignoniaceae) follow this pattern. All individuals of any one of the species flower together on the same day, providing a breathtaking mass of color for three or four days (fig. 153).

The fruiting seasons of some plants with bird-dispersed seeds appear to be timed to coincide with the arrival or passage of migratory birds. In North America one would expect plants to have ripe fruit earlier in southern latitudes, where spring is ear-

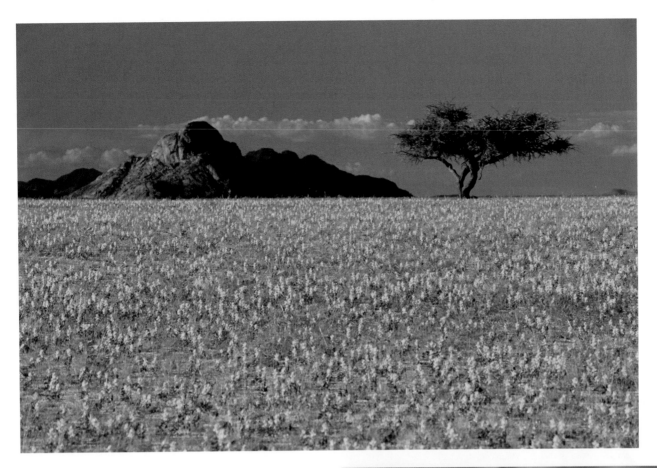

Figure 151. A legume (*Adenolobus pechuelii*) flowering in the Namib Desert after good rains. In temperate and other strongly seasonal climates, including deserts, the timing of flowering and fruiting in plants is determined mainly by temperature or rainfall.

Figure 152. A white-winged brush-finch (*Atlapetes leucopterus*) feeding on hollowheart berries (*Acnistus arborescens*). Hollowheart produces both flowers and fruits almost continuously for several months, a strategy that is possible only in the humid tropics. This photograph includes flower buds, open flowers, unripe berries, and ripe berries.

Figure 153. In the tropics, some species, including the gorgeous yellow trumpet tree (*Handroanthus ochraceus*), follow a "big-bang" mass flowering strategy in which all the local trees flower together on the same day.

lier and temperatures warmer. In fact, fruits generally ripen earlier in northern latitudes and later in the south (Stiles 1980). So, as migrating birds migrate south in the fall, they encounter a succession of fruit crops on which to feed. Much the same happens in Europe and other temperate areas. It is also likely that the ripening of some fruits in tropical Central and South America is timed to coincide with the passage of migrant birds. For example, huge numbers of Swainson's thrushes (*Catharus ustulatus*) pass through Costa Rica in April and early May on their way to their breeding grounds in North America. Their passage coincides with ripe fruit crops of *Hampea appendiculata* (Malvaceae) and *Hasseltia floribunda* (Salicaceae), both extremely popular with Swainson's thrushes and other birds.

In the humid tropics, the relatively benign climate permits fruiting at almost any time of year. In such conditions in Trinidad, ornithologist David Snow (1965) suggested that 20 coexisting species of *Miconia* (Melastomataceae) have evolved staggered fruiting seasons to avoid competition between them to attract birds to disperse their seeds. This pattern may well hold most of the time for *Miconia* (and probably other genera of fruiting trees), but it breaks down at times (see Melastomataceae, chapter 14).

POLLINATION, SEED DISPERSAL, AND COEVOLUTION

Strictly speaking, the term "coevolution" should be used only to describe situations in which two or more interacting species mutually or reciprocally influence changes in each other's evolution. This is a restrictive definition when applied to the complex interactions between flowers and pollinators or fruits and dispersers. Most plants are visited by many different pollinators and fruit eaters, and most of these animals pollinate or disperse the seeds of many plants. It is difficult to be sure that all these plants and animals have actually influenced each other in an evolutionary sense. Some may interact simply because they are preadapted to do so. Generalized relationships of this sort are best described by the term "diffuse coevolution." In other words, flowers and fruits may evolve characters (e.g., structures, colors, smells, rewards) in response to groups of pollinators or seed dispersers, while the latter evolve characters (specialized mouthparts, tongues, bills, etc.) in response to the flowers and fruits they exploit.

It is relevant that the rates at which plants and animals evolve are often very different. In the fossil record, plant species last 27–38 million years, whereas mammal and bird species generally last only 0.5–4 million years. In other words, pollinators and fruit-eating animals mostly have to adapt to the flowers and fruits that are available, not the other way around, and the vast majority of fruit-disperser relationships involve diffuse coevolution. The important family Lauraceae (wild avocados) provides an instructive example. Lauraceous fruits are very similar wherever they occur—in tropical America, Southeast Asia, and Australasia—and are similar even to fossil species from the Eocene, 50 million years ago. Lauraceous fruits have remained virtually unchanged everywhere throughout this immense time span, and a multitude of different birds, mostly now extinct, must have consumed them and dispersed their seeds. Because wild avocados have been, and continue to be, so conservative in their characteristics, it is obvious that those that exist today are adapted to be eaten and dispersed by a generalized set of frugivorous birds, not specifically by the quetzals, toucans, cotingas, and hornbills that consume them now and disperse their seeds.

Although most flower-pollinator interactions are of the "diffuse coevolution" type, there are notable

exceptions. Classic, well-studied examples of tight, coevolved flower-pollinator relationships include those between *Yucca* and yucca moths, figs and fig wasps (fig. 154), *Siparuna* and gall midges, and various orchids and their attendant bees, all of which are described elsewhere. Two other spectacular examples are worth mentioning here. The sword-billed hummingbird (*Ensifera ensifera*) has an extraordinary bill, 10 centimeters (4 inches) long, and mainly feeds at and pollinates two passion flowers (*Passiflora mixta* and *P. cumbalensis*) that have corollas too long to be utilized by any other hummingbirds (fig. 155). And the recently described nectarivorous bat *Anoura fistulata* (Muchhala, Mena, and Albuja 2005) has a tongue 8.5 centimeters (3.3 inches) long, the longest relative to its body size of any mammal. It is the only bat with a tongue long enough to reach the nectar in the flowers of *Centropogon nigricans* (Campanulaceae). Nathan Muchhala likened it to "a cat being able to lap milk from two feet away."

Tight, coevolved relationships between fruits and frugivorous animals are rare—even rarer than those between flowers and pollinators. A partial exception is the close relationship that exists between mistletoe berries (Loranthaceae and Viscaceae) and birds in various families that are specialized, structurally and physiologically, to eat them and disperse their seeds (see Loranthaceae and Viscaceae, chapter 14). Many different birds eat most small fruits, but mistletoe berries are eaten by only a few species in any one area and are their staple diet. Birds that coevolved with viscaceous mistletoes include chlorophonias and euphonias in the Neotropics (fig. 156), and flowerpeckers in Southeast Asia and Australasia. Among those that coevolved with loranthaceous mistletoes are silky-flycatchers, the mistletoe tyrannulet (*Zimmerius vilissimus*), and white-cheeked cotinga (*Zaratornis stresemanni*) in the Neotropics; the phainopepla (*Phainopepla nitens*) in North America; and waxwings (*Bombycilla*) in North America and Eurasia.

The specialized mutual dependency that exists between a number of Far Eastern and Australasian flowerpeckers (Dicaeidae) and viscaceous mistletoe berries is especially interesting. Apart from insects, the flowerpeckers, all of which have a gentle gut, feed almost exclusively on mistletoe berries and are effective dispersers of mistletoe seeds. The easily digestible berries pass through the birds very quickly, usually within a few minutes. This is partly because of the laxative effect of the berries,

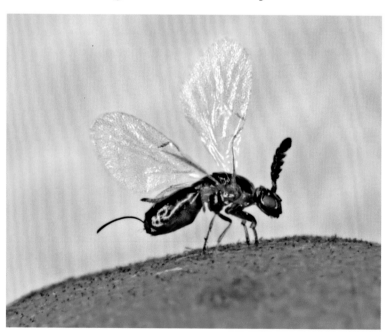

Figure 154. A female fig wasp (Agaonidae) that has just emerged from a fig (*Ficus*). The relationship between figs and fig wasps is one of the classic examples of coevolution. The female wasp is tiny, only 2–3 millimeters (0.08–0.12 inch) long, excluding its ovipositor.

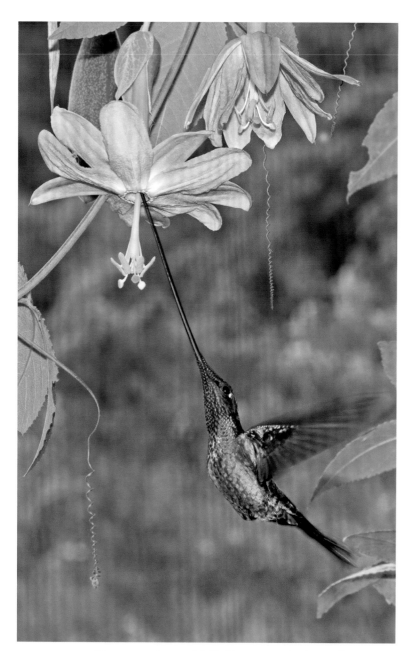

Figure 155. A sword-billed hummingbird (*Ensifera ensifera*) feeding at a passion flower (*Passiflora cumbalensis*) in a cloud forest in the Andes of Ecuador. With its matching bill, about 10 centimeters (4 inches) long, the sword-billed hummingbird is the only effective pollinator of *P. cumbalensis* and *P. mixta*, two high Andean passion flowers with an extremely long corolla.

Figure 156. A golden-browed chlorophonia (*Chlorophonia callophrys*) eating a mistletoe berry (*Phoradendron robustissimum*, Viscaceae). A close relationship exists between viscaceous mistletoe berries and various groups of birds, including chlorophonias and euphonias.

but mainly because the berries bypass the muscular stomach (gizzard) and progress directly into the intestine. On the other hand, any insects that are eaten need more processing than the berries and are diverted into the muscular stomach to be ground up. In these flowerpeckers the muscular stomach is reduced to a mere side pocket of the main digestive tract, with access by insect food controlled by a sphincter.

SELECTED NEOTROPICAL PLANT FAMILIES, GENERA, AND SPECIES

The following accounts are not intended to be comprehensive. They begin with brief introductory material about the worldwide and Neotropical status of the families concerned. Otherwise they deal only with certain Neotropical genera and species for which we have useful personal observations or photographs. The families included are listed in alphabetical order.

ALSTROEMERIACEAE: *Bomarea*

The Alstroemeriaceae is a small family closely related to and formerly included in the Amaryllidaceae. It includes three genera and about 280 species, about 200 of which are found in tropical America. The genus *Bomarea*, which concerns us here, ranges from southern Mexico to Bolivia. Most species are vines and reach their greatest diversity in montane rain forest in the Andes.

Pollination. The inflorescences of *Bomarea* are common and conspicuous in Andean forests. Pendent flowers in clusters of 10–60 or more are pollinated by hummingbirds. The flowers are quite tough and resilient in order to combat piercers (flower-piercers and some short-billed hummingbirds) that steal their nectar. Even so, bumblebees often bite holes in the base of the flower to reach the nectary and, in doing so, provide access for other nectar thieves. The tubular corollas of *Bomarea* flowers range in length from about 25 to 100 millimeters

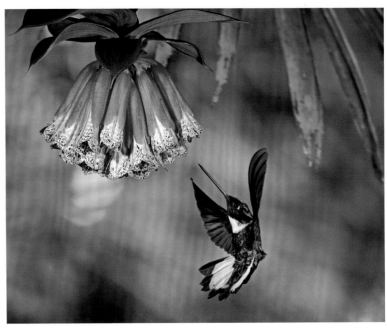

Figure 157. A collared inca (*Coeligena torquata*) about to feed at flowers of *Bomarea pardina* in the Andes of Ecuador.

(1–4 inches). The smaller species are visited and pollinated by small hummingbirds, such as the green violetear (*Colibri thalassinus*) and volcano hummingbird (*Selasphorus flammula*) in Costa Rica, and western emerald (*Chlorostilbon melanorhynchus*) in Ecuador. The larger species with a longer corolla are visited by the magnificent hummingbird (*Eugenes fulgens*) in Costa Rica and by incas in Ecuador (fig. 157).

Seed dispersal. Fruits of *Bomarea* are capsules that open to expose numerous seeds covered with red, fleshy arils. They have the characteristics of bird-dispersed fruits and are presumably dispersed by birds, but they are not at all popular and may be mimicking more nutritious fruits (fig. 158). We have watched capsules with exposed fruits for many hours with little to show for our efforts. The only

Figure 158. Capsules of *Bomarea pardina* splitting to expose seeds covered by a red aril. The fruits are not very attractive to frugivorous birds and may be mimicking other, more popular, red fruits.

species we have seen to take the fruits (a total of only four records) are Andean solitaire (*Myadestes ralloides*), golden tanager (*Tangara arthus*), and grass-green tanager (*Chlorornis rieferii*).

BIGNONIACEAE: Handroanthus, Tabebuia, and Cydista

Worldwide, the Bignoniaceae is a mainly pantropical family with 120 genera and about 800 species. Its center of diversity is in tropical America, where there are 80 genera and 600 species. Most species are trees, up to 40 meters (131 feet) tall, or woody lianas.

The Bignoniaceae includes several of the world's most beautiful trees. The South American *Jacaranda mimosifolia* and African tulip tree (*Spathodea campanulata*) are spectacular ornamentals that have been planted throughout the world's tropics. Equally lovely are the Central and South American species of *Handroanthus* (formerly *Tabebuia*) and *Tabebuia*, both of which are renowned for their massed floral displays. They occur over much of tropical Central and South America, from Mexico to northern Argentina and Chile, and several countries have adopted one or another species as their national tree or flower.

Handranthus species are noteworthy for their durable and insect-resistant timber. The wood is exceptionally hard and, with a specific gravity of up to 1.5, heavy enough to sink in water. Because it is so durable, it is frequently used for outdoor construction, as well as furniture.

We are concerned here with trees in the genera *Handroanthus* and *Tabebuia*, and lianas in *Cydista*.
Pollination. There are several species of *Handroanthus* and *Tabebuia* in different life zones in Costa Rica. We are familiar with *H. ochraceus* (with

Figure 159. The flowering of the pink trumpet tree (*Handroanthus impetiginosus*) follows the "cornucopia" strategy—mass flowering that continues for a few weeks.

Handroanthus ochraceus follows a "big-bang" mass-flowering strategy in which all individuals of the species flower together on the same day, four days after a dry season shower or sudden drop in temperature. Sometimes there are two or three flowering episodes in a dry season, each lasting about four days. The flowering behavior of *H. impetiginosus* is rather different and follows the "cornucopia" strategy—mass flowering sustained over a few weeks (fig. 159).

As well as legitimate pollinators, the dazzling displays of *H. ochraceus* and *H. impetiginosus* attract nectar thieves, some of which damage or eat the flowers.

yellow flowers), *H. impetiginosus* (magenta flowers), and *Tabebuia rosea* (pink flowers), all common trees in the deciduous forest in the dry northwestern part of the country. All are deciduous and follow a mass-flowering strategy while leafless, making them conspicuous to potential pollinators from afar. The most important pollinators are euglossine and anthophorid bees, well known to be long-distance fliers, easily capable of moving pollen between different individual trees. Apart from their color, the flowers are rather similar and share several characters that affect how they are pollinated—they have nectar guides that change color after the first day, signaling that they have been pollinated and lack nectar; newly opened flowers have a flattened corolla tube that can be forced open only by strong, medium to large bees; their nectar chamber can be reached only by long-tongued bees; and they have a sensitive, two-lobed stigma that closes as soon it receives pollen, even if self-pollinated.

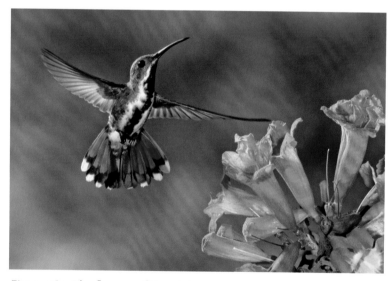

Figure 160. The flowers of the pink trumpet tree (*Handroanthus impetiginosus*) are an important nectar source for hummingbirds that breed in the dry season. Hummingbirds, such as this female green-breasted mango (*Anthracothorax prevostii*), pierce many flowers through the base of their corolla and steal nectar. Occasionally, they probe flowers legitimately and may pollinate some. The main pollinators are euglossine and anthophorid bees.

Figure 161. Other nectar thieves that pierce *Handroanthus* flowers include orioles, in this case a streak-backed oriole (*Icterus pustulatus*) at a yellow trumpet tree (*Handroanthus ochraceus*).

The flowers provide an important source of nectar for several species of hummingbird that breed in the dry season—a time when typical hummingbird flowers are scarce but many insect-pollinated trees, including "big-bang" species, are flowering profusely (fig. 160). The hummingbirds pierce many flowers through the base of the corolla and steal nectar but probe others legitimately and perhaps pollinate a few. Other nectar thieves include orioles (fig. 161), and the flowers provide a useful dry season food for monkeys and black ctenosaurs.

Species of *Cydista* are common dry forest lianas that have a "multiple-bang" flowering strategy—they flower synchronously several times a year. The showy magenta flowers lack nectar and apparently mimic other bignoniaceous species (such as *Handroanthus impetiginosus*), though it is strange that *Cydista* species, being mimics, are much commoner than the models. In fact, successful pollina-tion and fruit set are very uncommon. It has been suggested that *Cydista* species are common because vegetative reproduction is important in lianas. Several individual lianas are often found at intervals along a straightish line in the forest and probably sprouted from a long liana that fell to the ground and eventually rotted away.

Seed dispersal. The fruits of *Handroanthus*, *Tabebuia*, and *Cydista* are dry capsules that open to release winged seeds that are wind dispersed.

BROMELIACEAE (Bromeliad Family)

The family Bromeliaceae includes about 2,900 species in 56 genera. The largest genera are *Tillandsia* with over 540 species, *Pitcairnia* with over 350, *Vriesia* with 250, *Aechmea* with 230, *Puya* with 200, and *Guzmania* with over 280. Only one species is found outside the Americas—*Pitcairnia feliciana* is endemic to rocky outcrops in the highlands of Guinea in West Africa. It is thought that it must have reached Africa about 12 million years ago, presumably via long-distance dispersal by wind. The New World bromeliads range from as far north as Arizona and Virginia in the United States to Patagonia in southern South America. Spanish moss (*Tillandsia usneoides*) is remarkable in occurring more or less throughout this range. It is both the most northerly and most southerly occurring bromeliad, occupying a latitudinal range of over 8,000 kilometers (4,970 miles). It occurs in both humid and dry habitats; it even grows on telephone wires.

The family Bromeliaceae includes the commercially important pineapple (*Ananas comosus*), which originated in southern Brazil but is now cultivated throughout the tropics. Several other species have edible fruits that are eaten locally, and the leaves of

several species are a source of fibers used to make hammocks and fishing nets. In the past, Spanish moss was used for upholstery stuffing, for insulation, and as packing material.

Bromeliads occur in many habitats, ranging from arid deserts to very wet rain forests, and from sea level to over 4,000 meters (13,000 feet) in the

Figure 162. Bromeliads (*Tillandsia*) growing on a conifer in the mountains of western Mexico. The grayish color of *Tillandsia* bromeliads is due to specialized trichomes (scales) that absorb water and nutrients from the atmosphere.

Andes. They reach their highest diversity in Andean cloud forests and the *tepui* country of the Guiana Shield. About half of all bromeliads are terrestrial, and the other half are epiphytes. There is enormous variation in size. *Puya raimondii*, native to the high Andean paramo of Peru and Bolivia, is the largest bromeliad. Including its flowering spike, it can reach 10 meters (33 feet) in height and have about 3,000 flowers that produce six million seeds. At the opposite extreme, some epiphytic *Tillandsia* species are a mere 3 centimeters (1.2 inches) tall.

All epiphytic bromeliads, but especially those that live in an arid environment, have to overcome the challenge of collecting and conserving water. Many species in the genus *Tillandsia*, for example, have a grayish color because they are covered with specialized trichomes (scales) that absorb water and nutrients from the atmosphere, justification for their being called "air plants" (fig. 162). The trichomes also reduce water loss by reflecting sunlight. Some also use a modified form of carbon fixation that allows stomata in the leaves to remain shut during the heat of the day to reduce water loss, but open at night to collect carbon dioxide.

Other bromeliads solve the water problem differently. So-called tank bromeliads collect water in reservoirs formed by their leaves, which are arranged in tightly overlapping rosettes. Some of the larger species collect and store as much as 50 liters (13 gallons) of water. As well as collecting water, the reservoirs of tank bromeliads provide a source of water, food, and shelter for many animals, which, as they defecate or die, are in turn a source of nutrients for the bromeliads. Costa Rican biologist Claudio Picado (1913) surveyed tank bromeliads and discovered more than 250 species living in them. Regular inhabitants include lizards, frogs, salamanders, crabs, spiders, dragon-

Figure 163. Many bromeliads have a colorful flowering spike and are pollinated by hummingbirds. In this case a tawny-bellied hermit (*Phaethornis syrmatophorus*) is visiting an Ecuadorean bromeliad (*Pitcairnia nigra*). Note the orange pollen on the hermit's head.

Figure 164. A Geoffroy's long-tongued bat visiting a bromeliad with white flowers (*Werauhia gladioliflora*). Note the pollen on the bat's head.

fly larvae, rat-tailed maggots, mosquito larvae, protozoans, and others. Yet other visitors include monkeys, coatis, and toucans that ransack the bromeliads in search of a drink or tasty morsels. Small birds use the tanks to drink and bathe, while some poison dart frogs use them to rear their young.

Research by Thomas Givnish and colleagues (1984) has shown that at least two or three bromeliads are carnivorous. *Brocchinia reducta* is the most convincing candidate. It is a terrestrial species endemic to the highlands of the Guiana Shield of South America. It grows in areas with nutrient-poor soils, no doubt one reason it has become carnivorous. Its rosette of leaves forms a tight, vertical cylinder, coated on the inside with slippery, waxy scales that strongly reflect ultraviolet light. The water stored in the rosette of leaves is highly acidic and also has a fragrant odor. From above, the rosette may well resemble an ultraviolet flower. In any case, insects are attracted by the ultraviolet glow and sweet odor. They alight on the slippery, waxy leaves, slip into the pool below, and drown. Enzymes released by the bromeliad, together with bacteria, digest the corpses, making nutrients available for absorption by the plant.

Pollination. A few bromeliads with small, inconspicuous flowers are pollinated by insects, but the majority are pollinated by hummingbirds or bats. Species pollinated by hummingbirds tend to have a colorful flowering spike composed of red, pink, or orange bracts and contrasting white, yellow, or purple tubular flowers. Bromeliad flowers are quite variable in length. Short- to medium-flowered species are pollinated by hummingbirds with short or medium bills. Long-flowered species are pollinated by incas and hermits (fig. 163).

Bat-pollinated flowers are generally larger, with a

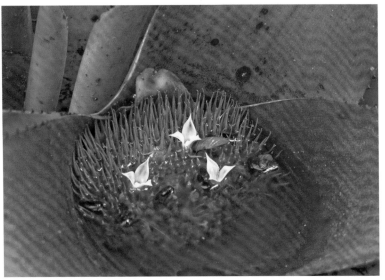

Figure 165. In tank bromeliads like this one (probably *Neoregelia*), flower buds develop underwater, where they are safe from being eaten by herbivorous insects.

Figure 166. The developing buds of the bromeliad *Mezobromelia capituligera* are protected by being immersed in a jellylike mucilage.

more open corolla, a creamy-white color, and usually a musky scent, and they produce copious nectar. In most respects, the flowers of *Werauhia gladioliflora*, a common bromeliad in Costa Rican cloud forests, are typical examples (fig. 164). However, they are unusual in that buds that are due to open begin to secrete nectar in the late afternoon, an hour or two before they open and nectar bats are active. Violet sabrewings have learned to take advantage by piercing the buds in the late afternoon and stealing the nectar.

In tank bromeliads, immature buds develop underwater, where they are protected from being damaged or eaten by herbivorous insects (fig. 165). In some other species (e.g., *Mezobromelia capituligera*), developing buds are protected by being immersed in jellylike mucilage (fig. 166).

Seed dispersal. The fruits of bromeliads in the subfamilies Pitcairnioideae and Tillandsioideae are dry capsules containing plumose seeds that are wind

Figure 167. A brown-throated sloth (*Bradypus variegatus*) in a *Cecropia* tree. Note the characteristic open structure of the tree and the pendent catkins.

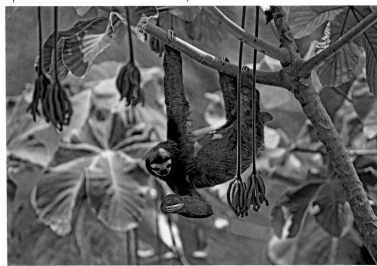

dispersed, in much the same way as dandelion seeds. Fruits in the subfamily Bromelioideae are edible, containing seeds that are dispersed by birds or mammals. *Bromelia pinguin*, for example, a native of dry forests from Mexico to Venezuela, has fruits 2–3 centimeters (ca. 1 inch) in diameter, containing up to a dozen seeds surrounded by a sweet, juicy pulp. They are adapted to be eaten by large vertebrates.

CECROPIACEAE: *Cecropia*

The Cecropiaceae is a pantropical family, but trees in the genus *Cecropia*, with more than 60 species, are confined to tropical America, where they are conspicuous and easily recognizable by their characteristic architecture and leaves (fig. 167). Species of *Cecropia* are fast-growing, often occurring in dense stands in disturbed areas—human-made clearings, landslides, light gaps, and riverbanks. They are prominent in humid lowland areas but also occur in submontane and montane forest up to at least 2,600 meters (8,500 feet) in the Andes. They are important pioneer species, contributing hugely to the seed bank. However, seeds remain viable for only a year or two and need full sunlight and warmth to germinate successfully. In favorable conditions, *Cecropia* trees grow 3–5 meters (10–16 feet) in a single year.

With the exception of a few species at high altitudes or on islands, species of *Cecropia* are noteworthy for housing aggressive, biting *Azteca* ants, which protect their leaves from being eaten by grasshoppers, caterpillars, and other herbivores. The ants also prune encroaching vines and creepers. In return, *Cecropia* trees provide hollow, bamboo-like internodes in their branches in which the ants live. In addition, feltlike patches (trichilia) on the base of the petiole of *Cecropia* leaves produce Müllerian bodies—food bodies about 1 millimeter (0.04 inch) long

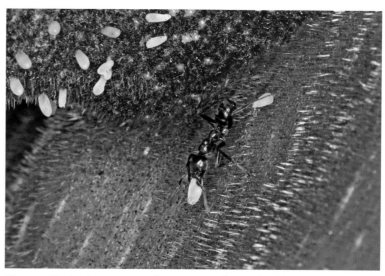

Figure 168. An *Azteca* ant collecting a Müllerian body—food that the ants harvest and eat. Müllerian bodies are provided in return for the protective services of the aggressive ants. The bodies are produced by trichilia on the base of the petiole of *Cecropia* leaves.

that the ants harvest and eat (fig. 168). They are rich in glycogen, a common form of energy storage in animals that is very rare in plants.

Müllerian bodies are also harvested by a diverse selection of birds (fig. 169). In our garden in Ecuador we have noted 11 species taking them, including a woodpecker, a spinetail, flycatchers, warblers, tanagers, brush-finches, and finches.

We were surprised to discover that Müllerian bodies are produced at an extraordinarily fast rate. A *Cecropia* tree close to our house produced Müllerian bodies from about midmorning until early afternoon. At startup, as many as 80 bodies appeared on a single petiole in about 10 minutes, each body taking no more than 10 seconds to appear and reach full size. Bodies harvested by *Azteca* ants and birds were replaced rapidly—again at rates of up to 80 per petiole in about 10 minutes.

Figure 169. Many birds take advantage of the availability of nutritious Müllerian bodies. Here a bananaquit (*Coereba flaveola*) is harvesting them.

Pollination. Species of *Cecropia* are dioecious, and male trees seem to mature a year or two earlier than females. The minute flowers are borne on fingerlike spikes, which are shorter and thinner in males than in females. They are wind pollinated.

Seed dispersal. The fruits of *Cecropia* are fleshy, fingerlike spikes, sometimes pendulous, within which tiny seeds are embedded. Consumers bite off and swallow chunks of the spikes, including the embedded seeds, which are later defecated. Their unusual structure makes them available to a great diversity of birds and mammals, both small and large. They are popular with fruit-eating birds of almost any size, including guans, pigeons, barbets, toucans, umbrellabirds, cocks-of-the-rock, thrushes, and tanagers, as well as such diverse mammals as fruit bats, monkeys, kinkajous, and tayras. *Cecropia* species tend to flower and fruit throughout the year, so fruits are often available when alternatives are scarce.

CHLORANTHACEAE: *Hedyosmum*

The Chloranthaceae includes four genera distributed throughout tropical regions, except Africa. *Hedyosmum* is the only New World genus and includes 44 species distributed in tropical regions from southern Mexico to Brazil. Most *Hedyosmum* species are canopy trees or shrubs and reach their highest diversity in montane rain forests in the Andes at elevations from 1,000 to 3,500 meters (3,300 to 11,500 feet). The Chloranthaceae appears very early in the fossil record of flowering plants, with fossil pollen prominent in mid-Cretaceous deposits.

Pollination. Most species of *Hedyosmum* are dioecious. Their flowers have numerous characteristics typical of wind-pollinated species, including small, greenish flowers that lack petals; copious dry, dustlike pollen; and large, dry stigmas. However, as is typical of rain forest trees, *Hedyosmum* occurs at relatively low densities, which is unusual for wind-pollinated plants. It seems likely that *Hedyosmum* is close to the limit at which wind pollination is feasible. On our property in Ecuador, *Hedyosmum* trees tend to occur in scattered, small groups of two to four individuals separated from other groups by 200 meters (650 feet) or more.

Seed dispersal. We have ample evidence that *Hedyosmum* trees are an important source of fruits for frugivorous birds. It was, therefore, a surprise to find that the genus is rarely mentioned in relevant scientific literature and does not feature in tables that summarize the results of studies of Neotropical fruit-eating birds (e.g., Snow 1981).

The fruit is a drupe surrounded by fused floral bracts that are succulent and purple when ripe, forming a starchy, oily food reward for birds (fig. 170). We are very familiar with one species of

Figure 170. The succulent fruits of *Hedyosmum*, which are purplish when ripe, are very nutritious and extremely popular with many specialized frugivorous birds, including quetzals, toucans, and cotingas.

Hedyosmum, a dioecious canopy tree 20–30 meters (65–100 feet) tall, that is common in cloud forests in the Mindo and Tandayapa areas of the western Andes of Ecuador. Its fruiting season lasts from about October or November to March or April. Each tree produces a succession of ripe fruits for two to three months, but some individual trees are consistently earlier or later than others, ensuring that fruit is available for a total of six or seven months. The fruit is extremely attractive to specialized frugivorous birds, including golden-headed and crested quetzals, toucans, mountain-toucans, toucanets, toucan barbets (*Semnornis ramphastinus*), green-and-black and scaled fruiteaters (*Pipreola riefferii* and *Ampelioides tschudii*), olivaceous pihas (*Snowornis cryptolophus*), and Andean cocks-of-the-rock. Because the fruits are quite small (averaging about 14 × 10 × 8 millimeters or 0.6 × 0.4 × 0.3 inch), they

are also suitable for smaller birds, such as glossy-black and pale-eyed thrushes (*Turdus serranus* and *T. leucops*), migrant Swainson's thrushes, and Andean solitaires. *Hedyosmum* is particularly important because it seems to be a reliable fruiter. In the eight years that we monitored fruiting trees in our study area, all female *Hedyosmum* trees produced a good crop of fruit every year. By contrast, no wild avocado trees (Lauraceae) produced more than two or three good crops in the same eight years.

We should also mention that *Hedyosmum* trees are so reliably attractive to birds that they feature in the tours provided in Ecuador by Angel Paz—a farmer turned conservationist. From October to April, tourist bird-watchers, who flock to see Angel feed worms to habituated antpittas (*Grallaria*), are also taken to several *Hedyosmum* trees (known locally as *tarquis*) for the chance to see quetzals, mountain-toucans, toucan barbets, and other fruit-eating birds.

CLUSIACEAE: *Clusia* and *Symphonia*

The Clusiaceae has a worldwide but mainly tropical distribution with about 1,600 species in 36 genera, including 750 species in 23 genera in the Neotropics. The mangosteen (*Garcinia mangostana*) is an economically important fruit introduced from Southeast Asia to other tropical areas. Many species of St. John's-worts (*Hypericum*) are grown as ornamentals.

We are concerned here only with *Clusia* species and *Symphonia globulifera*. *Clusia*, with about 300 species, is native to the Neotropics, ranging from the Florida Keys and southern Mexico to Bolivia and Brazil. *Clusia* species include trees, shrubs, and vines. Many are small evergreen trees that begin life as epiphytes but resemble strangler figs in developing roots that reach the ground and eventually strangle the host tree.

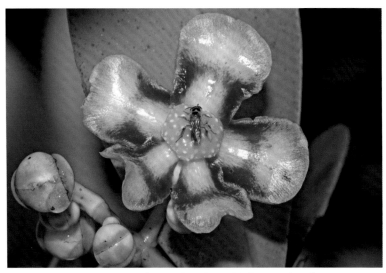

Figure 171. A stingless bee (Meliponini) collecting resin from a male flower of *Clusia croatii* in Costa Rica.

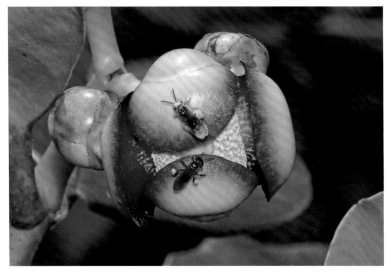

Figure 172. This Ecuadorean *Clusia* flower has a mound of resin at its center, surrounded by a band of stamens. The upper stingless bee has been collecting only pollen, the lower one only resin.

There are about 15 species of *Symphonia*. They have a center of diversity in Madagascar, and all but one are endemic there. The exception, *S. globulifera*, has a remarkable distribution, occurring widely in the wet tropics of both Africa and the Americas. It is a tree up to 30 meters (100 feet) tall.

Pollination. *Clusia* species are dioecious. Their pollination biology is varied, involving nectar, pollen, and floral resin as rewards, and stamens adapted for different pollinators. Some *Clusia* species have relatively conventional flowers that have normal stamens and secrete nectar as a reward. The flowers of the Costa Rican *Clusia stenophylla*, for example, are fragrant and attract moths at night and hummingbirds that mop up leftover nectar the next morning. Other species are less conventional. Instead of nectar, they provide floral resins as a reward that is used by orchid bees and stingless bees as nest-building material (fig. 171). The resins are doubly useful because they also have antibiotic properties. They are not effective against fungi but highly effective against certain bacteria that are deadly to bees and their larvae.

The *Clusia* resin is produced by the stamens in male flowers and by sterile stamens (staminodes) in female flowers. In many species, stamens are fused into a glandular mound that secretes a covering of sticky resin. Pollen sacs are exposed as bees excavate the resin and are collected along with the resin. In an Ecuadorean *Clusia*, a central mound of resin is surrounded by a band of stamens releasing abundant pollen. Bees are free to gather either the pollen or the resin (fig. 172).

Resin secretion by flowers may have originated to repel herbivores and only secondarily became a reward for pollinators. The resin is exceedingly sticky and probably distasteful. It is easy to believe

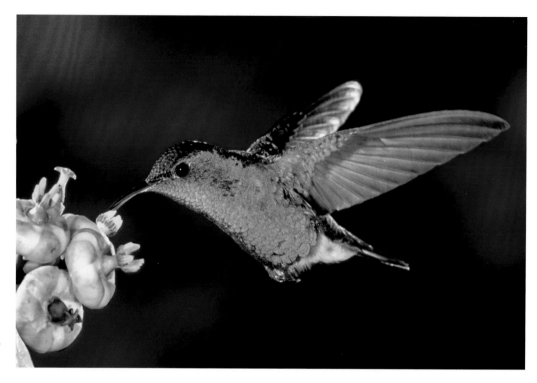

Figure 173. A coppery-headed emerald (*Elvira cupreiceps*) feeding at flowers of *Symphonia globulifera.*

it might deter small herbivores. In *A Naturalist in Costa Rica* (1971), Alexander Skutch described stingless bees using pellets of resin to immobilize ants that were raiding the bees' nest. The bees must be adapted in some way to avoid becoming stuck themselves while collecting the resin.

Symphonia globulifera has attractive pink flowers, sometimes earning it the name "peppermint candy tree." We have seen tall *S. globulifera* trees in flower in both Africa (above 2,000 meters or 6,500 feet in the Rwenzori Mountains) and southern Costa Rica. In Africa, the flowers are extremely popular with sunbirds, especially purple-breasted sunbirds (*Nectarinia purpureiventris*), that perch to feed. Large canopy trees in the south of Costa Rica are favorites of brown violetears (*Colibri dephinae*) that feed while hovering. However, in cloud forests in the Cordillera de Tilarán, *Symphonia globulifera* is not a very popu-

lar understory tree (perhaps a different species?); it is visited only occasionally by a motley selection of subcanopy hummingbirds, including green hermits (*Phaethornis guy*), stripe-tailed hummingbirds (*Eupherusa eximia*), and coppery-headed emeralds (*Elvira cupreiceps*) (fig. 173).

Because *Symphonia* originated in Africa, where there are no hummingbirds, one might expect that *S. globulifera* flowers in the Neotropics would be visited by honeycreepers and other perching birds, rather than hummingbirds. In our experience, visits by nonhummingbirds, other than bananaquits, are quite rare.

Symphonia globulifera is one of many trees that attract damage by monkeys when flowering. Researchers in Costa Rica reported massive destruction of flowers in Corcovado National Park by a troop of Central American spider monkeys (*Ateles*

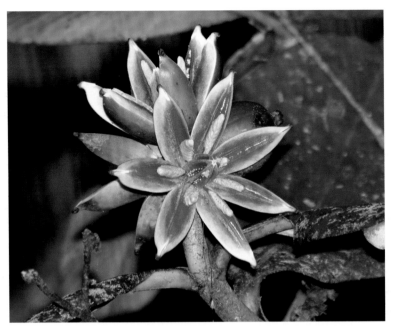

Figure 174. When *Clusia* fruits split open to expose their edible arils, they resemble colorful flowers. In this Ecuadorean species the arils are yellow against a red background, but orange against white is more usual.

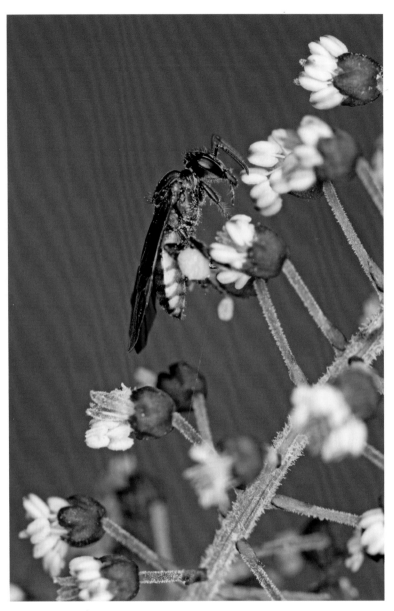

Figure 175. Some species of *Coriaria* are wind pollinated, but the Ecuadorean C. *microphylla* attracts stingless bees (*Parapartamona zonata*), which may be effective pollinators.

geoffroyi). The damage was sufficient to prevent any fruit set in trees within the troop's home range. Trees outside the home range set fruit as normal. **Seed dispersal.** *Clusia* fruits are hard capsules that split open (dehisce) in a star shape to reveal yellow or orange arils. At a distance, they resemble colorful flowers (fig. 174). The arils are rich in fat and are so popular with woodpeckers, honeycreepers, and tanagers that dominance hierarchies form at some trees. Alexander Skutch (1989) even saw red-legged honeycreepers (*Cyanerpes cyaneus*) try to steal arils that a golden-naped woodpecker (*Melanerpes chrysauchen*) was feeding to its young.

The fruit of *Symphonia globulifera* is an elliptical greenish drupe, about 25 millimeters (1 inch) long, that is eaten by both mammals and birds.

CORIARIACEAE: *Coriaria*

The Coriariaceae is a small family with a single genus with 5–20 species, depending on the taxonomy followed. The genus is widely distributed in warm temperate regions, excluding Africa. The tropical species found in the mountains of Central and South America, which concerns us here, is considered to be *Coriaria microphylla*. It is a sprawling shrub with a rather fernlike appearance.

Pollination. The flowers of some *Coriaria* species are wind pollinated, and some are self-compatible. However, *C. microphylla* attracts many stingless bees, which are likely to be effective pollinators (fig. 175).

Seed dispersal. The shiny black fruits of *Coriaria microphylla* are hallucinogenic, and so toxic that they are reputed to have caused the deaths of children and cattle. Crushed fruits of a Mediterranean species are used to poison flies, and fruits of a Chilean species to poison rats.

Nothing has been recorded about the dispersal of seeds. However, in Ecuador, the shiny black, fleshy fruits (achenes) of *Coriaria microphylla* (which measure about 7 × 5 millimeters or 0.3 × 0.2 inch) are eaten by numerous small fruit-eating birds (including flycatchers, thrushes, tanagers, and brush-finches), mainly when more popular fruits are scarce (fig. 176). Presumably birds defecate the seeds.

ERICACEAE (Heath Family)

Worldwide the Ericaceae includes about 123 genera and 4,000 species (including *Rhododendron* with 1,000 species), distributed mainly in temperate or cool, tropical climates. In the Neotropics there are 46 genera and 900 species, most of them shrubs or epiphytes in Andean and other highland habi-

Figure 176. Though not very popular, the small black fruits of *Coriaria microphylla* are eaten occasionally by many opportunistic frugivorous birds when other fruits are scarce.

tats. Ericaceous plants prefer acidic soils. They are often associated with mycorrhizal fungi that facilitate their uptake of nutrients, including nitrogen, an element often lacking in acidic habitats. Ericads are economically important in two main ways—blueberries, cranberries, and huckleberries (all *Vaccinium*) are important commercial fruit crops; while *Rhododendron* (which includes azaleas) and heathers are popular ornamental (but sometimes invasive)

Figure 177. This purple-throated woodstar (*Calliphlox mitchellii*) has a short bill and is visiting an epiphytic heath (*Macleania ericae*) with an appropriately short corolla.

Figure 178. This green-fronted lancebill (*Dorifera ludovicae*) is visiting an epiphytic heath (*Psammisia aberrans*) with a long corolla.

plants that are grown widely in temperate gardens.

Pollination. Some Neotropical genera and species (e.g., in *Pernettya* and *Vaccinium*) are visited and pollinated by bees and other insects, but most, including many in the genera *Cavendishia*, *Ceratostema*, *Macleania*, *Psammisia*, and *Satyria*, are pollinated by hummingbirds. Their flowers fit the hummingbird pollination syndrome in being tubular, largely red, and odorless, and in secreting copious, rather dilute nectar. Hummingbird ericads have corollas covering a range of lengths, from 15 to 45 millimeters (0.6–1.8 inches) or more, catering to species from tiny short-billed emeralds and woodstars to long-billed incas and lancebills. Using its long, extendible tongue, any hummingbird can feed at a range of corolla lengths. Even so, hummingbirds with the shortest bills tend to visit the shortest flowers (fig. 177), and those with longer bills tend to use longer flowers (fig. 178). In Costa Rican cloud forests, for

example, the coppery-headed emerald (*Elvira cup-reiceps*), with a bill 14 millimeters (0.55 inch) long, and the purple-throated mountaingem (*Lampornis calolaemus*), with a bill 19 millimeters (0.75 inch) long, visit many epiphytic ericads. Emeralds favor two species that have corollas less than 16 millimeters (0.63 inch) long and rarely visit the others, while mountaingems prefer ericads with corollas more than 18 millimeters (0.71 inch) long.

The flowers of many ericads are inhabited by flower mites (*Rhinoseius*), which feed on nectar. They make use of hummingbirds to move between flowers, hitching a lift on their bill or in their nostrils.

Seed dispersal. Most ericaceous fruits are dark blue or purple when ripe (as are blueberries and huckleberries) (fig. 179); others are reddish or even white (e.g., *Macleania ericae*). All are very popular with flowerpiercers, euphonias, and tanagers. Some *Psammisia* berries are green when ripe and are probably eaten by bats.

FABACEAE (*Inga, Calliandra, Erythrina,* and *Mucuna*)

The Fabaceae, containing plants commonly known as legumes, is a large and exceedingly diverse family, including 650–700 genera and about 18,000 species. In the Americas there are about 272 genera and 6,700 species. The family is sometimes split into three families, the Caesalpiniaceae, Mimosaceae, and Fabaceae (sensu stricto), which are here treated as subfamilies, the Caesalpinioideae, Mimosoideae, and Papilionoideae, respectively. The Fabaceae has examples of just about every vegetative form, including herbs, shrubs, a few epiphytes, vines, lianas, and trees, some of the latter being giant forest emergents.

Figure 179. The grass-green tanager (*Chlorornis riefferii*) is a stunning bird, here eating a berry of an epiphytic heath (*Cavendishia bracteata*) in a cloud forest in Ecuador.

Many legumes are of particular importance because they have the ability to fix nitrogen. This results from a symbiotic relationship between the host plant and species of bacteria (*Rhizobium*), which invade the roots and stimulate the formation of root nodules. Within these nodules the bacteria convert free atmospheric nitrogen to usable ammonia that fertilizes the plant, aiding its growth. When the plant dies, the fixed nitrogen fertilizes the soil and becomes available to other plants.

Many legumes are of great economic value. Their status as nitrogen fixers can reduce fertilizer costs and leads to their use in crop rotation to replenish depleted soils and as shade trees (species of *Inga* and *Erythrina*) in coffee plantations. Important legumes also include species that are cultivated for their seeds (pulses), which are rich in protein, such

as many beans, peas, lentils, and peanuts; species that are grown for pasture forage to be grazed by livestock, such as alfalfa and clover; species that are grown commercially as ornamental trees, such as *Acacia*, *Erythrina*, *Mimosa*, *Laburnum*, and the flamboyant tree (*Delonix*); species that have industrial uses, such as *Indigofera* for dyes; and finally, trees that are harvested for timber. The genus *Dalbergia*, for example, includes numerous beautiful and valuable hardwoods, such as Brazilian and Indian rosewood, African blackwood, tulipwood, cocobolo, and many others.

Regarding pollination and seed dispersal, we are concerned here only with the mimosoid genera *Inga* and *Calliandra*, and the papilionoid *Erythrina* and *Mucuna*.

Pollination. There are about 300 species of *Inga*, mostly trees, which are distributed more or less throughout the Neotropics. Their flowers have reduced sepals and petals but as many as 25–130 prominent white stamens, making them look like powder-puffs or pom-poms, which provide the visual attraction for pollinators. *Inga* species secrete plenti-

ful nectar and many have a distinctive odor that differs from species to species—sweet in some, suggesting that they are visited by moths, and yeasty in others, suggesting bats. Some have little or no obvious scent and attract hummingbirds and various insects. In spite of these differences, species that overlap in their flowering season (and many do) often attract many of the same visitors—a selection of bats, hummingbirds, hawkmoths, and other insects. One gets the impression that *Inga* species are hedging their bets but that flowering behavior is not always properly synchronized—that is, there is not always a good match between the availability of a nectar reward and the release of pollen. For example, in the dry forests of Costa Rica, *Inga vera* flowers open an hour or two before dusk and secrete abundant nectar, which is taken avidly by hummingbirds (fig. 180). Even so, the hummingbirds cannot be pollinators at that time because the anthers do not begin to shed pollen until after dark. The flowers are pollinated by bats—the secreted nectar accumulates and ferments during the course of the night, changing from sucrose to the glucose and fructose typical of bat-pollinated flowers. Hummingbirds return at dawn to mop up leftover nectar. Perhaps then they are effective pollinators?

The popularity of *Inga oerstediana*, another Costa Rican species, seems to vary from tree to tree. Some individuals are "hummingbird trees" that attract hummers throughout the day, often with several individuals of different species dividing the tree into territories. Other individual trees attract few hum-

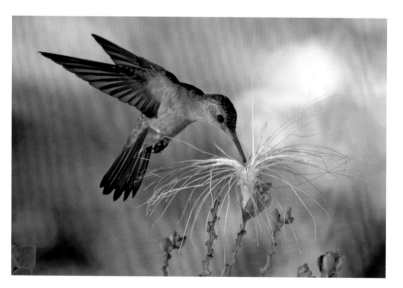

Figure 180. The flowers of *Inga vera*, here being visited by a cinnamon hummingbird (*Amazilia rutila*), open an hour or two before dusk and attract many hummingbirds.

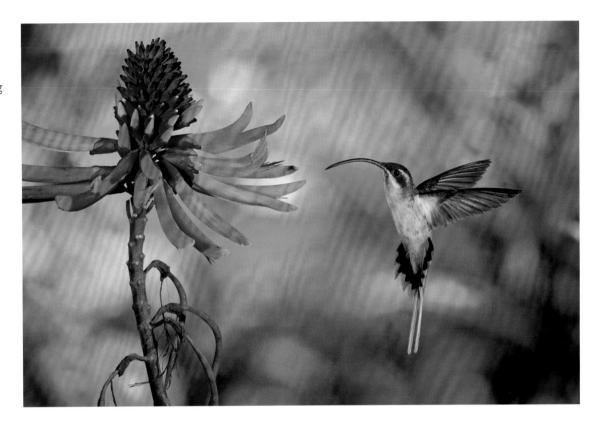

Figure 181. A tawny-bellied hermit (*Phaethornis syrmatophorus*) visiting the long, machete-shaped flowers of an Ecuadorean coral tree (*Erythrina*).

mingbirds, or none at all, and are presumably pollinated by moths or bats at night. Ironically, it is possible to see more hummingbirds at *I. oerstediana* than at typical hummingbird flowers. At one popular tree we noted 12 species in less than an hour, and 20 over the course of three or four days.

Calliandra is another mimosoid genus. It has about 140 species, all of which are native to tropical America. The flowers resemble the pom-poms of *Inga*, except that they are usually pink or red. Being red and secreting copious nectar, they conform to the hummingbird pollination syndrome. They are indeed visited by hummingbirds but also attract bats, hawkmoths, bees, and other insects. It is not always clear which of these are effective pollinators.

Erythrina includes about 130 species that are found more or less throughout the tropics. Most

have red flowers and are often called coral trees, though species with purple, orange, or green flowers also occur. The red and orange species lack any scent and sometimes produce so much nectar that drops overflow and fall to the ground. *Erythrina crista-galli* is sometimes called the "cry baby tree." The flowers come in two main types—long, machete-shaped flowers that are visited and pollinated by long-billed hermit hummingbirds (fig. 181), and flowers with a short corolla that are pollinated by short-billed hummingbirds, orioles, flowerpiercers, and honeycreepers. In Andean cloud forests we have also seen a species with cauliflorous green flowers that are pollinated by bats (fig. 182).

Mucuna is a genus of around 100 species, mainly vines, found throughout the tropics. Many species are pollinated by bats. The Costa Rican *Mucuna*

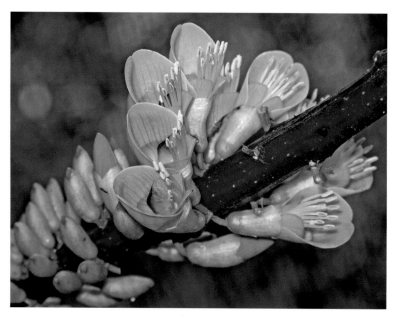

Figure 182. Not all coral trees have red or orange flowers. These green *Erythrina* flowers are cauliflorous, growing on the trunk of the parent tree. It is likely that the flowers are pollinated by bats.

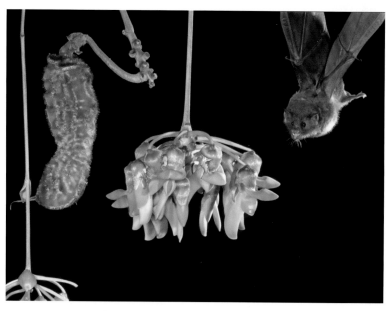

Figure 183. An Underwood's long-tongued bat (*Hylonycteris underwoodi*) approaching an inflorescence of *Mucuna urens*. The flowers have sonar guides. Note also the seedpod, which is densely covered with hairlike spines so irritating to the touch that one botanist described the pods as "diabolical."

urens, for example, has a strong fruity smell, reminiscent of squashed, ripe black currants, which attracts small nectar bats, especially the common long-tongued bat (*Glossophaga commissarisi*) and Underwood's long-tongued bat (fig. 183). The flowers of at least two species of *Mucuna* have "sonar guides." There are also species of *Mucuna* with orange flowers, clearly adapted to be pollinated by hummingbirds.

Seed dispersal. The fruits of *Inga* are tough, bean-like pods of various shapes and sizes, mostly 10–30 centimeters (4–12 inches) long, but much longer in some species. The pods contain numerous seeds embedded in an aril—a juicy white pulp with a sweet flavor reminiscent of vanilla ice cream. *Inga* trees are regarded as a useful source of food in many

Latin American communities. Their mature pods are often seen for sale on market stalls.

The fruits are also popular with diverse animals. Monkeys and squirrels open the pods and enjoy the sweet pulp; prehensile-tailed porcupines (*Coendou*) are seed predators that eat the fruits, including the seeds, while they are immature; and parrots clamber around the trees, acrobatically reaching the pods and extracting the seeds. An *Inga* tree in Ecuador sometimes attracted flocks of more than 50 red-billed parrots (*Pionus sordidus*) (fig. 184). Clumsy feeders, the parrots often dropped pods to the ground, where the seeds were later eaten or scatter hoarded by agoutis.

Seedpods of *Erythrina* species open to expose

dense coat of sharp, easily detached, golden hairlike spines that irritate when touched, providing excellent protection against monkeys and other mammalian seed predators. Once on the ground, the pods disintegrate and the seeds are scatter hoarded by agoutis. Species of *Mucuna* that habitually grow near rivers have buoyant, water-dispersed seeds that are carried downstream to the sea and sometimes drift across oceans to distant shores. By then, most are no longer viable.

HELICONIACEAE: *Heliconia*

The family Heliconiaceae includes 200 species worldwide in a single genus, *Heliconia*. Except for half a dozen species that occur in New Guinea, the Solomon Islands, Samoa, and Fiji (which will not be discussed here), species of *Heliconia* (often known as lobster claw plants) occur naturally only in Central and South America, where they are a characteristic and colorful part of the forest understory. They are sun-loving plants that live in light gaps in the rain forest. They are among the first plants to colonize new gaps and they grow rapidly, spreading by means of root sprouts (suckers), so that genetically identical offspring of just one or two individuals quickly occupy all the available space. The resulting thicket may last for several years but eventually dwindles as rain forest trees invade the gap and shade out the sun. Different species of *Heliconia* live in different types of light gaps. Some form big thickets in large gaps, while others grow only in small gaps, perhaps where a single large branch has fallen. Yet others grow only along forest streams. Nowadays, some species have become dominant plants of roadsides and overgrown pastures.

Heliconia species are the focus of an interesting and varied community of animals. Their flow-

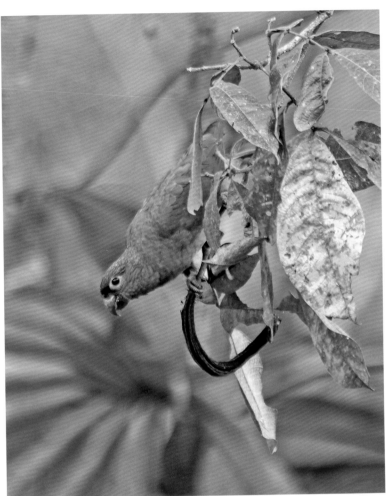

Figure 184. A red-billed parrot (*Pionus sordidus*) opening an *Inga* pod to get at the seeds. Most parrots are seed predators rather than fruit eaters.

hard, bright red or black-and-red seeds. Unlike many leguminous seeds, those of *Erythrina* lack an aril. In fact, they are mimetic seeds that offer no reward at all to the tanagers that are their potential dispersers and depend solely on fooling the occasional naive bird into swallowing them.

The seed pods of *Mucuna* have been aptly described as "diabolical." They are covered by a

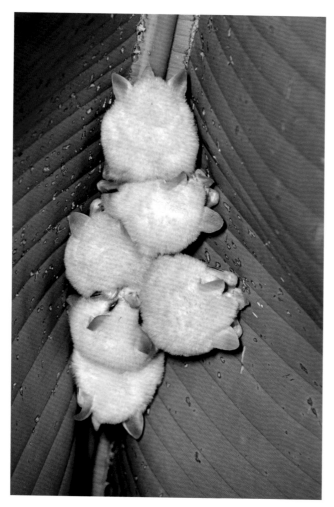

Figure 185. The huge leaves of *Heliconia* provide shelter for many animals. These cute Honduran white bats (*Ectophylla alba*), or Costa Rican white bats in this case, roost by day under *Heliconia* leaves modified to form a tent. Six bats in a roost is fairly typical, but we have seen as many as 18.

ers attract pollinating hummingbirds, and their broad, sturdy leaves provide both shelter and hunting areas for a variety of animal life. If you look into a young furled leaf, you may well be confronted by a frog, large katydid, or spider; or perhaps a group of sleeping disk-winged bats (*Thyroptera tricolor*).

These tiny bats roost together and attach themselves to the smooth leaf surface by means of suckers on their wings. Like other animals that sleep in unfurling leaves, they must search for a new roost every two or three days, for the leaves soon unroll. Several species of tent bats, including the tiny but cute Honduran white bat (*Ectophylla alba*), roost under mature leaves that they modify to provide shelter (fig. 185). They chew along each side of a leaf's midrib, so that the leaf blades collapse to form a tent. In the tent they are hidden from predators and sheltered from wind and rain. Groups of bats use the same tents for many weeks, until they disintegrate, and have traditional areas to which they regularly return. Anole lizards (*Norops*) are often seen on *Heliconia* leaves, either hunting for insects or displaying at each other with their brightly colored dewlaps. At night they sleep on the tips of leaves, a position where they can usually detect the movement of an approaching predator. However, nocturnal blunt-headed tree snakes (*Imantodes cenchoa*) are specialists. By reaching out from a neighboring leaf, these extremely attenuated snakes can detect and seize sleeping anoles without giving any warning.

Very few of the animals that frequent *Heliconia* leaves feed on the foliage itself, because the tissues are tough and full of bitter tannins. The few exceptions, such as the larvae of hispid beetles (Hispidae) and owl butterflies (*Caligo*), are able to detoxify the tannins and so eat the leaves with impunity. Hispid beetle larvae feed on the young rolled leaves and are responsible for the lacy pattern of holes that sometimes appears as a leaf unfurls. Owl butterfly larvae eat mature leaves. In addition to these herbivores, a few bugs suck the sap of *Heliconia*. These include colorful spittlebugs (Cercopidae), whose larvae blow bubbly nests in the axils of the bracts.

Figure 186. Some species of *Heliconia* have water-filled bracts that protect developing flower buds and support a thriving community of aquatic life. Visible here are mosquito larvae and the breathing tubes of several rat-tailed maggots, larvae of hoverflies (Syrphidae).

Another assortment of "guests" is associated with *Heliconia* bracts. Species with upright inflorescences have boat-shaped bracts that collect rainwater. Flower buds grow in the water, which prevents insects from chewing into the nectary at the base of the flowers and stealing nectar. These water-filled bracts support a thriving community of aquatic life, including protozoans, copepods, and the larvae of mosquitoes, beetles, and hoverflies (fig. 186). These animals are either carnivorous or live on plant debris, especially old flowers. In addition, the aquatic, rat-tailed maggots of hoverflies wriggle bodily into the flowers to steal nectar. This is hazardous, for we once saw one neatly speared by the sharp bill of a probing hummingbird. The hummingbird looked most surprised.

Mention must also be made of the golden morph of the eyelash pit viper, a snake that often coils near *Heliconia* flowers, lying in wait for hummingbirds. Its golden color may even attract the hummingbirds' curiosity. But catching a hummingbird is not easy; they have lightning-quick reactions and a lot of feathers. As often as not, the striking viper grasps nothing more substantial than wing or tail feathers.

Pollination. Old World *Heliconia* species are pollinated by nectar bats, but all Neotropical species are pollinated by hummingbirds. Although individual flowers last for only a single day, most species of *Heliconia* continue to flower for several months, flowers often overlapping with ripe fruits. The white or yellow flowers are small and relatively inconspicuous. However, they are housed in huge red, orange, or yellow bracts, which provide an attractive display for hummingbirds. The inflorescences can be upright or pendent and are sometimes very long—over 2 meters (over 6 feet) long in *H. longa*. Flowers of all *Heliconia* species secrete ample nectar for the hummingbirds that pollinate them and are shaped to accommodate their bills. There are two groups. The first includes the species that form large thickets; have short, straight flowers; and are visited by medium and short-billed hummingbirds, most of which are territorialists and defend several inflorescences against intruders (fig. 187). Intruding hummingbirds sneak in to get nectar whenever they can, usually when a territory holder is busy chasing another intruder. Territory holders tend to deliver pollen to nearby genetically identical plants. The sneaky intruders are probably better pollinators because they are forced to move over longer distances between thickets.

The second, and bigger, group of *Heliconia* species has long, curved flowers that match the long, curved bills of hermit hummingbirds (fig. 188). Hermits are trapliners that travel through the for-

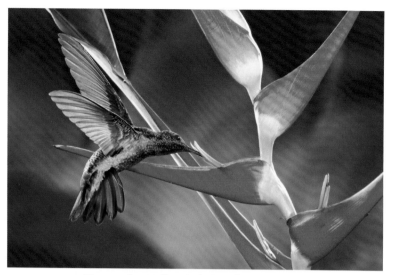

Figure 187. *Heliconia latispatha* is a short-flowered species that forms thickets in extensive forest clearings and other secondary habitats. Such thickets are usually guarded by territorial hummingbirds, in this case a male green-breasted mango (*Anthracothorax prevostii*).

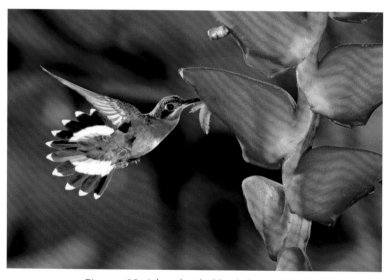

Figure 188. A band-tailed barbthroat (*Threnetes ruckeri*) feeding at *Heliconia pogonantha*, a species with long, curved flowers. Like other hermits, the barbthroat is a trapliner that visits widely spaced flowers along a set route.

est along set routes, visiting widely spaced flowers in sequence. They are the principal pollinators of the *Heliconia* plants that live in small gaps. From the point of view of the flowers, trapliners are desirable pollinators. They tend to carry pollen longer distances than territorialists and cross-pollinate unrelated plants.

It is common for several species of *Heliconia* to be found in the same general locality. At La Selva Biological Station in the Caribbean lowlands of Costa Rica, there are as many as 10 species, all competing for the services of the same hummingbird pollinators. To prevent the mixing of their pollen, different species bloom at different times of the year or in slightly different habitats. Whenever two or more species do flower together, their flowers are shaped so that pollen is brushed onto different parts of the bird. *Heliconia umbrophila* and *H. irrasa*, for example, bloom at the same time in small light gaps and are visited by the same hermit hummingbirds. One has down-curved flowers that brush pollen onto the chin of the bird, and the other has upcurved flowers that force the bird to turn its head upside down, so that pollen is brushed onto its crown. Another pair of species, *H. latispatha* and *H. imbricata*, are thicket-forming species with short flowers that bloom close by at the same time. The former puts pollen onto the lower part of the hummingbird's bill, while the latter has twisted flowers that brush pollen onto the top of the bill. Occasionally, we have seen a hermit with pollen on three or four different places—clearly, it must have visited three or four different species of flower.

Seed dispersal. The developing fruits of Neotropical *Heliconia* species contain three hard seeds covered by a thin, fleshy outer layer. They are green or yellow while immature and advertise that they are ripe

Figure 189. Most *Heliconia* species produce flowers and fruit for many months, often simultaneously. The inflorescence of this Ecuadorean *H. burleana* has buds, flowers, developing yellow fruits of different sizes, and two fruits that are bright blue, indicating that they are ripe.

by turning blue after about two to three months (fig. 189). Ripe fruits, which vary in size depending on species, are sought by a wide variety of fruit-eating birds. Bigger fruits are eaten mainly by motmots, toucans, and larger cotingas, such as umbrella-birds and cocks-of-the-rock, while smaller fruits are taken by manakins, tanagers, and finches. Seeds are either regurgitated or passed through the birds' guts unharmed. In addition to birds, squirrels sometimes eat the fruits. However, they consume the seeds, rather than the pulp. They are seed predators, not dispersers.

LAURACEAE (Avocado Family)

Worldwide the Lauraceae includes about 2,750 species in 52 genera, distributed mainly in the tropics, and reaches its highest diversity in northern South America, Southeast Asia, and Madagascar. There are 27 genera and about 1,000 species in tropical America. However, because species of Lauraceae are confusingly similar and difficult to identify, the total numbers of both genera and species are far from settled.

Most lauraceous species have aromatic bark and leaves containing essential oils that are sources for spices, fragrances, and medicinal ingredients. Several lauraceous products are economically important, notably cinnamon (*Cinnamomum zeylanicum*), camphor (*Cinnamomum camphora*), bay leaves (*Laurus nobilis*), and avocados (*Persea americana*), all of which are produced sustainably in plantations. A few species, notably the South American greenheart (*Chlorocardium rodiei*) and the South African stinkwood (*Ocotea bullata*), are harvested for their valuable timber. Unfortunately, they are harvested nonsustainably and several are close to extinction. Many others are harvested locally for their timber.

Figure 190. The flowers of lauraceous trees are small and greenish yellow. They are visited and pollinated by a diverse selection of small insects, including bees, wasps, and flies. In this case, avocado flowers (*Persea americana*) have attracted a bristly tachinid fly.

Pollination. Lauraceous flowers are generally small and whitish or greenish yellow. They are visited and pollinated by a great variety of small bees, wasps, and flies and conform to the "generalist insect" pollination syndrome (fig. 190). Some lauraceous flowers are unisexual (monoecious or dioecious), but most are bisexual and protogynous (i.e., the stigmas are receptive before pollen is released by the anthers). The avocado and at least a few species of *Ocotea* exhibit a complex variation of protogyny to ensure cross-pollination. In these species there are two complementary classes of flowers. In one the stigmas are receptive in the morning and the anthers shed pollen in the afternoon. In the other, the stigmas are receptive in the afternoon and the anthers shed pollen the following morning. The two classes reciprocate, the first being pollinated by the second in the morning, the second by the first in the afternoon.

Seed dispersal. Lauraceous fruits are drupes that have a relatively huge seed covered with a thin layer of dry but very nutritious flesh. They change color from green to black when ripe, and many in the genera *Nectandra*, *Ocotea*, and *Phoebe* are partially enclosed by a bright red receptacle that attracts attention. The fruits vary from 1 to 5 centimeters (0.4–2 inches) in length, but all have the general appearance of a miniature cultivated avocado. They are known as *aguacatillos* (little avocados) in Central and South America. They provide a complete diet for frugivorous birds, containing proteins, fats, and sugars and relatively little water. Most trees have a good crop only every other year.

High-investment, high-quality fruits tend to be large and are eaten only by large, so-called specialist frugivorous birds. Most lauraceous fruits conform to this pattern and are consumed in large numbers in the Neotropics by quetzals, toucans, and large cotingas. However, the Lauraceae is somewhat unusual in that it includes numerous species with fruits that measure only about 15 × 10 millimeters (0.6 × 0.4 inch). They are popular with large frugivorous birds but small enough to also be eaten by smaller species (fig. 191). In Costa Rica, fruits of *Ocotea tonduzii*, for example, are taken by many relatively small species, including tityras, flycatchers, robins, and migrants as small as a red-eyed vireo (*Vireo olivaceus*). At nests of masked tityras (*Tityra semifasciata*), we found that *Ocotea tonduzii* accounted for all but 2 of 106 fruits brought to the nestlings and 18–36 percent of all recorded food items.

During the breeding season, resplendent quetzals feed many lauraceous fruits to their nestlings, which

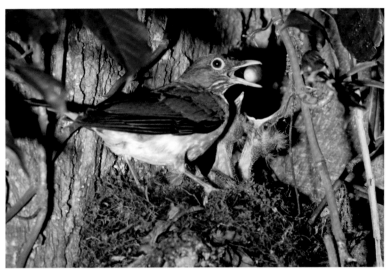

Figure 191. A white-throated thrush (*Turdus assimilis*) with a small wild avocado (*Ocotea tonduzii*) for one of its nestlings.

regurgitate the seeds inside the nest cavity (fig. 192). Large nestlings that are three to four weeks old end up sitting on top of a gooey, gelatinous heap of droppings mixed with seeds. We excavated one nest cavity after the young quetzals had fledged. As well as insect remains, we found over 300 large seeds (not counting hundreds of tiny fig seeds), of which 115 were the seeds of *Beilschmiedia brenesii* (measuring 17 × 45 millimeters or 0.7 × 1.8 inches) and 60 were seeds of other lauraceous species (*Ocotea* and *Nectandra*). Other identified seeds included 30 *Hasseltia floribunda*, 22 *Stauranthus perforatus*, and 13 *Guatteria consanguinea*, plus miscellaneous *Ardisia*, *Eugenia*, *Sideroxylon*, *Prunus*, and *Passiflora*.

LORANTHACEAE and VISCACEAE (Mistletoe Families)

The mistletoes in the Loranthaceae and Viscaceae were formerly united in a single fam-

ily (Loranthaceae), along with a small third family, the Eremolepidaceae. Both the Loranthaceae and Viscaceae are mainly subtropical or tropical in distribution, though some species of Viscaceae occur in temperate areas, notably the European mistletoe (*Viscum album*). Worldwide the Loranthaceae includes about 70 genera and over 900 species, with about 15 genera and 230 species in Central and South America. The Viscaceae includes 7 genera

Figure 192. A female resplendent quetzal feeding a large wild avocado (*Beilschmiedia pendula*) to a nestling.

and about 600 species, with 3 genera and about 360 species in tropical America. Almost all species of both families are hemiparasitic shrubs that grow on woody shrubs and trees. Exceptions include two loranthaceous species—the Australian Christmas tree (*Nuytsia floribunda*) and the Neotropical *Gaiadendron punctatum*—both of which are terrestrial root hemiparasites.

Pollination. Most loranthaceous species have bisexual flowers. About half are small and inconspicuous. They are visited and presumably pollinated by small insects, including small flies and wasps. Flowers of other loranthaceous mistletoes conform to the bird pollination syndrome. Colorful and tubular, they secrete copious nectar. The flowers of many species of *Psittacanthus*, for example, are red and yellow. Corolla length is variable. Flowers with a relatively short corolla attract short-billed hummingbirds (fig. 193). Other species have pendent flowers with a very

Figure 194. A loranthaceous mistletoe (*Psittacanthus*) growing high in the Ecuadorean Andes (3,500 meters or 11,483 feet). It is pollinated by long-billed inca hummingbirds (*Coeligena*) and probably sword-billed hummingbirds (*Ensifera ensifera*).

Figure 193. A lesser violetear (*Colibri cyanotus*) feeding at loranthaceous mistletoe flowers (*Psittacanthus ramiflorus*).

long corolla that are pollinated by long-billed hummingbirds, including sword-billed hummingbirds, incas, and lancebills (fig. 194).

All viscaceous flowers are small, inconspicuous, and greenish or yellowish, and they are pollinated by small insects, especially wasps.

Seed dispersal. Mistletoe berries in both the Loranthaceae and Viscaceae have unusual characteristics because their parasitic habit demands that seeds are "planted" on branches, which in turn demands special handling techniques by dispersers. The problems presented by the two families are different and demand different specialist dispersers.

In Central and South America, a cotinga, the mistletoe tyrannulet, and silky-flycatchers eat the fruits of loranthaceous mistletoes and disperse the seeds. The fruits are swallowed whole and the skin and pulp separated from the seeds in the giz-

zard. The seeds are then quickly regurgitated, usually within about five minutes. The regurgitated seeds are covered with strands of viscin—a sticky, gooey mucilage. The seeds stick to the bill and are then wiped, or "planted," onto a branch. It is a process that requires skill and experience. Young birds struggle to get rid of sticky seeds and viscin strands and usually take longer than adults to accomplish the task. White-cheeked cotingas, which live in *Polylepis* woodlands at high altitudes in the Andes of Peru, depend for food almost entirely on mistletoe berries (*Tristerix* and *Ligaria*). American ornithologist Ted Parker, in David Snow's *The Cotingas* (1982), described foraging bouts thus: "The cotingas . . . swallowed up to five berries in succession," and then "after five to ten minutes more, the sticky seeds were regurgitated, one by one, and wiped onto the surface of the limb. I never saw a seed fall to the ground during this process and assume that a very high percent of all fruits taken are successfully dispersed in this manner."

In Central and South America, viscaceous berries are eaten by chlorophonias and euphonias, but seldom if ever by the birds that specialize on loranthaceous fruits. Sarah Sargent (2000) has studied chlorophonias and euphonias in Costa Rica. They squeeze viscaceous berries in their bill. The skin separates easily and is discarded, while the pulp and enclosed seed are swallowed. Chlorophonias and euphonias have a gentle, nonmuscular stomach and lack a gizzard, enabling fruit pulp, which is rich in

carbohydrates, to be processed rapidly. Seeds pass through the gut and are defecated in only 8–60 minutes. The seeds, which lack a seed coat, are soft and vulnerable but remain embedded in a protective layer of indigestible viscin throughout their passage through the gut. Once defecated, the seeds usually remain connected to the bird's cloaca by a strand of sticky mucilage (fig. 195). Instead of falling to the ground, they dangle over the branch on which the bird is perched. With a quick squatting motion, the bird wipes its cloaca against the perch, leaving the seeds dangling below the branch. As it dries, the viscin strand contracts, eventually pulling seeds into

Figure 195. A female golden-browed chlorophonia (*Chlorophonia callophrys*) carrying nest material. Note that the bird has just defecated seeds of a viscaceous mistletoe (probably *Phoradendron robustissimum*) that are still connected to the bird's cloaca by a strand of sticky mucilage.

contact with the branch, where they germinate in due course.

MARCGRAVIACEAE
(Shingle Plant Family)

The Marcgraviaceae family is endemic to the Neotropics, its range extending from southern Mexico to Bolivia and Brazil. The family includes about 130 species in seven genera, confined mostly to lowland or montane rain and cloud forests. The growth form is variable, including terrestrial, hemiepiphytic, and epiphytic lianas, and small trees. All species have elaborate inflorescences, erect or pendulous, in the form of candelabra-like structures in *Marcgravia*, *Marcgraviastrum*, and *Schwartzia*; or flowering spikes in *Norantea*, *Sarcopera*, *Souroubea*, and *Ruyschia*. All have extrafloral nectaries of various shapes derived from bracts.

Pollination. Most genera and species conform to bat, bird, or insect pollination syndromes in their flowering characteristics. Even so, it is thought that many species can self-pollinate (autogamy), and at least one species, *Marcgravia coriacea*, is known to be capable of automatic self-pollination (cleistogamy).

Species of *Marcgravia* have an extraordinary candelabra-like inflorescence in which pitcher-like nectar cups, derived from bracts, hang beneath a rosette of flowers (fig. 196). In some species, the nectar cups are red or purple, suggesting that they are pollinated by hummingbirds. Nevertheless, one such species—the Cuban *M. evenia*—is defi-

nitely pollinated by a nectar bat (*Glossophaga soricina*); it even has a dish-shaped leaf above the inflorescence that acts as a sonar beacon, helping nectar bats home in on the flowers (Simon et al. 2011). In fact, most species of *Marcgravia* are probably pollinated by nectar-feeding bats or other small non-flying mammals, including woolly opossums (Tschapka and van Helversen 1999). Their flowers open at night and produce abundant nectar, some of which is left over the next morning. The excess nectar often attracts frantic activity by many hummingbirds. The amount of nectar can be significant.

Figure 196. The candelabra-like inflorescence of *Marcgravia nepenthoides* provides nectar to hummingbird pollinators in nectar cups that hang below a rosette of flowers. The nectar cups of this specimen will turn red once the flowers open.

In fact, Gary Stiles (1985) concluded that the breeding season of green-crowned brilliants (*Heliodoxa jacula*) in Braulio Carrillo National Park in Costa Rica is probably timed to coincide with the flowering of three species of bat-pollinated *Marcgravia*, rather than with the flowering of typical hummingbird flowers. However, it should be noted that the brilliants are not pollinators—in bat-pollinated *Marcgravia* species, the stamens drop off before dawn.

The strange inflorescence of *Schwartzia costaricensis* puzzled us at first. We had been told that, like species of *Marcgravia*, it is pollinated by bats, or perhaps mouse opossums (*Marmosa*) or other small nocturnal mammals. However, its red flowers and lack of odor suggested to us that it should be pollinated by hummingbirds, especially because many hummingbirds visited one of these trees near our house, usually in the afternoon and evening (fig. 197). Most of the hummingbird visitors were small and appeared to hover at the nectar cups without ever coming into contact with the flowers. The genuine pollinators turned out to be green-crowned brilliants, which were quite large and liked to perch to feed. As the brilliants stretched to reach the nectar cups, they maintained their balance by fluttering their wings, which often touched the flowers. Later, we found traces of pollen on the wings of several individuals. We also checked the flowers for the timing of nectar flow and found that it started an hour or two after dawn, peaked in the afternoon, and ceased at dusk—clearly there is no nectar reward for bats or other nocturnal mammals. The timing of nectar production is a little unusual—in most hummingbird flowers the flow peaks early in the morning and tails off before midday. The pattern in *Schwartzia costaricensis* accounts for the regularity

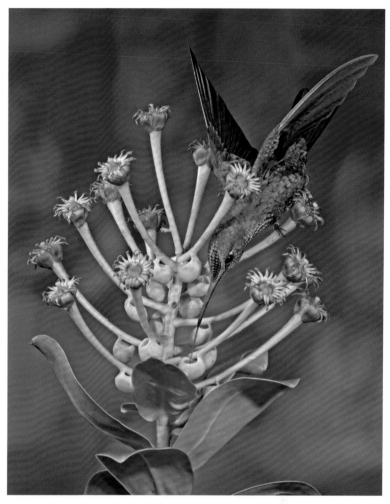

Figure 197. A green-crowned brilliant (*Heliodoxa jacula*) at an inflorescence of *Schwartzia costaricensis*. As the bird stretches to feed, it flutters to maintain its balance, touching the flowers with its wings and collecting pollen as it does so.

of hummingbird visits in the afternoon and may be an adaptation to avoid competition with other hummingbird flowers.

Species of both *Norantea* and *Sarcopera* have a spike of tiny flowers interspersed among large nectar cups, again derived from bracts. They are vis-

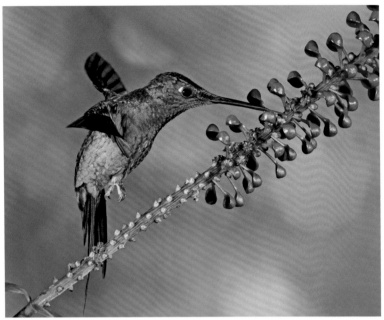

Figure 198. An empress brilliant (*Heliodoxa imperatrix*) feeding at the backward-pointing nectar cups of an Ecuadorean species of *Sarcopera*. Hovering hummingbirds do not come into contact with the small greenish flowers (visible below the hummingbird's feet) and are not pollinators.

ited and pollinated by birds. In lowland Costa Rica, *Sarcopera sessiliflora* is visited and pollinated mainly by birds that perch to feed, particularly orioles, tanagers, and honeycreepers. Hovering hummingbirds, such as white-necked jacobins (*Florisuga mellivora*), rarely touch the flowers. On the other hand, a species of *Sarcopera* in the western Andes of Ecuador, which grows at higher altitudes (mainly above 1,800 meters or 5,900 feet), is visited by at least eight species of hummingbirds, some of which perch to feed, plus just a few tanagers and flowerpiercers. The nectar cups of both species point back along the inflorescence, forcing nonhovering birds to perch among the open flowers in order to access the nectar (figs. 198 and 199). When the birds are perched in this position, their feet come into contact with the flowers and pick up pollen, which they carry from inflorescence to inflorescence. It is doubtful that hovering hummingbirds ever pollinate the flowers. Both *Norantea* and *Sarcopera* have long flowering seasons, with single or a few flowers opening daily for several months.

Much less is known about the pollination biology of *Souroubea* and *Ruyschia*. Species in both genera have characteristics that suggest they are pollinated by insects, probably butterflies and moths, and perhaps flies, but definitive observations are lacking.

Seed dispersal. Fruits of marcgraviaceous species are globular capsules that split to expose numerous small seeds embedded in brightly colored pulp. There is little published information about seed dispersal, but the fruits are obviously intended to be

Figure 199. A male Baltimore oriole (*Icterus galbula*) feeding at an inflorescence of *Sarcopera sessiliflora* in Costa Rica. To access the nectar cups, the oriole is standing among the flowers and is likely to get pollen on its feet.

Figure 200. The fruits of *Sarcopera* are attractive to numerous small frugivorous birds, especially euphonias and tanagers.

eaten by birds and the seeds defecated later. We have numerous personal records of at least 11 species of birds, including barbets, euphonias, honeycreepers, and tanagers, consuming the fruits of an unidentified species of *Sarcopera* in the Andes of Ecuador, *Sarcopera sessiliflora* in lowland rain forest in Costa Rica, and *Schwartzia costaricensis* in the highlands of Costa Rica (fig. 200).

MELASTOMATACEAE
(Melastome Family)

The Melastomataceae is a mainly tropical family containing about 155 genera and 4,500 species worldwide. There are about 100 genera and 3,000 species in tropical America, more than 1,000 of them species of *Miconia*. Melastomes include herbs, epiphytes, lianas, and trees up to 40 meters (131 feet) tall, but most are shrubs or small trees. Many are important pioneer species, among the first to colonize abandoned pastures, landslides, or other damaged habitats, and often successful enough to form monocultures that last for a few years. In the Neotropics, melastomes are a particularly important source of pollen for bees and of berries for small birds. They should be encouraged. They have little commercial value, though glory bushes (*Tibouchina*) have ornamental flowers and are often cultivated in tropical gardens.

Seasonality. Different species and genera of coexisting melastomes often have contrasting flowering and fruiting strategies. *Conostegia oerstediana*, for example, has very extended flowering and fruiting seasons, each lasting six months or more (fig. 201). Trees around our house in the Costa Rican highlands begin flowering in January or February (sometimes as early as late December) and continue flowering until June or even July. The first ripe fruits are ready by March or April and remain available until at least September. On the other hand, many species of *Miconia* flower several times in the course of a year. Flowering is highly synchronized, every flower on every tree for miles around opening within a day or two, often triggered by a heavy rain shower (fig. 202). Fruits begin ripening about two months later and remain available for a month or so. Each flow-

Figure 201. In Costa Rica, this melastome (*Conostegia oerstediana*) has very long flowering and fruiting seasons, each lasting six months or more. For several months of the year, as seen here, trees simultaneously have all flowering and fruiting stages from buds to ripe berries.

ering and fruiting episode is completed within only three or four months and is repeated two or three times a year.

Pollination. Melastome flowers are radially symmetrical (actinomorphic), though the arrangement of stamens and style is often slightly asymmetrical. Flowers are bisexual and most are white, pink, or purple, occasionally yellow, orange, or red. The majority of melastomes produce pollen as the sole reward, rather than nectar, and are buzz pollinated by bees. Buzz-pollinated melastome flowers have anthers with tiny apical pores through which pollen, which is dry and dustlike, can be "buzz released."

Some melastomes, notably some glory bushes (*Tibouchina*), have two types of stamens, one fulfilling the primary function of pollination, the other providing food to pollinators in the form of sterile food stamens (staminodes). The primary pollination stamens match the purple flower color, making them inconspicuous, while the food stamens are an eye-catching, contrasting yellow. Some species of *Tibouchina* change color after they are pollinated, presumably indicating to pollinators that rewards are no longer available (fig. 203).

A unique type of pollen flower is found in species of *Axinaea*, which have conspicuous, bulbous,

Figure 202. Flowering in *Miconia longifolia* and other *Miconia* species is highly synchronized. There are usually two or three flowering and fruiting episodes per year.

Figure 203. The stamens of many melastome flowers, including those of this Ecuadorean glory bush (*Tibouchina*), are bright yellow, enhancing their attractiveness to bees and providing an obvious place to land. It ensures that bees are in the perfect position to be covered with pollen when they buzz pollinate the flowers, causing pollen to spurt from the anthers.

Figure 204. A peg-billed finch (*Acanthidops bairdi*) feeding on pollen at a Costa Rican melastome (*Axinaea costaricensis*). The flowers have bellows-like, pollen-filled appendages on their stamens, which, when seized by a bird, squirt pollen onto the bird's face.

pollen-filled appendages on their stamens that are eaten by birds (Dellinger et al. 2014). In montane forest in Costa Rica the appendages of *Axinaea costaricensis* are eaten by peg-billed finches (*Acanthidops bairdi*) and various tanagers (fig. 204). When seized and compressed by a bird's bill, the bulbous structures act as a bellows and expel a jet of pollen onto the bird's head, where it is available to be transferred to the stigma of another flower.

Not all melastomes are pollen-only flowers. Some species of *Meriania*, for example, are conventional red hummingbird flowers that lack scent and produce nectar. The Ecuadorian *M. tomentosa* is visited by various montane hummingbirds, with the gorgeted sunangel (*Heliangelus strophianus*) and speckled hummingbird (*Adelomyia melanogenys*)

being the most frequent visitors and most likely pollinators. There are also records of *M. tomentosa* being visited by the nectarivorous Geoffroy's tailless bat.

Blakea chlorantha, studied by Cecile Lumer (2000) in the mountains of Costa Rica, is another nectar-producing species. Most *Blakea* species have pink or white buzz-pollinated flowers with a fragrant scent. They open by day, lack nectar, and are pollinated by bees. *Blakea chlorantha*, however, has greenish pendent flowers that produce nectar and open at night. Clearly, it is adapted to nocturnal pollinators and is thought to be pollinated by mice (*Oryzomys fulvescens* and others).

Seed dispersal. Melastome fruits are either dry, dehiscent capsules with wind-dispersed seeds or fleshy berries belonging to the syndrome of low-quality fruits dispersed by opportunistic frugivorous birds. Berries are small (4–30 millimeters or

0.16–1.2 inches in diameter), and red, blue, or black when ripe. Even small berries often contain 100 or more minute seeds, and some *Blakea* fruits contain as many as 1,000 seeds. Melastome berries are eaten by birds as different in size as guans, pigeons, trogons, barbets, and finches but are a particularly important staple food for small frugivorous birds such as manakins, thrushes, and tanagers. We have recorded 26 species of birds feeding on *Miconia longifolia* berries at La Selva Biological Station (fig. 205), and Alexander Skutch (1980) recorded 38 species at *Miconia trinervia* in southern Costa Rica. The larger berries of *Conostegia oerstediana*, a very common species around our house in Costa Rica, are typical bird fruits but are nevertheless attractive to opportunistic mammals. They are popular with mantled howler monkeys, white-faced capuchins, coatis, and fruit bats (and children), as well as at least 22 species of birds, ranging from black guans (*Chamaepetes unicolor*) and resplendent quetzals to tiny euphonias.

Figure 205. A golden-hooded tanager (*Tangara larvata*) feeding on *Miconia* berries in a rain forest in Costa Rica.

As mentioned earlier, the quantity of melastome seeds dispersed by mammals and birds can be prodigious. A study on Barro Colorado Island in Panama estimated that a troop of white-faced capuchins dispersed more than 300,000 seeds of *Miconia argentea* each day, equivalent to 150,000 seeds per hectare per year or 60,000 seeds per acre per year.

David Snow (1965) suggested that 20 coexisting species of *Miconia* in Trinidad have evolved staggered fruiting seasons to avoid competition between them to attract birds to disperse their seeds. This pattern may well hold most of the time for *Miconia* (and probably for other genera of fruiting trees), but it is liable to break down at times. During nine years in Ecuador, we monitored the flowering and fruiting seasons of *Miconia* and other melastomes. Each species followed its own basic pattern but showed some variation from year to year. Most species were out of sync most of the time, providing a more or less continuous supply of fruits. However, there were years when seasonal variations resulted in several species fruiting simultaneously, followed by weeks or months when none at all had ripe fruit. Even in the humid tropics, climate is complicated and unpredictable. For a clear picture, seasonality studies should be continued for many years.

MORACEAE: *Ficus* (Fig Family)

Ficus is the largest genus in the Moraceae, with about 750 species worldwide and 120 in tropical America, including woody trees, shrubs, and vines. In the tropics it is often the most species-rich genus in any habitat it occupies.

About half of *Ficus* species begin life as hemiepiphytes. Some of them are so-called strangler figs, which, after killing the host tree that has supported

them, grow to become some of the biggest trees in the forest, reaching heights of 50 meters (164 feet) or more. Strangler figs begin life as epiphytes on tree branches, often in the canopy, but quickly grow aerial roots that descend to the forest floor. Thereafter, they obtain water and nutrients from the ground and send down more and more aerial roots. Growing in the canopy, where there is abundant light, and not needing to put resources into a huge tree trunk, stranglers have a significant competitive advantage and eventually overshadow their host. Their aerial roots grow bigger in diameter, and wherever they touch they coalesce, eventually forming a "strangling" network around the host tree that may inhibit the transport of nutrients. Deprived of light and nutrients, the host tree slowly dies and its trunk rots. By then the cylinder of fused roots that enveloped the host is strong enough for the strangler to survive as a free-standing tree (fig. 206).

Strangler figs are a focus for all sorts of animal activity. When in fruit they often attract unrivaled gatherings of feeding mammals and birds. They also provide abundant nooks and crannies that offer safety and shelter for a great diversity of animal life. Animals that we have encountered while exploring stranglers include tarsiers (in both Borneo and Sulawesi), bats, owls, geckos, giant cockroaches, amblypygid whip scorpions, and giant centipedes.

Pollination. Figs have an extraordinary pollination system that coevolved with tiny fig wasps of the family Agaonidae. It has long been thought that every fig species has its own unique pollinator wasp, which in turn depends on the fig as a host for its larvae. It is now known that this one-to-one symbiotic relationship is sometimes broken. Nevertheless, the relationship between figs and fig wasps remains tightly coevolved (Janzen 1979; Cook and Rasplus 2003).

Figure 206. The hollow interior of a Costa Rican strangler fig (Ficus tuerckheimii) after the original host tree has died.

Fig trees lack obvious flowers. An inflorescence looks like an immature fruit (a fig) and is usually called a syconium. Each immature fig is actually a hollow sphere lined on the inside with hundreds or thousands of flowers, the number depending on its size. All Neotropical figs are monoecious and protogynous—their syconia contain both male and female flowers, the latter having a single ovary and styles of different lengths. Monoecious figs produce both seeds and wasps. Some fig trees in Asia and Africa are dioecious, in which case female trees produce only seeds, and male trees only wasps.

As stated, the fig trees we have watched and photographed in Costa Rica and Ecuador are monoecious, as they are throughout tropical America. When the immature figs are ready to be pollinated, they attract fig wasps, presumably by releasing a pheromone. Female wasps enter the immature green figs through a one-way entrance (the ostiole) at the end of the fig, which is partially blocked by overlapping scales. As the females squeeze past the scales, they are stripped of their wings and antennae and cleansed of dirt, bacteria, and fungal spores. Once inside, a wasp actively pollinates the female flowers with pollen previously stored in her abdominal pockets. She also lays eggs in any of the shorter-styled ovaries that she can reach with her ovipositor. Then she dies. After a month or two, there are mature seeds in the longer-styled ovaries and wasps ready to emerge in the others. The male wasps, which are wingless, emerge first and seek out ovaries containing females and mate with them. Then the females emerge (fig. 207). The males cooperate to cut an exit tunnel large enough for the females to exit the fig without damaging their wings. Meanwhile the male flowers have matured. Females find them, tear open the anthers, and stuff pollen into their abdominal pockets. They then exit and fly off in search of another tree at the correct, receptive stage and so repeat the cycle (fig. 208). The wingless males die inside the fig. The figs ripen soon after and are eaten by a great variety of mammals and birds. Incidentally, the flight of the females is not without its perils. The swarms of emerging wasps quickly attract foraging swallows and swifts. We have seen as many as 30 blue-and-white swallows (*Notiochelidon cyanoleuca*) swooping back and forth and feeding avidly on newly emerged wasps at a fig tree behind our house in the Tandayapa Valley in Ecuador (fig. 209).

Besides the pollinators, a number of other fig wasps parasitize the system by breeding in figs but taking no part in pollination. Some enter through the ostiole in the same way as the pollinators, but most have an extralong ovipositor and remain outside, drilling through the fig wall and laying their eggs (fig. 210). As many as 30 species of nonpollinating wasps have been found in a single fig, but fewer than 20 is more usual. Some fig wasps have wingless males with two or more very different morphs, some of which are specialized for fighting (fig. 211). W. D. Hamilton's description (1979) of the competition that goes on between the males inside a fig is quite lurid: "Their fighting looks at once vicious and cautious—cowardly would be the word except that, on reflection, this seems unfair in a situation that can only be likened in human terms to a darkened room full of jostling people among whom, or else lurking in cupboards and recesses which open on all sides, are a dozen or so maniacal homicides armed with knives." It has been estimated that a million wasps are "murdered" every time a large fig tree comes into fruit.

Seed dispersal. The fig pollination system demands

Figure 207. A female fig wasp (Agaonidae) emerging from an ovary inside a fig syconium. After filling their special abdominal pockets with pollen, female wasps exit the fig and search for another tree at the right stage to receive them.

Figure 208. A female fig wasp (Agaonidae) ovipositing into an ovary inside a fig. The wasp is about 2 millimeters (0.08 inch) long. The ostiole, the entrance to the fig, is visible in the bottom right of the photograph.

that at least some trees in every local community be flowering and fruiting throughout the year, ready to receive the female pollinating wasps that emerge from other figs and survive for only a few days. As a result, fig trees are considered to be "keystone" species—trees that play a crucial role in providing critical resources for a great diversity of animals, including mammals, birds, and insects, during times of food shortage. They are particularly important during the dry season, when other fruits are usually scarce or lacking. During the dry season in Manu National Park in Peru, for example, a single strangler fig, which can be immense and have a huge fruit crop, can attract over 100 common squirrel

Figure 209. When they are ready to fly off in search of another receptive fig tree, thousands of female fig wasps emerge from the figs at almost the same time and attract dozens of hungry swifts and swallows. In this case, the birds are blue-and-white swallows (*Notiochelidon cyanoleuca*).

Figure 210. Figs are also hosts for parasitic wasps with an extralong ovipositor that enables them to lay their eggs in a fig by drilling through the fig wall from the outside. This one is an African species (Torymidae) ovipositing into a South African fig (*Ficus capensis*). It is about 3 millimeters (0.12 inch) long, excluding its ovipositor.

monkeys (*Saimiri sciureus*), as well as spider and howler monkeys, parrots, toucans, and many others (Terborgh 1992).

The fruits of fig trees vary greatly in size, from about 10 to 60 millimeters (0.4–2.4 inches) in diameter. They conform to two fruit syndromes. Figs that are eaten by fruit bats and other mammals are usually larger and green or yellowish brown when ripe. They also have a strong fruity smell. Mammal figs are eaten by monkeys, coatis, kinkajous, and fruit bats while still on the tree and by peccaries, tapirs,

Figure 211. Male fig wasps (Agaonidae) are wingless and occur in two or three different morphs. This one is a specialized fighting morph with large jaws. It is about 2 millimeters (0.08 inch) long.

agoutis, and other mammals after they have fallen to the ground. Figs that are eaten by birds tend to be smaller, juicier, odorless, and red when ripe. Bird figs are attractive to many species of birds, ranging from large toucans, quetzals, and cotingas to tanagers and tiny euphonias. Figs adapted for birds are also eaten in large quantities by many mammals, particularly monkeys, coatis, and squirrels.

Figs are very popular at times, but not always. Even though they are considered to be keystone species, Neotropical figs do not have a particularly high nutritive value and are eaten in large quantities mainly in dry seasons when more appealing alternatives are unavailable. For example, figs on fruiting trees around our house in Monteverde in Costa Rica, and later in Ecuador, were sometimes eaten enthusiastically but went virtually unvisited when

popular alternatives (e.g., *Ocotea, Trema, Sapium, Hampea, Oreopanax, Acnistus, Miconia, Hasseltia*) were readily available. David Snow (1981) did not record any specialized frugivores eating figs in the course of his studies in Trinidad and suggested that figs are much less important for specialized frugivores in tropical America than they are in Africa, Southeast Asia, and Australasia. Our observations suggest otherwise. We think it is just a question of whether good alternative fruits are available. When preferred fruits are scarce, we have seen figs taken enthusiastically in large numbers by many specialized frugivorous birds, including quetzals, motmots, five species of toucans and toucanets, barbets, three-wattled bellbirds (*Procnias tricarunculata*), lovely cotingas (*Cotinga amabilis*), and Andean cocks-of-the-rock. A fruiting *Ficus pertusa* in the Peñas Blancas Valley in Costa Rica was visited by 37 bird species, including numerous specialist frugivores, within just a few days, while a *Ficus colubrinae* at La Selva Biological Station, also in Costa Rica, hosted 34 species in a similar time.

Because they are so small, fig seeds are defecated intact by most mammals and birds. Parrots are the only Neotropical birds that are important predators of fig seeds. In Costa Rica, Daniel Janzen (1983a) examined the stomach contents of an orange-chinned parakeet (*Brotogeris jugularis*) that had been eating figs. The stomach contained thousands of seeds, all of which had been broken open or cracked. And the droppings of parakeets showed no sign of intact seeds.

ORCHIDACEAE (Orchid Family)

The Orchidaceae is a cosmopolitan family of superlative plants with well over 20,000 species, close to 10 percent of all flowering plants. In size it is

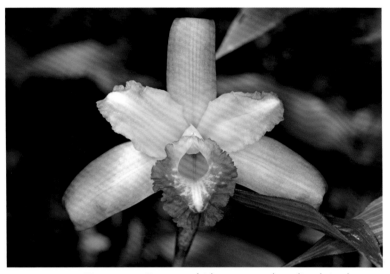

Figure 212. Some orchids are very short-lived. In the Neotropics most species of *Sobralia*, including this Ecuadorean *S. ecuadorana*, are one-day orchids—all individuals of a species flower together on the same day, usually over a wide area.

exceeded only by the daisy family (Asteraceae). Orchids occur just about everywhere that plant life exists, from above the Arctic Circle to southern South America (Tierra del Fuego) and even Macquarie Island in the Southern Ocean, halfway between Australia and Antarctica. They are most numerous and diverse in cloud forests on tropical mountains where high rainfall and mist favor the proliferation of epiphytes. In the Andes of South America, for example, Colombia, Ecuador, and Peru each harbor more than 3,000 species. Other centers of diversity include Malaysia and New Guinea. Much information about orchids has been summarized by Dressler (1981).

All orchids are herbaceous but vary enormously in stature. The miniature *Platystele jungermannioides* is less than 2 centimeters (0.8 inch) high when in full flower, while the Malaysian giant orchid

(*Grammatophyllum speciosum*) can be over 7 meters (23 feet) tall and weigh more than 1,800 kilograms (2 tons). Vanilla orchids (*Vanilla*), which clamber 30 meters (100 feet) or more up trees or cliffs, are giants in a different way. It has been estimated that about 25 percent of orchids are primarily terrestrial, 70 percent primarily epiphytic, and 5 percent capable of being either.

The basic plan of an orchid flower is very consistent, but there is enormous variety in the details. Orchids are bilaterally symmetrical (zygomorphic) and bisexual, and they have three sepals and three petals (fig. 212). The sepals and two of the petals are often similar, but the lower, middle petal is usually larger, more colorful, and fancier in structure, forming a complex lip. It is the main visual attraction for pollinators and also provides a landing platform. In the majority of orchids, the style and a single anther are united in a structure called a column, but they are kept separate by a flap of tissue (the rostellum) that reduces the possibility of self-pollination. Orchid pollen is sticky and is usually compacted into discrete masses called pollinia that are connected by a filament to a sticky pad (the viscidium), the whole structure then being called a pollinarium. This is the package that pollinators carry from flower to flower. It sticks to the pollinator by means of the sticky pad.

Some genera of orchids are famous for having long-lasting flowers, provided they are not pollinated. Examples include slipper orchids (*Paphiopedilum*) and moth orchids (*Phalaenopsis*), both of which may last for several months, and there are many others. Orchids are much involved in mimicry and deceit, so being long lasting may compensate for orchids receiving relatively few visits by pollinators. Other orchid flowers are very short-lived.

Figure 213. A passion-vine butterfly (*Heliconius clysonymus*) visiting an orchid (*Epidendrum radicans*) that offers no reward. Note the orchid's pollinarium on the butterfly's tongue.

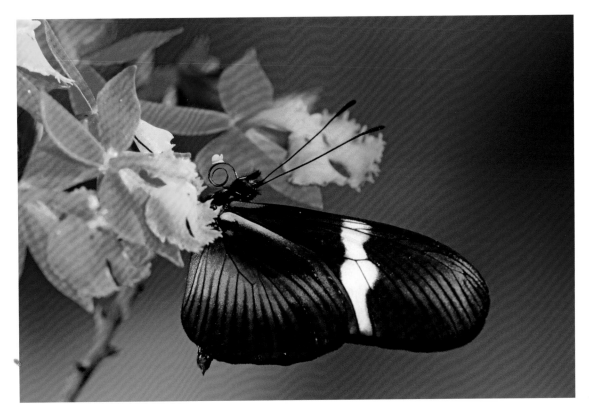

In the Neotropics, *Fregea amabilis* and most species of *Sobralia* last for just one day. One-day orchids typically flower synchronously over quite wide areas, often triggered by sudden temperature changes. In Southeast Asia, for example, the mass flowering of the pigeon orchid (*Dendrobium crumenatum*) occurs nine days after a sudden drop in temperature caused by heavy rain. Synchronous flowering obviously improves the chances of one-day flowers being pollinated.

Pollination. Because orchids have only a pollinarium, rather than abundant grains of powdery pollen, pollination becomes a gamble that demands great precision in pollen transfer between orchids. Darwin, in his brilliant book *The Various Contrivances by Which Orchids Are Fertilised by Insects* (1862), thought that the delivery of pollen in polli-naria explained the extraordinary adaptations that orchids use to ensure their successful pollination. Certainly, orchids are renowned for their highly specialized and specific pollination systems.

Many orchids offer little or no reward. They are either specific or generalized mimics of other flowers and depend on being visited by naive pollinators. Nilsson (1992) estimated that as many as 8,000 to 10,000 of the 20,000 to 30,000 species of orchids offer no reward and attract pollinators by deceit or fraud. A much-quoted example involves the closely related Neotropical orchids *Epidendrum ibaguense* and *E. radicans* (fig. 213), which are said to mimic the butterfly-pollinated flowers of the milkweed *Asclepias curassavica* (see fig. 80) and *Lantana camara* (see fig. 37). Other examples include species of *Oncidium* that mimic oil-producing flowers of

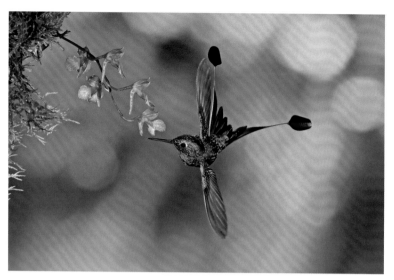

Figure 214. A male booted racket-tail (*Ocreatus underwoodii*) visiting a typical hummingbird-pollinated orchid (*Comparettia falcata*) in a cloud forest in Ecuador.

Malpighia (Malpighiaceae); Ecuadorean orchids that mimic the flowers of ericaceous shrubs; and Asian orchids that resemble rhododendron flowers.

Orchids that offer a reward are pollinated more or less normally and have characteristics that fit the bee, fly, moth, butterfly, or bird pollination syndromes already described. Bees and wasps are the most important pollinators of orchids, probably servicing about 60 percent of orchid species. Flies, moths, butterflies, and birds, in descending order of importance, account for most of the rest. No orchids are pollinated by wind or water.

Nectar is the most common reward offered by orchids, and it is frequently produced in a spur formed by the base of the lip. Less common rewards include oils produced by elaiophores in *Sigmatostalix* and *Ornithocephalus*. The Brazilian orchid *Maxillaria divaricata* attracts insects with wax secreted on its lip. And some orchids in the genera

Maxillaria and *Polystachya* produce edible, starchy pseudopollen on their lip, which is gathered by bees and other pollinators (see chapter 3). Many orchids offer perfumes as attractants to euglossine orchid bees. No orchids offer genuine pollen as a reward.

Birds are the only vertebrates involved in orchid pollination. In Central and South America, orchids in several genera are pollinated by hummingbirds (fig. 214). Most occur in cloud forests where cold, wet conditions often inhibit activity by bees and butterflies. Warm-blooded hummingbirds are active whatever the weather, so it is no surprise that hummingbird-pollinated orchids are more frequent in the highland cloud forests than in the lowlands. We have photographed several hummingbird-pollinated orchids in cloud forests in Costa Rica and Ecuador, including *Comparettia falcata*, at least six species of *Elleanthus*, three of *Epidendrum*, *Fregea amabilis*, *Masdevallia coccinea*, *Maxillaria fulgens*, and *Symphyglossum sanguineum*. In addition, numerous species of *Sobralia* and other large orchids are regularly pierced by wedge-billed hummingbirds for their nectar but are not pollinated. Bird-pollinated orchids are not confined to the Americas but are less common in the Old World, where several species of *Dendrobium* in Malaysia and New Guinea are pollinated by sunbirds. In most cases of bird pollination, the orchid's pollinarium becomes stuck to the bird's bill. Recently, a mechanism has been reported in which pollinaria are transferred from orchid to orchid on the feet of birds (Johnson and Brown 2004). The orchids concerned are two species of *Disa* with densely packed flower spikes that are pollinated by sunbirds in southern Africa.

Deception is the order of the day among those orchids that offer no reward. We have already described the way in which some orchids are trap

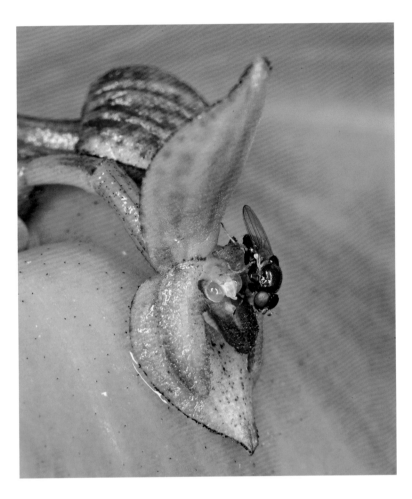

Figure 215. A miniature orchid (*Pleurothallis cordifolia*) being visited by a fly. Various species of *Pleurothallis* have been described as smelling of fish, rancid cheese, or dog feces.

orchids in different parts of the world. The orchids mimic female bees, wasps, or bristly tachinid flies (Tachinidae) and are pollinated when appropriate male insects attempt to mate with them. Pseudocopulation was first described in bee orchids, with over 30 species in Europe, North Africa, and the Middle East, each associated with a different solitary bee or wasp (fig. 216). The success of pseudocopulation is at least in part a result of the orchids

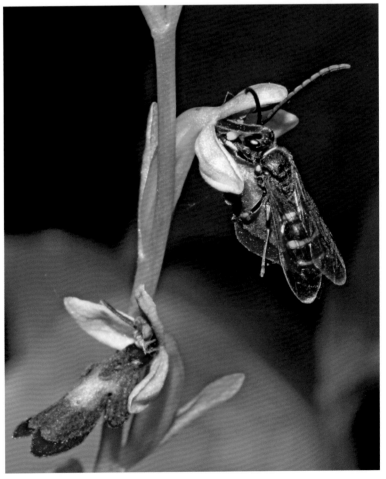

flowers and others mimic rotten meat, dung, or fungi and attract carrion or fungus flies looking for a place to lay their eggs (fig. 215). Perhaps the most remarkable examples of pollination by deception and mimicry involve pseudocopulation. This has evolved several times in unrelated groups of

Figure 216. The fly orchid (*Ophrys insectifera*) reproduces through pseudocopulation. The orchid mimics a female wasp, and here a male wasp (*Argogorytes mystaceus*) has been fooled into attempting to mate with it, thereby providing an opportunity for pollination to take place. Photo courtesy of Nick Owens.

Figure 217. This pseudocopulatory South American orchid (*Telipogon*) has a lip that mimics a bristly tachinid fly.

flowering when male bees and wasps are on the wing but before the females have emerged and are ready to mate. The timing is important because, given the choice, male bees and wasps do find females more attractive than the mimic orchids. The mimicry depends on sexual pheromones as well as visual and tactile signals involving shape, size, color, and texture. During attempted copulation, a pollinarium is attached to the pollinator in the hope that it will be transferred to another flower at the next attempted copulation. The mimicry is said to be species specific. Nevertheless, mistakes happen, and *Ophrys* hybrids are quite common.

Pseudocopulatory orchids also occur in Australia and tropical America. A great many Australian orchids in several genera are pollinated by a variety of wasps. Several species of tongue orchids (*Cryptostylis*) are pollinated by the ichneumon wasp (*Lissopimpla excelsa*), and various thynnid wasps (Thynnidae) pollinate hammer orchids (*Drakaea*), spider orchids (*Caladenia*), and others. Yet other hymenopterans (sawflies in the genus *Lophyrotoma*) pollinate duck orchids (*Caleana*). Again, the attraction is pheromonal as well as visual, and, unlike in the situation with *Ophrys*, natural hybrids are unknown. In tropical America, pseudocopulatory orchids in the genera *Telipogon* and *Trichoceros* mimic bristly tachinid flies (fig. 217).

Recently, a novel case of pheromone mimicry has been described in the Asian marsh helleborine (*Epipactis veratrifolia*). The orchid mimics the alarm pheromones of aphids, thereby attracting species of hoverfly whose larvae feed on aphids. Female hoverflies are deceived into laying their eggs on the orchid, but without aphids to eat, their hatchling larvae soon die. The hoverflies do, however, receive a small nectar reward in return for pollinating the orchid (Stoki et al. 2010).

Among the most complex orchids are those pollinated by tropical American orchid bees (Euglossinae). Both sexes of these fast-flying, long-tongued bees visit and pollinate many flowers, including nectar-producing orchids such as *Cattleya*, *Sobralia*, and others. Males are also attracted, often over great distances, by volatile, aromatic "perfumes" released by other orchids, notably a number of bizarre species in the genera *Stanhopea*, *Coryanthes*, *Gongora*, and *Catasetum*, that lack nectar or any other conventional reward (fig. 218). Male orchid bees visit the orchids to collect fragrances and store them as an "odor bouquet" in specialized matted fibers that form a "velvet patch" on their hind legs. The ways in which pollinaria are placed on the visiting bees are varied and often novel,

Figure 218. Male orchid bees (*Eulaema speciosa*) visiting and pollinating an orchid (*Acineta chrysantha*). The bees collect fragrances from the orchid, which they later modify to make sexual pheromones.

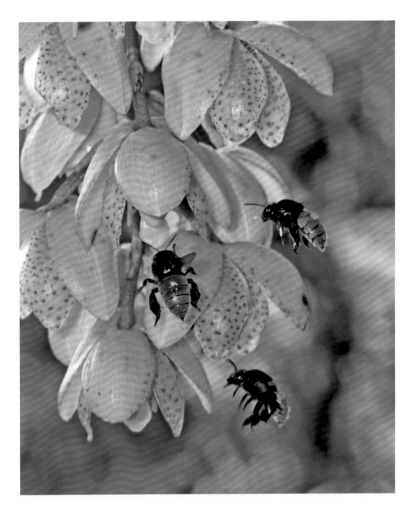

involving traps, slippery chutes, or even pollinaria being catapulted at bees with sufficient force to stun them. The pollinaria are glued to the bee with a quick-acting glue. Different orchids have different "perfumes" (figs. 219 and 220). Nevertheless, most species of orchid bees visit more than one species of orchid and frequently carry more than one type of pollinarium at a time. The efficacy of pollination is not usually impaired because different orchids place their pollinaria on different parts of the bee; at least 13 different locations have been described.

So what exactly do the orchid bees get out of this relationship? The precise function of the "odor bouquet" is unconfirmed, but it is thought that a mix of several hard-to-get substances provides a measure of a bee's competence and experience—an indicator to females of the male's suitability as a mate. A bee with an impressive, complex "odor bouquet" must have survived long enough to forage far and wide and probably has desirable genes. A male orchid bee's life is like some medieval "quest" in search of favors or trophies that have only symbolic value. It has also been suggested that the velvet patch on the male's hind leg is essentially a bag of mild poisons. In other words, the male is carrying a handicap—an "honest signal" to females of his superiority.

Seed dispersal. Though orchids are famous for their varied and complex pollination mechanisms, the

Figure 219. A male orchid bee (*Eulaema*) visiting an orchid (*Stanhopea wardii*). The bee already has a *Stanhopea* pollinarium attached to its thorax.

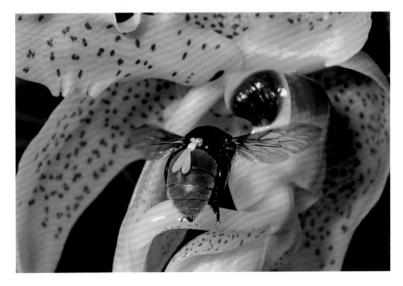

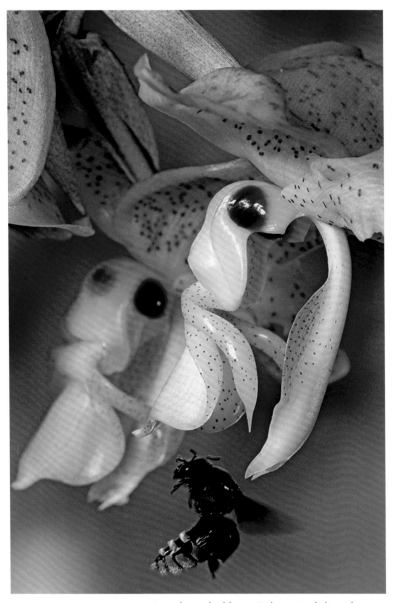

Figure 220. A male orchid bee (*Eulaema*) sliding down the slippery chute-like lip of a *Stanhopea wardii* flower and exiting the orchid. As it slides down the chute and falls, abdomen first, the orchid's structure ensures that it picks up a pollinarium, or, if the bee is already carrying one, that the pollinarium is detached and sticks to the stigma.

way in which their seeds are dispersed could hardly be simpler—in almost all species, the minute, dust-like seeds (as many as 250,000 per gram, or more than 7 million per ounce, and a staggering 3.7 million in a single seedpod of *Cycnoches chlorochilon*) are wind dispersed. *Vanilla* species are a rare exception in having seeds surrounded by a sweet pulp. Orchid bees (*Eulaema*) are attracted to the smell of the pods and sometimes pick up and carry off the seeds.

Because they lack nutrient resources, the dust-like seeds of orchids cannot germinate and grow without being associated with a symbiotic mycorrhizal fungus. The fungus must be present where the seed lands if it is to germinate. For many terrestrial orchids, the relationship is necessary throughout their life. For most epiphytic species, the relationship is necessary only until photosynthesis commences.

Given their complex interactions with pollinators and their dependence on mycorrhizal fungi for germination, both of which are seemingly chancy relationships, it is intriguing that orchids should have succeeded in becoming so much more diverse than almost all other families of plants.

PASSIFLORACEAE: *Passiflora* (Passion Flower Family)

The gorgeous blooms of passion flowers (*Passiflora*) are among the most ornate in the world. Most species are vines or lianas, and there are over 500 species worldwide, including 9 in the United States, and about 20 ranging from Southeast Asia through Australia to New Zealand. The majority of passion flowers, about 470 species, are found in the rain forests of Central and South America, though no more than a dozen or so occur in any one locality. The

flowers range in size from about 1 centimeter (0.4 inch) in diameter in the smallest species to 17 centimeters (7 inches) in *P. vitifolia* and to 15 centimeters (6 inches) long in *P. mixta*. The most striking feature of most passion flowers is the corona—a structure consisting of several rows of erect filaments that form a frill surrounding the nectary (fig. 221). The coronal frill excludes many undesirable visitors that might steal nectar without being effective pollinators.

Passion flowers are so called not because they have any aphrodisiacal properties, but rather because Spanish missionaries in South America saw in their elaborate structure symbols of Christ's Passion or crucifixion. They saw the five petals and five sepals of a typical species as symbolizing the apostles (excluding the disgraced Judas and Peter); the five anthers as the wounds Christ received on the cross; the three stigmas as the nails; the frilly corona as the crown of thorns; the calyx as the halo around Christ's head; and the tendrils (with which passion vines climb) as the whip with which Christ was scourged.

Passion vines and their flowers are of great interest because they are at the center of an intricate web of plant and animal interactions, involving herbivores, pollinators, and seed dispersers, that has been well studied by biologists, notably Lawrence Gilbert (1972, 1975) and his associates at the University of Texas at Austin.

While pollinators and seed dispersers have mutually beneficial relationships with plants, many other animals eat plants and can be very destructive. To protect themselves against herbivores, passion vines possess a range of toxic chemicals (cyanogenic glycosides and alkaloids) in their stems, leaves, and flowers. These chemical defenses are

Figure 221. An Ecuadorean passion flower (*Passiflora macrophylla*) showing its complex structure with five petals and five sepals, a corona forming a protective frill around the nectary, five stamens, and three styles.

extremely effective against almost all herbivores apart from a few coevolved specialist insects that feed on passion vines with impunity, and even store the toxins for their own defense against predators. This select group of insects includes the caterpillars of *Heliconius* butterflies, tiny flea beetles (Chrysomelidae), and flag-footed bugs (Coreidae).

All these insects have conspicuous warning colors—a signal to predators that they are distasteful and best left alone.

To combat these insects, passion vines have evolved additional defenses, though none are completely effective—passion vines and the insects that eat them are locked together in an "arms race" that neither has yet won. The additional defenses of passion vines include slow and irregular growth, so that the tender young shoots preferred by herbivorous insects are scarce and unpredictable. They also have a wide variety of leaf shapes, making it difficult for herbivores to develop search images. Some species have tiny yellow structures on their leaves that mimic butterfly eggs and induce female butterflies to move on and search for unoccupied shoots on which to lay their eggs. More widespread is the habit of enlisting the protection of ants and wasps. Passion vines attract ants and wasps with nectar produced in extrafloral nectaries—small nectar-producing cups on their bracts or leaves. In fact, almost every passion vine is the well-guarded property of an ant colony, though not all species of ants

make good guards. Some focus on the available nectar, which is rich in useful amino acids, and do little to protect vulnerable young shoots that lack well-developed nectaries. Other ant species patrol their vines aggressively (fig. 222). They harass large insects, making it difficult for them to feed or lay eggs, and systematically kill and remove any eggs or caterpillars they encounter. Many of the wasps are also predators of caterpillars and other larvae. Others are parasitic species that search the vines for insect eggs, larvae, or pupae in which to lay their own eggs.

Pollination. Bees or hummingbirds pollinate most passion flowers, though moths and bats interact with a few. In their color, smell (or lack of it), and complex structure, passion flowers fit conventional pollination syndromes. Hummingbird-pollinated passion flowers are invariably red and lack any odor. The gorgeous red blooms of *Passiflora vitifolia* grow in profusion in lowland rain forests in Costa Rica. They occur mainly in the forest understory and are intended for hermit hummingbirds, particularly long-tailed and bronzy hermits (*Phaethornis superciliosus* and *Glaucis aeneus*) (fig. 223). Being red, the flowers are inconspicuous to bees and most other insects. Also, a corona forms a stiff collar around the entrance to the nectary, hindering bees and other insects from getting at the nectar. On the other

Figure 222. A ponerine ant (*Ectatomma tuberculatum*) standing guard over the extrafloral nectaries on the bracts of a red passion flower (*Passiflora vitifolia*) in a rain forest in Costa Rica. In return for the nectar reward, ants patrol the passion vine and repel many insect herbivores and nectar robbers. In this case, the ant has not prevented a stingless bee from chewing a hole in the nectary.

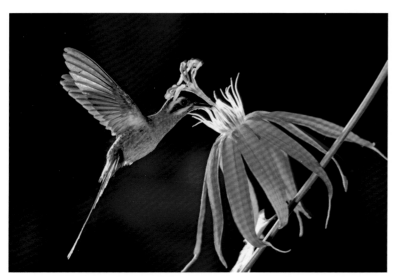

Figure 223. A long-billed hermit (*Phaethornis longirostris*) visiting a red passion flower (*Passiflora vitifolia*). Note the bird's crown in contact with one of the passion flower's anthers.

hand, a hummingbird hovering in front of a flower can easily insert its long, thin bill between or over the coronal filaments and into the nectary. Doing so brings the top of its head into contact with the anthers and stigmas, ensuring that pollination takes place.

The numerous bee-pollinated passion flowers are usually some shade of purple, blue, white, or yellow and have a distinctive scent that attracts bees or other insects. Although many bee-pollinated passion flowers have extrafloral nectaries, there are a few exceptions, notably the stinking passion flower (*Passiflora foetida*), a species with lovely delicate blue flowers and a very unlovely smell (fig. 224). The stinking passion flower has particularly effective chemical defenses that ensure that it is inedible to most herbivores, even starving horses. In addition, its flowers are protected by its finely branched floral bracts, which are covered with glandular hairs. The hairs exude sticky droplets that trap small herbivorous insects. The flowers open just before dawn, for just a few hours, and are promptly visited and pollinated by large *Ptiloglossa* and *Xylocopa* bees that alight on the landing platform provided by the corona. To reach the nectar chamber that surrounds the ovary, a visiting bee pushes under the anthers, probes the nectary with its tongue, and moves in a circle around the landing platform, extracting nectar. As it does so, it comes into contact with the anthers, and pollen is deposited on its back and wings.

Both hummingbird- and bee-pollinated passion flowers have an interesting mechanism that helps prevent self-pollination. The flowers last for only a day. When they first open, their anthers are curved downward so that they deposit pollen on visiting pollinators. Meanwhile, their styles and stigmas are upright, out of the way of visitors, and there is little chance of the flower's own pollen reaching the stig-

Figure 224. A stinking passion flower (*Passiflora foetida*) showing its protective floral bracts covered with glandular hairs that exude sticky droplets. The blue flowers are pollinated by bees.

mas. Only after half an hour or so do the styles bend downward, bringing the stigmas into contact with visiting pollinators. By then, most visitors are carrying pollen from other flowers, and the likelihood of cross-pollination is much enhanced.

Seed dispersal. Passion fruits have a tough, dry skin enclosing a mass of seeds embedded in gelatinous arils. The fruits are consumed by mammals and birds, depending on their size. *Passiflora alata* and *P. quadrangularis*, for example, have large egg-shaped fruits, about 10–15 centimeters (4–6 inches) long, that are chewed open by squirrels, monkeys, and other arboreal mammals. We have also seen collared peccaries (*Pecari tajacu*) feed on them after they have fallen to the ground. However, peccaries chew their food thoroughly and destroy most of the seeds they consume. Smaller fruits, 2–3 centimeters (ca. 1 inch) long, are swallowed whole by large frugivorous birds, such as quetzals, motmots, toucanets, cotingas, and jays (fig. 225). Several species of passion fruits are grown commercially for human consumption.

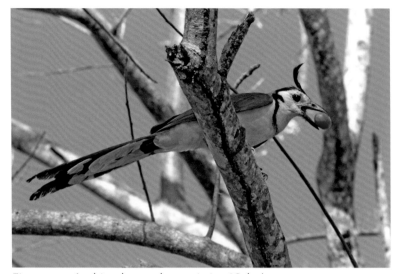

Figure 225. A white-throated magpie-jay (*Calocitta formosa*) with a passion fruit (*Passiflora foetida*) in its bill.

RUBIACEAE (Coffee and Quinine Family)

The Rubiaceae is a large, cosmopolitan, but predominantly pantropical family with a worldwide total of about 650 genera and 13,000 species, making it the fourth largest family of flowering plants. Totals for the Neotropics are 217 genera and more than 5,000 species. Vegetative forms include canopy trees, shrubs, lianas, herbs, and a few epiphytes. Shrubs are the more common form and are strongly represented in the understory and edges of Neotropical forests.

The family is the source of several important products used by humans, most notably coffee derived from shrubs found in northern Africa. Coffee is said to be, after oil, the second most important traded commodity, ahead of natural gas, gold, and wheat, providing employment for more than 25 million people.

The Rubiaceae is also the source of many alkaloids used as natural medicines, poisons, and hallucinogens. Quinine is the most widely used and useful of these alkaloids. It is derived from the bark of several Neotropical species of *Cinchona* and *Ladenbergia*. For about 300 years, before synthetic drugs were developed in the 1940s, quinine was the only remedy for malaria, the greatest killer in the history of humankind. Malaria is still a major cause of mortality. Estimates vary widely, but the number of cases of malaria is in the region of 200–300 million per year, resulting in up to a million deaths. Perhaps 90 percent of the deaths occur in Africa, and about 65 percent are of children less than 15 years old. New strains of malaria that are resistant to modern synthetic drugs are now evolving, so varieties of natural quinine may well regain their importance in the future.

The family is also the source of many ornamental shrubs and trees prized for their showy flowers or sweet, intoxicating odors. Examples include species of *Gardenia, Bouvardia, Ixora,* and *Warszewiczia.*

Pollination. Rubiaceous flowers are mostly bisexual and radially symmetrical. Many species (e.g., *Gardenia, Guettarda, Posoqueria*) have fragrant, white, tubular flowers that are pollinated by moths. The needle flower (*Posoqueria latifolia*) has an interesting way of getting pollen onto a visiting moth, first noted by the celebrated naturalist explorer Fritz Müller. Its long, white, tubular flowers open at dusk, emitting a sweet fragrance that attracts hawkmoths. Once open, the flowers expose five stamens (fig. 226). The five stamen filaments supporting the anthers arch

together under tension, while the anthers themselves are joined together, forming a narrow cone. They remain in this position until triggered by the delicate touch of a hawkmoth inserting its tongue into the corolla. The cluster of anthers then springs apart explosively and the central, lowermost stamen rams a mass of pollen onto the hawkmoth.

In the tropics, numerous plants belonging to the butterfly pollination syndrome attract butterflies with red flowers or flowers with additional red structures such as bracts or calyxes. A few rubiaceous species, including hot lips (*Psychotria*) and *Warszewiczia coccinea,* are good examples (fig. 227). Hot lips has small white flowers surrounded by a pair of red liplike bracts, while *Warszewiczia* has inconspicuous yellow flowers and enlarged red calyx

Figure 226. Needle flowers (*Posoqueria latifolia*) have a long white corolla and emit a sweet fragrance that attracts hawkmoths at dusk. Each flower has five stamen filaments that are connected and under tension (flower to right). When triggered by a moth, the anthers part explosively (flower to left), ramming pollen onto the moth.

Figure 227. In the tropics many butterfly flowers have conspicuous red bracts or other structures to help attract pollinators. The red calyx lobes of *Warszewiczia coccinea* are typical and naturally attract small hummingbirds as well as butterflies. In this case, the hummingbird is a male snowcap (Microchera albocoronata).

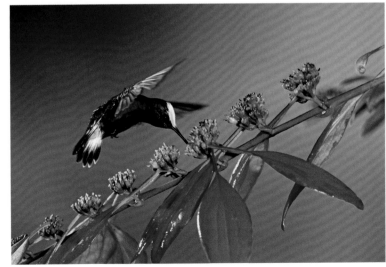

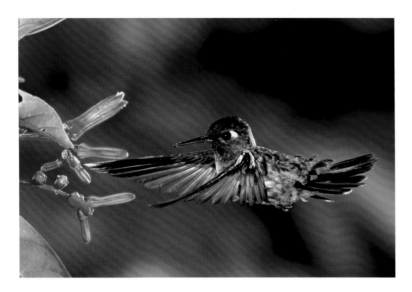

Figure 228. In the Caribbean lowlands of Costa Rica, the firebush (*Hamelia patens*) attracts many hummingbirds, including this violet-headed hummingbird (*Klais guimeti*).

familiar goosegrass or cleavers has fruits that are covered with hooked hairs that catch on the fur (or clothes) of passing mammals.

Edible fruits are all that concern us here and include species that vary widely in palatability. Many rubiaceous shrubs and small trees (e.g., *Hamelia*, *Guettarda*, and *Palicourea*) have a bountiful crop of smallish berries, about 1 centimeter (0.4 inch) in diameter, that are popular mostly with small frugivorous birds such as thrushes and tanagers (fig. 229). *Psychotria uliginosa* has similar berries that are less readily available. The berries remain red and unripe for months, advertising their presence, but ripen

Figure 229. Wintering summer tanagers (*Piranga rubra*) are common in Costa Rica. This male is eating a berry of a firebush (*Hamelia patens*), a species that is popular with many birds, including flycatchers, thrushes, and tanagers.

lobes. Both species inevitably attract small hummingbirds, such as snowcaps and green thorntails, as well as butterflies.

The firebush (*Hamelia patens*), which ranges from the southern United States to Argentina, has a typical orange-red tubular hummingbird flower that secretes plenty of nectar. In the Caribbean lowlands of Costa Rica, we have seen a thicket of firebush attract six or seven short-billed hummingbirds most mornings and many more over a period of days or weeks (fig. 228).

Despite their rather insignificant appearance, the flowers of the shrub *Gonzalagunia rosea* are popular with a surprisingly diverse selection of visitors. The fragrant pinkish flowers with a short, tubular corolla are attractive to small hummingbirds as well as bees, butterflies, and other small insects, many of which may be effective pollinators. The flowers of *Cinchona* (see chapter 3) are rather similar and they, too, attract small hummingbirds as well as insects.

Seed dispersal. Rubiaceous fruits are quite varied, including edible drupes and berries, and capsules that open to expose wind-dispersed seeds. The

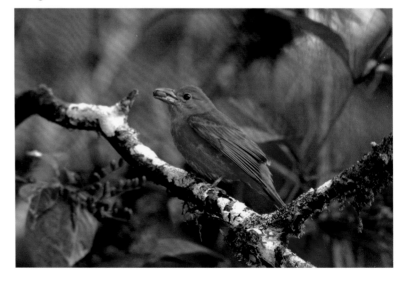

and turn black only at long intervals, one at a time. They are then quickly taken. In Costa Rica, they are popular with migrant wood thrushes (*Hylocichla mustelina*). The berries of *Palicourea demissa* are much bulkier (15–18 millimeters or 0.6–0.7 inch in diameter) and are preferred by bigger, more specialized frugivorous birds, including toucanets, Andean cocks-of-the-rock, scaled fruiteaters, and olivaceous pihas.

Among the least popular rubiaceous fruits are various white or blue berries that have a dry, Styrofoam-like consistency. In the mountains of northern Costa Rica, for example, the white berries of *Gonzalagunia rosea* are available for at least 8–9 months of the year but are seldom eaten except around November–January, when other fruits are usually scarce (fig. 230). At this time of year, many frugivorous birds, including blue-throated toucanets (*Aulacorhynchus caeruleogularis*) and black-faced solitaires (*Myadestes melanops*), the two most important seed dispersers in the area, leave the cloud forest and move to lower altitudes. At these times, *Gonzalagunia* berries are eaten by the few frugivorous birds that remain, mainly black guans (*Chamaepetes unicolor*), prong-billed barbets (*Semnornis frantzii*), and common bush-tanagers (*Chlorospingus flavopectus*). The strategy of *Gonzalagunia rosea* seems to be to invest minimal resources in individual berries but ensure that some are available for most of the year, covering any periods when preferred fruits happen to be scarce or lacking. Some other rubiaceous fruits have similar characteristics; for example, several species have lurid blue fruits, such as *Psychotria hazenii*, *P. brachiata*, and *P. pilosa*.

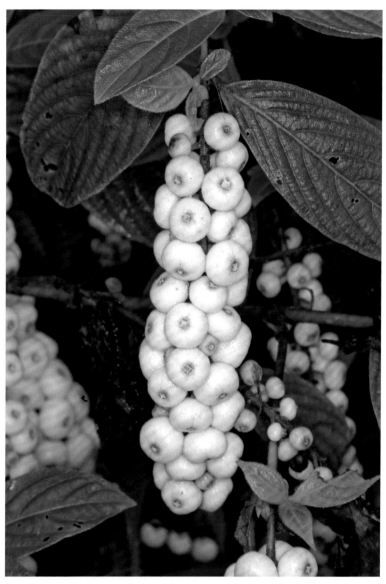

Figure 230. The fruits of *Gonzalagunia rosea* are not at all appetizing and are seldom taken unless more popular choices are unavailable. Most end up on the ground uneaten.

SIPARUNACEAE: *Siparuna*

This is a small family containing only two genera, one of which, *Siparuna*, is confined to the Neotropics. The single species in *Glossocalyx* occurs in forests in West Africa. There are at least 60 species of *Siparuna*, most of them shrubs and small trees. They occur in wet or moist forests from southern Mexico and the West Indies through northern South America to Bolivia and Paraguay, reaching their highest diversity in cloud forests in the Andes of Colombia, Ecuador, and Peru. All members of the family are easily recognized by the strong, aromatic, lemony smell of their crushed leaves and fruits.

Pollination. *Siparuna* plants can be monoecious or, more often, dioecious. The unisexual flowers are yellow to orange (or red in early fruiting stages) and lack obvious petals. The stamens and stigmas are enclosed inside a globular receptacle and are accessible only through a small pore in the floral roof. Receptive *Siparuna* flowers have a pungent, lemony scent that attracts gall midges (Cecidomyiidae), which use the flowers as brood sites (Feil and Renner 1991; Feil 1992). The midges, which are 2–3 millimeters (0.08–0.12 inch) long, are the only pollinators of *Siparuna* flowers. After emerging from pupae, female midges wait for nightfall to fly off, mate, and locate a flower in which to lay eggs (fig. 231). After alighting on a flower, a female inserts her abdomen into the pore at its center, remaining there for a minute or two while she lays an egg. When a male flower is visited, pollen grains become lodged among the hairs on the midge's abdomen and are available to be transferred to any female flowers that are visited later. Midge larvae develop rapidly in the flowers—some may complete their development while the flower remains on the tree, though others emerge from older flowers that have fallen

re 231. *Siparuna* flowers are pollinated exclusively by gall midges (Cecidomyiidae) that use the flowers as a brood site. Here a female gall midge (probably *Asynapta*) has just emerged from its pupa.

to the ground. Many more midges emerge from male flowers than from female flowers, suggesting that female flowers are inferior brood sites, or that female flowers containing larvae often abort. We have records of at least six midges emerging from a single male flower, though one or two is more typical.

Seed dispersal. The fleshy fruits of *Siparuna* are yellowish or reddish, splitting open (dehiscing) when ripe to expose drupelets with a red or orange aril (fig. 232). The nutritious, fat-rich arils are popular with diverse birds, which swallow and later defecate the seeds. In most *Siparuna* species the fruits hang below the underside of branches and, once open, are easily accessible only to specialist birds that habitually hover glean, notably *Mionectes* flycatchers and manakins. However, *Siparuna* often grows in edge situations, tangled with other vegetation. In such places, the fruits are often accessible to birds perched in adjoining vegetation and are then popular with assorted vireos, honeycreepers, tanagers, saltators, and other species.

SOLANACEAE (Potato and Tobacco Family)

The Solanaceae is an economically important family with an almost worldwide distribution, comprising about 95 genera and 2,200 species. The family is most diverse in tropical America, where it is represented by 63 genera (many of which are endemic) and almost 1,600 species. These species totals are very approximate and are based on a conservative total of about 1,200 species for *Solanum*. Estimates for *Solanum* by different authorities diverge widely, from about 1,000 species to over 2,000.

Solanaceous plants include herbs, vines, epiphytes, shrubs, and trees. They are found in most habitats, including the driest deserts and wettest forests. Noteworthy members of the family include the potato (*Solanum tuberosum*), native to the Andes of Peru and Bolivia (and, by weight, the fourth most important food plant in the world), and other well-known food plants, including the eggplant or aubergine (*S. melongena*), tomato (*S. esculentum*), and chil-

Figure 232. Fruits of *Siparuna* split open to expose tiny drupelets with a red aril. The dangling arils are accessible mainly to small frugivorous birds that hover glean, such as *Mionectes* flycatchers and manakins.

ies (*Capsicum*). The Solanaceae is also the source of tobacco (*Nicotiana tabacum*), apparently a hybrid of two wild species of *Nicotiana* that dates from pre-Columbian times, and numerous alkaloids used for medical purposes and as hallucinogens. Species of *Brugmansia* contain scopolamine, which, notably in Ecuador and Colombia, is sometimes used by criminals to incapacitate people. It is used to spike drinks or is smeared on car door handles. Several Neotropical species are used as ornamentals, including angel's trumpets, yesterday-today-and-tomorrow, sapphire flowers (*Browallia*), petunias (*Petunia*), and marmalade bush (*Streptosolen jamesonii*). Both yesterday-today-and-tomorrow and marmalade bush have flowers that change color, indicating that they have been pollinated and no longer

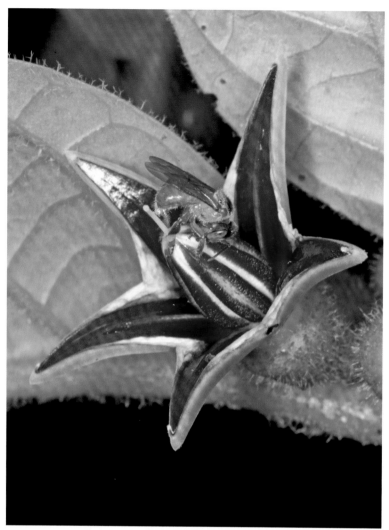

Figure 233. Many solanaceous flowers, such as *Lycianthes sanctaeclarae*, lack a nectar reward and are buzz pollinated by bees seeking pollen. The stamens often form a central cone that is grasped by the bees, in this case a stingless bee.

secrete nectar. Another popular ornamental, the Chinese lantern plant (*Physalis alkekengi*), is found from southern Europe to Japan.

Pollination. Solanaceous flowers are extremely variable in shape, size, and color, depending on the pref-

erences of their pollinators, which include small generalized insects, bees, butterflies, moths, hummingbirds, and nectarivorous bats.

The flowers of *Solanum, Lycianthes,* and *Lycopersicon* lack a nectar reward and are buzz pollinated by bees collecting pollen. Most are fairly small, but flower colors are varied—blue, pink, yellow, and white being common. Many have their stamens in a central, cone-shaped group that bees grasp while buzzing (fig. 233).

Other solanaceous flowers provide nectar for pollinators. Hollowheart has fragrant white flowers in clusters of 30 or more. Their tubular corolla is short enough to be exploited by stingless bees, other small insects, and occasionally small hummingbirds. Hollowheart flowers repeatedly through the year, often on branches still offering both unripe and ripe berries from previous flowerings.

Iochroma, with about 25 species in the Andes of South America, is closely related to *Acnistus.* Species of *Iochroma* have showy, tubular flowers. Several species with a long corolla fit the classic hummingbird pollination syndrome, being red and lacking a scent. Others are shorter and scented and are visited by insects. A few species have a mixture of characters. For example, *I. calycinum,* often called witches' fingers, is unusual in having long, purplish-blue flowers that produce copious nectar. They are popular with long-billed hummingbirds such as incas, even though purplish blue is a rather atypical color for a hummingbird flower (fig. 234).

Brugmansia is another solanaceous genus with

Figure 234. Many species of *Iochroma* have long, tubular flowers that are pollinated by long-billed hummingbirds. Here a collared inca (*Coeligena torquata*) is visiting blue flowers of *I. calycinum.*

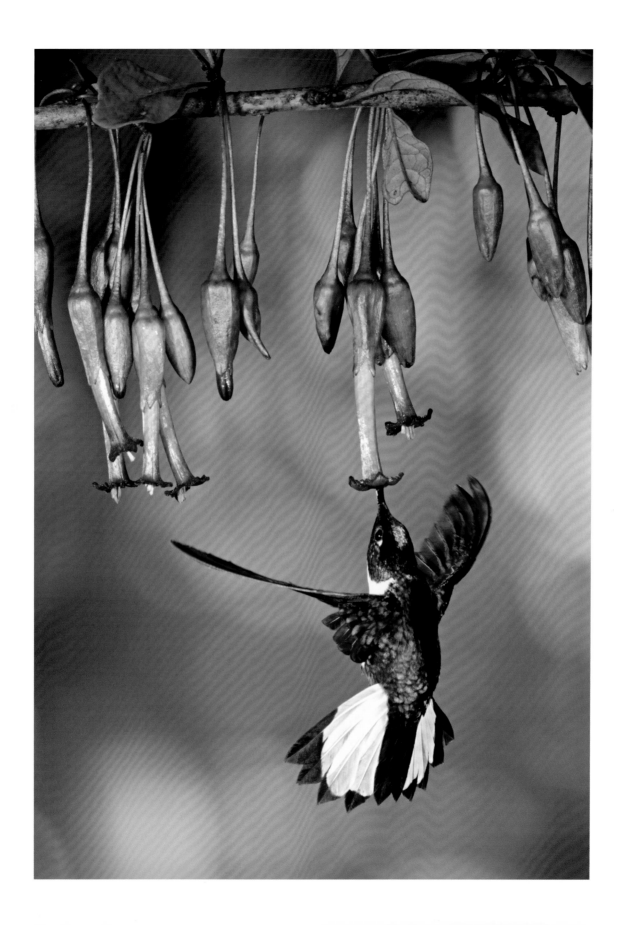

different flower types that attract different pollinators. Their huge, pendulous flowers, often called angel's trumpets, can be 30 centimeters (12 inches) long or more, and 20 centimeters (8 inches) wide at the mouth of the trumpet, and most come in pastel shades of white, cream, orange, or pink. They bloom at night and have a pleasant fragrance that attracts nocturnal hawkmoths. Two species—*B. sanguinea* and *B. vulcanicola*—fit the hummingbird pollination syndrome. They are red, lack any scent, and are visited by sword-billed hummingbirds and incas.

The Solanaceae also includes several plants with robust, bell-shaped, pendent flowers, often dangling on long petioles, that bloom at night and attract nectarivorous bats. They include species of *Trianaea* and *Merinthopodium* (formerly *Markea*) that flower continuously for weeks or months, opening a few flowers each night. The flowers open at dusk and last just one night.

Seed dispersal. In some solanaceous plants the fruit is a dehiscent capsule, as in *Brugmansia* and *Datura*, but in most it is a berry, examples being tomatoes, cape gooseberries (*Physalis peruviana*), tomatillos (*Physalis philadelphica*), and wolfberries (*Lycium barbarum*).

Here we are concerned only with various small berries (*Acnistus*, *Witheringia*, and *Solanum*) that are popular with small frugivorous birds or bats, in spite of seeming watery and not particularly nutritious. They often fill a major part of the diet of small frugivorous birds such as manakins, thrushes, and tanagers, and it seems likely they must provide trace elements that are rare elsewhere.

Figure 235. As well as piercing flowers to steal nectar, flowerpiercers pierce fruits to obtain juice. This masked flowerpiercer (*Diglossa cyanea*) is piercing a hollowheart berry (*Acnistus arborescens*).

In our garden in Ecuador, the most popular of these is hollowheart, a small tree that flowers and fruits simultaneously for much of the year. Its fruits are small orange berries (7–9 millimeters or 0.3–0.4 inch in diameter) that develop and ripen in five to six weeks. They are taken eagerly by at least 52 species of frugivorous birds, ranging in size from wattled guans (*Aburria aburri*) and band-tailed pigeons to a host of smaller flycatchers, thrushes, and tanagers, and often attract 20–30 species within just a few hours. No other fruits in the area are so universally popular, and they are clearly taken in preference to other popular small fruits, including figs,

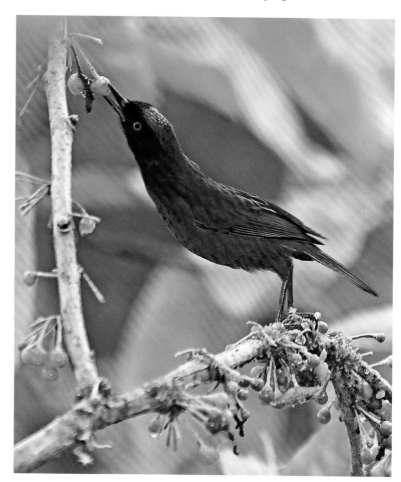

Figure 236. The fruits of *Witheringia* have laxative properties that hasten the passage of seeds through a bird's gut.

in diameter) are routinely taken before they are fully ripe (see chapter 10). Whenever they are overlooked and allowed to ripen, they are also popular with many birds, including guans, toucanets, flycatchers, silky-flycatchers, jays, and others (fig. 237).

melastomes (*Miconia*), and elderberries. They are also one of a few berries that are regularly pierced by hummingbirds (at least four species) and flower-piercers for the sake of their juice (fig. 235).

The fruits of *Witheringia* species are rather similar to those of hollowheart and are also popular with small frugivorous birds. *Witheringia* fruits have been studied in Costa Rica (Murray et al. 1994) (fig. 236). The fruits apparently contain a laxative chemical that speeds up the passage of seeds through the gut of one of its most important dispersers, the black-faced solitaire (and presumably other small frugivorous birds). There are positive and negative consequences for the seed dispersal of *Witheringia*—seeds that are defecated quickly spend less time in the bird's digestive tract and are more likely to germinate successfully. On the other hand, they are likely to be dispersed a shorter distance.

The fruits of many species of *Solanum* are very popular with fruit bats, such as the highland yellow-shouldered bat (*Sturnira ludovici*). In Costa Rica, fruits of *Solanum chrysotrichum* and *S. aphyodendron* (both about 12–18 millimeters or 0.5–0.7 inch

Figure 237. *Solanum* fruits are often taken by bats while still unripe. If they are allowed to ripen, they are also popular with birds, including this long-tailed silky-flycatcher (*Ptilogonys caudatus*).

GLOSSARY

abiotic pollination—Pollination involving wind or water, not an animal.

achene—A small, dry, indehiscent, one-seeded fruit.

actinomorphic—Having radial symmetry.

agamospermy—Asexual reproduction in which seeds are produced from unfertilized ovules.

aggregate fruit—A fruit formed when carpels coalesce; for example, a raspberry.

androecium—The collective term for a flower's stamens.

angiosperm—A plant that produces seeds inside flowers.

anther—The part of a stamen that manufactures and releases pollen.

aril—A fleshy, edible appendage or covering on a seed, often colorful to attract seed dispersers.

autogamy—Self-fertilization.

berry—A soft, often juicy, indehiscent fruit containing multiple seeds; for example, a blueberry or black currant.

bisexual—A flower with both male and female reproductive structures, including stamens and an ovary; the same as perfect or hermaphrodite.

bract—A modified leaf at the base of a flower, usually with a protective or advertising function.

buzz pollination—Pollination in which a bee clings to a flower and vibrates its indirect flight muscles, causing pollen to be released from the anthers.

calyx—A collective name for the sepals.

capsule—A dry fruit consisting of several segments that split open (dehisce) to expose many seeds.

carpel—A component of the female reproductive system, made up of an ovary, style, and stigma; one or more carpels form a pistil.

cauliflory—The production of flowers on the trunk or bare branches of a tree.

cleistogamy—Automatic self-fertilization, often without the flower opening.

clone—Here refers to a population of plants that are produced asexually and are genetically identical to their common ancestor.

conspecific—Belonging to the same species as another.

corolla—A collective name for the petals.

corona—A structure between the petals and stamens, derived from either; for example, a frill in passion flowers, or the trumpet-like structure in daffodils.

cross-pollination—Movement of pollen from the stamens of one flower to the stigma of a genetically distinct flower.

deceit pollination—The attraction of pollinators without the provision of a genuine reward.

dehiscence—The splitting open of dry fruits to display seeds, or of anthers to release pollen.

diaspore—A plant dispersal unit, usually a seed or a whole fruit; for example, a coconut or bur.

dichogamy—Refers to flowers in which pollen is released, and stigmas are receptive, at different times (see protandrous and protogynous).

dicots—Short for dicotyledons; one of the two groups of flowering plants, this one being characterized by having two embryonic seed leaves at germination (see monocots).

dioecious—Having male (staminate) and female (pistillate) flowers on separate plants (see monoecious).

drupe—A fleshy one-seeded fruit that does not dehisce; for example, a plum or cherry.

elaiophore—An oil- or lipid-producing gland in a plant.

elaiosome—An oily food body attached to seeds that attracts ants as seed dispersers.

epiphyte—A plant that grows on another plant.

ester—An organic compound found in floral fragrances.

extrafloral nectary—A structure outside a flower that secretes nectar and attracts ant guards; for example, on the bracts of some passion flowers.

follicle—A dry dehiscent fruit formed from a single carpel.

frugivore—An animal that eats fruit.

gymnosperm—A seed plant lacking flowers; for example, a conifer, cycad, etc.

gynoecium—The collective term for the female organs of a flower, composed of a pistil or pistils, containing carpels with ovules and a terminal stigma.

heliotropism—Diurnal or seasonal motion of a flower so as to face the sun.

hemiepiphyte—A plant that begins life as an epiphyte but later develops aerial roots that descend to the ground.

hemiparasite—A plant that photosynthesizes but also extracts nutrients from its host.

heterostyly—Having two or three different style lengths in different individual flowers.

inbreeding—Reproduction between genetically related individuals.

indehiscent—Refers to fruits that remain closed when ripe.

inflorescence—A cluster of flowers, usually forming a functional unit in terms of the attraction of pollinators.

instar—A developmental stage of an insect or other arthropod between molts.

maxillae—A pair of mouthparts in an insect.

monocots—Short for monocotyledons; one of the two groups of flowering plants, this one being characterized by having a single seed leaf at germination (see dicots).

monoecious—Having separate male (staminate) and female (pistillate) flowers on the same plant (see dioecious).

multiple fruit—A fruit formed from multiple ovaries; for example, a pineapple.

mycorrhiza—A symbiotic relationship between a fungus and the roots of a plant.

nectar—A watery secretion containing sugars and other nutrients.

nectar guide—A contrasting pattern on flower petals that indicates the location of nectaries.

nectary—A structure or tissue that secretes nectar.

New World—The Americas, including the islands in the Caribbean and other offshore islands.

Old World—The part of the world known before the European discovery of the Americas, comprising Europe, Asia, and Africa; used in contrast with the New World (the Americas).

ostiole—The opening into the interior of a fig syconium.

outbreeding—Breeding between individuals that are not closely related.

ovary—Female organ at the base of a pistil that contains the ovules.

ovule—Female organ that becomes a seed after fertilization.

perfect—See bisexual.

perianth—Collective term for the calyx and corolla.

petal—A sterile segment of the corolla, often colored or scented.

pheromone—A volatile chemical released by one organism that influences the behavior of another.

pistil—A structure formed when a flower's carpels are fused together to resemble a single, giant carpel.

pistillate—A unisexual flower with a functional pistil but without functional stamens.

pollinarium—The pollen-bearing structure of orchids that is attached to insects during pollination; composed of a viscidium, stipe, and pollinia.

pollination syndrome—A suite of flower characters that match the characteristics of appropriate pollinators.

pollinium—An aggregate mass of pollen grains that are transferred during pollination as a single unit; characteristic of orchids and milkweeds.

protandrous—Refers to a flower in which the stamens release pollen and wither before the stigma is receptive.

protogynous—Refers to a flower in which the stigma is receptive before pollen is released.

pseudobulb—A bulb-like swelling of orchid stems that stores nutrients and water.

pseudocopulation—A form of pollination brought about by deceit; male insects attempt to mate with a flower that resembles a female of the species in some important way, visually or by odor.

pyrrolizidine alkaloid—Toxic protective chemical in plants that specialized insects collect and use for their own defense.

raceme—An unbranched inflorescence with the flowers borne on short stalks. The uppermost flowers are the youngest.

receptacle—The expanded top of a flower stalk just below the flower.

samara—An indehiscent winged fruit.

scopa—A storage area for the pollen that bees groom from their body and carry to their nest; it can be on their legs or thorax, or under their abdomen.

seed dispersal syndrome—A suite of fruit characters that match the characteristics of appropriate seed dispersers.

self-pollination—Pollination with pollen from the same flower or same plant.

sepal—A segment of the calyx.

sonication—See buzz pollination.

spadix—A spikelike inflorescence of small flowers on a fleshy stem; for example, the inflorescence of aroids.

spathe—A sheathlike bract that surrounds a spadix.

stamen—A male flower organ composed of a filament and a pollen-bearing anther.

staminate—A unisexual flower with functional stamens but without a functional pistil.

staminode—A sterile stamen, often visually attractive and providing a food reward to potential pollinators.

stigma—The terminal portion of a carpel or pistil where pollen is received.

stigmatic exudate—Sticky fluid on a stigma that is involved in pollen reception; sometimes becomes a reward for small pollinating insects.

stipe—In orchids, a stalk connecting pollinia to the viscidium.

strangler—A plant that begins life as an epiphyte but later develops aerial roots that descend to the ground, surround the host plant, and eventually kill it.

style—The slender stalk that connects the ovary to the stigma.

syconium (plural syconia)—A hollow, fruit-like structure, lined inside with tiny flowers; characteristic of figs.

sympatric—Refers to species that have overlapping ranges.

tepal—Refers to sepals and petals that resemble each other.

terpenoid—An organic compound with defensive functions in flowers; also found in floral fragrances.

trichilium (plural trichilia)—A dense pad of hairlike outgrowths on the petiole of some species of *Cecropia*; produces Müllerian bodies as food for ants.

umbel—A flattish-topped inflorescence with the flowers on many short stalks emanating from a central point.

viscidium—In orchids, a sticky pad that serves to attach a pollinarium to a pollinator.

viscin—A sticky substance surrounding the seeds of some plants; for example, mistletoes.

zygomorphic—Having bilateral symmetry.

REFERENCES

We have not included a comprehensive set of references to the enormous amount of work that has been done on pollination and seed dispersal. We have restricted the reference list to several general sources and to studies that we have found most relevant to the content of our book. Between them, the included references are more than adequate to guide interested readers to the rest of the literature. The books by Endress; Proctor, Yeo, and Lack; van der Pijl; and Willmer are particularly comprehensive.

Ågren, J., and D. W. Schemske. 1991. Pollination by deceit in a neotropical monoecious herb, *Begonia involucrata*. *Biotropica* 23:235–41.

Anderson, J. T., J. S. Rojas, and A. S. Flecker. 2009. High-quality seed dispersal by fruit-eating fishes in Amazonian floodplain habitats. *Oecologia* 161:279–90.

Armstrong, J. E., and A. K. Irvine. 1990. Functions of staminodia in the beetle-pollinated flowers of *Eupomatia laurina*. *Biotropica* 22:429–31.

Baker, H. K., and I. Baker. 1975. Studies of nectar constitution and plant-pollinator coevolution. In *Coevolution of Animals and Plants*, edited by L. E. Gilbert and P. H. Raven, 100–140. Austin: University of Texas Press.

Bawa, K. S. 1985. Reproductive biology of tropical lowland rain forest trees. II. Pollination systems. *American Journal of Botany* 72 (3):346–56.

———. 1990. Plant-pollinator interactions in tropical rain forests. *Annual Review of Ecology, Evolution, and Systematics* 21:399–422.

Bernhardt, P. 1999. *The Rose's Kiss: A Natural History of Flowers*. Washington, DC: Island Press.

———. 2000. Convergent evolution and adaptive radiation of beetle-pollinated angiosperms. *Plant Systematics and Evolution* 222:293–320.

Birkinshaw, C. 2001. Fruit characteristics of species dispersed by the black lemur (*Eulemur macaco*) in the Lokobe Forest, Madagascar. *Biotropica* 33 (3):478–86.

Blake, S., S. L. Deem, E. Mossimbo, F. Maisels, and P. Walsh. 2009. Forest elephants: Tree planters of the Congo. *Biotropica* 41:459–68.

Buchmann, S. L. 1987. The ecology of oil flowers and their bees. *Annual Review of Ecology, Evolution, and Systematics* 18:343–69.

Burkle, L. A., J. C. Marlin, and T. M. Knight. 2013. Plant-pollinator interactions over 120 years: Loss of species, co-occurrence, and function. *Science* 339:1611–15. doi:10.1126/science.1232728.

Cook, J. M., and J.-Y. Rasplus. 2003. Mutualists with attitude: Coevolving fig wasps and figs. *Trends in Ecology and Evolution* 18 (5):241–48.

Corbet, S. A. 2006. A typology of pollination systems: Implications for crop management and the conservation of wild plants. In *Plant-Pollinator Interactions: From Specialization to Generalization*, edited by N. M. Waser and J. Ollerton, 315–40. Chicago: University of Chicago Press.

Darwin, C. 1862. *The Various Contrivances by Which Orchids Are Fertilised by Insects*. London: John Murray.

da Silva, H. R., M. C. de Britto-Pereira, and U. Caramaschi. 1989. Frugivory and seed dispersal by *Hyla truncata*, a neotropical treefrog. *Copeia* 3:781–83.

Dellinger, A. S., D. S. Penneys, Y. M. Staedler, L. Fragner, W.

Weckwerth, and J. Shönenberger. 2014. A specialized bird pollination system with a bellows mechanism for pollen transfer and staminal food body rewards. *Current Biology* 24 (14):1615–19.

Dressler, R. L. 1981. *The Orchids: Natural History and Classification.* Cambridge, MA: Harvard University Press.

du Toit, J. T. 1990. Giraffe feeding on *Acacia* flowers: Predation or pollination? *African Journal of Ecology* 28:63–68.

Endara, L., D. A. Grimaldi, and B. A. Roy. 2010. Lord of the flies: Pollination of *Dracula* orchids. *Lankesteriana* 10 (1): 1–11.

Endress, P. K. 1994. *Diversity and Evolutionary Biology of Tropical Flowers.* Cambridge: Cambridge University Press.

Feil, J. P. 1992. Reproductive ecology of dioecious *Siparuna* (Monimiaceae) in Ecuador—a case of gall midge pollination. *Botanical Journal of the Linnean Society* 110:171–203.

Feil, J. P., and S. S. Renner. 1991. The pollination of *Siparuna* (Monimiaceae) by gall-midges (Cecidomyiidae): Another likely ancient association. *American Journal of Botany* 78:186.

Feinsinger, P., and R. K. Colwell. 1978. Community organization among neotropical nectar-feeding birds. *American Zoologist* 18:779–95.

Garibaldi, L.A., I. Steffan-Dewenter, R. Winfree, M. A. Aizen, R. Bommarco, S. A. Cunningham, C. Kremen, et al. 2013. Wild pollinators enhance fruit set of crops regardless of honey bee abundance. *Science* 339 (6127): 1608–11. doi:10.1126/science.1230200.

Gentry, A. H. 1983. *Tabebuia ochracea* ssp. *neochrysantha* (guayacán, corteza, cortes, corteza amarilla). In *Costa Rican Natural History*, edited by D. H. Janzen, 335–36. Chicago: University of Chicago Press.

Gilbert, L. E. 1972. Pollen feeding and reproductive biology of *Heliconius* butterflies. *Proceedings of the National Academy of Sciences, USA* 69:1403–7.

———. 1975. Ecological consequences of coevolved mutualisms between butterflies and plants. In *Coevolution of Animals and Plants*, edited by L. E. Gilbert and P. R. Raven, 210–40. Austin: University of Texas Press.

Givnish, T. J., E. L. Burkhardt, R. E. Happel, and J. D. Weintraub. 1984. Carnivory in the bromeliad *Brocchinia reducta*, with a cost/benefit model for the general restriction of carnivorous plants to sunny, moist, nutrient-poor habitats. *American Naturalist* 124:479–97.

Goldwasser, L. 2000. Scarab beetles, elephant ear (*Xanthosoma robustum*), and their associates. In *Monteverde: Ecology and Conservation of a Tropical Cloud Forest*, edited by N. M. Nadkarni and N. T. Wheelwright, 268–71. New York: Oxford University Press.

Haber, W. A. 1983. *Hylocereus costaricensis* (pitahaya sylvestre, wild pitahaya). In *Costa Rican Natural History*, edited by D. H. Janzen, 252–53. Chicago: University of Chicago Press.

Haber, W. A., and G. W. Frankie. 1982. Pollination of *Luehea* (Tiliaceae) in Costa Rican deciduous forest. *Ecology* 63:1740–50.

Hallwachs, W. 1986. Agoutis (*Dasyprocta punctata*), the inheritors of guapinol (*Hymenaea courbaril*: Leguminosae). In *Frugivores and Seed Dispersal*, edited by A. Estrada and T. H. Fleming, 285–304. Dordrecht, Netherlands: Junk.

Hamilton, W. D. 1979. Wingless and fighting males in fig wasps and other insects. In *Reproduction, Competition and Selection in Insects*, edited by M. S. Blum and N. A. Blum, 167–220. New York: Academic Press.

Hansen, D. M., K. Beer, and C. B. Müller. 2006. Mauritian coloured nectar no longer a mystery: A visual signal for lizard pollinators. *Biology Letters* 2:165–68.

Hartshorn, G. S. 1983. Plants, introduction. In *Costa Rican Natural History*, edited by D. H. Janzen, 118–57. Chicago: University of Chicago Press.

Hawthorn, L. R., G. E. Bohart, and E. H. Toole. 1956. Carrot seed yield and germination as affected by different levels of insect pollination. *Proceedings of the American Society for Horticultural Science* 67:384–89.

Hladik, A., and C. M. Hladik. 1969. Rapports tropiques entre végétation et primates dans le forêt de Barro Colorado (Panama). *Terre et vie* 1:25–117.

Holland, R. A., M. Wikelski, F. Kümmeth, and C. Bosque. 2009. The secret life of oilbirds: New insights into the movement ecology of a unique avian frugivore. *PLoS ONE* 4 (12): e8264. doi:10.1371/journal.pone.0008264.

Howe, H. F. 1983. *Ramphastos swainsonii* (dios tede, toucan de Swainson, chestnut-mandibled toucan). In *Costa Rican Natural History*, edited by D. H. Janzen, 603–4. Chicago: University of Chicago Press.

Howell, D. J. 1976. Plant-loving bats, bat-loving plants. *Natural History* 85 (2): 52–59.

Jansen, P. A., B. T. Hirsch, W.-J. Emsens, V. Zamora-Gutierrez, M. Wikelski, and R. Kays. 2012. Thieving rodents as substitute dispersers of megafaunal seeds. *Proceedings of the National Academy of Sciences, USA* 31:12610–615. doi:10.1073/pnas.1205184109.

Janson, C. H., J. Terborgh, and L. H. Emmons. 1981. Non-flying mammals as pollinating agents in the Amazonian forest. *Biotropica* 13 (S):1–6.

Janzen, D. H. 1971. Euglossine bees as long-distance pollinators of tropical plants. *Science* 71:203–5.

———. 1977. Intensity of predation on *Pithecellobium saman* (Leguminosae) seeds by *Merobruchus columbinus* and *Stator limbatus* (Bruchidae) in Costa Rican deciduous forest. *Tropical Ecology* 18:162–76.

———. 1979. How to be a fig. *Annual Review of Ecology, Evolution, and Systematics* 10:13–51.

———. 1980. Specificity of seed-attacking beetles in the deciduous forests of Costa Rica. *Journal of Ecology* 68:929–52.

———. 1983a. *Brotogeris jugularis* (perico, orange-chinned parakeet). In *Costa Rican Natural History*, edited by D. H. Janzen, 548–50. Chicago: University of Chicago Press.

———. 1983b. Insects, introduction. In *Costa Rican Natural History*, edited by D. H. Janzen, 619–45. Chicago: University of Chicago Press.

Janzen, D. H., and P. S. Martin. 1982. Neotropical anachronisms: Fruits the gomphotheres ate. *Science* 215:19–27.

Jenkins, R. 1969. Ecology of three species of saltators with special reference to their frugivorous diet. PhD thesis, Harvard University.

Johnson, S. D., and M. Brown. 2004. Transfer of pollinaria on birds' feet: A new pollination system in orchids. *Plant Systematics and Evolution* 244:181–88.

Koptur, S. 1984. Outcrossing and pollinator limitation of fruit set: Breeding systems of neotropical *Inga* trees (Fabaceae: Mimosoideae). *Evolution* 38:1130–43.

Kress, W. J., G. E. Schatz, M. Andrianifahanana, and H. S. Morland. 1994. Pollination of *Ravenala madagascariensis* (Strelitziaceae) by lemurs in Madagascar: Evidence for an archaic coevolutionary system. *American Journal of Botany* 81:542–51.

Krishna, S., and H. Somanathan. 2014. Secondary removal of *Myristica fatua* (Myristicaceae) seeds by crabs in *Myristica* swamp forests in India. *Journal of Tropical Ecology* 30 (3): 259–63.

Kroon, F., and D. A. Westcott. 2001. Helmet heads. *Nature Australia* 26 (12): 62–69.

Lee, M. A. B. 1985. The dispersal of *Pandanus tectorius* by the land crab *Cardisoma carnifex*. *Oikos* 45:169–73.

Lumer, C. 2000. The reproductive biology of *Blakea* and *Topobaea* (Melastomataceae). In *Monteverde: Ecology and Conservation of a Tropical Cloud Forest*, edited by N. M. Nadkarni and N. T. Wheelwright, 273–76. New York: Oxford University Press.

McKey, D. 1975. The ecology of coevolved seed dispersal systems. In *Coevolution of Animals and Plants*, edited by L. E. Gilbert and P. H. Raven, 159–91. Austin: University of Texas Press.

Moermond, T. C., and J. S. Denslow. 1985. Neotropical avian frugivores: Patterns of behaviour, morphology, and nutrition, with consequences for fruit selection. *Ornithological Monographs* 36:865–97.

Morandin, L. A., and M. L. Winston. 2006. Pollinators provide economic incentive to preserve natural land in agro-ecosystems. *Agriculture, Ecosystems and Environment* 116:289–92.

Motta-Junior, J. C., and K. Martins. 2002. The frugivorous diet of the maned wolf, *Chrysocyon brachyurus*, in Brazil: Ecology and conservation. In *Seed Dispersal and Frugivory: Ecology, Evolution and Conservation*, edited by D. J. Levey, W. R. Silva, and M. Galetti, 291–303. Wallingford, UK: CABI Publishing.

Muchhala, N., P. V. Mena, and L. V. Albuja. 2005. A new species of *Anoura* (Chiroptera: Phyllostomidae) from the Ecuadorean Andes. *Journal of Mammalogy* 86:457–61.

Mullin, C. A., M. Frazier, J. L. Frazier, S. Ashcraft, R. Simonds, and J. S. Pettis. 2010. High levels of miticides and agrochemicals in North American apiaries: Implications for honey bee health. *PLoS ONE* 5:e9754.

Murray, K. G., S. Russell, C. M. Picone, K. Winnett-Murray, W. Sherwood, and M. L. Kuhlmann. 1994. Fruit laxatives and seed passage rates in frugivores: Consequences for plant reproductive success. *Ecology* 75 (4):989–94.

Muscarella, R., and T. H. Fleming. 2007. The role of frugivo-

rous bats in tropical forest succession. *Biological Reviews* 82:573–90.

Nilsson, L. A. 1992. Orchid pollination biology. *Trends in Ecology and Evolution* 7 (8):255–59.

Olesen, J. M., and A. Valido. 2003. Lizards as pollinators and seed dispersers: An island phenomenon. *Trends in Ecology and Evolution* 18 (4):177–81.

Olsson, M., R. Shine, and E. Ba'k-Olsson. 2000. Lizards as a plant's "hired help": Letting pollinators in and seeds out. *Biological Journal of the Linnean Society* 71:191–202.

Ospina, H. M. 1969. Los antipolinizadores. *Orquideología* 4:23–27.

Pesendorfer, M. B., T. S. Sillett, W. D. Koenig, and S. A. Morrison. 2016. Scatter-hoarding corvids are seed dispersers for oaks and pines: A review of a widely distributed mutualism and its utility to habitat restoration. *Condor* 118 (2):215–37.

Picado, C. 1913. Les broméliacées épiphytes considérées comme milieu biologique. *Bulletin scientifique de la France et de la Belgique* 5:215–360.

Proctor, M., P. Yeo, and A. Lack. 1996. *The Natural History of Pollination*. Portland, OR: Timber Press.

Raguso, R. A. 2004. Flowers as sensory billboards: Progress towards an integrated understanding of floral advertisement. *Current Opinion in Plant Biology* 7:434–40.

Riba-Hernandez, P., and K. E. Stoner. 2005. Massive destruction of *Symphonia globulifera* (Clusiaceae) flowers by Central American spider monkeys (*Ateles geoffroyi*). *Biotropica* 37:274–78.

Roubik, D. W., and P. E. Hanson. 2004. *Orchid Bees of Tropical America: Biology and Field Guide*. Santo Domingo de Heredia, Costa Rica: Editorial INBio.

Russo, S. E., and C. K. Augspurger. 2004. Aggregated seed dispersal by spider monkeys limits recruitment to clumped patterns in *Virola callophylla*. *Ecology Letters* 7:1058–67.

Sargent, S. 2000. Specialized seed dispersal: Mistletoes and fruit-eating birds. In *Monteverde: Ecology and Conservation of a Tropical Cloud Forest*, edited by N. M. Nadkarni and N. T. Wheelwright, 288–89. New York: Oxford University Press.

Shilton, L. A., and R. H. Whittaker. 2009. The role of pteropodid bats in re-establishing tropical forests on Krakatau.

In *Island Bats: Evolution, Ecology, and Conservation*, edited by T. H. Fleming and P. A. Racey, 176–215. Chicago: University of Chicago Press.

Simon, R., M. W. Holderied, C. Koch, and O. von Helversen. 2011. Floral acoustics: Conspicuous echoes of a dish-shaped leaf attract bat pollinators. *Science* 333:631–33.

Skutch, A. 1971. *A Naturalist in Costa Rica*. Gainesville: University Press of Florida.

———. 1980. *A Naturalist on a Tropical Farm*. Berkeley: University of California Press.

———. 1989. *Life of the Tanager*. Ithaca, NY: Cornell University Press.

Smith, N.P., S. A. Mori, A. Henderson, D. W. N. Stevenson, and S. Heald, eds. 2004. *Flowering Plants of the Neotropics*. Princeton, NJ: Princeton University Press.

Snow, D. W. 1965. A possible selective factor in the evolution of fruiting seasons in tropical forests. *Oikos* 15:274–81.

———. 1976. *The Web of Adaptation: Bird Studies in the American Tropics*. London: Collins.

———. 1981. Tropical frugivorous birds and their food plants: A world survey. *Biotropica* 13:1–14.

———. 1982. *The Cotingas*. Ithaca, NY: Cornell University Press.

Stiles, E. W. 1980. Patterns of fruit presentation and seed dispersal in bird-disseminated woody plants in the eastern deciduous forest. *American Naturalist* 116:670–88.

Stiles, F. G. 1985. Seasonal patterns and coevolution in the hummingbird-flower community of a Costa Rican subtropical forest. *Ornithological Monographs* 36:757–87.

Stocker, G. A., and A. Irvine. 1983. Seed dispersal by cassowaries (*Casuarius casuarius*) in northern Queensland's rainforests. *Biotropica* 15:170–76.

Stoki, J., J. Brodmann, A. Dafni, M. Ayasse, and B. S. Hansson. 2010. Smells like aphids: Orchid flowers mimic aphid alarm pheromones to attract hoverflies for pollination. *Proceedings of the Royal Society B: Biological Sciences*. doi:10.1098/rspb.2010.1770.

Swaine, M. D., and Tom Beer. 1977. Explosive seed dispersal in *Hura crepitans* L. (Euphorbiaceae). *New Phytologist* 78:695–708.

Terborgh, J. 1992. *Diversity and the Tropical Rain Forest*. New York: Scientific American Library.

Traveset, A. 1998. Effect of seed passage through vertebrate frugivores' guts on germination: A review. *Perspectives in Plant Ecology, Evolution and Systematics* 1/2:151–90.

Tschapka, M., and O. von Helversen. 1999. Pollinators of syntopic *Marcgravia* species in Costa Rica lowland rain forest: Bats and opossums. *Plant Biology* 1:382–88.

van der Pijl, L. 1961. Ecological aspects of flower evolution. II. Zoophilous flower classes. *Evolution* 15:44–59.

———. 1972. *Principles of Dispersal in Higher Plants*. New York: Springer-Verlag.

van Roosmalen, M. G. M. 1985. *Fruits of the Guianan Flora*. Utrecht, Netherlands: Institute of Systematic Botany.

Vogel, S. 1969. Flowers offering fatty oil instead of nectar. *Abstracts, XI International Botanical Congress, Seattle*, p. 229.

von Frisch, K. 1954. *The Dancing Bees*. London: Methuen.

von Helversen, D., and O. von Helversen. 1999. Acoustic guide in bat-pollinated flower. *Nature* 398:759–60.

Wheelwright, N. T., and G. H. Orians. 1982. Seed dispersal by animals: Contrasts with pollen dispersal, problems of terminology, and constraints on coevolution. *American Naturalist* 119:402–13.

Whitaker, A. H. 1987. The roles of lizards in New Zealand plant reproductive strategies. *New Zealand Journal of Botany* 25:315–28.

Willmer, P. 2011. *Pollination and Floral Ecology*. Princeton, NJ: Princeton University Press.

INDEX

abiotic pollination, water category, 69. *See also* wind pollination

Acacia species, 43, 122–123

Acanthidops bairdi (peg-billed finch), pollination, 169

Acanthosicyos horridus (nara melon), ecological importance, 125

Accipiter superciliosus (tiny hawk), hummingbird predation, 84

Acer pseudoplatanus (sycamore), seed dispersal, 89

Acineta chrysantha, pollination, *181*

acoustic nectar guides, 30–31, 154, 164. *See also* bat *entries*

Acrobates pygmaeus (feathertail glider), pollination adaptations, 42

actinomorphic flowers, structure of, 15

Adansonia (baobab trees), pollination, 43

Adelomyia melanogenys (speckled hummingbird), pollination, 169

Adenolobus pechuelii, flowering timing, *131*

Aellopus species (hawkmoth), pollination, *39*

agamospermy, defined, 37

Agapostemon (sweat bees), pollination, *54*

aggregate fruits, defined, 87

Aglaiocercus coelestis (violet-tailed sylph), pollination, 48

Aglais io (peacock butterfly), pollination, *63*

agoutis, 100–101, 154, 155

Ágren, J., 72

agricultural development, impact, 3–4, 7–8

Agrius convolvuli (convolvulus hawkmoth), pollination, 65

Albizia saman (raintree), seed predators, 126

Alcea rosea (hollyhock), flower structure, 21

Allophylus racemosus (bird fruit), seed dispersal, 92

almond tree (*Terminalia catappa*), seed predation, 127

Alouatta palliata (mantled howler monkey), pollination, 43

Alsomitra macrocarpa, seed dispersal, 118–119

Alstroemeriaceae family, overview, 136–137

Amazilia species (hummingbirds), 129, 152

amino acids, bat flowers, 41–42

Amorphophallus titanum (titan arum), olfactory signals, 77

Anacardium occidentale (cashew), seed dispersal, *113*

Ananas comosus (pineapple), economic importance, 139

Anderson, Jill, 114

androecium, structure of, 13

Angraecum sesquipedale (Madagascar star orchid), flower structure, 21

anole lizards (*Norops*), *Heliconia* hosting, 156

Anoura species (bats), 22, 134, 169

anthers: eelgrasses, 69; in fertilization process, 17; in flower structures, 13; insect-pollinated flowers, 19, 54, 76, 78; for intersexual mimicry, 72; self-incompatibilty adaptations, 33, 34, 35; in self-pollination process, 31, 32; skink-pollinated flowers, 49; wind-pollinated flowers, 67

anthers, family/genera overviews: Fabaceae family, 152; *Ficus* species, 172; Lauraceae family, 160; Melastomataceae family, 168; Passifloraceae family, 183, 185; Rubiaceae family, 187

Anthophora (flower bees), ecological importance, 6

Anthracothorax prevostii (green-breasted mango), *138, 158*

antipollinators. *See* predation *entries*

ants: guarding of plants, 83, 147, 184, *184*; plant defenses against, 82–83; pollination effectiveness, 67; seed dispersal, 89, 114

aquatic plants, pollination, 69
Aquilegia species (columbines), *22, 82*
Ara macao (scarlet macaw), seed predation, *127*
Archilochus colubris (ruby-throated hummingbird), migration, 44
Arctium lappa (greater burdock), seed dispersal, *115*
arils, family/genera overviews: *Bomarea* species, 137; *Clusia* species, 148; Fabacae family, 154, 155; Passifloraceae family, 186; *Siparuna* species, 191
arils, generally: overview, 87, 88–89; mimicry of, 123; and seed dispersal, 94, 114, 120
Arisarum proboscideum (Mediterranean mousetail arum), brood site mimicry, 74
aroid family, pollination, 59–60, 61, 74, 76–77
arum species, olfactory signals, 26, 60–61, 74, 77
Ascidae (flower mites), 81, *83*, 151
asexual dispersal, water plants, 120
asexual reproduction, overview, 37
aspen, quaking (*Populus tremuloides*), Utah grove, 37
Ateles species (spider monkeys), flower predation, 80, 147–148
Atlapetes leucopterus (white-winged brush-finch), seed dispersal, *131*
Attenborough, David, 77
aubretia (*Aubrieta deltoidea*), *58*
Aulacorhychus species, *12*, 123, *129*, 189
Autographa gamma (silver Y moth), pollination, 66
avocados, wild (*Ocotea* species): crop production patterns, 145; family overview, 159–161; fossil evidence, 133; fruit structure, *87*; seed dispersal, 105–107, 111; seed size, 90–91
Axinaea species, pollination, 168–169
Azteca ants, guarding of plants, 143

baboon, Chacma (*Papio ursinus*), seed dispersal, 97
Baker, Herbert, 21–22
Baker, Irene, 21–22
balsa flower (*Ochroma pyramidale*), pollination, 43
bananaquit (*Coereba flaveola*). Müllerian bodies, *144*
Banksia, seed dispersal, 122
baobab trees (*Adansonia*), pollination, 43
barbthroat, band-tailed (*Threnetes ruckeri*), pollination, 158
Bassaricyon gabbii (northern olingo), seed dispersal, *98*
bat flower species, pollination, *41*, *75*, 76
bat-pollinated flowers: *Centropogon* coevolution, 134; nectar guides, 30–31; nectar value, 22; olfactory signals, 29
bat-pollinated flowers, family/genera overviews: bromeliads, 141; Fabaceae family, 152, 153–154; *Heliconia* species, 156, 157; Marcgraviaceae family, 164, 165; Melastomataceae family, 169
bats: pollination syndrome overview, 40–41; seed dispersal, 86, 95–96, 151, 195
Bauhinia purpurea (orchid tree), seed dispersal, 117
Bawa, Kamal, 41
bears, seed dispersal, 100
Beccari, Odoardo, 114
bee-pollinated flowers: color signals, 38; constancy factor, 70; mimicry strategies, 55, 72; olfactory signals, 29, 30, 77; pollen transfer process, 18–19, 54–55; resin value, 23; structural characteristics, 21, 71
bee-pollinated flowers, family/genera overviews: Clusiaceae family, 146–147; *Coriana* species,

148; *Handroanthus* species, 138; Melastomataceae family, 168, 169; Orchidaceae family, 178, 179–181, *182*; Passifloraceae family, 184–185; Solanaceae family, 192
Beer, Tom, 117
bees: ecological crisis, 4–7; nectar thieving by, 80; pollination syndrome overview, 52–55; predators of, 84
beetle-pollinated flowers: olfactory signals, 29; syndrome overview, 59–62; unspecialized types, 50, 55
begonia (*Begonia involucrata*), *72, 73*
Beilschmiedia brenesii, 167
Bernhardt, Peter, 59, 72
berries, defined, 87
Bidens andicola (daisy), pollination, 52
big-bang strategy, flowering, 130, 138
Bignoniaceae family, overview, 137–139
bilateral symmetry, pollinator benefits, 15, *16*, 52–53
bird-dispersed seeds, family/genera overviews: *Bomarea* species, 137; *Cecropia* species, 144; Clusiaceae family, 148; *Coriaria* species, 149; Ericaceae family, 151; *Fabaceae* species, 154; *Ficus* species, 175; *Hedyosmum* species, 144–145; *Heliconia* species, 159; Lauraceae family, 160–161; Loranthaceae family, 162–163; Marcgraviaceae family, 166–167; Melastomataceae family, 169–170; Passifloraceae family, 186; Rubiaceae family, 188–189; *Siparuna* species, 191; Solanaceae family, 194. *See also* seed dispersal syndromes, bird category
bird fruit (*Allophylus racemosus*), seed dispersal, *92*
bird-pollinated flowers, family/genera overviews: Loranthaceae family, 162; Marcgraviaceae family, 165–166; Melastomataceae family, 169; Orchidaceae family, 178; *Symphonia*

globulifera, 147. *See also* humming-
 bird-pollinated flowers
birds: bur perils, 115; fruit consump-
 tion overview, 86–89; migration and
 fruiting timing, 130, 132; Müllerian
 body consumption, 143, *144*; pollina-
 tion syndrome, 40–41, 44–48, 64;
 predators of, 112–113, 124, 126–128,
 175; seed predation, 124, 126; wasp
 predation, 172
Birkinshaw, Christopher, 97
blackbead, catclaw (*Pithecellobium
 unguis-cati*), seed dispersal, *89*
blackberry (*Rubus fruticosus*), seed dis-
 persal, *88*
blackbird (*Turdus merula*), seed disper-
 sal, *87*
Blakea species, 169, 170
blowflies, 26, 57, 75
bog-stars (*Parnassia*), floral deceit,
 72–73
bois boeuf (*Gastonia mauritiana*), polli-
 nation, *49*
Bomarea species, overview, 136–137
Bombus species. *See* bumblebee-polli-
 nated flowers; bumblebees
Bombylius major (dark-edged bee fly),
 pollination, *28*, 58
borage (*Borago officinalis*), flower struc-
 ture, *14*
Bothriechis schlegelii (eyelash pit viper),
 84, 187
Bourdain, Anthony, 94
Bradypus variegatus (brown-throated
 sloth), on *Cecropia* tree, *142*
bramble flower (*Rubus fruticosus*), pol-
 lination, *51*
Brassica napus (rapeseed), economic
 importance, 4
breeding sites, 77–79, 172, 174
brilliants (*Heliodoxa* species), pollina-
 tion, *165*, 166
Brocchinia reducta, water trapping, 141
Bromeliaceae family, overview, 139–143
bromeliads, 19, 80, 83, *141*

brood site pollination, 74–76, 190
Brotogeris jugularis (orange-chinned
 parakeet), seed predation, 175
bruchid beetles, seed predation, 126
Brugmansia species, 191, 192, 194
Brunfelsia pauciflora (yesterday-today-
 and-tomorrow), 27, 191
brush-finch, white-winged (*Atlapetes
 leucopterus*), seed dispersal, *131*
brush flowers, structure, 13, 15
bullfinches, 80, 126
bumblebee-pollinated flowers: buzz
 pollination process, 54–55; color sig-
 nals, 27; constancy factor, *70*; nectar
 theft, *82*, 136; self-incompatibility
 adaptation, 33; structure characteris-
 tics, *20*, *21*, *52*. *See also* bee-pollinated
 flowers
bumblebees (*Bombus* species*), eco-
 logical importance, 6. *See also* bee
 entries
burdocks, seed dispersal, 115
Burkle, Laura, 5
burnet, six-spotted (*Zygaena filipendu-
 lae*), pollination, 66
burs, perils, 115
bush babies (*Galago*), pollination, 43
Bushman's hat (*Hoodia gordonii*), *30*, 75
buttercup, common meadow
 (*Ranunculus acris*), reproduction, 37
butterflies, insect predation, *85*
butterfly bush (*Buddleia davidii*), polli-
 nation, *63*
butterfly-pollinated flowers: alkaloids
 value, 23, 24; color signals, 27, *28*; in
 Heliconia species family, 156; olfac-
 tory signals, 29; in Rubiaceae family
 overview, 187–188; syndrome over-
 view, 62–64
buzz pollination, 19, 53–54, 168, *169*,
 192

Cacajao (uakaris), seed predation, 124
cacao (*Theobroma cacao*), 2, *3c*, 59

cacti: flower structure, 13, *14*; pollina-
 tors, 27, 41, 65–66
Caesalpinia bonduc (gray nickernut),
 seed dispersal, 122
Caligo (owl butterflies), *Heliconia* feed-
 ing, 156
Calliandra species, 15, 153
Calliphlox mitchellii (purple-throated
 woodstar), pollination, 150
Calocitta formosa (white-throated mag-
 pie-jay), seed dispersal, 186
Caltha palustris (marsh marigold),
 flower structure, 13
Caluromys (woolly opossums), pollina-
 tion, 43
calyx: color signals, 26, 45, 62; nectary
 protection, 82; in Passifloraceae
 family overview, 183; in Rubiaceae
 family overview, 187–188; structure
 of, 13
Canna seeds, 91, 117–118
Capanea affinis, pollination, 47
capuchin, white-faced (*Cebus capuci-
 nus*), 92, 97, 170
cardinal, red-capped (*Paroaria gularis*),
 seed dispersal, *103*
Cardisoma carnifex (crab), seed disper-
 sal, 114
Carduelis carduelis (European gold-
 finch), seed predation, 126
Carnegiea gigantea (giant saguaro cac-
 tus), bat pollination, 41
carpels, 13, 15
carrion flowers, 29, 74–76
carrot, wild (*Daucus carota*), pollina-
 tion, 50
cashew (*Anacardium occidentale*), seed
 dispersal, *113*
cassowary, southern (*Casuarius casuar-
 ius*), seed dispersal, 107–108
castor-oil plant (*Ricinus communis*),
 flower structure, 37
Catharus ustulatus (Swainson's thrush),
 102, 132

Cebus capucinus (white-faced capuchin), 92, 97, 170

Cecropiaceae family, overview, 143–145

Cecropia species, 42, 143–144

Centaurea cyanus (blue cornflowers), 9, 70

Centropogon nigricans, pollination, 134

Chaerophyllum temulum (rough chervil), pollination, 51

Chaetocercus berlepschi (Esmeraldas woodstar), pollination, 39

Chalcomitra senegalensis (scarlet-chested sunbird), pollination, 45

chamber blossom group, beetle-pollinated flowers, 59–60

Chamerion angustifolium (rosebay willowherb), self-incompatibility adaptation, 33

chervil, rough (*Chaerophyllum temulum*), pollination, 51

Chiropotes (bearded sakis), seed predation, 124

Chloranthaceae family, overview, 144–145

chlorophonia, golden-browed (*Chlorophonia callophrys*), 135, 137, 163

Chlorornis riefferii (grass-green tanager), seed dispersal, 151

chocolate, 3c, 58–59

Chrysanthemum segetum (corn marigold), cultivation value, 9

Chrysocyon brachyurus (maned wolf), seed dispersal, 100

chupa-chupa tree (*Quararibea cordata*), pollination, 42–43

Cinchona, 30, 188

Cirsium vulgare (spear thistle), pollination, 20

clay licks, parrot consumption, 128

cleaver (*Galium aparine*), seed dispersal, 115

cleistogamous flowers, pollination, 32

clovers, floral structure, 15–16

Clusiaceae family, overview, 145–148

Clusia species, 23, 145–147

Coccothraustes coccothraustes (hawfinch), seed predation, 126

cock-of-the-rock (*Rupicola peruvianus*), seed dispersal, 110

Cocos nucifera (coconut palm), seed dispersal, 121

Coeligena species (inca hummingbirds), 47, 136, 162c, 193

Coereba flaveola (bananaquit). Müllerian bodies, 144

coevolution, diffuse, 133–135

coffee family, 2, 186

Colibri species (violetears), 19, 147, 162

color signals, family/genera overviews: bromeliads, 141–142; Fabaceae family, 152, 153; *Handroanthus* species, 138; *Heliconia* species, 157; Marcgraviaceae family, 164; Melastomataceae family, 168, 169; Passifloraceae family, 184; Rubiaceae family, 187–188; Solanaceae family, 191, 192, 194

color signals, generally: overview, 26–27, 28, 38; bat-pollinated flowers, 41; bird-pollinated flowers, 45–46, 64; gecko-pollinated flowers, 50; for seed dispersers, 102; wind-pollinated flowers, 67

color signals, insect pollinators: bees, 52; beetles, 59, 61; butterflies, 62; flies, 58; moths, 65, 66; unspecialized types, 50; wasps, 56

Colossoma macropomum (tambaqui), 114, 126

Columba palumbus (wood pigeon), seed predation, 126

columbines (*Aquilegia* species), 22, 82

Colwell, Robert, 47

Combretum farinosum, pollination, 46

Comparettia falcata, pollination, 178

Conostegia oerstediana, 167, 168, 170

coral tree (*Erythrina costaricensis*), seed dispersal, 123

Corbet, S. A., 50

corbiculae, honeybees, 55

coreid bugs, seed predation, 126

Coriariaceae family, overview, 149

Coriaria species, overview, 149

cornflower, blue (*Centaurea cyanus*), 9, 70

cornucopia strategy, flowering, 138

corollas, family/genera overviews: Ericaceae family, 150–151; Loranthaceae family, 162; Rubiaceae family, 187; Solanaceae family, 192

corollas, generally, 13, 41, 47

corpse flower (*Rafflesia arnoldii*), structure, 75

corvids, seed dispersal, 112

Costus pulverulentus (ginger flower), defenses, 83

cotingas, mistletoe seed dispersal, 162–163

cowslip (*Primula veris*), flower structure, 35, 36

crab (*Cardisoma carnifex*), seed dispersal, 114

crane's bill (*Geranium* species), 55, 117

crossbills (*Loxia*), seed predation, 126

cross-pollination, overview, 31, 32–36, 70–71

crucifers, structure of, 13

Cryptostylis (tongue orchids), pollination, 180

ctenosaur, black (*Ctenosaura similis*), seed dispersal, 113

cuckoo, squirrel (*Piaya cayana*), insect predation, 84

cucurbit vine (*Psiguria*), pollination, 64

Cyanerpes cyaneus (red-legged honeycreeper), seed dispersal, 148

Cyclocephala sexpunctata (scarab beetle), pollination, 61

Cycnoches chlorochilon, seed dispersal, 182

Cydista species, seed dispersal, 139

daisies, 15–16, 52, 90
dance language, honeybees, 55
Darwin, Charles, 65, 114, 176
Dasyprocta species, 100, 101
dates, cultivation history, 2
Daucus carota (wild carrot), pollination, 50
deceit and mimicry strategies, pollination: overview, 72–73; false brood sites, 74–76; in Orchidaceae family overview, 177–179; trap flowers, 34, 59, 61, 76–77
deceit and mimicry strategies, seed dispersal, 123
dehiscent fruits, 88
Dendrobium species, pollination, 177, 178
Denslow, Julie, 109–110
desert climates, pollination syndromes, 40–41
desert pea, Sturt's (*Swainsona formosa*), flower structure, 17
dichogamy, overview, 33–34
Digitalis purpurea (common foxglove), self-incompatibility adaptation, 33, 35
Diglossa cyanea (masked flowerpiercer), nectar thieving, 194
Dimorphotheca sinuata (Namaqualand daisies), seed characteristics, 90
dioecious species, overview, 36–37
Dipodomys spectabilis (banner-tailed kangaroo rat), seed predation, 125
Dipsacus (teasels), ant defenses, 83
Disa species, pollination, 178
disk nectaries, structure of, 20
Dolichovespula sylvestris (European tree wasp), orchid pollination, 56
Dorifera ludovicae (green-fronted lancebill), pollination, 150
dormancy, seed, 91, 122
Dracula species, mimicry strategy, 74, 75

drift seeds, 121–122
drupes, defined, 87
dry fruits, overview, 88–89
dung flowers, 29, 34, 74–77, 179
durian fruits, overview, 93–94
Dutchman's pipe (*Aristolochia pichinchensis*), 77

earthworms, seed dispersal, 114
echolocation, nectar guides, 30–31, 154, 164. *See also* bat *entries*
ecological farming, 8
Ectatomma tuberculatum (ponerine ant), guarding of plants, 184
Ectophylla alba (white bat), *Heliconia* hosting, 156
eelgrass (*Zostera*), pollination, 69
Eichhornia crassipes (water hyacinth), color signals, 73
Elaeocarpus angustifolius (blue quandong), seed dispersal, 107–108
elaiophores, pollinator rewards, 23, 178
elderberries (*Sambucus peruviana*), seed dispersal, 102
elephants, seed dispersal, 94, 99–100
Elleschodes (weevils), pollination, 79
elm, English wych (*Ulmus glabra*), flower structure, 19
Elodea canadensis (Canadian waterweed), seed dispersal, 120
emerald, coppery-headed (*Elvira cupreiceps*), 26, 40, 147, 151
Emmons, L. H., 42
Endara, Lorena, 74
Endress, Peter, 59
Ensifera ensifera (sword-billed hummingbird), 134, 135, 136, 162c
Entada gigas (sea heart), seed dispersal, 121, 122
Ephedra foeminea, pollination, 10
Epidendrum species (orchids), 64c, 177
Epipactis species, 56, 180
Epiphyllum lepidocarpum (epiphytic cactus), pollination, 27

Episyrphus balteatus (marmalade hoverfly), pollination, 20
Ericaceae family, overview, 149–151
Erythrina species, 123, 153, 154–155
Euglossa platymera (orchid bee), pollination, 53
Eulaema speciosa (orchid bee), pollination, 181, 182
Eulemur macaco (black lemur), seed dispersal, 97
Eupherusa eximia (stripe-tailed hummingbird), nectar thieving, 80, 82
Eupomatia laurina (spice bush), 59
explosive pods, seed dispersal, 116–117
exudates, stigmatic, 23

Fabaceae family, overview, 151–155
fairy (*Heliothryx* species), nectar thieving, 80
falcon, barred forest- (*Micrastur ruficollis*), hummingbird predation, 84
false brood sites, 74–76
Feinsinger, Peter, 47
Ferocactus wislizeni (Arizona barrel cactus), flower structure, 14
Ficus species, overview, 170–175
figs: cultivation history, 2; family overview, 170–175; seed dispersal, 197, 199; wasp relationship, 56, 78, 134
figwort, common (*Scrophularia nodosa*), pollination, 56
filcher behavior, hummingbirds, 47–48
finches, 109, 126, 169
firebush (*Hamelia patens*), pollination, 46, 188
firecrown, green-backed (*Sephanoides sephanoides*), pollination, 44
fishes and seeds, 86, 126
fleshy fruits, overview, 86–90
floating-hearts, yellow (*Nymphoides*), warmth reward, 25
florets, 16, 18c
Florisuga mellivora (white-necked jacobin), 15, 166

flowerpeckers, mistletoe relationship, 134–135

flowerpiercers, 80, 126, 136, *194*

flowers, overview: constancy factor, 70–71; in human history, 1–8; plant evolutions, 10–12; seasonality factors, 130–132; structure of, 13–17. *See also specific topics, e.g.,* bat-pollinated flowers; color signals *entries;* pollination *entries*

flycatcher species, 84, 162–163, *195*

fly-pollinated flowers: in Lauraceae family discussion, *160;* mimicry strategy, 74, *75;* structural characteristics, 50, *51;* syndrome overview, 38, 57–59

food crops, 1–3, 5, 7, 139

forget-me-not, wood (*Myosotis sylvatica*), structure, 27, *28*

fossil evidence: Chloranthaceae family, 144; earliest pollinators, 18; fish-dispersed seeds, 114; insects, 10, 59; plant evolution, 10, 12, 133; wind pollination, 38–39

foxes, seed dispersal, 100

foxglove, common (*Digitalis purpurea*), self-incompatibility adaptation, 33, *35*

Frankie, Gordon, 71

frog, tree (*Xenohyla truncata*), seed dispersal, 113

fruit bats, seed dispersal, 95–96

fruits, overview: crops, 2–3, 5; seasonality of, 130–132; types of, 86–90. *See also* predation risks; seed dispersal *entries*

fungus flowers, 74, 75

Galago (bush babies), pollination, 43

Galium aparine (cleaver), seed dispersal, *115*

Garcinia mangostana (mangosteen), economic importance, 145

Garrulus glandarius (Eurasian jay), hoarding behavior, 112

Gastonia mauritiana (bois boeuf), pollination, *49*

gazania flower, terracotta (*Gazania krebsiana*), *62*

geckos, pollination, 48–49

gemsbok (*Oryx gazella*), seed dispersal, *125*

Gentry, Alwyn, 84

Geranium species (crane's bill), 55, *117*

germination, 88, 91, 99, 108

ginger flower (*Costus pulverulentus*), defenses, *83*

giraffes, pollination, 43

Givnish, Thomas, 141

Glaucis species (hermits), *71, 184*

gliders, pollination adaptations, 42

Gliricidia sepium, pollination, 44

Gloriosa species, flower structure, 35, *36*

glory bushes (*Tibouchina*), 167, *168, 169*

glossary, 197–199

Glossophaga species (bats), pollination, 154, *164*

gnat, dark-winged fungus (*Sciara hemerobiodes*), pollination, 50

goldenrod, Canadian (*Solidago canadensis*), pollination, 57

goldfinch, European (*Carduelis carduelis*), seed predation, *126*

Goldwasser, Lloyd, 60, 61

Gonzalagunia rosea, 188, 189

Grammatophyllum speciosum (giant orchid), size, 176

grapes, cultivation history, 2

grasses/grass seeds: dispersal, 115; food crops, 2–3, 7; pollination, 17, 67, 69; predators, 100, 124, 125, 126

gravity, seed dispersal, 117–118

Greta annette (glasswing butterfly), 23, 24, 62, 64

gymnosperms, evolution history, 10

gynoecium, structure of, 13

Haber, Bill, 65–66

Haber, William, 71

Hallwachs, Winnie, 101

Hamilton, W. D., 172

Hampea appendiculata, fruit timing, 132

Handroanthus species (trumpet trees), 132, 137–139

Hansen, Dennis, 50

Hartshorn, Gary, 86

Hasseltia floribunda, fruit timing, 132

hawfinch (*Coccothraustes coccothraustes*), seed predation, 126

hawk, tiny (*Accipiter superciliosus*), hummingbird predation, 84

hawkmoth-pollinated flowers: color signals, 26, 27; olfactory signals, 26, 39–40; in Solanaceae family overview, *194;* spatial effects, 71; structural characteristics, 39

hawkmoths, pollination syndrome overview, 65–66

hazel catkins, flower structure, *68*

heath family, overview, 149–151

Hedera helix (ivy flower), pollination, *58*

Hedyosmum species , overview, 144–145

Heliangelus strophianus (gorgeted sunangel), pollination, 169

Helianthus (sunflower), structure, 18

Helicodiceros muscivorus (dead horse arum), olfactory signals, 26

Heliconiaceae family, overview, 155–159

Heliconia species, pollination, 46

Heliconius clysonymus (passion-vine butterflies), pollination, 62, 64, *177*

Heliodoxa species (brilliants), pollination, *165, 166*

Heliothryx species (fairy), nectar thieving, 80

heliotropic flowers, 23, 25

helleborine, marsh (*Epipactis veratrifolia*), mimicry strategy, 180

Helophilus pendulus (hoverfly), *51, 88*

Helversen, Dagmar, 31

Helversen, Otto von, 31

hermit species: mite transport, 83; trapline behavior, 71

hermit species, in family/genera overviews: Bromeliaceae family, 141; *Erythrina* species, *153*; *Heliconia* species, 157–158; Passifloraceae family, 184, *185*

heterostyly, 35

Hevea brasiliensis (rubber tree), seed dispersal, 117

hollowheart (*Acnistus arborescens*), *104*, *128*, *129*, *131*, *192*, 194–195

hollyhock (*Alcea rosea*), flower structure, *21*

honeybees, 4–7, 54–55, *60c*. See also bee entries

honey bush (*Richea scoparia*), pollination, 49

honeycreeper, red-legged (*Cyanerpes cyaneus*), seed dispersal, 148

Hoodia gordonii (Bushman's hat), *30*, 75

Hoplodactylus species (geckos), pollination, 48–49

horses, seed dispersal, 101–102

hot lips (*Psychotria elata*), *26*, 187–188

hoverflies: flower structure signals, *51*; fruit feeding, 88; in Orchidaceae family overview, 180; pollination importance, 20, 57, *58*

Howe, H. F., 129

human transport, seed dispersal, 3, 115–116

hummingbird-pollinated flowers: coevolution relationships, 134, *135*; color signals, 27, 38, 64; olfactory signals, *30*; structural characteristics, 15, 16, 46–47

hummingbird-pollinated flowers, family/genera overviews: *Bomarea* species, 136–137; bromeliads, 141; Clusiaceae family, 146, *147*; Ericaceae family, 150–151, 152–153; Fabaceae family, 152; *Handroanthus* species, 138–139; *Heliconia* species, 157–158; Marcgraviaceae family, 164–165, 166; Melastomataceae family, 169; Orchidaceae family,

178; Passifloraceae family, 184–185; *Psittacanthus* species, *162*; Rubiaceae family, 187, 188; Solanaceae family, 192–194

hummingbirds: mite transport, 81; nectar-feeding, 22; nectar thieving by, 80, *82*, 129; pollination syndrome overview, 39–40, 44, 46–48; predators of, 84; territorial behavior *vs.* traplining, 47–48, 71, 157–158

hyacinth, water (*Eichhornia crassipes*), color signals, 73

hydrangeas, 27, 74

Hylocereus costaricensis (cactus flower), pollination, 65–66

Hylocichla mustelina (wood thrush), *Psychotria uliginosa* berries, 189

Hylonycteris underwoodi (Underwood's long-tongued bat), 22, *31*, 41, 154

Hymenopus coronatus (orchid mantis), insect predation, 84

Icterus species. *See* orioles (*Icterus* species)

Imantodes cenchoa (blunt-headed tree snake), lizard predation, 156

inca, collared (*Coeligena torquata*), 47, *136*, *193*

indehiscent fruits, 89–90

inflorescences, types of, 15–17. *See also* structural characteristics, family/genera overviews

Inga species, 40, 71, 152–153, 154

insects: fossil evidence, 10, 59; seed predation, 126, 183–184. *See also* pollination syndromes, insect category

intersexual mimicry strategy, 72

Iochroma calycinum (witches' fingers), flower structure, 16

Iochroma species, 192, *193*

irises: flower structure, 13; nectar guides, *29*; pollination strategies, 59, 73; seed dispersal, 120

ivy flower (*Hedera helix*), pollination, 58

Jacaranda mimosifolia, ornamental value, 137

jacobin, white-necked (*Florisuga mellivora*), *15*, 166

Jansen, Patrick, 100

Janson, C. H., 42

Janzen, Daniel, 52, 100–101, 126, 175

jay, Eurasian (*Garrulus glandarius*), hoarding behavior, 112

Jenkins, R., 123

kangaroo rat, banner-tailed (*Dipodomys spectabilis*), seed predation, 125

kingbirds (*Tyrannus* species), feeding patterns, 102

Klais guimeti (violet-headed hummingbird), pollination, 188

Knautia arvensis (field scabious), pollination, *66*

Koptur, Suzanne, 71

Kress, W. J., 43

Lampornis calolaemus (purple-throated mountaingem), pollination, 151

lancebill, green-fronted (*Dorifera ludovicae*), pollination, 150

lantanas (*Lantana* species), 27, *28*, *64c*, 177

Lapeirousia oreogena (iris, painted petal), *29*, *59*

Lauraceae family, overview, 159–161

Lawrence, Felicity, 7

legumes, 88, 117, 151–155

leguminous flower (*Pterocarpus michelianus*), pollination, 43

lemurs, 43, 97

Leptonycteris yerbabuenae (lesser long-nosed bat), seed dispersal, 41

Leucospermum cordifolium (pincushion protea), pollination, 45

lilies, flower structure, 13, 35, *36*. See also water lilies

Liomys salvini (spiny pocket mouse), seed predation, 128

lizards, 48–50, 156

lobster claw plants (*Heliconia* species), 46, 155–159

Lophocebus aterrimus (black-crested mangabey), seed predation, 124

Loranthaceae family, overview, 161–164

Loxia (crossbills), seed predation, 126

Lucilia (greenbottle blowflies), pollination, 57

Luehea candida, pollination, 71

Lumer, Cecile, 169

macaws, 124, 127. *See also* parrots

Macleania ericae, pollination, 150

Macrocarpaea valerioi (Costa Rican bat flower), pollination, *41*

magnolia (*Magnolia poasana*), pollination, *60*

magpie-jay, white-throated (*Calocitta formosa*), seed dispersal, 186

maize, 1–2, 5

malaria, 186

mammal-dispersed seed, family/genera overviews: bromeliads, 143; *Cecropia* species, 144; *Fabaceae* species, 154; *Ficus* species, 174–175; Melastomataceae family, 170; Passifloraceae family, 186. *See also* seed dispersal syndromes, mammal category

mammal-pollinated flowers, family/genera overviews: Marcgraviaceae family, 164, 165; Melastomataceae family, 169

mammals: pollination syndrome overview, 41–43; seed predation, 124. *See also* bat *entries*

mangabey, black-crested (*Lophocebus aterrimus*), seed predation, 124

mango, green-breasted (*Anthracothorax prevostii*), *138*, 158

mangosteen (*Garcinia mangostana*), economic importance, 145

mangroves, seed dispersal, 120–121

mantis species, 84, *85*

marauder behavior, hummingbirds, 47–48

Marcgraviaceae family, overview, 165–167

Marcgravia species, pollination, 43

marigold species, 9, 13

marmalade bush (*Streptosolen jamesonii*), color signals, 191

marsupials, pollination adaptations, 42

Martin, Paul, 100–101

Mary's bean (*Merremia discoidesperma*), seed dispersal, 121–122

Maxillaria species (orchids), *16*, 178

Mechanitis species (ithomiine butterflies), pollination, *28*, *64*

Megachile (leafcutter bees), ecological importance, *6*

Melanerpes species (woodpeckers), seed dispersal, 112–113, 148

Melastomataceae family, overview, 167–170

Melipona species (stingless bees), 23, 72, *146*, 147

Meriania species, pollination, 169

Merinthopodium species, pollination, 194

Merremia discoidesperma (Mary's bean), seed dispersal, 121–122

Mezobromelia capituligera, defense mechanisms, 142

mice, 42, 128, 169

Miconia species, 97, 132, 167–168, 170

Micrastur ruficollis (barred forest-falcon), hummingbird predation, 84

Microcebus (mouse lemurs), pollination, 43

midges, *3c*, 58–59, 78, 190

milkweed (*Asclepias curassavica*), 64, 177

mimicry. *See* deceit *entries*

Mimulus species (monkeyflowers), 27, 73

mistletoes, 134–135, 137, 161–164

mites, flower (*Ascidae*), 81, *83*, 151

Moermond, Tim, 109–110

monkeyflowers (*Mimulus* species), 27, 73

monkeys: flower predation, 80, 147–148; pollination, 42–43; seed dispersal, 96–97; seed predation, 124, 173–174

monoecious species, overview, 36

Moraceae family, overview, 170–175

Morandin, Lora, 8

moth-pollinated flowers, family/genera overviews: Clusiaceae family, 146; Rubiaceae family, 187; Solanaceae family, 194

moths, generally: olfactory signals, 29; pollination, 65–66, 78–79; seed predation, 126

mountaingem, purple-throated (*Lampornis calolaemus*), pollination, 151

Muchhala, Nathan, 134

Mucuna species, 31, 153–154

Müller, Fritz, 187

Müllerian bodies. *Cecropia* species, 143, *144*

Müllerian mimicry, 51–52

Mullin, C. A., 7

multiple-bang flowering strategy, 139

multiple fruits, defined, 87

Myadestes melanops (black-faced solitaires), 189, 195

Myosotis sylvatica (wood forget-me-not), structure, 27, *28*

Myristica fatua (nutmeg), seed dispersal, 114

nara melon (*Acanthosicyos horridus*), ecological importance, *125*

A Naturalist in Costa Rica (Skutch), 147

nectar: flower sites, 20–21, *22*; predation risks, 80–82, 136, 138–139, 142; value to pollinators, 19–22, 27

nectar guides, overview, 27–28. *See also* color signals *entries*; olfactory signals *entries*; structural characteristics *entries*

Nectarinia purpureiventris (sunbird), pollination, 147

needle flower (*Posoqueria latifolia*), pollination, 187

neonicotinoids, 7

Nesocodon mauritianus, pollination, 50

nickernut, gray (*Caesalpinia bonduc*), seed dispersal, 122

nightshade flower, horned (*Solanum rostratum*), pollination, 54

Nilsson, L. A., 177

Niveoscincus microlepidotus (snow skink), pollination, 49

Norantea species, overview, 165–166

Norops (anole lizards), *Heliconia* hosting, 156

Notiochelidon cyanoleuca (blue-and-white swallow), insect predation, 172, 174

nutcracker, Clark's (*Nucifraga columbiana*), hoarding behavior, 112

nutmegs, seed dispersal, 91, 114

Nymphoides (yellow floating-hearts), warmth reward, 25

Ochroma pyramidale (balsa flower), pollination, 43

Ocotea species. *See* avocados, wild (*Ocotea* species)

Ocreatus underwoodii (booted racket-tail), 178

oilbird (*Steatornis caripensis*), 106, 107

oil-collecting bees, 55

oil flowers, 22–23

Olesen, J. M., 50

olfactory signals, family/genera overviews: bromeliads, 141, 142; Fabaceae family, 152, 154; Melastomataceae family, 169; Orchidaceae family, 177, 179, 180–

181; Passifloraceae family, 185; Rubiaceae family, 187, 188; *Siparuna* species, 190; Solanaceae family, 194

olfactory signals, generally: overview, 28–30; brood-site mimicry, 74–77; mammal-pollinated flowers, 41, 42; seed dispersers, 93–94, 95–96, 107

olfactory signals, insect pollinators: bees, 23, 52; beetles, 59, 61; brood-site mimicry, 74–76; flies, 26; moths, 26, 65; trap flowers, 76–77; unspecialized types, 50; weevils, 79

olingo, northern (*Bassaricyon gabbii*), seed dispersal, 98

Oncidium species (orchids), overview, 177–178

Ophrys species (bee orchids), 32, 55, 179

opossums, pollination, 42–43

orangutan, Bornean (*Pongo pygmaeus*), seed dispersal, 94

Orchidaceae family, overview, 175–182

orchids, generally: bee pollination, 55; bird pollination, 71; butterfly pollination, 64c; deceitful pollination strategies, 72, 74, 76; flower structures, 13, 15, 16, 21; insect pollination, 55, 56, 64c; rewards for pollinators, 23, 55; seed dispersal, 114, 118; seed size, 90; self-pollination, 32; wasp pollination, 56

orchid tree (*Bauhinia purpurea*), seed dispersal, 117

orioles (*Icterus* species): nectar thieving, 80, 139; pollination, 22, 44, 166

Ormosia, seed dispersal, 123

Ornithocephalus species, 177

Oryx gazella (gemsbok), seed dispersal, 125

Oryzomys fulvescens (mice), pollination, 169

Osmia leaiana (orange-vented mason bee), pollination, 55

Ospina, H. M., 84

ovary, structure, 13

Pachira quinata (pochote flower), nectar theft, 81

pacu, red-bellied (*Piaractus brachypomus*), seed dispersal, 114

painted-bowls group, beetle-pollinated flowers, 59, 61–62

Palicourea demissa, berry characteristics, 189

palms, 43, 91, 114, 121

Paphiopedilum (slipper orchids), flower life, 176

Papio ursinus (Chacma baboon), seed dispersal, 97

parakeet, orange-chinned (*Brotogeris jugularis*), seed predation, 175

Parapartamona zonata (stingless bee), pollination, 148

Paraponera clavata (bullet ant), plant guarding, 83

Parategeticula species (yucca moth), pollination, 78–79

Parker, Ted, 163

Parnassia (bog-stars), floral deceit, 72–73

Paroaria gularis (red-capped cardinal), seed dispersal, 103

parrots, 124, 127, 154, 155, 175

pasqueflower (*Pulsatilla vulgaris*), 13, 14

passerine species, nectar-feeding, 22

Passifloraceae family, overview, 182–186

passion flowers, generally: defense mechanisms, 83; flower structure, 13; mites, 83; pollination, 71, 134, 135; seed dispersal, 12

Patagioenas fasciata (band-tailed pigeon), seed predation, 126

Paz, Angel, 145

peccary, collared (*Pecari tajacu*), seed dispersal, 186

pendant flowers, structure, 15

perianth, types of, 13, 14

pesticide exposure, 7–8

petals, arrangement types, 13–17

Petaurus breviceps (sugar glider), pollination adaptations, 42

Phaethornis species (hermits), *83*, *141*, *153*, 184, *185*

Phalaenopsis (moth orchids), flower life, 176

Pharomachrus species (quetzals), viii, 104–107, 160

Phelsuma ornata (ornate day gecko), pollination, 49

Phyllostomidae family, seed dispersal, 95–96

physiological self-incompatibility adaptation, 33

Piaractus brachypomus (red-bellied pacu), seed dispersal, 114

Piaya cayana (squirrel cuckoo), insect predation, 84

Picado, Claudio, 140–141

piercer behavior, hummingbirds, 47–48

pigeons, seed predation, 126

Pijl, L van der, 114, 115

pineapple (*Ananas comosus*), economic importance, 139

pine species, fire-based seed dispersal, 123

Pionus sordidus (red-billed parrot), seed predation, 154, *155*

Piper lanceifolium, seed dispersal, *96*

Piranga rubra (summer tanager), 84, *85*, 188

piranhas (*Serrasalmus*), seed dispersal, 126

pirapitinga (*Piaractus brachypomus*), 114, 126

pistils, structure, 13

Pitcairnia species, *19*, *139*, *141*

Pithecellobium unguis-cati (catclaw blackbead), seed dispersal, *89*

Pithecia (sakis), seed predation, 124

Platystele jungermannioides, size, 176

Pleurothallis cordifolia, pollination, *179*

plum, hog (*Spondias mombin*), seed dispersal, 99

pochote flower (*Pachira quinata*), nectar theft, *81*

pollination, family/genera overviews: Bignoniaceae family, 137–139; *Bomarea* species, 136–137; bromeliads, 141–142; *Cecropia* species, 144; Clusiaceae family, 146–148; *Coriaria* species, *148*, 149; Ericaceae family, 150–151; Fabaceae family, 152–154; *Ficus* species, 171–173; *Hedyosmum* species, 144; *Heliconia* species, 157–158; Lauraceae family, 160; Loranthaceae family, 162; Marcgraviaceae family, 164–166; Melastomataceae family, 168–169; Orchidaceae family, 176–181; Passifloraceae family, 184–186; Rubiaceae family, 187–188; *Siparuna* species, 190; Solanaceae family, 192–194; Viscaceae family, 162

pollination processes, generally: flower constancy factor, 70–71; flower structure advantages, 13–17; pollen transport, 17–18; rewards for pollinators, 18–25; signals to pollinators, 25–31

pollination syndromes: overview, 38–41; bird category, 44–48, 64; lizard category, 48–50; mammal category, 41–43; water category, 69; wind category, 67–69. *See also specific pollinated flower entries, e.g.,* bat-pollinated flowers; hummingbird-pollinated flowers

pollination syndromes, insect category: overview, 38–40; ants, 67; bees, 52–55; beetles, 59–62; butterflies, 62–64; flies, 38, 57–59; moths, 65–66; thrips, 67; unspecialized species, 50–52, 62; wasps, 55–57. *See also specific pollinated flower entries, e.g.,* bee-pollinated flowers; hawk-moth-pollinated flowers

pollinator crisis, overview, 4–8

Polystachya species, pollination, 178

Pongo pygmaeus (Bornean orangutan), seed dispersal, *94*

poppies: flower structure, 13; pollination, 19; seed dispersal, 119; self-incompatibility adaptation, 33, *34*; symbolism of, 1

Populus tremuloides (quaking aspen), Utah grove, 37

porterweed (*Stachytarpheta frantzii*), *39*, *53*

Posoqueria latifolia (needle flower), pollination, 187

possum, honey (*Tarsipes rostratus*), pollination, 42

postdispersal seed predators, 128–129

potato family, overview, 191

predation risks: defense mechanisms, 81–82, 88, 183–184, *185*; flowers, 80–83, 147–148; fruits, 88, 126, 129; hummingbirds, 84; insects, 84, *85*, 172, *174*; lizards, 156; nectar, 80–81, 136, 138–139, 142

predation risks, seeds: overview, 86, 124; birds, 112–113, 124, 126–128, 175; defense mechanisms, 88, 111, 155; fishes, 126; insects, 126; mammals, 100, 124, *125*, 128–129, 159. *See also* seed dispersal *entries*

primates, seed dispersal, 96–97. *See also* monkeys

primrose, European (*Primula vulgaris*), flower structure, 35

Primula veris (cowslip), flower structure, 35, *36*

Probergrothius sexpunctatus (pyrrhocoreid bugs), pollination, *11*

proline, bat flowers, 41–42

Promerops cafer (Cape sugarbird), pollination, 45

protandry, overview, 33

protea, pincushion (*Leucospermum cordifolium*), pollination, 45

Protea species, pollination, 42

protogyny: overview, 33–34, 36; in arum family overview, 60–61; in *Ficus*

species overview, 172; in Lauraceae family overview, 160

Psammisia aberrans, pollination, *150*

pseudocopulation, 32, 55, 57, 179–180

Pseudocreobotra species (mantises), 84, 85

pseudoflowers, 72–73, *74*

pseudonectaries, 72–73

pseudopollen, 72–73

Psiguria (cucurbit vine), pollination, *64*

Psittacanthus species, color signals, 162

Psychotria species, *26*, 187–189

Pterocarpus michelianus (leguminous flowers), pollination, *43*

Pteropodidae family, overview, 95

Pulsatilla vulgaris (pasqueflower), 13, *14*

puncturevine (*Tribulus terrestris*), seed dispersal, 115–116

Puya raimondii, size, 140

pyrrhocoreid bug (*Probergrothius sexpunctatus*), pollination, *11*

Pyrrhula pyrrhula (Eurasian bullfinch), flower predation, 80

pyrrolizidine alkaloids, 23, *24*, 64

quandong, blue (*Elaeocarpus angustifolius*), seed dispersal, 107–108

Quararibea cordata (chupa-chupa tree), pollination, 42–43

Quararibea costaricensis, pollinators, 39–40

quetzals (*Pharomachrus* species), viii, 104–107, 160

quinine family, medicinal uses, 186

racket-tail, booted (*Ocreatus underwoodii*), *178*

radial symmetry, pollinator benefits, 15, 52

radish, wild (*Raphanus raphanistrum*), color signals, 27

Rafflesia arnoldii (corpse flower), structure, 75

Raguso, R. A., 25

raintree (*Albizia saman*), seed predators, 126

Ramphastos swainsonii (chesnut-mandibled toucan), *105, 109,* 110

Ramphocelus passerinii (scarlet-rumped tanager), seed dispersal, 123

Ranunculus acris (common meadow buttercup), reproduction, 37

rapeseed (*Brassica napus*), economic importance, 4

Raphanus raphanistrum (wild radish), color signals, 27

Ravenala madagascariensis (traveler's palm), pollination, 43

resins, floral, 22–23, 146–147

Rhagonycha fulva (red soldier beetle), pollination, *50*

Rhododendron species, 149–150

ribbonweed (*Vallisneria spiralis*), pollination, 69

rice, 1–2, 5

Richea scoparia (honey bush), pollination, 49

Ricinus communis (castor-oil plant), flower structure, 37

Rio Declaration, 8

rockroses, pollination, 19

rodents, 42, 100, 124, 125, 128, 169

Romulea sabulosa (satin flower), structure, *14*

Roosmalen, M. G. M. van, 86

rose, Guelder (*Viburnum opulus*), structural characteristics, 73

rowan berry (*Sorbus aucuparia*), seed dispersal, 87

rubber tree (*Hevea brasiliensis*), seed dispersal, 117

Rubiaceae family, overview, 186–189

Rubus species, 51, 88, 106–107

Rupicola peruvianus (cock-of-the-rock), seed dispersal, 110

Ruyschia species, pollination, 166

sabrewing, violet (*Campylopterus hemileucurus*), 80, 142

Saimiri sciureus (squirrel monkeys), seed predation, 173–174

saki species, seed predation, 124

salator species, seed dispersal, 123

Sambucus peruviana (elderberries), seed dispersal, *102*

sandbox tree (*Hura crepitans*), seed dispersal, 117

Sarcopera species, overview, 165–167

Sargent, Sarah, 163

satin flower (*Romulea sabulosa*), structure, *14*

Saurauia montana, seed dispersal, *98*

scabious, field (*Knautia arvensis*), pollination, 66

scatter hoarders, seed dispersal, 111–113

scent guides. *See* olfactory *entries*

Schemske, D. W., 72

Schistes geoffroyi (wedge-billed hummingbird), 80, 178

Schwartzia costaricensis, 165, 167

Sciara hemerobiodes (dark-winged fungus gnat), pollination, 50

Sciurus variegatoides (variegated squirrel), nectar thieving, *81*

scopolamine, uses, 191

Scrophularia nodosa (common figwort), pollination, 56

sea heart (*Entada gigas*), seed dispersal, *121, 122*

seasonality factors, flowering and fruiting, 130–132

secondary pollen presenters, 18

seed dispersal: human transport, 3, 115–116; importance of, 86, 91; rewards timing, 12

seed dispersal, family/genera overviews: Bignoniaceae family, 139; *Bomarea* species, 137; bromeliads, 142–143; *Cecropia* species, 144; Clusiaceae family, 148; *Coriaria* species, 149; Ericaceae family, 151; Fabaceae family, 154–155; *Ficus* species, 172–175; *Hedyosmum*

species, 144–145; *Heliconia* species, 158–159; Lauraceae family, 160–161; Loranthaceae family, 162–164; Marcgraviaceae family, 166–167; Melastomataceae family, 169–170; Orchidaceae family, 181–182; Passifloraceae family, 186; Rubiaceae family, 188–190; *Siparuna* species, 191; Solanaceae family, 194–196; Viscaceae family, 163–164

seed dispersal syndromes: overview, 92–93; adhesive structures, 114–116; amphibians, 113; explosive pods, 116–117; fire, 122–123; fish, 113–114; gravity, 117–118; invertebrates, 114; mimicry, 123; reptiles, 113; water, 119–122

seed dispersal syndromes, bird category: overview, 102; consumption adaptations, 108–111; high-quality fruits, 104–108; low-quality fruits, 102–104; scatter hoarders, 111–113

seed dispersal syndromes, mammal category: overview, 86, 93–94; adhesive structures, 114–115; arboreal carnivores, 96–98; elephants, 99–100; fruit bats, 95–96; Pleistocene megafauna, 100–102; primates, 96–97; terrestrial carnivores, 100; ungulates, 98–99

seeds, overview, 86–91

Selasphorus rufus (Rufous hummingbird), migration, 44

self-incompatibility adaptations, 33–37

self-pollination: prevention adaptations, 33–37; processes of, 31–32

sensory billboard idea, 25–26

sepals, arrangement types, 13–17

Sephanoides sephanoides (green-backed firecrown), pollination, 44

Setophaga petechia bryanti (mangrove warbler), pollination, 46

Shilton, Louise, 95

Shingle plant family, overview, 165–167

Siparunaceae family, overview, 190–191

Siparuna species, 78, 190–191

skink, snow (*Niveoscincus microlepidotus*), pollination, 49

Skutch, Alexander, 147, 170

sloth, brown-throated (*Bradypus variegatus*), on *Cecropia* tree, 142

snake, blunt-headed tree (*Imantodes cenchoa*), lizard predation, 156

Snow, David, 92–93, 107, 132, 163, 170, 175

snowcap (*Microchera albocoronata*), pollination, 187

Sobralia ecuadorana (one-day orchid), flower timing, 176

Solanaceae family, overview, 191–195

Solanum species, 54, 95, 191–192

Solidago canadensis (Canadian goldenrod), pollination, 57

solitaire, black-faced (*Myadestes melanops*), 189, 195

sonar guides, 30–31, 154, 164. *See also* bat *entries*

Sorbus aucuparia (rowan berry), seed dispersal, 87

Souroubea species, pollination, 166

spadix structure, aroids, 60–61, 74

Spanish moss (*Tillandsia usneoides*), 139, 140

Spathodea campanulata (tulip tree), ornamental value, 137

spatial incompatibility, self-pollination avoidance, 35

spice bush (*Eupomatia laurina*), 59, 79

spiders, crab, insect predation, 84

spiderwort (*Tradescantia*), pollination, 20

spittlebugs, *Heliconia* nesting, 156

Spondias mombin (hog plum), seed dispersal, 99

Sprengel, Christian, 27

squirrels, 81, 159

Stachytarpheta frantzii (porterweed), 39

stamens, family/genera overviews: Clusiaceae family, 146; Fabaceae family, 152; Melastomataceae family, 168–169; Rubiaceae family, 187; *Siparuna* species, 190; Solanaceae family, 192

stamens, generally: in flower structure, 13, 20, 71; in pollination process, 18, 35, 79; self-incompatibilty adaptations, 35, 36

Stanhopea wardii, pollination, 181, 182

Stapelia acuminata (carrion flower), pollination, 75

starfish flowers (*Stapelia*), pollination, 75

Steatornis caripensis (oilbird), 106, 107

stigmas: bisexual flowers, 31, 32, 33; for intersexual mimicry, 72; in Lauraceae family overview, 160; in Passifloraceae family overview, 183, 185–186; pollination role, 13, 17; self-incompatibilty adaptations, 34, 35; in *Siparuna* species overview, 190; skink-pollinated flowers, 49; trap flowers, 76; wind-pollinated flowers, 67, 68; yucca moth pollination, 78

Stiles, Gary, 164–165

Strangalia maculata (longhorn beetle), pollination, 51

strangler figs, 170–171, 173–174

Streptosolen jamesonii (marmalade bush), color signals, 191

structural characteristics: bird-pollinated flowers, 46; as deceitful pollination strategy, 72–73; hybridization prevention, 71; insect-pollinated flowers, 50–53, 56–62, 65, 66; mammal-dispersed seeds, 95, 96; trap flowers, 76–77; wind-dispersed seeds, 118; wind-pollinated flowers, 67

structural characteristics, family/genera overviews: *Bomarea* species, 136–137; bromeliads, 140–142;

Cecropia species, 144; Clusiaceae family, 146–147; Ericaceae family, 150–151; Fabaceae family, 151, 152, 153; *Ficus* species, 172; *Handroanthus* species, 138; *Hedyosmum* species, 144–145; *Heliconia* species, 157–158; Loranthaceae family, 162; Marcgraviaceae family, 164–166; Melastomataceae family, 168–169; Orchidaceae family, 176; Passifloraceae family, 183, 184–186; Rubiaceae family, 187–188; *Siparuna* species, 190; Solanaceae family, 192, 194. *See also* seed dispersal, family/genera overviews

Sturnira ludovici (highland yellow-shouldered bat), seed dispersal, 95

sugarbird, Cape (*Promerops cafer*), pollination, 45

sunangel, gorgeted (*Heliangelus strophianus*), pollination, 169

sunbirds, 45, 46, 147, 178

sunflower (*Helianthus*), structure, 18

Swaine, M. D., 117

Swainsona formosa (Sturt's desert pea), flower structure, 17

swallow, blue-and-white (*Notiochelidon cyanoleuca*), insect predation, 172, 174

sycamore (*Acer pseudoplatanus*), seed dispersal, 89

sylph, violet-tailed (*Aglaiocercus coelestis*), pollination, 48

Symphonia globulifera, 80, 145–147

Tabebuia species, overview, 137–139

Tacca integrifolia (white bat flower), pollination, 75, 76

tambaqui (*Colossoma macropomum*), 114, 126

tanagers: in Ericaceae family overview, 151; in Fabaceae family overview, 155; fruit spoiling, 126; insect predation, 84, 85; in Rubiaceae family over-

view, 188; seed dispersal, 104, 109, 123, 128

tank bromeliads, 140–141, 142

tapir, Baird's (*Tapirus bairdii*), fig seed dispersal, 99

Tarsipes rostratus (honey possum), pollination, 42

teasels (*Dipsacus*), ant defenses, 83

Tegeticula yuccasella (yucca moth), pollination, 78–79

Telipogon, insect mimicry, 180

temperate climates, flowering/fruiting timing, 130–132

temporal incompatibility, self-pollination avoidance, 33–34

tent bats, *Heliconia* roosting, 156

tepals, types, 13–15

Terborgh, J., 42

Terminalia catappa (almond tree), seed predation, 127

territorialist behavior, hummingbirds, 47–48, 71, 157

Theobroma cacao (cacao), 2, 3c, 59

thermogenesis and insects, 23

thimbleberry, red (*Rubus rosifolius*), seed dispersal, 106–107

thistle, spear (*Cirsium vulgare*), pollination, 20

Thraupis species (tanagers), seed dispersal, 123, 128

Threnetes ruckeri (band-tailed barbthroat), pollination, 158

thrips, pollination, 67

thrum form, flower structures, 35

thrush species, 102, 132, 167, 189

Thyroptera tricolor (disk-winged bats), *Heliconia* hosting, 156

Tillandsia usneoides (Spanish moss), 139, 140

tityra, masked (*Tityra semifasciata*), avocado seeds, 160

tobacco family, overview, 191

toucan, chestnut-mandibled (*Ramphastos swainsonii*), 105, 109, 110

toucanet species, 12, 123, 129, 189

Tournefortia glabra, butterfly rewards, 24

Tradescantia (spiderwort), pollination, 20

trample burs, perils, 115

trap flowers, 34, 59, 61, 76–77

trapliner behavior, hummingbirds, 47–48, 71, 157–158

Traveset, A., 88

Trema, seed dispersal, 103

Trianaea species, blooming patterns, 194

Tribulus terrestris (puncturevine), seed dispersal, 115–116

trichomes, epiphytic bromeliads, 140

Trichosalpinx dura, pollination, 56

Trigona species (stingless bees), pollination, 72

Triplaris cumingiana, seed dispersal, 118

Trochetia species, color signals, 50

trogon, black-headed (*Trogon melanocephalus*), 109, 110

tropical climates, flowering/fruiting timing, 130–132

trumpet trees (*Handroanthus* species), 132, 137–139

tubular flowers, structure, 15–16

tulip tree (*Spathodea campanulata*), ornamental value, 137

tumbleweeds, seed disperal, 119

Turdus species, 87, 167

tyrannulet, mistletoe, seed dispersal, 162–163

Tyrannus species (kingbirds), feeding patterns, 102

tyrosine, bat flowers, 41–42

uakaris (*Cacajao*), seed predation, 124

Ulmus glabra (English wych elm), flower structure, 19

umbellifer family, unspecialized pollinators, 50–52

ungulates, seed dispersal, 93, 98–99, 125

unisexual flowers, overview, 36–37
United Nations, pesticide statement, 8
Urosticte benjamini (purple-bibbed whitetip), pollination, *30*

Vaccinium species, economic importance, 149
Valido, A., 50
Vallisneria spiralis (ribbonweed), pollination, 69
van der Pijl, Leendert, 38
Vanilla species (orchids), 176, 182
Varecia variegata (black-and-white ruffed lemur), pollination, 43
Varroa destructor, threat from, 7
velvet patches, bee orchids, 55, 180–181
violetears (*Colibri* species), *19*, 147, 162
violets, pollination timing, 32
viper, eyelash pit (*Bothriechis schlegelii*), 84, 187
Virola calophylla, seed dispersal, 128–129
Viscaceae family, overview, 161–164
viscin, mistletoe seed dispersal, 163
Vogel, S., 55
Volucella zonaria (hornet hoverfly), pollination, *58*

Wallace, Alfred Russel, 94
warbler, mangrove (*Setophaga petechia bryanti*), pollination, *46*
warmth rewards, 23, 25, 60–61
Warszewiczia coccinea, pollinators, 187–188
wasp-pollinated flowers, family/gen-

era overviews: *Ficus* species, 171–173, *174*, *175*; Loranthaceae family, 162; Orchidaceae family, 178, *179*–180; Viscaceae family, 162
wasps: coevolution with figs, *50*, 78, 134; passion flower protection, 184; pollination overview, 29, 56–57; predators of, 84, *85*
water barriers, 83
water-dispersed seeds, 119–122, 155
water lilies, 13, 61, *69*, 120
water pollination, 69
waterweed, Canadian (*Elodea canadensis*), seed dispersal, 120
The Web of Adaptation (Snow), 92–93, 107
weevils (*Elleschodes*), pollination, 79
Welwitschia mirabilis, 10, *11*
Werauhia species, 80, *141*, 142
wheat, 1–2, 5, 7
Whitaker, A. H., 48–49
whitetip, purple-bibbed (*Urosticte benjamini*), pollination, *30*
Whittaker, Robert, 95
whorl arrangements, 13
wild bees, importance, 5–7. *See also* bee *entries*
Willmer, P., 57
willowherb, rosebay (*Chamerion angustifolium*), self-incompatibility adaptation, 33
wind-dispersed seeds: overview, 118–119; in Bignoniaceae family overview, 139; in Bromeliaceae family overview, 142–143; habitat common-

alities, 86; in Orchidaceae family overview, 182
wind pollination: overview, 67–69; in *Cecropia* species overview, 144; climate factors, 41; in *Coriaria* species overview, 149; flower structures, 17, *19*, 32; food crops, *2*, 5; fossil evidence, 10, 38–39; in *Hedyosmum* species overview, 144; trees, 10, 36
Winston, Mark, 8
witches' fingers (*Iochroma calycinum*), flower structure, *16*
Witheringia species, seed dispersal, 195
wolf, maned (*Chrysocyon brachyurus*), seed dispersal, 100
woodpeckers (*Melanerpes* species), seed dispersal, 112–113, 148
woodstar species, pollination, *39*, 150

Xanthosoma undipes (elephant's ear arum), olfactory signals, 60–61
Xenohyla truncata (tree frog), seed dispersal, 113

yesterday-today-and-tomorrow (*Brunfelsia pauciflora*), 27, 191
Yucca species, pollination, 78–79

Zostera (eelgrass), pollination, 69
Zygaena filipendulae (six-spotted burnet), pollination, 66
zygomorphic flowers, 15
Zygothrica (fruit flies), pollination, 74, *75*